BRITISH MUSEUM

OCCASIONAL PAPER NUMBER 116

THE INTERFACE BETWEEN SCIENCE AND CONSERVATION

edited by Susan Bradley

BRITISH MUSEUM OCCASIONAL PAPERS

Publishers: The British Museum
Great Russell Street
London WC1B 3DG

Production Editor: Josephine Turquet

Distributors: British Museum Press
46 Bloomsbury Street
London WC1B 3QQ

Occasional Paper No. 116, 1997

The Interface between Science and Conservation
Edited by Susan Bradley

ISBN 0 86159 116 X
ISSN 0142 4815

Front cover: A pastiche of a Roman mirror exposed by the signature of its maker A.P.Ready, Restorer, British Museum, 1930.
(See Podany and Scott page 214, and Figure 5.)

For a complete catalogue giving information on the full range of available Occasional Papers
please write to:
The Marketing Assistant
British Museum Press
46 Bloomsbury Street
London WC1B 3QQ

Printed and bound in the UK by The Chameleon Press Limited

CONTENTS

FOREWORD

It is a truism to say that there are too many conferences being organised these days. So why are we organising another? The answer is that we recognise the importance of bringing colleagues to the British Museum and we have, hopefully, organised a conference on a subject which has not been excessively explored before. At the Conservation Department in the British Museum we feel that we are well-placed to host a meeting on the interface between science and conservation as we have a large number of dedicated conservators *and* a team of conservation scientists.

So what is the role of these scientists? Are they only there to trouble shoot for the conservators or to carry out research projects requested by conservators? The answer, of course, is that they do both of these things, but also much much more. Conservation science *is* a speciality in its own right in which scientists, usually with a background in chemistry or materials science, develop an understanding of why and how museum objects deteriorate and then research into methods and materials for arresting that deterioration. In fact, interventive (active) conservation with an emphasis on maximum cleaning and full restoration has been giving way for some time to carefully thought out conservation regimes based on minimum intervention (careful cleaning and stabilization) combined with controlling the ambient relative humidity, temperature and light levels. Hence, one of the current growth areas of conservation science is a study of the environment with an increasing interest in pollution.

The 'interface' is important because of the all-too-frequent failure of disparate groups to communicate. Thus, however wonderful the discoveries of the conservation scientists are, if they fail to communicate them to the conservators they have wasted their time. And failure to communicate has been a perpetual complaint of conservators in general during the past two or three decades, surfacing, in particular, in the perennial moan that *Studies in Conservation* is too scientific.

Hopefully this will change as the formal teaching courses in conservation better tailor their scientific content to the real needs of the students *as perceived by conservators*, and not necessarily as perceived by the scientists available to do the teaching. Thus it is very relevant that one of the topics of the following pages *is* science in the education of conservators. Other topics are the conservation scientist, scientific research in conservation, new directions in conservation, and an examination of the interface. It remains to be seen whether the problem of 'communication' is aired.

When I joined the British Museum Research Laboratory in 1966, the Keeper was Dr A.E. Werner, for whom it was a pleasure to work. Tony Werner started his career teaching chemistry at Trinity College, Dublin, and came to the British Museum in 1954 via the Scientific Department of the National Gallery where he had served under F.I.G. Rawlins, (a founding fellow of IIC and its first Secretary General) who was the Scientific Advisor to the Trustees at that time. At both the National Gallery and at the British Museum (where he became Keeper of the Research Laboratory in 1959 following the 'retirement' of Harold Plenderleith) Tony Werner researched the application of modern synthetic materials for the conservation of antiquities and works of art. Close collaboration with conservators was fundamental to his way of working and it is both appropriate and a pleasure, therefore, to dedicate this volume to him.

Andrew Oddy
February 1997

This volume is offered to

A. E. ANTHONY WERNER

M.A., M.SC., D.PHIL., F.S.A., F.M.A.

Keeper of the British Museum Research Laboratory 1959-75
Professor of Chemistry, Royal Academy 1962-75
Chairman Pacific Regional Conservation Centre 1975-82

A tribute from friends and colleagues in the world of conservation

ACKNOWLEDGEMENTS

When I suggested that the theme for this conference should be 'The Interface between Science and Conservation', I knew that the editing and production of the preprints, and the organisation of the conference would be a lot of work, but even my expectations have been exceeded.

I would like to start by thanking the authors of the papers (and speakers), without them there would be no conference; Vivienne Tremain and Anita Martin for word processing the papers, through several drafts; Sara Carroll for checking the final scripts for grammar and consistency in spelling; and Josephine Turquet the Editor for the Occasional Paper Series for layout and production, and for her enthusiasm for the project.

I would also like to thank Sara Carroll and the rest of the Department of Conservation Administration Group, particularly Stella Lyne and Brenda Burr for the organisation of the conference. They have been cheerful and supportive throughout.

The Department of Conservation acknowledges with gratitude the support of the Samuel H. Kress Foundation.

Susan Bradley
4 March 1997

THE IMPACT OF CONSERVATION SCIENCE IN THE BRITISH MUSEUM

Susan Bradley

ABSTRACT

The role of the conservation scientist is to act as an interpreter between science and conservation. Since 1919 scientists in the British Museum have been struggling with this role. By carrying out research into deterioration and conservation they have contributed much to the long term preservation of the collection. By working with staff outside conservation they have been able to extend their involvement in collection care and have a real impact on the Museum.

Key Words

conservation, science, research, deterioration, materials, treatment, storage, environment

INTRODUCTION

Scientific conservation of antiquities is based on a sound knowledge of the collection and its purpose, coupled with a good understanding of deterioration, and of strategies for preventing deterioration and for treatment. The regular monitoring of the objects after conservation is also of importance. The role of the conservation scientist is to act as an interpreter between science and conservation, bringing together scientific knowledge, conservation knowledge and curatorial knowledge to produce a scientific approach to conservation. To do this there must be a dialogue between the scientist, the conservator and the curator. The scientist cannot simply say 'bring me your problems and I will solve them'. Such an approach is fraught with problems. It is the author's view that the achievement of an appropriate dialogue is dependent on the close proximity of the different disciplines, such as is achieved in the British Museum, coupled with a respect for the knowledge and skills, indeed the professionalism, of colleagues from the other disciplines.

The benefits which have accrued from systematic research carried out by the conservation scientists employed in the British Museum extend much further than improvements in the materials and methods used by conservators. They extend into almost every aspect of collection care.

THE EARLY YEARS

The British Museum has employed scientists to investigate deterioration and conservation of the collection since 1919, when Alexander Scott was seconded to the Museum for a period of three years. Scott recommended that scientists be permanently employed in the Museum, and in 1922 the Research Laboratory was set up. Scott held the post of Director from 1931 to 1938, when Harold Plenderleith became the Keeper, a post which he held until 1959. Under his Keepership a wide range of investigations were carried out. The breadth of the work allowed Plenderleith to write the first comprehensive text on conservation (Plenderleith 1956). In order to understand the processes of deterioration it was necessary to know what the objects were made of, and the nature of the alteration products. At that time there was no distinction between the scientists working on conservation problems, and those working on technology. All efforts combined to increase the understanding of deterioration, and the devising of methods for conservation.

The Scientists

The scientists working on the collections came from the main scientific disciplines. They applied their scientific knowledge to the multiplicity of problems affecting the collection, benefiting from the small volume of literature which existed on the deterioration and conservation of collections. Scott and Plenderleith identified the problems associated with pollutant gases in the atmosphere, and with gases given off by materials used in the storage and display of the collection. They correctly diagnosed the adverse effects of high humidity on the stability of metals, and the problems associated with the presence

of soluble salts in porous materials. Their work focused on analysing objects to identify the materials present and how they were made; and devising treatments. Some of the early treatments are still in use today, but many are now considered inappropriate. However our views are tinged with the benefit of hindsight. How the treatments we devise stand up is yet to be seen.

In the 1920s and 1930s the number of materials used in the treatment of objects was much smaller than it is today. The common chemicals we use were readily available. Materials for use as adhesives, fillers and consolidants were mainly natural products such as animal glue, dammar resin and waxes, such as bees wax and paraffin wax, and plaster of Paris. Synthetic materials were available, and widely used for many purposes, including household and industrial adhesives. Wisely the great majority of these materials were not used in the treatment of the collection. Plenderleith voiced his concern about the use of cellulose acetate in the Barrow process for laminating documents, '..cellulose acetate may be accepted as innocuous and durable, the sheets for laminating contain a relatively high percentage of plasticizer and it is by no means certain that this will remain in the film indefinitely...' (Plenderleith 1966, 60-2). Cellulose nitrate was the first synthetic adhesive to gain widespread use in conservation in the Museum. The use of other synthetic resins and adhesives did not start until the early 1950s, their introduction being largely pioneered by Tony Werner who joined the staff of the Research Laboratory in 1954, and was Keeper from 1959-75. The scientists recognised that discolouration, loss of adhesion and insolubility were problems likely to be associated with the materials they introduced, but it was not until later that systematic testing was introduced. There was also no control over how the materials were used, and misuse, or excessive use has created problems, as has been seen with soluble nylon.

In the 1950s the first large scale preventive conservation strategy was successfully implemented in the Museum. Working with Mavis Bimson, Robert Organ studied the problem of weeping and crizzling glass. They concluded that the problem could be controlled by keeping weeping glass at a relative humidity of below 42%, the equilibrium relative humidity of potassium carbonate, which they had identified as the deliquescent salt on the surface of weeping glass. As a result of this work, a dehumidified case was constructed for the storage of the Museum's weeping glass (Organ and Bimson, 1957). Later, by

careful experimental work, Organ showed that bronze disease could be prevented by controlling the relative humidity to below 40% (Organ 1963). As a result, dehumidified showcases and a store room were created for the collection of bronze artefacts in the Department of Western Asiatic Antiquities. Both strategies are still in use and have proved to be successful in preventing continued decay.

Tony Werner investigated the deterioration of a group of sculptures from India. Using information supplied by S. Paramasivan, Government Chemist of the Archaeological Survey of India (Paramasivan 1960), he correctly assigned the deterioration to the high levels of, and fluctuations in, the moisture content of the air in London. A controlled environment store was created and the sculptures arranged as if in a gallery to allow access for scholars. It was not until the 1980s, when a petrologist was employed, and new diffraction equipment purchased, that a full investigation of the stone linked the deterioration to its chemistry and mineralogy and confirmed the strategy for preservation (Bradley and Freestone 1992).

The scientists working on conservation during the period 1919-1966 established scientific conservation, and scientific research, as central to the preservation and understanding of the collection in the Museum.

The Conservators

When Scott joined the Museum there were few staff employed to conserve or restore the collection, and there were certainly no trained conservators. In the nineteenth and the first half of the twentieth century the staff working on the collection were craftsmen, often employed to undertake specific tasks, and later employed permanently as museum assistants. They worked in the curatorial departments and their work was controlled by the curatorial keepers.

Craftsmen (conservators) were also employed in the Research Laboratory to work on the treatment of objects. They were thought of as an elite group. Their work was largely dependent on the work being carried out by the scientists. Although they could work on any objects from the collection, they were mainly involved in the manufacture of complex facsimiles, and on the dismantling and conservation of complex metal objects. Herbert Maryon worked in the Laboratory from 1945-63 when he reconstructed the objects from Sutton Hoo. Maryon was an expert in metalworking and had produced one of the

standard texts on the subject (Maryon 1912). There was considerable cooperation between the scientists and the conservators, which appears to have been born of mutual respect and working there was seen as a pleasure (McIntyre 1997). In the Research Laboratory collaboration between scientist and conservator was a serious endeavour.

The employment of craftsmen to undertake conservation work had continued for two reasons; their highly developed skills; and the lack of training courses for conservators. What was probably the first training course in Conservation was set up at the Institute of Archaeology in London in the mid to late 1950s by Ione Gedye. The first conservators from that course were employed in the Museum in 1959-61. They had the advantage of a scientifically based training in conservation. In 1964 the Museum created a conservation grade, and all those employed on the conservation of the collection were transferred to this grade. Now most of the Museum's conservators have been trained in a conservation discipline, and have, to varying degrees, received some training in science. This, and the organisation of conservation in the Museum have changed the nature of the scientist-conservator relationship.

1966-97

Thirty years ago the work of the conservation scientist in the British Museum was, to a large extent, reactive. Apart from going into stores or conservation workshops to sample objects and to advise on treatments, the scientists domain was the laboratory. Conservators visited the laboratory to ask questions about conservation practice and materials, often leaving bits of objects for experimentation. However there was much more involvement with practical conservation than there is today, and in part this must be attributed to the interest in practical techniques shown by Andrew Oddy, who joined the Research Laboratory in 1966 and who is now Keeper of Conservation. When in 1972 the author joined the laboratory to work as a conservation scientist, one conservator, Hannah Lane, was a member of the research team. For a number of years there were also one or two students from the Institute of Archaeology Conservation course carrying out the work for their final year project. At this time the link with the Institute of Archaeology was strong, to the extent that the staff of the laboratory collaborated with the Institute to put on an annual 'Short course for

Conservation'. Through these activities, teaching conservation, helping students, and carrying out occasional treatments ourselves, the scientists achieved a level of knowledge of conservation practice, and a perception of the conservator view point, which it is difficult to achieve today.

Within the Research Laboratory the division between those scientists working on conservation based problems and those working in archaeometry was already apparent. With the creation of the Department of Conservation in 1975, they were split between two departments, although the two groups continued to (and still do) use the same equipment and exchange information. Two conservation scientists, the author and Vincent Daniels, were transferred to the new department, to form what was to become the Conservation Research Group. Now there are six scientists in the group each with, or developing, a specific area of expertise.

The changing scientist–conservator relationship

When the Department of Conservation was formed conservators from the curatorial departments and the conservation scientists were brought together in the new department. The potential of this reorganisation to have a positive influence on research work was not clear at first In fact one of the first effects was to distance the scientists from the conservators when working conservators were removed from the laboratory. This left us rather isolated, a situation which was reinforced as the conservators worked to establish the new structure, and make the change from general to specialist conservator in material based sections. This change left the scientists as the only group in the Department working on all the materials in the collection.

The new system put in place a hierarchy for the conservators, and changed the way they interfaced with the conservation scientists. For quite a long time popping in to ask a question simply did not happen. This was a loss to the scientists, because we became less well informed about the conservation work which was being undertaken. However it had an advantage, in that we were freed to undertake some more speculative research. At this time, investigations on the use of low pressure plasma (Daniels et al. 1979), and on the use of Paralyene, a protective polymer deposited from the vapour phase (work which was not published), took place. Neither was introduced into conservation in the Museum. During this work there

was little interaction with the conservators, something which is likely to have affected their enthusiasm for both projects.

Whilst working on a method for rebacking mosaics (Bradley et al. 1983) the importance of regaining an understanding with the conservators became apparent. This work was the focus of much discussion between the Keeper of Conservation, the Head of Conservation Research, the author, the Head of Ceramics Conservation and the curators. It did not involve the conservator who was actually carrying out the conservation of mosaics. When asked to prepare samples and to assist with bend tests, using a 'home made' three point bend apparatus, the conservator's view of how the tests should be conducted was found to diverge from that of the author. It was obvious that if the conservator had been involved in the discussions an appreciation of the different aspects of the experimental work would have been gained. Equally, the author would have been aware of the conservator's concerns, which did not emerge in the discussions, but were valid.

Since then the scientists have made considerable efforts to involve conservators in their work. The most important part of any research project is to define the problem and the aims. This requires discussion with the requestor, who can be a scientist, conservator or curator; discussion with other staff, particularly curators, who may have relevant information, or a view on the outcome and end use of the work; and a literature review. The process finishes with a written project outline. It is not possible to target work precisely to the requirements of the collection without the input of the conservators and curators

Conservators are often involved in the experimental work by preparing test substrates or samples and occasionally conducting tests and making measurements. This should mean that our work on materials and treatments is appropriately targeted. It also allows those conservators who have had some science training, and have an interest in research, to use these skills. However many conservators do not have an interest in, or the requisite skills to undertake scientific research, but have highly developed conservation skills. It is important that these differences in people are respected. The training in scientific theory and practice and experimental design received by a scientist on a chemistry, physics or materials science course is at a totally different level from that received by a conservator on a conservation course. It cannot be effective for conservators to spend a lot of their time on scientific research when the institution employs scientists to undertake these activities. Nor would it to be right for scientists who have learned some conservation 'on the job' to undertake conservation work on the collection. In the present system of working the Museum benefits in both improved treatments and materials for conservation, and improved conservation skills.

Deterioration, materials and treatments

Understanding deterioration of the collection is of the greatest importance. Until we know what the cause is we cannot decide on an approach to treatment. Deterioration studies have been carried out on a number of groups of objects from the collection, some initiated by the scientists and some by conservators and curators. The studies have included Egyptian limestone sculptures (Oddy et al. 1976, Bradley and Middleton 1988), archaeological iron (Green and Bradley 1997) sugar objects from Mexico (Daniels 1996) and black dyed flax (Daniels 1997). Some of these, and other studies, have indicated that control of environmental factors is the best approach to controlling deterioration. The conservator still has to deal with objects which are already deteriorated; objects where the previous conservation, such as an adhesive or consolidant, has started to fail; and objects which are damaged or broken due to poor storage or handling. To do this work they need a combination of well developed practical skills and good conservation treatments and materials.

In the 1970s there was considerable interest in new materials amongst the conservators. Some of the first work undertaken by the scientists in the new Department was to put in place schemes for systematic evaluation of conservation materials. Different artificial ageing regimes, and testing procedures, were investigated before a standard approach was developed (Blackshaw and Ward 1983, Shashoua 1993). The standard approach allowed us to directly compare the results of tests carried out at different times, but it had to be extended to observe the effects of combinations of materials which we had found could adversely affect ageing properties (Bradley and Green 1987). Furthermore, comparing naturally aged samples of resins with artificially aged samples has given a clearer insight into the relevance of artificial ageing regimes. This approach was used when the stability of cellulose nitrate adhesive was investigated (Shashoua et al. 1990).

Through the introduction of this standard approach to the ageing and evaluation of materials, the scientists have been able to ensure that the materials we have tested and are used in conservation are long lasting and will not damage the objects on which they are used. This benefits the collection by reducing problems of deterioration caused by conservation materials and reducing the need for repeat conservation.

Testing materials and finding them suitable for the purpose envisaged is only one of the steps towards devising, or introducing a new conservation process. Ultimately the conservator has to make the process work, and the scientist has to stand back.

The author was lucky enough to be involved in a collaboration with conservators of stone objects which introduced organo silanes to the Museum, and produced some of the best conservation carried out in the Department of Conservation. We were faced with the need to conserve a number of highly deteriorated Egyptian limestone sculptures, and the failure of treatments for stone which had been used in the Museum. Organo silanes had been used successfully by other conservators, most notably in Italy and Germany. They had been designed as treatments for sandstone, and used with apparent success on marble, but were thought unsuitable for use on limestone. Working in the stone conservation workshop, and with the stone conservators led by Seamus Hanna, an investigation was undertaken which showed that organo silanes could be used on limestone (Bradley, 1985, Hanna 1984). The curator responsible for the sculptures was shown the results of the work at various stages, and supported the use of the materials on the highly degraded sculptures. When treatments were carried out there was a continuing dialogue between the conservators and the author on the issues which arose once the methods were put into practice. These treatments were carried out in the period 1983-87 and are now being reviewed. The objects have survived, which they would not have done without the treatment.

This type of close co-operation is beneficial to the conservator and the scientist, both learning how the other works and thinks. Unfortunately this level of co-operation is rarely achieved.

Environment and control

Today preventive conservation appears to be top of the conservation agenda, and the impression is given that implementing preventive strategies will replace the employment of conservators and save money. This is rubbish. Preventive conservation strategies should reduce the extent of deterioration and prolong the lifetime of the collection. Full air conditioning will provide a stable RH and temperature and reduced levels of pollutant gases and dust, creating a much improved environment for the collection. Simply by keeping objects clean the amount of remedial conservation needed will diminish. The problem is that for the British Museum, with a large collection of mixed materials, the cost of implementing such a strategy would be prohibitive.

Preventive conservation has to work alongside practical conservation, but it is a discipline in its own right, and one which needs different skills from those required for practical conservation. In the British Museum, preventive conservation has become the provence of the conservation scientists.

The scientists involvement in environmental matters started with an investigation of corrosion of objects on display. Some evaluation of materials used in the display of objects in the Museum had been undertaken prior to 1972, in response to objects corroding. A request from the Wallace Collection to investigate the tarnishing of silver objects within three months of being put on exhibition was the impetus for more structured research. A standard approach to the screening of materials was developed, and implemented as a routine part of the selection of materials for use inside showcases in new exhibitions (Oddy 1973, Blackshaw and Daniels 1978). We demonstrated the adverse effects some materials could have, and introduced a system whereby the designers had to consult us about materials before purchase. The consultation and testing process set up in 1972-3 has expanded to cover all the materials used in the display and storage of the collection.

However, there are materials which we cannot replace, and the use of wood products to make some of the internal fittings of showcases, such as backboards for pinning objects, is the most problematic. By regular monitoring of alteration in the collection the scientists have built up a picture of the risk involved in exposing objects to acid vapours given off by wood, and for the great majority of the collection, as yet, no quantifiable risk exists. However caution dictates that we select wood products which outgas least, and also look for ways of ameliorating the outgassing when required (Thickett 1997).

Testing materials removes several agents of decay from the collection, but pollutant gases are still present

in the air and one way of reducing their effect is to introduce scavenger systems. Scientists have been working with the Museum designers to remove sulphide containing gases from showcases used to display silver objects (Lee 1996, Lee 1997).

Through the introduction of a simple screening test the conservation scientists have become involved in many aspects of the exhibition process in the Museum working with the designers, architects and mechanical and electrical engineers. The staff who work in these areas are responsible for putting in the infrastructure which will maintain the environmental conditions required for the collection. Whether the strategy being suggested is simple, such as controlling relative humidity in a showcase, or complex, such as an air conditioning system, without their help and enthusiasm implementation will be impossible. Working with the staff in these areas, and with the conservators, and using their knowledge of the collection, the conservation scientists have been ideally placed to develop an overview of the environmental requirements for the collection and formulate an environmental policy (Bradley and Oddy 1993, Bradley 1996). The difference between the conservator's and the scientist's view of environment has been the approach taken. The conservator's view on environmental conditions was based on published data. The scientists looked at the conditions in which the objects were kept, and how the objects responded. The scientist's view was that when the objects were stable they would benefit from maintenance of existing conditions, rather than being subjected to other conditions on exhibition, or on loan.

In 1993 the author was asked to undertake a review of the storage strategy in the Museum (Bradley 1994). There are 160 separate stores at the four sites occupied by the Museum, and the review could not have been completed successfully without the support and assistance of other members of the conservation science team. Every store was visited, and the volume of objects, the quality of the storage, and the structure and environment of the room assessed. The potential for growth of the collection over the next 50 years was estimated, based on the increase in the collection during the previous 10 years. During the review it was possible to identify physical handling as the main cause of damage to the collection, a problem made worse by overcrowding. The recommendations made in the report were related to reorganisation to reduce the occurrence of physical damage in storage, and to make better use of available space, and to bring together objects of the same type where

environmental control was the best way of preventing deterioration. The main recommendation was to centralise all off site storage into one location, improving the quality of storage, access to the collection, and providing space to expand storage of the existing collection, and allow for growth of the collection. The recommendation to centralise off site storage, and one to create a centralised store for Egyptian stone sculpture and other sensitive stone objects, are in the process of implementation. Both will have a tremendous impact on collection care, and access.

CONCLUSIONS

Through systematic investigation of deterioration of groups of objects, and through the implementation of well documented procedures for evaluating conservation materials, the conservation scientists in the British Museum have provided a sound scientific base for the work undertaken by the conservators. By working not only with the conservators, but also with curators, designers, architects and engineers, the scientists have been able to design, and help in the implementation of environmental strategies which have improved collection care. The development of the British Museum Study Centre and the new stone sculpture store are particular examples of new initiatives which their work has helped to bring about.

If we had stayed in the laboratory conducting research this would not have been possible. By splitting our work between research in the laboratory, and involvement in issues in the wider Museum we have been able to contribute to both conservation and long term collection care, demonstrating the impact of conservation science in the British Museum.

ACKNOWLEDGEMENTS

I would like to thank Andrew Oddy for his support for the more recent work reported here, particularly the work on the storage of the collection; my colleagues in the Conservation Research Group, Vincent Daniels, Lorna Lee, Yvonne Shashoua, David Thickett and Richard Kibrya for their hard work; and conservator colleagues, past and present but particularly Hannah Lane, Hazel Newey, and Seamus Hanna from whom I have learned a lot.

REFERENCES

Blackshaw, S.M. and Daniels, V.D. 1978. Selecting safe materials for use in the display and storage of antiquities, in *5th Triennial Meeting, Zagreb 1978*, ICOM-CC, 78/23/2/1, ICOM, Paris.

Blackshaw, S. and Ward, S. 1983. Simple tests for assessing materials for use in conservation, in *Resins in Conservation* (eds J.O. Tate, *et al.*), SSCR, 2/1-2/15, Edinburgh.

Bradley S.M. 1985. Evaluation of organo silanes for use in consolidation of sculpture displayed indoors, in *Vth International Congress of Deterioration and Conservation of Stone* (ed G. Felix), Press Polytechniques Romands, 759-68, Lausanne.

Bradley, S.M. 1996. Development of an environmental policy for the British Museum, in *11th Triennial Meeting, Edinburgh 1-6 September 1996* (ed J. Bridgland), ICOM-CC, vol 1, 8-13, James and James, London.

Bradley, S.M., Boff, R.M. and Shorer, P.H.I. 1983. A modified technique for the lightweight backing of mosaics, *Studies in Conservation*, **28**, 161-70.

Bradley, S.M. and Freestone, I. 1992. A note on the chemistry and petrology of the Amaravati stone, its susceptibility to deterioration and the strategy for its preservation, in Knox, R. *Catalogue of the Amaravati Sculptures*, BMP, 230-1, London.

Bradley S.M., and Green L.R. 1987. Materials for filling and retouching ceramics - hidden dangers, in 8th Triennial Meeting, Sydney 6-11 September 1987 (ed K. Grimstad), ICOM-CC, vol. 1, 981-4, The Getty Conservation Institute, Los Angeles.

Bradley S.M, and Middleton, A.P. 1988. A study of the deterioration of Egyptian limestone sculptures, *JAIC*, **27**, 64-86.

Bradley, S. 1994. *A Review of the Storage Strategy in the British Museum*, British Museum Internal Report.

Bradley, S.M. and Oddy, W.A. 1993. *Environmental Policy for the Preservation of the Collections in the British Museum*, British Museum Internal Document.

Daniels, V.D. 1996. Maori black mud dyeing of phormium tenax fibre, in *Dyes in History and Archaeology* (ed P. Walton), 14, 9-13.

Daniels, V.D., Holland, L. and Pascoe, M.W. 1979. Gas plasma reactions for the conservation of antiquities, *Studies in Conservation*, **24**, 85-92.

Daniels, V., and Lohneis, G. 1997. Deterioration of sugar artefacts, *Studies in Conservation*, **42**, 17-26.

Green, L.R. and Bradley, S.M. 1997. An investigation of strategies for the long term storage of archaeological iron, in *Metals 95* (eds I.D. MacLeod *et al.*), James and James, London.

Hanna, S.B. 1984. The use of organo-silanes for the treatment of limestone in an advanced state of deterioration, in *Adhesives and Consolidants* (eds N.S. Brommelle, *et al.*), IIC, 171-6, London.

Lee, L.R. 1996. *Investigation of Materials to Prevent the Tarnishing of Silver*, British Museum, Department of Conservation, Conservation Research Group Internal Report 1996/1.

Lee, L.R. 1997. Tarnish prevention - A passive approach to the conservation of silver, forthcoming.

Maryon, H. 1912. *Metalwork and Enamelling*, Chapman and Hall, London.

McIntyre, I, 1997. Personal Communication.

Oddy, W.A. 1973. An unsuspected danger in display, *Museums Journal*, **73**(1), 27-8.

Oddy, W.A., Hughes, M.J. and Baker, S. 1976. The washing of limestone sculptures from Egypt and the Middle East, *Lithoclastia*, **2**, 5-10.

Organ, R. 1963. The examination and treatment of bronze antiquities, in *Recent Advances in Conservation*, (ed G. Thomson), Butterworths, 104-10, London.

Organ, R. and Bimson, M. 1957. The safe storage of unstable glass, *The Museums Journal*, **56**, 265-72.

Paramasivan, S. 1960. *Disintegration of Amaravati Sculptures*, Archaeological Survey of India, unpublished report.

Plenderleith, H. J. 1956. *The Conservation of Antiquities and Works of Art*, Oxford University Press, London.

Plenderleith, H. J. 1966. *The Conservation of Antiquities and Works of Art*, Oxford University Press, 61-2, London.

Shashoua, Y.R. 1993. Mechanical testing of resins for use in conservation, in 10th Triennial Meeting, Washington 22-27 August 1993 (ed J. Bridgland), ICOM-CC, vol. 2, 580-5, ICOM, Paris.

Sashoua, Y., Bradley, S.M. and Daniels, V.D. 1992. Degradation of cellulose nitrate adhesive, *Studies in Conservation*, **37**, 113-19.

Thickett, D.T. 1997. *Investigation of Sealing Methods for Timber Composites*, British Museum Department of Conservation, Internal Report 1997/4.

Susan Bradley, Department of Conservation, The British Museum, Great Russell Street, London WC1B 3DG
E-mail: s.bradley@british-museum.ac.uk.

THE DEVELOPMENT OF CONSERVATION SCIENCE AT THE TATE GALLERY

Stephen Hackney

ABSTRACT

Conservation Science is a recent addition to the range of activities at the Tate Gallery. It is closely linked to other conservation work and provides analytical and environmental support, which is particularly important for preventive conservation. Progress has been slow because it has relied on external funding for any new initiatives and continuity of funding remains a problem. Conservation science is leading to a better understanding of the works of art in the collection and a better appreciation of their condition. This in turn affects attitudes to their care and preservation.

Key Words

conservation, science, research, works of art, paintings, sculpture, funding, analysis, preventive, original, materials, techniques.

INTRODUCTION

The Tate Gallery Conservation Department was established in the early 1950s with the appointment of the first paintings restorer for the recently independent collection, formerly an annexe of the National Gallery. It grew over the years by the addition of more paintings restorers, carpenters, a photography department, paper conservation, sculpture conservation, frame conservation and conservation science. Because of the variety of the Tate's collections it has grown to become one of the largest fine art conservation departments. The range of undertakings are more akin to those of a major national museum than an art gallery. The Tate's historic British art collection and twentieth century international art collection include nearly all materials and techniques used in creating paintings and sculpture. The earliest painting is from 1545 but the majority of works are from the nineteenth and twentieth centuries.

The small conservation science section is a late addition and belatedly represents an acknowledgement of a much earlier change in attitude to the care of the collections. From being painting restorers operating a cycle of cleaning, lining, varnishing and retouching, repairing and hiding the worst degradation and damage, we have become conservators, attempting to prevent unnecessary degradation, and to help interpret each work through a knowledge of its material and condition. From highly skilled individual artisans working to exacting standards, with a few traditional materials on specific paintings, we are now transformed into a team of museum professionals. We are educated to postgraduate level, in a range of disciplines, capable of understanding and working effectively with a wide range of materials, and caring for a large and varied collection of works of art. This change has occurred throughout the conservation profession as a response to the challenges presented by collections. It comes from within the profession, in part by the action of museum conservation staff, and has not been imposed, but is a response to circumstances. With it we have gained a great deal but also lost a little.

Nowhere has this change been more necessary than for the modern collection at the Tate Gallery. Uniquely we have the opportunity to prevent damage and degradation to newly created and acquired works of art for which, in many cases, adequate methods of restoration have not yet been found and conservation ethics have not been agreed. This is preventive conservation at its most obvious. It has proved to be a convenient vehicle for the introduction of preventive conservation methods to more traditional works and for the development of collections care policies, the benefits of which are now becoming widely appreciated. A further stimulus to this approach is the expectation that the entire collection should be available for display, that is, used to maintain constantly changing displays at Millbank, Liverpool, St Ives and soon Bankside, and for loans in the UK and internationally.

Expectations have increased inexorably and conservators have responded with foresight and imagination, but in the process the stakes are further raised. When a problem recurs it is tempting to reuse an earlier imaginative solution. Whether this solution remains appropriate for new circumstances or for an entire range of related works is not always clear. In many cases it may still be appropriate, but when we are working in a constantly changing world we need to reassess our methods continuously. Research is therefore needed by everyone. Some individuals are well equipped to carry out limited projects in specific areas and conservation has developed in this way for many years. Increasingly though, shortage of time because of other commitments and the complexity of many unsolved problems has forced a different approach. In certain areas only those with access to appropriate equipment and with the specific skills to operate it can be expected to make progress. Conservation science, then, springs from the need for specialist technical skills not readily available to the conservator. It implies communication between conservator and scientist to identify the problems, devise methods of research and interpret results. It is multidisciplinary and open-ended.

ANALYSIS

At the Tate these specialist skills and instrumentation have been most needed for the analysis of original materials. This has become the core of conservation science. Analysis of nineteenth-century materials, specifically those of Turner (Townsend 1995), and later twentieth-century media (Learner 1995) have formed two important projects. Success in finding funding for these projects has enabled the establishment of a laboratory and its equipment. The intention is to continue investigating artists' practice with projects such as one planned on Reynolds; another for a publication on techniques of artists represented in the collections; and a third on the use of acrylic and other contemporary media. In addition we hope to establish in collaboration with the Royal College of Art/Victoria and Albert Museum (RCA/V&A) conservation course, and the Institute of Atomic and Molecular Physics (FOM-AMOLF), a study of early twentieth- century materials. We are also seeking funding for collaborative research into traditional canvas supports, their deterioration and treatment. The choice of specific artists' materials projects depends on how well an artist is represented

in the collection and the extent of current interest, for instance, a forthcoming major loan exhibition (Jones 1987). Such timeliness might allow a link with an exhibition and lead to the availability of sponsorship funding. The ability to carry out a project depends on the equipment and the staff available. Joint projects between scientist and conservator can be particularly fruitful but all projects are limited to some extent by the availability of instrumental analysis. The practice is to use the simplest techniques first, resorting to increasingly expensive instruments if necessary. It is an important role of the conservation scientist to know what techniques are likely to be useful and to facilitate access. This is not always possible and it is often the medium that creates the greatest problems of analysis.

FUNDING

It is of course the cost of conservation science that limits its development. In-house work by salaried staff using dedicated instruments produces the best results most efficiently. Such research is informed by the needs of the institution and engenders a long-term commitment that encourages the accumulation and sharing of knowledge, experience and capability. However, to establish new projects, resources need to be sought. Funding can be achieved from charities or from sponsorship. We are very grateful to the Leverhulme Trust whose funding in recent years has allowed the work on Turner and on twentieth-century media to be successfully completed and, even more importantly, allowed us to demonstrate the value of our work within the museum. Such enlightened support is unfortunately rare. Increasingly conservation receives sponsorship for specific treatments and a proportion of this funding is directed to science. European research projects are a further possible source of funding but they are not particularly appropriate for our area. Seeking and raising funding is a time-consuming business and sometimes a wasteful exercise. There is a real danger that projects are devised to fit in with available funding sources rather than the needs of the gallery.

One consolation of preparing detailed fund-raising applications is that the time spent on considering what can be achieved by a specific project and in defining the expected duration and course is not entirely wasted. Even if the current application is unsuccessful, the process of writing the proposal can help to define future priorities and to justify other work. But if research priorities are defined too tightly, speculative

research is inhibited and the ability to respond quickly to new circumstances is seriously limited.

Volunteers provide another opportunity to carry out research, although usually only for a short period of time. The criteria for useful research by volunteers are:
- a small well-tailored project that fits into the overall direction;
- a highly motivated and scientifically educated volunteer funded to cover living costs;
- a well-planned work programme;
- close supervision;
- space and access to specific equipment.

The goals must be realistic and closely tied to the ongoing research of a member of staff, and selection of the researcher is critical. If just one of the ingredients is missing the project will not be successful and much time will be lost in supervision.

A most obvious route is to turn to existing research organisations such as other museums, universities and specialist research institutes. Other museums have similar problems and therefore are sympathetic, but frequently suffer the same sort of constraints and do not have spare resources. However there is much to be gained by informal contacts and exchange of services, when this is possible. Research institutes are sometimes willing to help with specific problems but in general have increasingly to take a commercial approach and are therefore extremely expensive.

Universities are obvious bedfellows for conservation, but in practice collaboration is not always as successful as might be hoped. Their funding often comes from research grants and these are usually geared towards the development of new methods. The aim of the university is to prove that a new method works and its funding extends only to the tantalising point when the potential is proved but its application has not yet been exploited. This demonstrates an obvious gap that is not covered by research funding. What is needed is funding specifically to develop and exploit existing methods for the purposes of museums. This argument has been made on several occasions. For archaeometry at least some attempt to satisfy this demand was made through the now defunct funding body, the Science Based Archaeological Committee (SBAC). I see no reason why research funding should not go directly to the museum sector, earmarked for the development of applications appropriate to our needs. It could be allocated by a committee which judges applications on their suitability for progress in conservation rather

than for progress in science. It would clearly be much more efficient for us to spend our time and ingenuity devising successful conservation programmes rather than always trying to stretch our interest to state of the art research. Funding could come from lottery funds and be distributed competitively, based on individual proposals, but judged by peers within conservation. With it, as a group, we would gain the benefits of in-house research as well as the benefits of well planned ideas and justified decisions.

It is a problem for conservation science at the Tate that it is developing at a time when there is very little money in museums, except for new building. This may change but despite current funding limitations we can still optimise what we achieve.

CONSERVATION SCIENCE

Conservation science is not solely concerned with research and analysis. There are many aspects of the museum that benefit from scientific methods. In conservation environmental control is an important activity. Although not directly responsible for the building, a conservation scientist must have an overview of conditions in the museum and work towards improvements. This is a long-term process gaining mainly from major building works. There is also a need to preserve existing capabilities and standards on a day-to-day basis and to ensure maintenance is carried out effectively and that display changes do not introduce new problems. Again, the scientist must work closely with conservators as well as buildings and exhibitions staff. Lighting, RH and temperature, pollution and pests need to be investigated, monitored and controlled.

Handling, packing and transport (Green 1991), glazing, framing (Hackney 1990), and display (Perry 1990), are further areas where conservation science is needed. The development and assessment of conservation materials and processes continues. New materials such as stable varnishes and adhesives, and new methods such as cleaning or structural treatments, are continuously reassessed. Progress and improvement in these areas is frequently made by conservators, but by employing the methods of conservation science. Here demarcation becomes blurred and it is best to think in terms of scientific method rather than of conservators and scientists (Urbani 1996). Indeed working alone a conservation scientist would not make much progress. There are still areas within the museum where important

contributions can be made by a whole range of professional and non-professional staff. They work in an environment informed by science, and it is the job of conservation science to show its relevance to their decisions. In the ongoing debate on conservation ethics this contribution need not be restricted to the provision of supporting services, although that is important, but by providing the possibility of elegant long-term solutions and drawing attention to the inadequacy of present methods, scientists can alter opinions. By the analysis of original materials the effects of conservation treatments become better understood, and a greater respect for the original work of art is engendered. Indeed, as we improve analytical techniques the conservator finds it increasingly difficult to carry out any treatment that does not involve a detectable unwanted side-effect. The present emphasis on non-interventionist or minimal treatments is certainly influenced by this phenomenon.

As we learn more about deterioration processes by breaking them down into their different mechanisms it becomes possible to make better predictions about the ageing of specific works of art or their component parts. This not only allows us to prevent the worst types of deterioration mechanism, such as UV, light or pollution damage, but also informs us of the history and condition of the work. In some cases it might be argued that we should respect these signs of age. Admiration of craquelure (Philippot 1996) on a painting is influenced by its inevitability. If a painting were not cracked we would suspect that it were not old and therefore not genuine. But if we were able to prevent cracking or make it invisible, this would change our attitude and we would see it as an unwanted web between ourselves and the painting. The study of ageing processes serves to undermine the less precise attitudes of historicism. No longer do we stand by for Time to smoke our pictures (Hedley 1993) or allow them to moulder into worth. But then, what are valid signs of age?

CONCLUSION

The details of the interactions between specialists is the subject of other papers. There are many disciplines in conservation and whichever hat we wear it is not our training but how we apply our knowledge that matters. Conservation science is not the exclusive territory of scientists and scientific objectivity only exists in the context of interpretation and opinion.

Much is demanded of conservation science. The enormous range of skills and attitudes required ideally demand a large group of specialists who work as a team and communicate well amongst themselves and their colleagues. At the Tate we have not yet achieved a critical mass in conservation science and in the current economic climate we never will. But interaction between conservators and scientists is very good and recognised as important. Increasingly we are turning outwards to develop dialogues with other institutions. The problems are larger than any one institution can deal with and the solutions are rarely unique. By improving communications between museums and other institutions it ought to be possible to develop better career structures and even training opportunities.

A debate on conservation ethics must precede the implementation of any new or improved treatment and its outcome will depend on the nature and purpose of each collection. This debate feeds back into research proposals. The complexity of the definition of each problem and the variety of solutions has increased enormously. The development process is long and sometimes discouraging, but increasingly the accumulation of knowledge maps out a range of options and these options will remain valid choices even though ethics and attitudes change. In conservation as elsewhere knowledge and scientific method are intertwined. As a more realistic attitude to the benefits and limitations of science has developed the value of the knowledge that can be gained from the study of works of art in our care has become more apparent (Rees Jones 1962). In the long run when many new technical fixes have been found wanting this will be the most significant contribution of conservation science.

Changing attitudes toward the use and interpretation of objects in our collections and to their value in our culture and history increasingly raise questions as to the aims of conservation. Even though the range of views now expressed challenge the application of both traditional and science-based conservation practice they also reflect the value of the understanding gained through science and reinforce the assumptions inherent in conservation research.

REFERENCES

Green, T. 1991. Performance criteria for packing, in *Art in Transit: Studies in the Transport of Paintings* (ed M.F. Mecklenburg) National Gallery of Art, 59-68, Washington, DC.

Hackney, S. 1990. Framing for conservation at the Tate Gallery, *The Conservator*, **14**, 44-52.

Hedley, G. 1993. Long lost relations and new found relativities: Issues, in *The Cleaning Of Paintings. Measured Opinions* (ed C. Villers), UKIC, 172-8, London.

Jones, R. 1987. The artist's training and techniques, in *Manners and Morals*, Tate Publications, 19-29, London.

Learner, T. 1995. The analysis of synthetic resins found in twentieth century paint in media, in *Resins Ancient and Modern* (eds M.W. Wright and J.H. Townsend), SSCR, 76-84, Edinburgh.

Perry, R. 1990. Problems of dirt accumulation and its removal from unvarnished paintings: A Practical Review, in *Dirt and Pictures Separated* (eds S. Hackney *et al.*), UKIC, 3-6, London.

Philippot, P. 1966. La notion de patinage et le nettoyage des peintures, *Bulletin de l'Institute Royal du Patrimoine Artistique*, Brussels, **9**, 138-43.

Rees Jones, S. 1962. Science and the art of picture cleaning, *Burlington Magazine*, **104**(707), 60-2.

Townsend, J.H. 1995. *Turner's Painting Technique*, 2nd edn, Tate Publications, London.

Urbani, G. 1996. The science and art of conservation of cultural property, in *Historic and Philosophical Issues in the Conservation of Cultural Heritage* (eds N.S. Price *et al.*), The Getty Conservation Institute, 445-50, Los Angeles.

Stephen Hackney, Head of Conservation Science, The Tate Gallery, Millbank, London SW1P, 4RG

CONSERVATION SCIENCE: A VIEW FROM FOUR PERSPECTIVES

Norman H. Tennent

ABSTRACT

This paper draws upon the author's experience in the application of science to the study and conservation of museum and gallery collections and historic buildings. The role of conservation science is considered from four standpoints; the conservation scientist in museums and galleries, universities, national research institutes and the private sector. The virtues and disadvantages of conservation science in these domains are highlighted. The need for both fundamental research and routine application of scientific methods is discussed in terms of the potential and the restrictions in each of the four areas. Research into polymer degradation, corrosion analysis, pollution monitoring, and glass conservation illustrate the discussion. The following issues are addressed:

- *the appropriate critical mass of any productive scientific team;*
- *the need for the availability of good support facilities;*
- *the value of the physical proximity of scientists to collections and conservators;*
- *the need for integration of scientists into non-museum conservation projects at an early stage and the need to budget for analysis and testing;*
- *the need to allow conservation scientists to develop specialisms while remaining competent over a broad range of subjects;*
- *the need for the application of sophisticated instrumental techniques complementary to simple tests;*
- *the importance of knowledgeable conservation scientists to guide academic research.*

The importance of good communication and relevant publications in the field of conservation science is stressed.

Key Words

conservation science, museums, galleries, national institutes, private sector, communication, publication

INTRODUCTION

This is not the meeting to address at length the question, 'What is conservation science?', but in so far as this issue is implicit in considering the interface between science and conservation, I feel some comments are appropriate in order to clarify my own standpoint. I have discussed this topic previously in an article which was intended to focus on what I believe is the prime function of a conservation scientist, namely to provide knowledge or technical information which enables more effective preservation and conservation of cultural heritage, be it fixed or moveable cultural property. Few would disagree with this rather bland definition but the matter becomes more contentious when one considers individual topics. To be specific, is, for example, the microscopical examination of paint cross-sections conservation science? My opinion is that only when conclusions are drawn from that examination which directly help the practice of conservation can it truly be called conservation science rather than the technical study of paint constituents and structure. The discipline of conservation is certainly enriched by knowledge of artists' techniques and materials and, in this specific example, the scrutiny of paint cross-sections *may* be crucial in guiding the conservator's approach but *need not* have any direct consequence for the work of the conservator in the studio.

In the conservation of cultural heritage, the value of scientific investigations covers a spectrum ranging from those of critical importance, without which a project cannot be undertaken, to those of tenuous relevance. All knowledge gained is important but its value in enhancing the practice of conservation (including preventive conservation) varies. These concepts have been discussed by others. Torraca (1996), de Guichen (1991) and Talley (1997) have, in particular, each described the role of the conservation scientist in terms which fit my own experiences of the field. Many conservators will not only be amused by, but will also recognise de Guichen's analogy of conservation scientists trying to communicate with conservators; like satellites launched for a specific

purpose but which then drift out of orbit while continuing to send ever more unintelligible messages back to earth.

My own conclusions about priorities for conservation research, formulated a few years ago (1994), but still, I believe, relevant are the need for:

- the adoption of a concerted approach to problems of deterioration, treatment, and environmental factors in storage and display, involving teams with scientific skills that cross many disciplines ;
- the re-establishment of the pre-eminence of the problem rather than the instrumental means for solving problems;
- the integration of conservators' and art historians' experience at all stages in conservation research;
- the interpretation of scientific aspects of conservation for conservators, art historians and architects in a way that does not oversimplify the issues;
- the complementary use of simple test methods, rigorously executed, and sophisticated, 'state-of-the-art' methodology for problem solving.

It is in the context of these priorities that I wish to discuss the interface between science and conservation from four perspectives; the conservation scientist working in a museum laboratory, a university chemistry department, a national conservation laboratory, and the private sector.

I believe that I am the only conservation scientist who has worked in each of these domains for extended periods. In particular, self-employed conservation scientists working in the private sector, are rare indeed. I will, therefore, draw on personal experiences gained over a period of 21 years as a conservation scientist; initially with Glasgow Museums (Europe's largest municipal art collection) and subsequently from ten years as a freelance conservation scientist. During this period, experience of research in the other domains has been gained from honorary research positions at two major chemistry departments (Glasgow University, 1987-93 and Strathclyde University, 1993-5) and, since the end of 1995, with the Central Research Laboratory, Amsterdam (now part of The Netherlands Institute for Cultural Heritage). Since 1975, an understanding of the value of student projects in conservation research has been fostered by the joint research supervision of a total of 30 undergraduate, postgraduate or postdoctoral projects in six universities, and involvement with several conservation dissertations from training colleges in the

United Kingdom and The Netherlands. Work as a consultant for The Getty Conservation Institute and The Canadian Conservation Institute, for example, has added an institutional dimension to free-lance work in the private sector.

MUSEUM LABORATORIES

Conservation scientists working in museums and galleries have the advantage that the motivation of their work is the conservation of the collections for whose care they are employed. In principal, this brings relevance to their work in that it must clearly serve the needs of that museum's conservators as the first priority. In practice, conservator's needs are so many, so varied and so complex that the talents of in-house conservation scientists, invariably few in number, are severely stretched. Inevitably, only a small proportion of conservators' problems can be tackled by their scientist colleagues. This results in a fundamental dilemma. If one year's work in a museum provides, as can be the case, enough problems for a lifetime's research, how are the problems to be addressed effectively? It is little wonder that museum conservators become frustrated by the inability of the resident scientists to fulfil their requests in a timely fashion. One consequence can be that the museum conservation scientist retreats more and more into his or her own research; projects which may be worthwhile but are not driven and fine-tuned by the pressure of a conservation deadline. To maintain close communication with conservators, I believe that museum conservation scientists must, as a matter of necessity:

- *prioritise conservation research which tackles common problems of collection types, rather than individual problems of a solitary artifact.* In particular, by focusing on preventive conservation issues the cost-benefit return for research can be optimised. This maximises the impact of a lengthy investigation which, from the scientist's perspective is 'careful and thorough', but for the conservator is often merely 'slow';
- *act as a channel by which research carried out elsewhere may be of benefit to the scientist's own museum.* The scientific information of relevance to conservation is so diverse that in many instances an expert already exists with the required knowledge, in a well-developed or even in published form. Undoubtedly the Internet provides a challenging

prospect for enhancing museum conservation research;

- *work in collaboration with scientists in other museums, universities and - where they exist - conservation institutes.* Good collaboration maximises both research productivity and quality. It not only benefits conservators but also stimulates the museum scientist and focuses the collaborator's research;
- *develop one area of in-depth expertise.* The museum conservation scientist must be a jack of all trades but it is important for personal satisfaction as well as the growth of the profession as a whole that each scientist be given the opportunity to develop one or more specialism over a long period, perhaps his or her entire career. This will ensure depth and breadth of the skills available in museum laboratories;
- *carry out investigations of the correct scale.* A simple idea, rigorously evaluated, is of greater benefit to museums than an over-ambitious scheme, not thoroughly executed;
- *train conservators to ask the correct questions framed in the context of the preservation strategy or conservation treatment under consideration.* A useful working rule in museums is that no analysis should be requested unless the conservator can justify how the results will facilitate the design of a treatment methodology or preservation approach.

Museum scientists are so few in number that it seems wise for museums to rationalise their efforts in order to develop complementary skills in one country or region. The corollary of this is that time should not be wasted duplicating work carried out by conservation scientists elsewhere. In the field of polymer ageing, for example, it is too common for one scientist to complete tests on a polymer only for another museum to begin an assessment for its own conservators. This is largely a result of the lack of accepted test standards in conservation research. I have referred before (Tennent 1994) to the need for widely accepted standards for polymer testing rather than the *ad hoc* approach taken at present. Progress of this kind can only be made at an international level and, alas, there is no sign that the conservation community is sufficiently unified or ready to make this step.

UNIVERSITY RESEARCH

Conservation science can be greatly enhanced by the involvement of research at the level provided by the knowledge and facilities available in universities. In the academic world, the knowledge and expertise of skilled researchers in scientific disciplines relevant to conservation (and are there, indeed, any scientific disciplines not relevant to conservation?) is second to none. They are truly at the cutting edge of science. Furthermore, in terms of instrumentation to pursue research, universities outstrip not only museum laboratories but also the major national research laboratories. It is no over-statement to say that the range and quality of instrumentation in a single major university in any nation is greater than the combined instrumentation of all that nation's conservation laboratories of every description.

On the other hand, university science departments lack a deep knowledge of the nature and characteristics of conservation science, the complexity of conservation problems and the need for relevant pragmatic research. This means that the specialism which makes for excellence in academic research may result in an overly-narrow approach to problem-solving in conservation science. In fact, problem-solving in the practical manner required for conservation is often the antithesis of the focused, specialised approach which results in major advances in many areas of university research.

The point was well made by Sir John Kendrew, the noted biochemist and Nobel Laureate, who was invited to consider the role of the international scientific community in the advancement of conservation (Kendrew 1991). Sir John's advice on how best to involve scientists whose experience lies in spheres other than conservation was wise and has been, I believe, largely unheeded. He warned:

> Do not use Ph.D students. The kind of project that wins someone a doctorate seldom consists of research that would be helpful [to conservation]; it is generally too specialised and too narrowly focused. Rather, mobilise senior scientists who are wider in their interests; and try to persuade them to get the research done at the postdoctoral level. Also, bring the scientists along to the dig or the building under restoration, and make them work there. ... Don't let them shut themselves away in university laboratories all their time; that will prevent good collaboration and insulate them from the real problems.

Though in complete agreement with Sir John Kendrew's advice, it is my experience, from the

supervision of five Ph.D projects, that useful results can be obtained for conservation if the subject of the research is very carefully defined at the outset and both university and conservation science supervisors work closely together with a clear understanding of their respective priorities.

I refer to the issue of conservation science publications below, but the danger of scientists who are 'shut away' and not fully conversant with the complexities of conservation is that their published contributions can become, at best, unhelpful or, at worst, condescending. De Witte has pointed out the reality of these dangers when he refers to one university-based scientist who, in writing about 'Textile Conservation', demonstrates that, though knowledgeable about textiles, he 'does not appear to know the conservation profession exists' (De Witte 1993). Of that author's 47 references not one was from the conservation literature.

To be specific, I wish to draw on an example from my own polymer degradation research. In the selection of polymers for use as adhesives in glass and ceramics conservation, epoxy resins have a range of properties which are ideal for the purpose. They are marred, however, by their propensity to yellow with age. A conservator will be well-satisfied if the result of ageing tests on a range of epoxy resins is the recommendation of a single water-white resin which does not yellow.

Universities are generally less well placed to fulfil requests for appropriate durable adhesives such as epoxies than a museum laboratory with accelerated-ageing apparatus, and colour measuring equipment for opaque or transparent systems (including the determination of CIE colour coordinates). These facilities are found in few university chemistry departments, but constitute the core apparatus for conservation science laboratories involved in materials testing. In contrast, a university specialising in polymer chemistry will be ideally placed to investigate the precise mechanisms of epoxy resin yellowing. For this, the relevant equipment - infrared and ultraviolet-visible spectrophotometers, nuclear magnetic resonance spectrometers, mass spectrometers, appropriate chromographic instrumentation, flash photolysis equipment, etc. - will be on hand, as it is in no conservation laboratory, to determine the precise degradation mechanism.

An understanding of thermal- and photo-degradation mechanisms of polymers does not, however, in itself guarantee the possibility of providing conservators with suitable polymers. Thus,

for epoxy resins (despite the intense research afforded by involvement with an internationally renowned university professor specialising in polymer degradation, and the focus of a three-year Ph.D research project, executed by a first-rate student) university research (Grassie et al. 1985a, Grassie et al. 1985b, Grassie et al. 1985c, Grassie et al. 1986a, Grassie et al. 1986b) had less direct benefit for conservation than targeted evaluations by conservation scientists working in a museum laboratory and national research institute (Tennent 1979, Down 1984, Down 1986).

In reality, this example marks the distinction between fundamental and applied research, but these terms, without strict definition and explanation, are dangerous. I believe the term 'targetted research' is a useful one for conservation: the prime target must be ability to tackle any conservation project better, in a satisfactory timescale. The notion of timescale is important for, in conservation, we are often faced with problems which need a solution now, not in several years, after completion of the appropriate research. This is, alas, the real world in which we live. Universities provide the opportunity for intensive, long-term research which can complement the hand-to-mouth existence of conservation scientists working in museums and the private sector.

The potential of the skills of university researchers, combined with sophisticated instrumentation, is convincingly illustrated by a simple, successful example of cooperative research which I took part in five years ago. The collaboration was between a museum, in this case the British Museum, and a university; Glasgow University, with whom I was affiliated at the time. The problem was a straightforward one. Using X-ray diffraction (XRD), no conservation scientist had been able to characterise the product of hydrogen sulphide pollution blackening of basic lead carbonate (lead white) used as a painting material, though it was not doubted that its identity was lead sulphide (Carlyle and Townsend 1990). At the British Museum, Daniels and Thickett had also failed to obtain an XRD pattern from the blackened material produced during laboratory experiments to examine the reversion of blackened lead white on paper by hydrogen peroxide. Electron diffraction can often be successful in characterising materials when XRD fails to give a diffraction pattern. In this case, lead sulphide was successfully identified by electron diffraction of the sample supplied by the British Museum (Daniels et al. 1992). Since the lead sulphide crystallite sizes were rather

small (*c.* 3-30nm) the material was essentially amorphous to X-rays, but gave a good diffraction pattern when examined by transmission electron microscopy (TEM). The point is that transmission electron microscopes are found in virtually no conservation laboratory but are not at all uncommon in universities.

In the same vein, the full chemical analysis of 'Efflorescence X', a product of reaction of calcareous artifacts with acetic acid pollution from wooden museum cabinets, had eluded the efforts of conservation scientists for over 20 years, since it was first reported but never characterised. It required the development of the appropriate analytical methodology (ion chromatography), the involvement of a university chemistry department with an outstanding analytical chemistry research group, and intensity of a three-year Ph.D research project to determine the precise stoichiometry of Efflorescence X and establish, with sound statistics, the uniformity of its composition on artifacts from many museum sources (Gibson *et al.* 1997). No museum or national laboratory could have justified the use of its scientists' expertise, time or resources to accomplish this. That said, these new findings represent a major advance in understanding this aspect of the effect of pollution on museum collections.

NATIONAL INSTITUTES

In many ways the large conservation institute with its own research laboratory has the ideal blend of the virtues of the museum laboratory and the university science department. National laboratories have the resources to build up a powerful and effective battery of instrumentation but, because conservation research is their *raison d'être*, the research is in tune with the needs of conservation and there is an innate understanding of the nature of conservation research; its history, its idiosyncrasies and its inter-relationship with other branches of science. The national conservation research laboratory is ideally placed to be all that is excellent in research at the interface of science and conservation. Empirical testing and more fundamental long-term projects can co-exist without jeopardising the service to the community it serves.

A real virtue of national conservation institutes is that they can provide a nucleus of conservation scientists, sufficient in number to reach the 'critical mass' which prevents dissipation of effort and creates an *esprit de corps* which magnifies each scientist's

potential. In contrast, those museums fortunate enough to have a conservation science section rarely have a large team of scientists. I was appointed 21 years ago to establish a conservation science laboratory within Glasgow Museums. It grew from nothing and the number of scientists eventually doubled; from one to two! While a museum with two conservation scientists may be the envy of many with none, this number is insufficient to cater at all adequately for the vast conservation needs of a large museum service. Few museums, even those with as distinguished and long-standing a history as the museum organising and hosting this conference, achieve the critical mass of conservation scientists which enables cross-fertilisation of ideas from many disciplines. Only when the correct critical mass is reached can the whole be greater than the sum of the parts. Precisely when this is achieved is a matter for discussion, but my own view is that less than five scientists is too few, five to ten may be adequate and 10-20 is ideal. Museums may occasionally attain an adequate complement of conservation scientists but only in national conservation institutes is the ideal achieved *de facto*.

If lively interaction between conservation scientists is a likely benefit of national institutes, the isolation of these scientists from the community they serve is an equally likely danger. The contrast with museum scientists is again pertinent. They are confronted daily by the collections they care for and the conservators they work with. National institutes are normally, geographically, somewhat remote from the conservation needs they serve. Scientists in national laboratories have consequently to make a greater effort to ensure that the relationship with their conservation community has the vitality of that of museums.

National conservation research institutes have the scope to attain their greatest potential by collaborating with universities, industry and museum research laboratories. Alas, in many countries the existence of museum laboratories and a national research institute is mutually exclusive and the benefits to conservation are thereby, in my opinion, diminished. Britain and the USA have no national research institutes but do have active museum laboratories. The Netherlands, Belgium and Canada, to cite but three examples, have national research laboratories, but no major museum laboratories. I believe that the options should not be 'either'/'or'. The concept of combining the virtues of both domains has a potential impact which has not, to my knowledge, been assessed in the countries of which I have experience. Unfortunately in a period

when not only museum laboratories but also national laboratories are under financial pressure this goal is difficult to realise.

In all these situations, it is important to remember that conservation scientists, whatever their workplace, have their own personalities. The dynamism of one individual can overcome institutional deficiencies. Individualism in conservation research of immense importance, I believe, but time will tell if the present era of conservation is suffering from a lack of this attribute.

PRIVATE SECTOR

As yet, conservation projects in the private sector do not feature a conservation science component as regularly as conservation in museums and galleries. This is partly as a result of the law of supply and demand - the restriction being the availability of conservation scientists with suitable experience. Since free-lance conservation scientists are almost non-existent in the world market place, the private sector must turn to scientists working in one of the institutions described above, who can then work as a consultant on 'the firm's time' or independently.

The private sector suffers from the lack of what Torraca calls the 'conservation technologist'. In industry, where technologists are standard members of a project team, they perform a key function; the ability to 'translate data into efficient processes' (Torraca 1996). The role and importance of conservation scientists working as technologists is explored by Torraca in a masterly article which should be mandatory reading for anyone involved at the interface of science and conservation, particularly in the private sector. His comments on the need for more technologists, more testing, standard test procedures, and pragmatic solutions mirror my own opinions so closely that I shall not attempt to improve on his perspicacity. Torraca's vision - and I share it - is that with the advent of the conservation technologist, the emphasis will shift from 'spectacular performances in restoration to periodic maintenance routines (survey, documentation, monitoring, repair, environmental protection)'.

In view of the need for routine scientific research to enable conservation projects to be executed effectively, there is a fundamental requirement to integrate conservation science into projects in the private sector. Works of art do not provide the opportunity for trial and error, but failures are inevitable unless scientific investigation is built into a project as an integral component at an early stage.

There are many examples of poor conservation which could have been improved by the involvement of conservation scientists. It also has to be admitted that scientists have produced remedies which subsequently turned out to be injurious to the artifacts they were supposed to protect (Tennent 1994). Torraca cites the complete destruction of eleven charred papyrus scrolls as a result of a failed experiment by Sir Humphrey Davey who in 1818 was sent to Naples in order to devise a rapid means to unroll the scrolls and learn the content of the first Classical Library ever discovered. Thus 'one of the first recorded attempts of scientists to meddle in the conservation of antiquities was a complete failure' (Torraca 1996). The advancement of science and the greater caution of scientists has ensured that conservation science can now play a safer role than at the beginning of the nineteenth century, when Davey was working, or a century later when Scott described several treatments now thought to be rather dubious (in addition to many which persisted for over half a century) (Scott 1926).

From my experience, the greatest scope for the free-lance conservation scientist, in Britain at least, is at present in architectural conservation. In this area, the concept of different contractors who bring various skills to a project seems to be better established than in objects' conservation where budgets are admittedly usually significantly smaller. The concept of museums contracting-in conservation science expertise is at present little more than embryonic, perhaps in part due to the fact that when resources are tight a conservation science consultant is not thought to be essential. While few would agree with the statement by a former director of a major Scottish museum that 'conservation is a luxury I can live without', it seems that conservation science is still often regarded as a non-essential indulgence.

The urgent need to preserve rapidly-deteriorating artifacts, buildings or monuments brings with it a dilemma. In the preservation of cultural heritage the need for safe, effective, durable conservation has to be set against the often imperfect understanding of decay mechanisms, the many rudimentary methods of treatment and the unknown long-term behaviour of most commercial products. The maxim 'when in doubt, do nothing', while laudable, is often unrealistic. In the private sector especially, financial constraints and the need for a timely completion date are added restrictions in the pursuit of excellence in

conservation. This is probably most acutely felt in architectural conservation where conservators and conservation scientists have to comply with the contractual obligations, containing severe financial penalties, placed on architects and conservation sub-contractors alike.

In this framework the freelance conservation scientist must endeavour to reconcile what is often an impossible conflict. It is frequently necessary to recommend suitable treatments when the required knowledge does not exist and there is insufficient provision, in terms of time or finances, to reach a valid conservation strategy as a result of scientific tests. Even when a conservation scientist is contracted to give advice - and this is by no means common - there is often little opportunity to undertake any detailed, long-term testing.

One example may help illustrate this; the restoration of the Rose Window of York Minster in the 1980s. The fire which damaged the Minster left virtually every piece of glass in the Rose Window severely cracked. The restoration was of great urgency and received extensive media coverage. A key factor in the planning was the integration of scientific advice on the most suitable adhesives to be used for the glass repair. Fortunately, the results of 'targeted research', carried out previously (Tennent 1979, Down 1984, Down 1986, Tennent and Townsend 1984) but of relevance to York Minster meant that refractive index measurements could be made on the Rose Window glass which, allied to the results of ageing tests on epoxy resins, enabled a sound restoration approach to be adopted. Had this research not been previously carried out, it would have taken several years to undertake the necessary investigations before work on the Rose Window could even have begun. In the majority of projects much essential research does not take place because of the need for immediate action. Fortunately we need never ask what the situation would have been in the York Minster project if the prerequisite research had not been already executed.

In the private sector there is still great scope, therefore, for the involvement of conservation scientists. There are at present two main barriers; the shortage of free-lance conservation scientists and the failure to appreciate the importance of science (or technology) as an essential component of complex conservation projects. In my experience the best architects involved with conservation are now attempting to incorporate conservation science as a matter of priority. There is now a growing understanding that the role of conservation scientist can be, at least, to act as a knowledgeable arbitrator, balancing the needs of the artifact or monument with the technical know-how available.

COMMON GROUND

Communication

It would be unwise to give the impression that conservation scientists are solely researchers, though admittedly in universities this may be their primary role. In all four domains, it is an obligation of the conservation scientist to function as an interpreter of complex scientific issues in a way that takes all the relevant information, synthesises it and presents it so that it is digestible to conservators, curators, art historians, designers, administrators, architects, building engineers, fellow scientists and, not least, the general public. In other words, an effective conservation scientist must also be a teacher who communicates the relevance of the science which underpins good conservation. It is a poor conservation scientist who resembles the priest who was 'so heavenly minded that he was no earthly good'. Conservation scientists find a unifying function, no matter what their field of activity, in informed and imaginative communication. This belief finds resonance in the firmly-held view of Professor Stephen Rees Jones, one of a small group of scientists, art historians and curators who in the 1930s and '40s laid the foundations of modern conservation, that science should be used, to quote his son, 'to explain and educate' in the field of conservation' (Rees Jones 1997).

The conservation scientist can - and must - inform decision-making at all levels in order to ensure truly professional progress in conservation. One consequence of this will be the avoidance of a slavish, unthinking adoption of rules of thumb which are meant to be an aid to effective conservation, not an end in themselves. In preventive conservation, for example, who other than a conservation scientist could claim with authority that, in the selection of preferred relative humidity, there are circumstances when '50% RH is too high, 70% is too low and 100% is just right' (Padfield 1994)?

Publication

The common ground where conservation scientists also convene with conservators is in the dissemination of their work through the published literature. The sharing of knowledge through publication is, from all four domains under consideration, most highly developed in universities. Unfortunately, national grant funding bodies are increasingly basing university grant allocations on past publication records. This brings a new motivation to publication; the need to generate more Ph.D studentships or other tangible rewards. The dangers which this motivation present to scholarship are self-evident and can lead to an affliction of many academics which I shall refer to as 'premature publication'. The onset of this malady can be recognised by the publication of information which fails to satisfy the reader adequately. The conservation community is, alas, also guilty of encouraging premature publication. Conferences unite a disparate conservation profession but they are also now a business - they make money! They can make still more money when there are conference proceedings to sell. There is a strong case to be made that there are too many conferences, each with its attendant set of preprints or postprints. To cite but one example, is there really sufficient new research on stone conservation to justify the many conference proceedings which have to be tediously mined for any substantial new information? I sympathise with the despair felt by Padfield who, when reviewing a large set of conference papers totalling more than one thousand pages (Padfield 1992), found a 'hollow echo' of the enthusiasm and stimulating dialogue that conferences almost invariably generate.

There is another serious, and perhaps more insidious, aspect of universities' encouragement of academic reward for publications. Journals are ranked: respected journals in the main-stream of science, for example *Nature* or *Analytical Chemistry*, to quote two journals at random, merit a high ranking and publications therein bring more credit to the authors. The situation in Britain is so bizarre that it seems a seminal review article brings less credit than a short piece of new research in a highly ranked journal. Unfortunately for conservation, *Studies in Conservation*, the premier journal of the field, has a low or non-existent ranking in comparison to main-stream science journals. For academic credit, as opposed to dissemination of knowledge in the appropriate journal, an article published in Studies in Conservation might as well never have been written.

There is a surprising corollary to this. Conservation science articles have appeared in chemistry journals of good standing which would have a very dubious chance of publication in *Studies in Conservation*. It seems likely that the editors of these journals are unaware of the sophisticated and extensive literature in conservation science, thereby enabling pedestrian conservation science to appear in their pages, salvaged from rejection by the 'novel' application of science to the conservation of works of art.

What is the answer to this problem? In my view the time is right for the publication of a *Journal of Conservation Science*. This would establish conservation research on a par with other areas of applied science. It would be a place for the truly scientific articles which make *Studies in Conservation* (and, increasingly, sets of conservation proceedings) indigestible to many conservators and completely unpalatable to most art historians. It would avoid *Studies in Conservation* becoming a hybrid which satisfies neither scientists nor conservators. It would not remove the science from *Studies in Conservation* entirely but would clear the ground for articles where the science is presented in an equal partnership with conservation. In the as yet non-existent *Journal of Conservation Science*, work of major importance to advancing our knowledge but, at present, of uncertain relevance to the daily work of the conservator, would find its true home.

The general concept is that conservation science articles should appear in the correct place. There may be times when this is a journal from a main branch of science, a journal of primary relevance to conservators or a journal of primary relevance to conservation scientists. It is also true that many articles by scientists in other disciplines - textile science, wood technology or corrosion science to give but three examples - are of major relevance to conservation scientists. In this melting pot of scientific endeavour, the value of *Art and Archaeology Technical Abstracts*, the principal abstract journal for the field, is inestimable. Its pages constitute a library of current research which finds its common theme in the conservation and technical study of cultural heritage. It truly is the interface between conservation science and other fields in the published literature. Here, if nowhere else, scientists from museums, universities, national institutes and private practice find fertile common ground.

REFERENCES

Carlyle, L. and Townsend, J.H. 1990. An investigation of lead sulphide darkening of nineteenth century painting materials, in *Dirt and Pictures Separated* (ed V. Todd), UKIC, 40-3, London.

Daniels, V., Thickett, D., Baird, T. and Tennent, N.H. 1992. The reversion of blackened lead white on paper, in *Conference Papers Manchester 1992* (ed S. Fairbrass), IPC, 109-15, Leigh Worcestershire.

De Witte, E. 1993. Book review of Polymers in Conservation, *Studies in Conservation*, 38, 67-8.

Down, J.L. 1984. The Yellowing of epoxy resin adhesives: report on natural aging, *Studies in Conservation*, 29, 63-76.

Down, J.L. 1986. The yellowing of epoxy resin adhesives: report on high intensity light aging, *Studies in Conservation*, 31, 159-70.

Gibson, L.T., Cooksey, B.G., Littlejohn, D. and Tennent, N.H. 1997. Investigation of the composition of a unique efflorescence on calcareous museum artifacts, *Analytica Chimica Acta*, in press.

de Giuchen, G. 1991. Scientists and the preservation of cultural heritage, in *Science, Technology and European Cultural Heritage* (eds N.S. Baer *et al.*), Butterworth-Heinemann, 17-26, Oxford.

Grassie, N., Guy, M.I. and Tennent, N.H. 1985a. Degradation of epoxy polymers: Part 1 - Products of thermal degradation of bisphenol-A diglycidyl ether, *Polymer Degradation and Stability*, 12, 65-91.

Grassie, N., Guy, M.I. and Tennent, N.H. 1985b. Degradation of epoxy polymers: Part 2 - Mechanism of thermal degradation of bisphenol-A diglycidyl ether, *Polymer Degradation and Stability*, 13, 11-20.

Grassie, N., Guy, M.I. and Tennent, N.H. 1985c. Degradation of epoxy polymers: Part 3 Photo-degradation of bisphenol-A diglycidyl ether, *Polymer Degradation and Stability*, 13, 249-60.

Grassie, N., Guy, M.I. and Tennent, N.H. 1986a. Degradation of epoxy polymers: Part 4 Thermal degradation of bisphenol-A diglycidyl ether cured with ethylene diamine, *Polymer Degradation and Stability*, 14, 125-38.

Grassie, N., Guy, M.I. and Tennent, N.H. 1986b. Degradation of epoxy polymers: Part 5 Photo-degradation of bisphenol-A diglycidyl ether cured with ethylene diamine, *Polymer Degradation and Stability*, 14, 209-16.

Kendrew, J. 1991. The role of the international scientific community in the protection of European cultural heritage, in *Science, Technology and European Cultural Heritage* (eds N.S. Baer *et al*), Butterworth-Heinemann, xxvii-xxx, Oxford.

Padfield, T. 1994. The role of standards and guidelines: are they a substitute for understanding a problem or a protection against the consequences of ignorance?, in *Durability and Change: The Science, Responsibility and Cost of Sustaining Cultural Heritage* (eds W.E. Krumbein *et al.*), 191-200, John Wiley and Sons Ltd, Chichester.

Padfield, T. 1992. Book review of Science, Technology and European Cultural Heritage, *Studies in Conservation*, 37, 278-9.

Rees Jones, S. 1997. *IIC Bulletin*, 1, 1-2.

Scott, A. 1926. *The Cleaning and Restoration of Museum Exhibits*, HMSO, London.

Talley Jr., M. K. 1997. Conservation science and art: plum puddings, towels and some steam, in *Conservation Science in the UK - II* (ed N.H. Tennent) in press.

Tennent, N.H. 1994. The role of the conservation scientist in enhancing the practice of preventive conservation and the conservation treatment of artifacts, in *Durability and Change: The Science, Responsibility and Cost of Sustaining Cultural Heritage* (eds W.E. Krumbein), John Wiley and Sons Ltd, 165-72, Chichester.

Tennent, N.H. 1979, Clear and pigmented epoxy resins for stained glass conservation: light ageing studies, *Studies in Conservation*, 24, 153-64.

Tennent N.H. and Townsend, J.H. 1984. The significance of the refractive index of adhesives for glass repair, in *Adhesives and Consolidants* (eds N.S. Brommelle, E.M. Pye, P. Smith and G. Thomson), IIC, 205-12, London.

Torraca, G. 1996. The scientist's role in historic preservation with particular reference to stone conservation, in *Historical and Philosophical Issues in the Conservation of Cultural Heritage* (eds N.S. Price *et al.*), The Getty Conservation Institute, 439-44, Los Angeles.

Dr Norman H. Tennent, The Netherlands Institute for Cultural Heritage, Gabriël Metsustraat 8, 1071 EA Amsterdam, The Netherlands.

THE RELEVANCE OF SCIENCE TRAINING TO THE CONSERVATION PRACTITIONER NOW

Gillian Roy

ABSTRACT

Science, along with conservation practice and material culture, is by now widely accepted as an essential part of conservation training. The aim of this paper is to examine the role of science training in helping to shape the careers of conservators, many of whom are currently facing the pressures of changing practice and modern management. It is tempting to assume that all conservators have undergone formal systematic college or university training in conservation because they are the most visible group, but this is not always the case.

Key Words

conservator, science training

INTRODUCTION

Before the 1960s conservators looked to scientists principally as providers of recipes for dealing with deterioration or aesthetic disfigurement. Training in conservation was through apprenticeships to master craftsmen, or to artist-restorers. During the '60s and '70s, a period of curiosity, heightened awareness, and debate developed as conservation training courses began to set up systematic programmes of applied science. As conservation graduates began to filter into the museum world in significant numbers, the focus shifted to research. In the boom period of the '80s scientists and conservators sought better to understand the mechanisms of deterioration and the techniques of manufacture of the objects entrusted to their care, and to communicate in language understandable to each other. The ICOM Committee for Conservation held an interim meeting of the Working Group on Training in Conservation and Restoration, entitled *The Role of Science in Conservation Training*, at the British Museum in 1986. The view was expressed that through the study of science, conservators would learn to analyse their objectives rather than rely on

intuitive and emotional responses to objects. For educators, the atmosphere was optimistic. The subsequent development of degree and postgraduate courses changed the status of conservation, and it moved out of the workshop and into the studio and laboratory. Graduating students had a fair expectation of employment in conservation related work, if they wanted it. Political and economic factors in the 1990s have changed the working ethos of this country; inevitably museums must follow suit.

TRAINING IN SCIENCE

Ten years ago, Johan Lodewijks (1986) observed the necessity of distinguishing between the 'scientific knowledge which is required for all conservators and the knowledge which is necessary or useful in relation to the specialisation in which the conservator is being educated'. Other science educators bemoaned the lack of prior training in science of the majority of conservation students. This situation is unfortunately much the same today, as standards in the teaching of science and technology in schools are reported to be falling below that of the rest of Europe. Conservation science teachers in the UK are still caught in the debate about whether to concentrate first on establishing basic scientific principals and numeracy, or whether it is more effective to introduce applied science at the beginning of a course in conservation. It is still difficult for those without a firm base in 'the knowledge which is required by all conservators' to progress successfully to the specialist level.

A conservation student's practical training is on now on 'fast forward'. In the master/disciple way of learning, years would have been taken to absorb technique and skill by observation and repetitive practice. Science training has tried to accelerate this process. A British Museum conservator who underwent training in Japan a couple of years ago, recounted that all questions to the master had to be left to the end of the day, requiring trainees to consider their questions carefully and distil random

curiosity about what they had observed into a meaningful enquiry. In a similar way, a western conservation student in the laboratory will try to evaluate data from, for example, a tensile strength testing apparatus. He/she will observe, note and think laterally, before approaching the tutor for help with interpretation.

The culmination of formal training in science is generally in the form of a research or investigative project. The wider professional value of any of this research depends on whether the studies are published and whether they are carried out to a rigorous professional standard. The best of them demonstrate a very secure knowledge of science and applied theory. In assessing project work, it is difficult to distinguish the contribution made by a dedicated member of science staff to the interpretation of the data from that of the student, but it is precisely that interaction and dialogue which students should be able to carry with them into the workplace.

SCIENCE IN THE WORKPLACE

Theoretically conservators today are expected to fully understand the scientific principals of the treatments they carry out, and to contribute to research in order to further their careers. In reality, project design and interpretation can often be a source of conflict between the scientist and the conservation practitioner, whose wish to create realistic samples is time-consuming, expensive and often imprecise. Scientist-driven research may not always relate as closely to the question as the conservator would wish, either because of the scientist's desire to obtain results or because the question was not framed well enough.

Only a few conservators in large institutions have direct access in their workplace to facilities for scientific research. Similarly, conservators in private practice find it especially difficult to offer in-depth examination of objects and analytical testing services. They are therefore reliant on being able to carry out simple examination techniques to test materials or to identify substances used in previous restorations. Even in institutions where facilities exist, they are frequently under exploited by conservators who are preoccupied with meeting treatment targets. They often cannot take time for in-depth examination, even when it is demanded by rare and complex objects.

A recent example of analytical examination, that of a Tibetan *thang'ka* at the Musée Guimet (Colinart

1996), contributed significantly to a knowledge bank for conservators of culturally unfamiliar objects. Previous restoration was identified through the discovery of a more recent cadmium red pigment, and chemically altered orpiment was noted. This is the kind of research a conservator instinctively relates to, because it is the kind of deconstruction process they are used to; a virtual, if not actual, dismantling of a damaged object which involves getting to know each component part intimately before reassembly. This process may occur as a result of purely visual examination, instrumental analysis, or actual treatment procedure.

A course in advanced techniques of examination was held last year at Winterthurm Museum in the USA with the important objective of helping scientists and conservators communicate more effectively. Few participants would, however, have access to the range of sophisticated analytical techniques which was demonstrated, but it will have helped them to formulate their problems in such a way that the analysts can answer the questions (Polak and Munn 1996). The quality of the results depend on posing sensible questions.

THE CONSERVATION PRACTITIONER

What are the ideal characteristics of conservators? The question was posed by Joyce Hill Stoner (1995). She presents what, at first reading, seems to be a rather romantic portrait of an applicant for conservation training. In pursuit of connoisseurship, they are polite, loyal and humble; their interests are in music, theatre, literature, cookery or gardening. On reflection however, it is a rather accurate picture of real life, but reinforces the suspicion that some conservators may find it hard to stand up to the harsher demands of employment in the twenty-first century. Connoisseurship though, has its dangers in presenting what can be an intangible and unattainably elitist target. Miguel de Corzo, Director of the Getty Conservation Institute (1995) also noted the devotion, knowledge and intellectual passion most conservators bring to their work. Their passion for artistic or historic artefacts is the starting point for most professional careers.

Conservators develop a high level of manual and visual expertise, defined in terms of skill which is innate, learned or practised, but difficult to quantify. The long and arduous training in Japan for mounting hanging scrolls, for example, is difficult for a western

conservator to complete. The best traditional training in Japan establishes some of the most refined manual sensibility and awareness of the properties of materials. Options chosen for the consolidation of Japanese paintings may often be as much to do with the artefacts' traditional materials of manufacture, as they are with scientific research. Modern synthetic materials are usually considered unsympathetic and *Nikawa* (deer skin glue) is widely favoured. On the other hand, a conservator of Egyptian polychrome wooden coffins who is faced with delaminating layers of wood, linen, and gesso will opt for a synthetic resin, filling cracks with a mixture of synthetic resin and glass microballoons. This is doubtless dictated by strength, but also highlights different, and often conflicting, decision making requirements brought about by working in a living craft tradition or a dead one.

A conservator's evaluation of exactly the right amount of humidity to introduce into a large sheet of short fibred Chinese paper for safe handling, when applying a lining, is explained by Timothy Vitale (1987). The language used to describe the relationship between porosity and capillarity and water vapour is readily understandable to most conservators. The superficially more familiar language of the historian provides technological reference but does not describe the activity adequately (Dwan 1993). The more conservators themselves can articulate what they are doing, the more they can take control of their own judgements and interpret their activity to others.

CHANGING PRACTICE

Concentration on individual objects, research into the application of more sophisticated techniques, and a preoccupation with the effects of chemical treatments however, no longer hold top priority for curators and conservation managers. Preservation strategies, protective housing and high technology storage are now seen as investment in the future (Michalski 1990).

The interface between conservation and curation has always had its problems. The Department of National Heritage in its recent report *Treasures in Trust* (DNH 1996) puts the responsibility for the care of the collections firmly on the curators; conservation is regarded as a service. Curators have sometimes seen their role as watchdogs, sometimes rightly, but sometimes in ignorance of the rapid development of conservators' expertise in the science of the museum environment, which may threaten their absolute authority. Experienced conservators are often in the position of negotiators trying to reconcile demands for flexibility of the *rules* with an explosion of scientific research into microclimates, exhibition case design, or atmospheric pollutants in museums. The newly trained conservator fresh from the academic challenge of a postgraduate dissertation, often feels diminished and powerless in employment as the extent of interventive practice he/she can carry out is limited.

This is particularly evident in the change in working procedures for paper conservation in large institutions. Conservators faced with rehousing huge numbers of prints, for example, have discontinued washing. It is still considered beneficial by most conservation scientists, but an instinctive risk assessment indicates that the speedy washing of old master prints is likely to cause more harm than good. Bleaching has been discontinued following the adverse results of scientific research. Deacidification of iron gall ink drawings is no longer practised because of the residual toxicity of one of the agents, and the likelihood of colour changes. Restoration is discouraged in line with the general move towards minimal intervention. It is hard for the conservator not to be overwhelmed by negatives if he/she is remote from the curatorial policy for preservation of the collections.

The conflicting priorities between dealing with a mass of deteriorating material and the time spent on radical intervention have been addressed by research into management and information systems analysis (Keene 1990), surveying collections, and risk assessment. These procedures have all been the subject of intensive research by conservation scientists or by conservation managers. The implementation of the Delta Plan was carried out with a technological, missionary zeal, which replaced the contemplation and communion which had ignored the creeping decay in Dutch museums. 'In our modern society, developments move at lightening speed. Today's technological innovations are overtaken once again by tomorrow's new inventions. For many people the past is mainly a place to escape to nostalgic dreams before coming back to the order of the day' (d'Ancona 1994).

MULTI-DISCIPLINARY SKILLS

One of the most marked changes in the last ten years is the expansion of a conservator's work into a great number of related areas of expertise: engineering, science of the museum environment, lighting, and architecture.

However a conservator of philatelic material was recently asked to advise on the installation of air conditioning when making an advisory visit to the collections of a museum on a tropical island. Another organic artefacts conservator formed a team with an environmental engineer and an architect in order to draw up plans for the conservation of painted wooden churches in Romania. Recent large scale sponsorship by millennium lottery or heritage lottery grants has also involved conservators in unfamiliar responsibilities which require an ability to appreciate manufacturers' specifications or read architectural plans accurately. They must also be able to order and specify complex equipment or to decide whether the cost of developing a piece of equipment is appropriate and whether the end product is marketable enough to earn some of the money back. The solution is not to make conservators into technicians or salesmen but to give them the technical knowledge and confidence not to be taken in by 'techno-babble'. Scientific literacy forms a basis for communication and scientific education will allow a sensible relationship with business and industry. It encourages conservators not to cocoon themselves in a protective shell of exclusivity.

The more public participation in conservation can also bring adverse attention. An article about the British Association Annual Festival of Science last year commented on the role played by the media in exploiting the sensational aspects both of science and scientific research. Conservation is no longer exempt from public scrutiny and when proof is required of correctness the only recourse is scientific proof. The possibility of involvement in litigation has to be considered as well as unwelcome media attention.

DEFINING EXPERTISE

Alan Cummings (1995) described 'a tendency to demand competence in young conservators over too broad a range of skills and knowledge at too shallow a level'. In learning environmental science, for example, there is a risk of giving a quite misleading impression of what level constitutes expertise in order to make a complex subject more comprehensible to the students.

In its rather obsessive preoccupation with defining 'the profession', conservation is currently showing some symptoms of dyslexia in an inability to prioritise information, serving up an indigestible mix of important fact and minute detail with equal emphasis. Conservators, insecure in their professional expertise based on practical activity, feel obliged to claim respectability as pseudo scientists, philosophers or historians. They need a language of their own.

The ownership of expertise is ill-defined in conservation. Ingo Sandner (1990) notes a certain degree of suspicion between the various experts in conservation and an overlapping of interests. Scientific analysis which does not lead to treatment resolution is not always a legitimate part of conservation. A recent enquiry to the Department of Conservation at the British Museum from a museum in the Balkans, about the possible removal and conservation of a roll of papyrus from inside the bandages of an Egyptian mummy, was referred to a curator/archaeologist who answered in depth, detailing the sophisticated, analytical examination which would be required before proceeding. In this case the curator was best placed to ask what kind of information was required and to direct the enquirer to the right sources.

Ernest van de Wetering, (Van de Wetering and Van Wegen 1987) organised an experimental symposium on communication in conservation, in Amsterdam in 1984, at which speakers from 11 different disciplines took part. He noted the problems of defining the limits of non-specialist interpretation as '… rather casually trespassing the borders of disciplines which are not ours …. Being aware of what is going on in other disciplines may at least prevent us from fooling around too simplistically with outdated or plainly wrong ideas which we ascribe to those fields'.

EMPLOYMENT AND INVESTMENT IN TRAINING

When asked to comment on the changes in conservation he had observed in the past ten years, Miguel de Corzo, Director of GCI, referred to the information society, new tools in marketing and management, and the conservators' involvement in public awareness programmes. He spoke about bringing the message of conservation to the outside world.

David Leigh's (1990) intentionally provocative analysis, albeit tongue-in-cheek, described the conservator as retiring and timid, unwilling or unable to grasp the reins of management. He asked whether management skills should be added to the already overcrowded syllabus in conservation training. Chris Caple (1993) presented a realistic way of developing a student's managerial confidence through project work.

Employment trends generally mean that for many people joining the job market part-time or temporary work are the only available options. Flexibility is the buzz word. People will have to take responsibility for making themselves more employable by building a skills bank so as to become job-mobile. The question is whether further training will be provided or underwritten by an employer or whether individuals will have to mastermind and pay for their own accumulation of skills. The emphasis on versatility however must be based on a sound scientific appreciation of the properties of materials, if the clock is not to be turned back. Once a conservator has acquired a scientific education at degree or postgraduate level, he needs to maintain and develop his knowledge. What is often the case with those who have not had the benefit of a firm scientific base, is an increasing amnesia which crystallises into a few standard maxims, becoming less and less accurate as the years roll on. At best this is simply negative, at worst it can result in a huge waste of money in the over-specification of environmental conditions and purchase of materials. If institutions or individuals are going to invest money in training, they must be persuaded that appropriate scientific skills maximise conservation efficiency.

CONCLUSION

Investment in expertise cannot be viable when there is a too rapid turnover and short contracts. It is essential to pool resources in whatever training systems are best suited to conservation, be it graduate or post graduate, NVQ, modern apprenticeship, or in-house training, to ensure that conservation does not lose the opportunity to develop as a discipline. The body of scientific knowledge which will form the basis of a profession is not yet widely available to all conservators, either because they have not had the benefit of science training or because it has not been thorough enough. The tools of management and the marketplace are not the only ones which should determine the future and improve standards in conservation practice.

REFERENCES

Caple, C. 1993. The development of managerial and communication skills in conservation trainees: the Durham experience, in *10th Triennial Meeting, Washington 22-27 August 1993* (ed J. Bridgland), ICOM-CC, vol. 2, 715-720, Paris.

Colinart, S. 1996. Apport de l'analyse PIXE à l'étude de la technique picturale d'un thang-ka peint du musée Guimet de Paris, in *11th Triennial Meeting, Edinburgh 1-6 September 1996* (ed J. Bridgland), ICOM-CC, vol. 1, 206-10, James and James, London.

de Corzo, M. 1995. Newsletter of the Getty Conservation Institute, **10**(111).

Cummings, A. 1995. The eternal triangle, professionalism, standards, and standardisation in conservation teaching, in *A Qualified Community: Towards Internationally Agreed Standards of Qualification for Conservation* (eds J. Cronyn and K. Foley), ICOM-CC Training in Conservation and Restoration Working Group Interim Meeting, Maastricht 6-8 April 1995, 59-62, ICOM-CC, Paris.

d'Ancona, H. 1994. Preface to Delta Plan, *Preservation of Cultural Heritage in the Netherlands*, Ministry of Welfare, Health and Cultural Affairs.

Dwan, A. 1993. *A method for examining and classifying Japanese papers used by artists in the late nineteenth century*, Monograph Series II, National Gallery of Art, Washington.

DNH, 1996. *Treasures in Trust*, Department of National Heritage Report.

Hill Stoner, J. 1996. Training in conservation and restoration, in *11th Triennial Meeting, Edinburgh 1-6 September 1996* (ed J. Bridgland), ICOM-CC, vol. 1, 134-139, James and James, London.

Keene, S., 1990, Management Information for Conservation, in *9th Triennial Meeting, Dresden 26-31 August 1990* (ed K. Grimstad), ICOM-CC, vol. 1, 185-191, Paris.

Leigh, D. 1990. New perceptions, new expectations, in *The Graduate Conservator in Employment: Expectations and Realities* (ed S. Price), ICOM-CC Training in Conservation and Restoration Working Group Interim Meeting, Amsterdam 31 August - 1 September 1989, 111-119, Opleidung Restauratoren, Amsterdam.

Lodewijks, J. 1986. The role of science in conservation, in *The Role of Science in Conservation Training* (ed C. Pearson and P. Winsor), ICOM-CC Training in Conservation and Restoration Working Group Interim Meeting, London, 6-10 October 1986, 1-7 ICOM, Paris.

Michalski, S. 1990. An overall framework for preventative conservation and remedial conservation, in *9th Triennial Meeting, Dresden 26-31 August 1990* (ed K. Grimstad), ICOM-CC, vol. 2, 589-591, Paris.

Polak, E. and Munn, J. 1996. An investigation of three metal point markings on a grounded paper using different application modes of the scanning electron microscope, *The Paper Conservator* **20**, 33-59.

Sandner, I. 1990. Restorer or restoration engineer?, in *9th Triennial Meeting, Dresden 26-31 August 1990* (ed K. Grimstad), ICOM-CC, vol.2, 696-700, Paris.

Vitale, T. 1987. Observations on the theory, use and fabrication of the fitted glass beads, small suction disk device, *The paper conservator*, **12**, 47-67.

Van de Wetering, E. and Van Wegen, D. 1987. Roaming the Stairs of the Tower of Babel, Efforts to expand Interdisciplinary Involvement in the Theory of Restoration, in 8th Triennial Meeting, Sydney 6-11 September 1987 (ed K. Grimstad), ICOM-CC, The Getty Conservation Institute, Los Angeles.

Gillian Roy, Department of Conservation, The British Museum, London, WC1B 3DG

LITERACY IN SCIENCE: USING THE LANGUAGE IN CONSERVATION

Mary M. Brooks and Sheila Fairbrass

ABSTRACT

Scientific knowledge, skills and understanding are integral to conservation practice and therefore critical in conservation teaching and learning. This paper explores the barriers conservation students, who often come from a predominately arts/humanities background, may experience in becoming scientifically literate. Approaches to teaching science are compared with strategies used for teaching and learning a new language. Methods used to teach science within the postgraduate Diploma course in Textile Conservation taught at the Textile Conservation Centre in affiliation with the Courtauld Institute of Art, University of London are outlined.

Key Words

science, education, conservation, literary, textile

INTRODUCTION

The concepts and practice of science are an integral part of conservation. Scientific literacy is therefore critical in the training of professional conservators competent to work in both the public and private sectors. This paper explores the nature of the scientific knowledge and understanding which conservators require and the real and perceived difficulties which may hinder this. The methodology of science teaching will be discussed in comparison with strategies for teaching and learning a foreign language. Strategies for enabling conservators to learn the language of science and so gain the confidence necessary to develop the required knowledge, skills and judgment are discussed. Scientific literacy is a defined outcome of the postgraduate Diploma Course in Textile Conservation taught at the Textile Conservation Centre in affiliation with the Courtauld Institute of Art, University of London and some of the educational methods used are described.

WHAT IS 'SCIENCE' IN CONSERVATION?

Conservation is an interdisciplinary profession which requires the integration of scientific, contextual and aesthetic knowledge and manual skills to achieve an effective result, either preventive or interventive. Defining what science in conservation actually means is critical as there is frequent confusion between acquiring a certain type of knowledge relating to material science and developing a certain rational methodology. Stress placed on the former can obscure the critical importance of the latter as an intellectual approach informing all aspects of conservation. Both types of scientific literacy are required for a competent conservator. In addition to enabling an understanding of the 'hard facts' of chemistry, mathematics and physics, conservation training needs to facilitate a structured 'scientific' approach to problem solving.

The processes involved in problem solving, however the problem is categorised, may be identified as:

1. stating the problem – recognition;
2. researching the background – setting the parameters;
3. proposing working hypothesis (model making);
4. testing hypothesis (experimentation);
5. reassessing model in light of experimental results (adaptation);
6. practical application;
7. evaluation – the 'usefulness' of model for further work (consolidation).

This methodology is applicable not just to 'hard' science but to problem solving in other areas as well; it is an attitude as well as a technique. This conceptual approach may be used to solve 'scientific' problems such as the optimal environmental condition for a particular collection or an object related problem such as the development of an appropriate treatment strategy for an historic textile.

SCIENCE IN CONSERVATION COURSES

The need for both a knowledge of science and a scientific approach has been discussed and quantified in various papers. Pearson and Ferguson have proposed guidelines for conservation courses which are designed to 'produce a qualified, appropriately competent conservator' (1996, 66). The ideal conservation course is described as including technology and materials science as well as the chemistry, biology and physics of deterioration processes and conservation methods. Significantly, the qualified conservator is also described as possessing the ability to solve problems and test solutions - in other words, the ability to use a scientific approach to problem solving. Numerous papers describe the scientific content of a conservation course. For example, Park (1990) outlines the content of the Courtauld Institute of Art Diploma in Wall Paintings as covering basic science, applied conservation science, the environmental causes of deterioration and scientific examination. Sale (1990) has described, from the perspective of a recent graduate, the special block on the Winterthur Museum / University of Delaware MSc programme which aims to enable students to build on theory and analysis so they can undertake a written scientific study involving the characterisation or analysis of materials.

Most conservation courses require some level of scientific examination success prior to entry. The level required varies according to the context and the nature of the course. The two-year MA in the Conservation of Historic Objects (Archaeology) offered by Durham University specifies an A level in chemistry whilst the three year Diploma in Textile Conservation offered by the Textile Conservation Centre requires, at minimum, a GCSE pass or equivalent. A higher level qualification is preferred. With international candidates coming from a wide range of educational backgrounds, it may be necessary to ask candidates to undertake an entrance test or offer a primary introduction in core scientific knowledge, before moving on to more complex study. It is certainly important to ensure that the scientific teaching and learning is undertaken at an appropriate level.

FEAR OF SCIENCE: PROBLEMS WITH SCIENCE LEARNING AND UNDERSTANDING

There are many barriers - linguistic, symbolic and emotional - for student conservators, who may have a predominantly non-science background, in learning and applying science knowledge. Science is a new language for such students which requires a new vocabulary and grammar with different thought patterns. To learn any new language is to take part in a new culture. Membership of such a culture, be it a new foreign language or a scientific discipline, confers power. Each language group creates its own social group and shared conventions. Conversely, the linguistic repertoire is fundamental in defining those who are in or out of the group (Romaine 1994). Jargon can include or exclude. It is not surprising that those who do not speak the language, or who have previously had a bad experience, may approach a second attempt at learning and group membership with a mixture of emotions ranging from uncertainty to fear and prejudice. The need for conservators, conservation scientists and other scientists to be able to communicate effectively with each other has often been discussed; Feller has succinctly summarised the problem and benefits of effective dialogue in the conservation culture (Feller 1983).

Fear of science may be reinforced by a variety of other factors. The sense of science as an alien culture was reinforced by the traditional English education approach, now breaking down, which rigorously divided 'arts' and 'science'. The cultural bias which stemmed from this division is reinforced by underlying cultural attitudes to science and scientists. Zinburgh (1996) explored the reasons and implications of such a view amongst Americans and concluded that rather than 'just indifference to scientists, the public maintains a largely negative attitude toward them'. Studies which have attempted to overcome such inherent bias towards the stereotype of a scientist as an isolated, bald or wild haired, white man - either Einstein or Dr. Jekyll - or an unattractive, primly dressed, bespectacled woman report that children do not have a positive view of the role of scientists (Hill and Wheeler 1991). In their polemic against science in conservation Beck and Daley (1993) echo this view in the emotive description of scientific conservation: 'The white coat has replaced the artist's smock in the restorer's studio and a training in chemistry presently counts more than training in art history'. There is a second important

theme to bear in mind when considering cultural attitudes to science. Several studies (Hill and Wheeler 1991; White and Mitchell 1994) have examined gender attitudes to science amongst schoolchildren and conclude that girls in particular perceive science as alien and unappealing. The need to address this 'image problem' is implicitly recognised in the contemporary development of courses in science communication which aim to enable science graduates to develop effective communication skills which go beyond oral and writing skills. For example, Cardiff University offers an MSc which is based at the interactive Techniques Centre. This adopts a hands-on approach to learning science which aims to be 'inspirational and motivational' (Lawton 1996). Scientists have recognised that they need to communicate effectively with the largely alienated non-scientific community. However, it is worth noting that resistance to a new subject is not a phenomenon experienced in science alone. Haycraft (1983) has noted the need to overcome intolerance when teaching English as a foreign language to adult learners.

SCIENCE AS LANGUAGE

There are some obvious similarities between learning a scientific discipline and learning a foreign language. Each requires the development of understanding of a new structure of thought and the vocabulary and grammar to go with it. It is all too easy for learning and teaching to focus on the evidence of learning – the production of a string of rote learned words and phrases or equations and nomenclature, and confuse this with the development of fundamental comprehension. Learning the vocabulary is the easy bit; it is the acquisition of the grammar that allows complexity of thought and meaning. This is the critical area which allows the student to progress.

Modern language teaching uses a variety of teaching and learning approaches. Cook (1991) has identified different styles each with distinct advantages and disadvantages. He categorises these as:

- the academic style - focusing on grammar and structure;
- the audio-lingual style - focusing on the heard and the spoken;
- the social communication style - focusing on verbal skills and facilitating communication;
- the combination style using elements of all above.

The academic style can result in a student developing the ability to understand the structure of the written language, but lacking in good verbal communication skills. A student who had learned using the audio visual and social styles could gain good communication skills without fundamental understanding of the underlying structure and grammatical concept of the language. Ideally, a combination of these approaches enables a student to understand both the concept of the language structure, learn the grammar and vocabulary, and be able to apply it in a social situation. Cook (1991) stresses that effective learning and teaching of a second language is facilitated by background knowledge. Contextualising the vocabulary and structure enables students to develop academic and communication skills and apply these skills effectively.

Slightly simplistic equivalences may be made be between the elements of learning a foreign language and learning the language of chemistry:

vocabulary = chemical terminology and symbols;
grammar = equations and bonding behaviour;
oral skill = experimental design skill.

Beyond the basics, the learning and practice of a new language requires the development of internalised understanding – the sense that an agreement is incorrect or a particular equation cannot be balanced in a particular manner. Understanding the concepts and reasoning behind a scientific discipline can be compared with the difference between reading prose and poetry in a foreign language: a new level of intuitive understanding and enjoyment is suddenly, and sometimes surprisingly, achievable. However, the science/language analogy cannot be strained too far. A living language is organic and fluid; it often has regional variations and unclear geographical boundaries. In contrast, the language and symbols of science are, theoretically, rational and logical with a clear structure and a single meaning. It might appear that change only comes about by international agreement. It comes as a shock to students to discover that rationality in the 'naming of parts' is not absolute. Each year, we see students grappling with the fact that the solvent labelled by the manufacturer on the bottle as acetone

CH3
|
C = O
|
CH3

may also be described as dimethylketone and propanone. Only an understanding of the precision of the nomenclature enables students to understand the real meaning of the symbols. This also helps in understanding why such precision is necessary.

Reality, of course, also plays a part here; scientists and conservators alike need to be able to hold effective conversations. The use of shortened names - the equivalent of 'slang' - has developed causing further confusion to new students learning these different levels of scientific language. The *New Scientist* (1996) quoted the case of the immunosuppressant tacrolimus. The formal name, accurately delineating its nature, is (-)-(1R, 9S, 12S, 13R, 14S, 17R, 18E, 21S, 23S, 24R, 25S, 27R) - 17-allyl-1, 14-dihydroxy-12-[(E)-2-[(1R,3R,4R) - 4 -hydroxy - 3 - methoxy-cyclohexyl] 1- methylvinyl] - 23, 25 -dimethoxy -13,19,21,27 - tetramethyl-11, 28-dioxa -4- azatricyclo- [22.3.1.0 (4.9)] octacos-18-ene-2, 3, 10, 16-tetrahydrate. No wonder it has the common name FK-506.

Nevertheless, useful analogies may be drawn between language and science teaching. Applying such a model to teaching conservation science reinforces the need for an approach which relates the learning of vocabulary and grammar (chemical names, reactions, equations) with their application to conservation issues. In most teaching/learning situations, the teacher 'knows' more than the student. Communicating that knowledge effectively enables a learner to acquire new concepts and information, and to overcome previous, erroneous assumptions and misinformation.

Teaching and learning in conservation science should aim to overcome the barriers discussed previously and enable students to develop an ability to think scientifically, as well as to marshal scientific 'facts'. Shallow learning where students learn the vocabulary by rote for reproduction in examinations but are unable to internalise the concepts and approach, as well as the knowledge in practice needs to be avoided. A lack of understanding of analytical procedures and what they can and cannot offer the conservator has been discussed by Ford (1987). His solution to this problem was to instigate a set of carefully structured laboratory practicals engineered to ensure an understanding and practice of scientific methodology; the equivalent of a language laboratory putting rote learned vocabulary and grammar to the test. Of course, the availability of suitable scientific facilities and analytical equipment should help enable students to develop and practice this language effectively.

Conservation students do have some advantages in tackling the language of science. Many are coming to their primary conservation course as mature students. Cook (1991) argues that older learners are often 'better' than younger ones because they are more strongly motivated and can perceive the application of the discipline of learning in a wider context. However, to become a competent practitioner, the motivation must extend beyond the immediate need to satisfy the science lecturer or pass a particular examination; it is not enough simply to pass an exam and forget. Conservation science must be integrated in conservation thinking and practice and not just happen in the lecture theatre and science laboratory.

Studies of secondary schoolchildrens' attitudes to learning have suggested that one reason why science becomes less popular as students progress up the school is that the teaching method tends to preclude independent experimentation and deduction (White and Mitchell 1994). One student wrote 'All we do is sit there and watch demonstrations and listen to the teacher talk. Everyone just sits there and looks like they're listening. I hate science.' (Baird *et al* 1990). The obvious conclusion for conservation students is to ensure the approach taken does not militate against participation in the learning process. As noted, conservation students are often mature students who are strongly motivated and may tackle a scientific subject which they had previously rejected precisely because they perceive the needs and the benefits. It is also important to ensure that those students who do have a thorough grounding in a scientific subject are not alienated but are enabled to apply their knowledge in a new context. Understanding the language of science is more effective when the teaching relates the 'facts' to the concepts and practice of conservation. The teaching approach should encourage metacognition, the knowledge and ability to manage the process of thinking and learning. Students with the confidence to undertake independent learning, and the ability to ask questions of themselves and others, and assess the relevance of the response, are better prepared to undertake the problem solving required of the practising conservator. White and Mitchell (1994) stress that teachers seeking to encourage positive learning behaviours need to modify their own teaching styles. In a similar fashion, Haycroft (1983) stresses the need to use positive teaching strategies which use relevant and realistic examples to enable adult English language

students to overcome psychological resistance and develop knowledge and confidence. Relating conservation teaching to solving real conservation problems is clearly a beneficial strategy approach which will not only illuminate why such knowledge and understanding is critical, but also enable students to apply such learning.

POSTGRADUATE DIPLOMA COURSE IN TEXTILE CONSERVATION

The postgraduate Diploma Course in Textile Conservation was first offered in 1978 by the Textile Conservation Centre and the Courtauld Institute of Art, University of London. The course aims to enable postgraduate students to acquire the knowledge, skills and attitudes to practise textile conservation in a professional context. Course outcomes which particularly relate to the role of science in conservation are:
- an understanding of the aesthetic, historic and technological significance of textiles in order to solve conservation problems;
- an understanding of the materials, construction and deterioration of textiles in order to solve conservation problems;
- the ability to propose, evaluate and implement both interventive and preventive conservation treatments;
- the ability to conduct necessary research and communicate the results effectively.

The aim is not to enable students to become fully fledged research or analytical scientists but rather to enable them to become confident in dealing with material science aspects of conservation. Students need to be equipped with the vocabulary and grammar of science so that they can:
- understand and practice a scientific approach to science in conservation and have the capability to develop these skills at higher levels;
- understand science research related to textile conservation and be able to read and evaluate it in a critical manner;
- extract and use the information in an appropriate way;
- apply a scientific methodology to problem solving;
- initiate useful research;
- conduct a dialogue with colleagues on scientific issues;
- accept unknown/hypotheses /no correct answer.

The desired outcomes determine how 'science' is integrated into the course as part of an holistic approach to identifying and solving conservation problems. Particular stress is placed on developing a critical approach to scientific research – just because it is in print does not mean that it is necessarily useful or 'true'. The overall educational methodology of the course aims to encourage independent problem solving. The use of feedback as positive reinforcement has been discussed in previous papers (Brooks and Eastop 1996; Singer and Eastop 1990) and this approach is followed in the teaching and assessment of the science elements.

The structure and content of scientific teaching in the course is influenced by the typical background of the students. Many students, although possessing qualities and qualifications which give them the potential to become competent textile conservators do not, for the reasons discussed above, have science qualifications above the minimum required level. A breakdown of the type of first degrees (and above) obtained by Diploma students between 1991-96 is given in Figure 1. With this mix of 'soft' and 'hard' science backgrounds, it is important that students are rapidly brought 'up to speed'. The first term of the course includes a focused ten-day science block which starts with basic chemistry and chemical nomenclature. This is particularly important for overseas students in familiarising them with both scientific and English vocabulary. The block covers moles and molarity, water, acids and bases and concludes with an introduction to polymer chemistry. Although a formal learning situation, the teaching strategy develops the sessions as round table discussions on chemistry and chemical concepts.

The link with topics and conservation practices which students will encounter later in the course, such as dyeing chemistry, bleaching and the use of solvents in cleaning and adhesives, is stressed. The practical laboratory sessions are organised and assessed together with the Centre's Conservation Science Advisor and Co-ordinator. They deal overtly with weighing and measuring, chemical bonds and water hardness but actually have a dual function. They enable students to develop confidence in using scientific equipment, especially glassware; reinforce the need for accuracy and the concept of errors as well as simple statistical analysis of results. Learning organisational skills in the laboratory and working in groups is also stressed. Writing laboratory reports is a key element in this block, the equivalent of undertaking a language school's 'prose' exercise. The

methodology adopted here is designed to develop students' report writing skills so that they can easily adapt to the style used in most conservation journals thus facilitating both their comprehension of such research and also, hopefully, encouraging their own future contributions. Even students who have higher scientific qualifications attend this introductory block as it is specifically directed towards conservation science understanding. It is also an important stage in the development of the group and gives them their first experience of team projects and presenting their work according to required formats.

This approach is followed throughout the remainder of the science teaching and learning in the course which includes the degradation of materials, environmental science and wet and solvent cleaning chemistry, as well as more specialist topics in the second year such as the chemistry of dyes and finishes, adhesives and enzymes. The third year of the course aims to enable students to further develop their knowledge and skills by carrying out two twelve-week projects. One is an Object Treatment Project and the other is an Investigation Project. Both relate directly to real conservation problems, echoing the approach taken in modern language teaching, and draw on both science knowledge and scientific methodology. A recent third-year student Investigation Project 'Evaluating mixtures of anionic and non-ionic surfactants for wet cleaning historic textiles' (Lewis 1996) provides a useful example of how the scientific teaching and learning throughout the course enables students to tackle a small scale, but relevant, scientific investigation. This project was supervised by the Lecturer in Conservation Science and the Senior Lecturer, both with extensive theoretical and practical experience. The project focused on the most appropriate surfactant type mixtures to use when wet cleaning different textile fibres. The knowledge required to undertake this work included the chemistry of water and surfactants together with the ability to formulate a working hypothesis, set up and evaluate a series of controlled experiments, process the results statistically and then apply the conclusions to anticipated practical conservation problems. The ability to read and evaluate conservation science literature critically is also central to such an investigation. Undertaking such a project successfully both requires and enables the students to have confidence in both science 'facts' and methodology.

There is also the possibility that the positive completion of a small but well done piece of research involving both a knowledge of science and a scientific methodology, will engender a lasting interest and enjoyment in conservation science which will remain throughout professional life.

CONCLUSION

The competent understanding and practice of science in conservation is not just a matter of knowledge and understanding but also of effective communication. Confidence in scientific literacy and conservation concepts can be likened to being able to say the same thing in two different languages, both giving an insight into the ideas expressed by the other. The discipline involved in learning conservation science, and a scientific methodology for problem solving, feeds into conservation practices and provides a framework for the investigation and dissemination of new ideas.

ACKNOWLEDGEMENTS

The authors would like to thank Nell Hoare, Director of the Centre, for permission to publish. We would also like to record our thanks to our colleagues Dinah Eastop (Senior Lecturer), particularly for editorial advice, together with Janet Farnsworth (Conservation Science Advisor and Co-ordinator) and Alison Lister (Lecturer) for many useful discussions on teaching and learning science in conservation.

REFERENCES

Baird, J.R., Gunstone, R.F., Penna, C., Fensham, P.J. and White, R.T. 1990. Researching balance between cognition and affect in science teaching and learning, *Research in Science Education* 20, 11-20 (quoted in White and Mitchell).

Beck, J. and Daley, M. 1993. *Art Restoration: the Culture, the Business and the Scandal*, John Murray, London.

Brooks, M.M. and Eastop D.D.M. 1996. Evaluating professional and educational outcomes of a conservation programme: the role of the *viva voce* examination, in *A Qualified Community: Towards Internationally Agreed Standards of Qualification for Conservation* (eds J. Cronyn and K. Foley), ICOM-CC Training in Conservation and Restoration Working Group Interim Meeting, Maastricht 6-8 April 1995, 23-31, ICOM-CC, Paris.

Cook, V. 1991. *Second Language Learning and Language Teaching*, Edward Arnold, London.

Feller, R.L. 1983. Concerning the place of science in the scheme of things, in *Training in Conservation* (ed N.S. Baer), Institute of Fine Arts, New York University, 17-32, New York.

Ford, B. 1987. Analytical chemistry for conservation students, in *8th Triennial Meeting Sydney 6-11 September 1987* (ed K. Grimstad), ICOM-CC, vol. 3, 1028-32, The Getty Conservation Institute, Los Angeles.

Haycroft, J. 1983. *An Introduction to English Language Teaching*, Longman Handbooks for Teachers, 4th impression, Longman, Harlow.

Hill, D. and Wheeler, A. 1991. Towards a clearer understanding of students' ideas about science and technology: an exploratory study, *Research in Science and Technological Education*, **9**(2), 125-37.

Lawton, G. 1996. Imitators follow Imperial lead. Chemists to make complex simple, *Times Higher Educational Supplement*, 16 August, 7.

Lewis, J. 1996. Evaluating mixtures of anionic and non-ionic surfactants for wet-cleaning historic textiles. Unpublished Diploma Report, Textile Conservation Centre.

New Scientist. 1996. Feedback, 17 Oct, 92.

Park, D. 1990. The Courtauld Institute of Art/Getty Conservation Institute course in the conservation of wall paintings: the curriculum of a specialist postgraduate course, in *The Graduate Conservator in Employment: Expectations and Realities* (ed S. Price), ICOM-CC Training in Conservation and Restoration Working Group Interim Meeting, Amsterdam 31 August - 1 September 1989, 1-23, Opleiding Restauratoren, Amsterdam.

Pearson, C. and Ferguson, R. 1996. A proposal for guidelines for conservation teaching, in *A Qualified Community: Towards Internationally Agreed Standards of Qualification for Conservation* (eds J. Cronyn and K. Foley), ICOM-CC Training in Conservation and Restoration Working Group Interim Meeting, Maastricht 6-8 April 1995, 63-67, ICOM-CC, Paris.

Romaine, S. 1994. *Language in Society. An Introduction to Sociolinguistics*, Oxford University Press, Oxford.

Singer, P. and Eastop, D. 1990. Developing student assessment techniques in conservation training, in 9th Triennial Meeting Dresden 26-31 August 1990, (ed K. Grimstad), ICOM-CC, vol. 2, 700-3, Paris.

White, R.T. *Learning Science*, Basil Blackwell, Oxford.

White, R.T. and Mitchell, I.J. 1994. Metacognition and the quality of learning, *Studies in Science Education*, **23**, 21-37.

Zinburgh, D.S. 1996. Science's image crisis. *Times Higher Education Supplement*, 12 July 1996, 12.

Mary M Brooks* and Sheila Fairbrass, The Textile Conservation Centre, Apartment 22, Hampton Court Palace, East Molesey, Surrey, KT8 9AU, UK
* Author to whom correspondence should be addressed.

Degree/Previous experience

Figure 1 Distribution of students by degree or previous experience

THE SIGNIFICANCE OF PHYSICS IN CONSERVATION RESEARCH AND EDUCATION

Raik Jarjis

ABSTRACT

The study reported in this paper advocates integrating the primary subject of physics within conservation research and education; and it encompasses details of a mechanism for achieving this goal. Furthermore, it includes an overview of some relevant principles of physics and physical methodology, plus a discussion of selected physics topics within the context of conservation education. The study also includes development of a conservation research theme with particular reference to a recent initiative in physics-based microanalysis of historical manuscripts.

The paper concludes that the integration of physics within conservation research and education should be also fostered by international bodies seeking to develop and implement policies for global conservation of cultural heritage.

Key Words

physics, education, scientific conservation, cultural heritage, museum science, archaeometry, ion beam analysis, microanalysis

INTRODUCTION

It is not difficult to note the separation that prevails between the artistic and scientific disciplines within the museum culture of today. Whilst it could be argued that this is a reflection of society in general, it is necessary to stress that interdisciplinary initiatives should be cultivated in order to enrich this culture and sustain relevant conservation practises. Within this context I would like to state that formulating rationale and mechanism for integrating physics within the professional discipline of scientific conservation is potentially a significant development which merits consideration. The underlying background for such an initiative is that the conservation applications of chemistry and biology are already well placed, whereas the adoption of physics is yet to take place.

In this instance I endeavour to elaborate on the significance of physics as a possible primary subject in scientific conservation, and also to address other relevant issues which in my view signify the present moment in conservation development. To this effect the present paper aims to formulate terms and questions which are relevant to scientific conservation, and more specifically to its research and education foundations. However, for such a fundamental exercise to have any meaningful and lasting relevance it is necessary that it is pursued with vigour by taking into account the intellectual significance of fundamental physics, and also by considering applied physics within the conservation context. To do so I aim to answer a very basic question indeed, 'Is physics relevant?'. In addition, I endeavour to put forward a balanced argument through the exposition of specific topics, which were selected on the basis that they are relevant to practical conservation and to the broadening of its intellectual foundations.

FUNDAMENTAL PHYSICS AND THE SCIENTIFIC METHOD

It is important to advocate that appreciation of the essence of the physics discipline is worthwhile, not only for developing technical applications of physics but also for enriching the actual mechanism of applying scientific conservation in general. In order to appreciate this point I would like first of all to emphasise that basically physics is the science that is concerned with matter and motion, and it is to physics that some of the most interesting of nature's basic questions apply. In particular, the questions of how the material world is put together and what it is made of have for long occupied the thoughts of individuals who would now be called physicists. An essential part of the quest to answer these fundamental questions lies in the methodology of the physical science which is based on observation, hypothesis, experimentation and interpretation. By applying the

scientific method to the physical world it has been possible to postulate and prove that our world is governed by fundamental laws which could be expressed mathematically. In addition, this has necessitated developing physical units of measurements, such as in measuring distance on both the nuclear and astronomical scales. A crucial element in this progress has been the development of experimental physics in order to prove theoretical postulations by carrying out measurements using specially developed experimental techniques and instruments.

APPLIED PHYSICS

This aspect of the discipline of physics is in general more accessible to the practising conservator because it is historically easier to appreciate. For example, the adoption of applied mechanics and optics over the past centuries has been quite successful within diverse cultural developments. In addition, the twentieth century has witnessed the emergence of modern technology which borrows heavily from various applied topics of the physics discipline, including even quantum mechanics which is arguably one of the most abstract of scientific endeavours. Whilst the scientific method is also applicable in this case, one should add that applied physics has its own specific requirements which stem from the mechanism of applying fundamental physics principles and laws within different disciplines. In conservation, whilst applied physical techniques such as electron microscopy, are readily in use, the underlying academic subject has not been fully considered.

INTERFACING PHYSICS WITH CONSERVATION

Having described the principles of fundamental and applied physics I would like now to discuss the possibility of formulating a mechanism for interfacing physics with conservation. To do this I would like first of all to refer to the main responsibilities of the conservator which lie with the conservation and restoration of objects. In order to exercise these responsibilities effectively, or to develop research foundations, the conservator should be familiar with both the macroscopic and microscopic characteristics of the artefacts and their environments. This would facilitate better understanding of the fabrication details and surface properties. In addition, this knowledge could be applied for assessing the effects of time, environment, handling, and both past and present restorations. For this reason it is advisable that during training scientific conservators should acquire a good grounding in physics principles and methodologies. This aspect of the training should not only complement those of chemistry and biology but it should also facilitate developing richer personal appreciation of the 'conservation domain', e.g. environment, artefacts, and conservation principles. By taking into account the details given so far it is possible for me to propose a mechanism for interfacing physics with conservation (Fig. 1).

In order to elaborate on the above statement let us consider the case of preventive conservation by taking into account environmental control as well as postulating the effects of handling etc.. In this case physics-based conservation should incorporate appreciation of the volume density and dynamics of environmental molecular species under certain conditions of pressure, flow rate, humidity, temperature and lighting characteristics. In addition, the approach should encompass familiarity with assessing the interaction of the molecular species with the surface of an artefact, molecular diffusion as a function of time and temperature, and light and thermal effects on the integrity of the artefact. These microscopic considerations and those of classical mechanics should be invaluable on a routine basis, and also for planning exhibitions, and designing display and storage facilities.

By taking into account the above details and those included in the previous sections I can state that the incorporation of fundamental and applied physics in conservation education and research should make the following contributions:

- Stronger foundations for the scientific approach to conservation;
- Possible scientific theory for conservation;
- Understanding and measurement of relevant natural phenomena and conservation induced effects;
- Effective application of the existing physical techniques; and also development of new physical techniques and instruments specifically for conservation;
- Improvement in the development of new conservation methods and strategies.

It is important to point out that the above points are worthy of more detailed examination. However, in this foundation paper I shall refrain from doing so, and opt for providing a scientific background by discussing a selection of physics topics.

SELECTED PHYSICS EDUCATIONAL TOPICS

Energy and the Building Blocks of Matter

Energy is one of the most fundamental aspects of physical science, yet it is the least obvious topic to consider within the context of conservation education. Even so, I do advocate that discussing this subject is taken seriously, and with caution. To do this it is quite worthwhile to introduce a fundamental model which encompasses dramatic interplay between energy and matter. This model is that of the birth and expansion of the Universe, which also illustrates the manifestation of the laws of physics through the mechanism of cooling down due to expansion (Fig. 2). This model also provides some parallels with the interrelationship between volume, temperature, pressure, molecular distance, and energy within gases. This foundation for the concept of energy could then be extended to the different phases of matter and different forms of energy. Thermal energy is particularly important in this case, and it could be discussed in terms of an example, such as its effect on the integrity of an artefact which consists of different materials each having different characteristics of heat transfer, heat capacity, and specific heat capacity.

Understanding of the electromagnetic spectrum in terms of energy, frequency, wavelength, and interaction with matter is very important indeed within the museum environment. It is also important within this context to study the basis of molecular-, atomic- and nuclear-based responses of a given artefact to the transfer of non-thermal forms of energies due to unintentional or deliberate exposures. For example light at specific frequencies can undergo absorption by particular molecules located at the surface of an artefact due to transfer of its energy into vibration/excitation energy. Whilst this process could be used for molecular fingerprinting (physical methods of analysis), it could also be of concern for the conservator due to its possible damage-inducing effects. It is also useful to expand on this issue of energy/material interaction by pointing out that as the energy of the incident electromagnetic wave increases, i.e. shorter wavelength, excitation could manifest itself in different forms, i.e. atomic or nuclear, at even deeper layers within the bulk of the artefact material, e.g. ionisation.

Planned progress through the above educational component should lead to the concept of the building blocks of matter and materials science.

Mechanics of Materials and Structures

The fabrication of sculptures and the construction of artefact support and display units are just two of the many applications which require understanding of basic mechanics. In such structural mechanics cases it is also important to be familiar with the concept of force and friction, and the interaction between objects. In addition, material mechanics should also be introduced through the study of stress and strain, strength and hardness, and plasticity and elasticity. In addition, mechanics of the molecular forces should be introduced. This is particularly important for many phenomena which are encountered on a daily basis. For example, the physics of surface tension is important in pottery fabrication, and in applying oils to surfaces. Within this context the degree of wettability of surfaces, capillarity of certain structures, and diffusion of atoms within solid surface layers are all important physical parameters for the practising conservator. Notable examples of their applications are environmentally induced surface modifications, such as corrosion, and also the application of protective surface coatings, e.g. decorative gilding, and protective surface coatings.

Optics, Colour, and Vision

Within the context of the museum culture it is essentially the 'visual' with its relevant historical/intellectual background that merits curatorial/conservation considerations. This requires that the aesthetics, not only of an accurate presentation/preservation of the object/image, but also of an enhancement of its appeal using lighting and colour ambience, are taken into account. It also follows that when this is considered within the framework of physics it is possible to interpret the action as manipulation to a form of energy, 'light', by applying various physical phenomena, e.g. intensity, wavelength, absorption, reflection, and refraction in

order to stimulate a specific visual sensation under safe conditions.

For the above to take place scientifically one should be familiar not only with light as a wave-form but also with the concept of the 'photon' in order to understand vision. In addition, luminous energy, flux, and intensity should be introduced in order to understand the science of light measurement, 'photometry', and also to assess light induced damage and plan lighting strategies. In addition, light reflection and refraction, plus opacity and transparency should be considered from the point of view of the optical effects of light interaction with artefact surface. Diffraction of light could be also taken into account in connection with the electromagnetic spectrum and the brilliant colours of certain plumage and minerals.

For vision, physics is certainly useful for understanding light entry to the eye and the sensations that follow as a result of photochemical-neural processes. Furthermore, physics is essential for learning how colour vision, dark-adapted vision, and vision in bright light are affected by physiological aspects of the retina, which exhibit differential sensitivity to brightness and to the wavelength of the incident light photons.

Physical Methods of Analysis

It is important that practising conservators should have access to some of the many physical techniques which are available for analysing or studying the structure of works of art, or for determining environmental characteristics. In a sense this is one branch of applied physics which is already familiar in the field of conservation. It is, however, important to emphasise that although it is very useful to incorporate an educational element on the instrumentation and application of the different methods, it would be particularly rewarding if such an effort were complemented with a rigorous study of fundamental physics. This would allow a better assessment of the potential of individual methods and provide important information for selecting the necessary methods and interpreting the relevant scientific results. The corresponding physics educational component should draw on several other components, e.g. energy and radiation physics, in order to define the interaction characteristics of relevant analytical sources of energy, e.g. electrons or light. Physics should also provide an explanation of the nature and origin of the generated analytical signals. This is because it is only through understanding the physics of source interactions with the sample/artefact that effective information is obtained.

The second relevant issue involves planning an analytical programme in which physics principles are applied in order to calculate detection sensitivities, determine if it is necessary to carry out quantitative analysis, assess the destructive nature of the technique, and work out procedure for macro- or micro-analysis.

PHYSICS AND CONSERVATION RESEARCH

It is not feasible at this early stage to produce a comprehensive assessment of the range of physics research applications. However, it is quite worthwhile to refer to a new trend in which physics principles are employed in the design and implementation of a major project which has conservation research implications. This is embodied in the recent initiative in which a laboratory and microanalytical methods were developed at Oxford within the context of conservation (Jarjis 1995, 1996a, 1996b). The methods are capable of multi-dimensional analysis of small samples, or full artefacts without sampling, e.g. bronze sculptures or manuscripts; and they employ a scanning beam of MeV protons from a nuclear accelerator. In principle the physical process is relevant to the energy educational element (see 'Energy and the Building Blocks of Matter'), in that it involves incremental transfer of the energy carried by the beam of energetic protons to atomic species within the depth of the material under study in order to generate signals which are atomic or nuclear in origin. The relevant interactions manifest themselves mainly by instant emission of X-rays, as in Proton Induced X-Ray Emission, PIXE, scattered protons, as in Rutherford Back-Scattering, RBS, or other nuclear products, as in Nuclear Reaction Analysis, NRA. These physical techniques are discussed elsewhere (Jarjis 1995, 1996a). However it is worthwhile to point out that by analysing their products it is possible to generate details about the elemental concentrations and distributions both laterally and as function of depth.

To put this within a conservation perspective let me for example refer to the Oxford method of Ion-Beam Codicology, IBC (Jarjis 1996a). This method employs the above techniques to reveal microanalytical and structural details about historical

manuscripts without sampling. As a primary method IBC is capable of determining the inorganic compositions of papers, inks and pigments plus the characteristics of surface layers, and some aspects of conservation treatments. Furthermore, it is important to emphasise that conservation considerations have been taken into account in designing a relevant laboratory at Oxford. Analysis of, for example, the ink of a full stop is performed under predetermined proton beam exposure while the manuscript is supported on a special cradle (Fig. 3).

It is also worthwhile to indicate that IBC is capable of generating both numerical data and multi-dimensional elemental maps, and it is envisaged that the scientific laboratory will be used in the near future for developing a data base for Islamic manuscripts and for characterising relevant conservation treatments. An example of the elemental imaging obtained using IBC is presented in Figure 4.

CONCLUSIONS

Details given in this paper constitute a foundation for the integration of physics as a primary subject within conservation research and education. Whilst a full treatment of the subject is beyond the scope of the present study, the outlined approach and information are sufficient for developing a mechanism for physics-based conservation initiatives that not only adopt physics techniques and data but also aspects of fundamental physics and its methodology. This could be considered in isolation by the practising conservators. However it is much more profitable if relevant developments are carried out in collaboration with professional physicists who should be encouraged to develop an interest in conservation of cultural heritage. It is also worthwhile to emphasise that in view of the limited resources available within the field of conservation it is important that the issue of integrating the primary subject of physics is viewed by the international planning bodies within the wider perspective of developing modern global strategies for conservation.

Finally, it was pointed out in the introduction that in undertaking this treatment of the subject I initially asked myself a very basic question, 'Is physics relevant?'. In response I exerted scientific discussion and analytical assessment; and hence I trust that the product of the endeavour is sufficient for assisting the reader to reach a similar answer to mine, 'yes'.

ACKNOWLEDGEMENTS

The study which is presented in this paper was motivated by the response to the physics course which I developed for the International Centre for the Study of the Preservation and Restoration of Cultural Property, ICCROM, in Rome. Hence, I would like to take this opportunity to express my gratitude to the SPC 96 students and co-ordinator, Katriina Simila.

REFERENCES

Jarjis, R.A. 1995. Ion-beam archaeometry: Technological assessment of ancient and Medieval materials, in *Application of Particle and Laser Beams in Materials Technology* (ed P. Misalides), Kluwer Academic Publishers, 443-61, Dordrecht.

Jarjis, R.A. 1996a. Ion-beam codicology: Its potential for developing scientific conservation of Islamic manuscripts, in *Conservation and Preservation of Islamic Manuscript* (ed Y. Ibish and G. Atiyeh), Al-Furqan Islamic Heritage Foundation Publication, 93-117, London.

Jarjis, R.A. 1996b. Back-scattering spectroscopy developments for the University of Oxford scanning external proton milliprobe (SEPM), *Nuclear Instruments and Methods*, B 118, 62-71.

Raik Jarjis, University of Oxford, Nuclear Physics Laboratory, Keble Road, Oxford, OX1 3RH, UK.

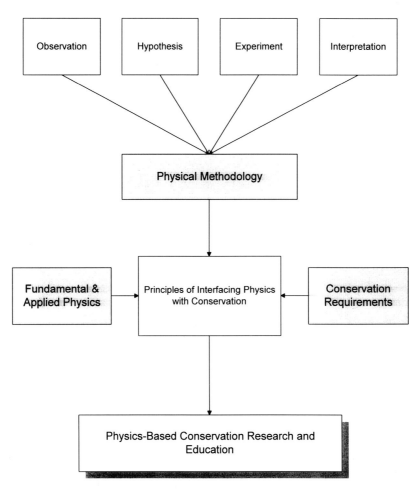

Figure 1 A flow chart of the mechanism for integrating physics within the discipline of conservation of cultural heritage

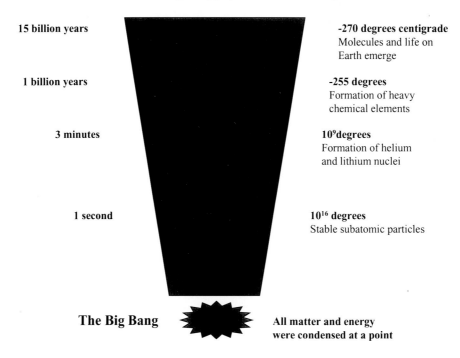

Figure 2 A simplified schematic representation of the birth and expansion of the Universe. This is a model for understanding the interplay between energy and matter. As the Universe expands it cools down, i.e. lower mean energy per unit volume. Hence, molecules are eventually formed when the energy of the system is adequately low for sustaining molecular bonding.

Figure 3 A photograph of the University of Oxford Laboratory for the Scientific Analysis of Manuscripts. Analysis is carried out at atmospheric pressure and without sampling. A scanning beam of protons from a nuclear accelerator is directed through the narrow vacuum tube shown at the right. The beam then emerges in air towards a well defined location within a page. **PIXE** X-rays which are emitted from this location are detected by the cooled detector which is mounted over the top of the supporting frame.

Figure 4 Results of Ion-Beam Codicology, **IBC**, obtained without sampling using the Oxford scientific facility, (see Fig. 3). Shown are **PIXE** elemental distribution maps having frame size of 2mm. The maps are for two adjacent lines of gold ink, left row, and blue ink, right row; which are present within a page of seventeenth-century Islamic manuscript. The colour yellow denotes the highest concentration. The **PIXE** maps show that the gold ink contains Au, Cu, Zn and S; whilst Al, Si, K, and Co, (not shown), are constituents of the blue ink.

SCIENTIFIC EXAMINATION AND THE RESTORATION OF EASEL PAINTINGS AT THE COURTAULD INSTITUTE OF ART: SELECTED CASE STUDIES

Aviva Burnstock

ABSTRACT

The Department of Conservation and Technology at the Courtauld Institute of Art offers a three year postgraduate Diploma in the Conservation of Easel paintings. Under supervision, students carry out historical and scientific investigations of paintings which influence their decisions about their subsequent conservation treatments and display. Three case studies have been selected which illustrate the relationship between scientific examination and conservation of the paintings, the interpretation of scientific data and its influence on choice of treatment. Cases were selected which are both typical of the approach to conservation training at the Courtauld Institute and interesting as unique objects which presented a range of different problems, including assessment of condition, approach to cleaning and identification of the deterioration of original materials. The paintings chosen for discussion show, in particular, the role of science in the treatment of the works, and the point at which the work of the scientist ends and the work of the conservator begins.

Key Words

easel paintings, X-radiography, infra-red reflectography, SEM/EDX, gels

INTRODUCTION

This paper describes the application of selected science-based techniques in the conservation and restoration of easel paintings by students at the Courtauld Institute of Art. Three case studies have been chosen, which illustrate the relationship between scientific examination and treatment, the role of the conservator as a practitioner and undertaker of technical studies, and the part played by specialist scientists.

Cases were selected which presented a range of problems, including assessment of condition, identification of the deterioration of original materials and considerations regarding different approaches to treatment.

In each case, students carried out the historical and technical examination of the paintings and the treatments, under the guidance of the Department's four members of staff. Interpretation of the data and decisions about the treatment were taken by consensus between the staff and the student responsible for the work. In each case, the role of the conservator and the analytical scientist is discussed, in particular, the role of science in the treatment of the works, and the point at which the work of the scientist ended and the work of the conservator began.

TECHNICAL EXAMINATION AND ANALYSIS

Under supervision, from the first term, students carry out historical and scientific investigations of paintings which influence decisions about their subsequent conservation treatments and display.

In the first year, students are introduced to the theory and practical application of a selection of basic analytical techniques which have been applied to the technical examination of paintings. Non-destructive techniques include X-radiography, infra-red reflectography (IR) and photography for documentation of the painting's condition at various stages of treatment (including raking light and ultraviolet illumination). Samples of paint are taken by students, for examination of the paint layer structure and identification of pigments. Students prepare cross-sections, pigment dispersions and thin sections for identification of materials using the light microscope. Confirmation of the analysis of inorganic pigments is done, where sufficient sample is available, using microchemical tests or energy dispersive X-ray

spectroscopy (EDX), operated by a member of staff. By their final year, students are equipped to identify most inorganic pigments using microscopy and to be able to assess the class of organic media present (on the basis of a combination of ultraviolet examination and staining tests on paint samples). Where other methods of analysis are required, students are introduced to the appropriate techniques, for example, where SEM micrography could be used to characterise a surface alteration.

Following a general theoretical introduction to analytical methods, technical study is based around the paintings assigned to individual students. Application of the most appropriate techniques for the specific problems posed by each painting is stressed, rather than routine analysis. In the case of techniques relying on specialist equipment not housed in the Department, such as gas chromatography with mass spectrometry(GCMS), or Fourier-transform infra-red spectroscopy (FTIR), students, where possible, take the appropriate samples and prepare them for analysis using resources at King's College or UCL. Where analysis is carried out by specialists outside the Department, the emphasis is on interpretation of data. The student is responsible for careful documentation of the sample site, gathering information about conservation history (for example, considering the influence of previous restoration on the painting). The methods used for sample preparation and the limitations of the analytical techniques applied are considered in the interpretation of the results of analytical data so that useful conclusions can be reached.

CASE STUDIES

Case study 1. *The Dream of the Virgin* by Simone dei Crocifissi of Bologna, c.1370 (see Fig. 1, illustrating the painting before treatment).

The Dream of the Virgin attributed to Simone dei Crocifissi of Bologna was brought to the Courtauld Institute for examination and treatment from the Society of Antiquaries of London in January 1994, and allocated to Annette King, a student in her final year of the course (King 1994). Superficial examination, using a low-powered binocular microscope, ultraviolet and raking light suggested that the paint layers and poplar panel support were stable, and that the panel had at some time been cut down on all sides. This in itself is not unusual, as there are

many examples of altarpieces which were dismantled into convenient and saleable fragments which are now presented as independent works. There was evidence that the appearance of the painting was significantly altered by earlier restoration campaigns: areas of background which were originally water gilded were covered by a matt lustreless metallic paint and extensive application of brown repaint was apparent, particularly around the edges of the painting. The image was obscured by a significantly yellowed natural resin varnish. Based on evidence from surface examination alone, the possibilities for improvement in the appearance of the painting did not look promising: extensive restorer's repaint is often an indication that the original beneath is significantly damaged.

An X-radiograph taken of the whole painting provided significant insight into the structure and condition of the painting (Fig. 2). Additions to both upper corners were evident in the radiograph, which altered the shape of the top of the painting from an ogee arch to its current rectangular format. The additions to the corners were coated with gesso and gold paint which exhibited a different craquelure from the main part of the picture. Damage to the edges of the painting, incurred when the panel was cut down, including losses to ground and paint was indicated by saw-marks, which were clearly visible in the X-radiograph. Close examination of the radiograph, and comparison with the surface of the painting provided evidence of restorer's alteration of the original: two towers were visible, to the sides of the crucifix, painted beneath the area covered by gold paint. The outline of the figure of Christ showed adjustments, and beneath areas of brown repaint around the edges of the image, a layer of original paint was evident. Characteristic craquelure in the background of the painting showed up on the radiograph, and was not visible on the surface. This suggested that there was a layer of gilding beneath the gold paint, however nothing could be ascertained about the condition of the gold layer from the radiograph due to the thinness of the metal leaf.

The presence of original paint beneath the brown repaint was confirmed by examination of the paint layer structure and by preparation of paint cross-sections taken from strategic areas. The sample sites were selected by defining critical areas for study based on information from the X-radiograph and the surface of the painting. Samples were limited by the availability of suitable sites, such as discrete losses or the edges of cracks. The surface area of a typical

sample was 1mm diameter or smaller. A sample from the cross, taken from above Christ's head, showed that an original water-gilded gold leaf background complete with gesso and red bole extended underneath at least two layers of regilding. The brown paint used for the cross, which was painted over the layers of regilding and metallic paint was composed of a mixture of pigments, including particles of chrome yellow which was available to artists only from the nineteenth century (Kuhn and Curran 1986). An earlier restoration of the back-ground included the application of a layer of calcium sulphate gesso over the original gold leaf. The gesso and layers of brown and gold repaint covered the outline of Christ, which altered the original shape.

An assessment of the binding medium used for the original paint and the repaint layers was made by staining paint cross-sections using the protein stain Amido Black, and the fluorescent stain Rhodamine B as an indicator of drying oil media (Martin 1977). Although results of medium analysis of paint layers using staining techniques are often unreliable and without suitable controls, these stains have found some use as indicators of the class of organic material present. In this case, protein (probably egg-tempera) was indicated in the paint layers of the three samples tested, while layers of brown repaint, including the cross, reacted with Rhodamine B, suggesting that a drying oil was used as the binding medium.

Careful cross-referencing of the image and analytical data with empirical observations combined to establish the existence of a consistent, reasonably well preserved original painting beneath the restorers' additions. It was possible to identify the deterioration of some pigments in the original paint from examination of the paint cross-sections. For example, the organic red dyestuff associated with a red lake pigment had faded, both where it was used as a glaze and where the red was mixed with azurite for the purple drapery of the female figure on the lower right of the painting. The extent of wear and deterioration of other parts of the original paint layer, such as the Virgin's blue drapery, which incorporated coarsely ground azurite pigment were more difficult to assess in advance of actual removal of superficial layers of varnish and repaint. A cross-section from the Virgin's robe showed a coherent layer of azurite beneath a thick layer of repaint. Examination of the surface using a binocular microscope suggested that the original paint, although abraded and light-scattering in appearance, could be seen beneath the repaint.

In this case, infra-red reflectography provided little additional information about the painting technique and condition of the original paint. Infra-red images enhanced the contrast between some areas of repaint and original paint.

On the basis of the conclusions from the technical study, the decision to remove the added layers was taken. At this point, the restoration process, including an empirical assessment of the solubility of layers of surface dirt, varnish and repaints and their removal proceeded, unaided (or unimpeded) by scientific analytical procedures. Figure 3 shows the painting after removal of the varnish layers and much of the brown repaint around the edges. Part of the added layers of gesso and gold paint in the background have been removed to reveal the towers which were evident in the X-radiograph.

Further cleaning revealed the original gilded background, in almost pristine condition, complete with intricate pattern of punching in the halos and background (Fig. 4). None of the techniques used for technical study provided evidence which predicted that the punched decoration was preserved beneath the layers of earlier restoration. The significance of the decorative punching and confirmation of the status of the painting was clarified using traditional art historical investigation of the artist's oeuvre (Personal communication 1994). The curved top and evidence of reduction in the panel on all sides suggests that it belonged to the upper part of a polyptych, perhaps similar to Simone's *Coronation of the Virgin* in the Bologna Pinocateca. A version of the same subject by the artist now in the Pinocateca Nazionale in Ferrara depicts the figure of Christ crucified on a tree of life, rather than a cross. The original version of the subject of the painting under treatment was painted in a similar manner.

Future treatment will include completion of the cleaning, reintegration of the image, and reframing of the painting. Decisions about the presentation and display will be taken in the light of some of the results from its technical examination, including the condition of the original paint and its current status as a fragment of an altarpiece. The environmental conditions in which it will hang or be stored will also be considered.

In this case, scientific investigation of the painting played a significant part in the decision to restore the painting. Evidence which suggested that an original paint layer was in reasonable condition beneath the layers of old restoration tipped the balance in favour of an intervention treatment which would not

otherwise have been attempted. The decisions regarding the process of restoration and approach to presentation, however, were the responsibility of the restorer.

Case study 2. *Portrait of a Dutch Gentleman* by Cornelius Johnson van Ceulen, 1657 (see Fig. 5)

The technical examination and treatment of a traditional mid-seventeenth century *Portrait of a Dutch Gentleman*, signed and dated 'Cornelius Jonson van Ceulen, Fecit 1657' was carried out by final year student Rachel North (1996).

Superficial examination of the portrait showed dark blue edges corresponding to the frame rebate which had protected the painting from light. Outside the area protected by the rebate, the background exhibited a patchy, unsaturated surface of pale greenish-blue. Examination in UV light suggested that there were at least two campaigns of retouching above and beneath a significantly yellowed natural resin varnish. At this stage, removal of the varnish layers was carried out, using solvents. The removal of the yellow film and overlying repaints revealed the original paint of the background and enhanced contrast in colour between the protected and exposed paint. Thin scumbles of repaint which was significantly darker in tone than the original background were evident, and visually disturbing. Tentative attempts to remove the repaint recovered patches of the original background which were darker than the surrounding paint, and less saturated than the edges protected by the frame.

An investigation of the nature of the paint alteration was carried out: paint samples were taken from the exposed and protected areas of the background, and prepared for examination of the paint layer structure using light microscopy. Figure 6 shows a thin cross-section of a sample from the darkest blue background unprotected by the rebate, photographed using transmitted tungsten light. The uppermost part of the paint layer appears translucent and yellowish in colour, whereas the lower part of the paint layer is coloured deep blue. Comparison of the condition of the same paint layer from other parts of the background suggested that the blue pigment was indigo, an organic dyestuff notoriously friable on exposure to light, used for the darkest part of the background and mixed with a proportion of lead white for the lighter areas. The identification of indigo was suggested indirectly, by two negative results: no colour change was observed in a sample of blue pigment on application of a drop of concentrated alkali, the microchemical test used to distinguish indigo from Prussian blue (ferric ferrocyanide) (Plesters 1956). Iron, present in Prussian blue is usually detected using EDX analysis; elemental analysis of the blue pigment present in samples from the background did not produce spectra containing iron, however, the presence of the element calcium suggested that chalk was mixed with indigo. (This was confirmed using electron microscopy; coccolyths present in natural chalk deposits were visible beneath a thin layer of binding medium on the surface of samples of indigo paint). The method of choice for positive identification of indigo using high performance liquid chromatography (HPLC) is not currently available for occasional analyses of paint samples in accessible university departments. Analysis of dyestuffs, including indigo in small mixed paint samples is difficult without dedicated equipment and expertise.

Cross-sections showed that loss of colour of the blue pigment indigo in light-exposed areas of the paint film was dependent on the depth of penetration of radiation and the admixture of white. Where indigo was used pure (as in the sample illustrated in Fig. 6) the loss of colour was complete to a depth of 3-4μm; where the paint layer was thicker, or protected entirely from light (by the frame rebate) the blue dyestuff retained some or all of its intensity. Admixture of white pigment exacerbated the fading of the blue, probably by increasing exposure due to light scatter within the paint film. Therefore, the contrast between areas of light and dark blue in the background are likely to have increased, with partial fading of areas of pure indigo and almost complete loss of blue from the lighter areas.

Changes in surface saturation, in addition to the fading of indigo, contributed to the alteration of the light exposed parts of the background. To provide more information about the nature of the surface changes, a series of samples were taken from representative areas of surface of the paint layer from the background, where the paint was well preserved (beneath the rebate) and from faded areas, and examined using scanning electron microscopy(SEM). The surface of a sample from the unfaded, protected paint film was characterised by a layer of unbroken organic binding medium, while light exposed paint had developed a roughened surface with network of fine cracks.

The results of these analyses suggested that the alteration of the background was caused by a combination of the fading of indigo and alterations in the binding medium at the surface, including roughening and cracking, which lead to loss of colour saturation produced by light-scattering. Evidence of the original appearance of the background remained in the protected areas of the rebate. Although an awareness of the cause of the alterations played a role in the approach agreed for the reintegration of the background, the final decision was a compromise, based on an acceptance of the deterioration of the pigment. Possible approaches to conservation could include repainting the background, imitating the hue preserved under the rebate, and estimating the modulations in tonality using inert modern pigments bound in a stable, reversible, synthetic resin medium for the repainting. This was deemed to be too great an intervention, and an alternative approach was adopted, (also using a stable retouching medium, Paraloid B-72®) which aimed to minimise the patchy discontinuities between areas of remaining darkened restorers' paint and the faded or partially faded original paint remaining.

This case study is not unusual; it is one example of a large group of paintings which have suffered deterioration of a pigment which has lead to a striking alteration in the appearance of the painting. Other examples include the partial blackening of vermilion (Gettens et al. 1993), darkening of copper pigments in oil media and discolouration of smalt in oil. All of these alterations are irreversible; however, if the change is well documented, and if part of the original condition of the paint film remains unaltered, the argument for a more wholesale repainting of the altered areas may have greater validity, at least from the viewpoint of the analytical scientist. In practice, decisions about the final presentation of paintings with this kind of defined alteration vary widely, and may be influenced by the presentation of other works in the same collection, the painting's age and general condition, and consideration for preserving aspects of the history of the object. In any case, these decisions are taken by the conservator rather than the scientist.

Case study 3: Cleaning of a *Portrait of Charles Tudway*, by Thomas Gainsborough *c.*1761

A full-length *Portrait of Charles Tudway*, by Thomas Gainsborough from the Courtauld Institute Galleries was cleaned in 1993 by final year student Lesley Stevenson (Stevenson 1993). Figure 7 shows the painting before treatment. Structurally, the painting was in a stable condition, and required no treatment. Using a combination of non-destructive techniques for technical examination, an assessment of the condition of the paint and superficial varnish layers was made. As the result of the drying of the original paint, wide cracks were apparent which had been inpainted, in some areas covering original paint, during an earlier restoration. The aged restorers' paint had darkened and had a disfiguring effect on the image. Patchily applied layers of a natural resin varnish, now significantly yellowed, altered the image: there was an overall loss of the sense of depth of the composition, in particular, the landscape in the background, and the light, fluid use of oil paint (rather like water-colour) characterising Gainsborough's technique, was obscured.

Prior to the decision to remove layers of dirt and varnish, an assessment of the solubility of the varnish layers was carried out. A traditional method was used, which involves the application of a series of free solvents of increasing polarity (on cotton wool swabs) while observing under a binocular microscope the swelling or softening of the surface layer. Inhomogeneities in the varnish film and the response of differently pigmented areas of the paint layer to solvents were taken into account by testing a comprehensive range of sites. The aim was to find a solvent which removes a specific layer evenly, and at a controllable rate, without affecting the layer (of varnish or paint) beneath. Solvents which fulfilled these criteria were found which could remove layers of varnish and old repaints from the background and flesh of the figure, but cleaning areas of black, including the hat, shoes and breeches was problematic. The solvent selected for removal of the varnish (propan-2-ol) removed black pigment in these areas, as did more polar solvents, while solvents of lower polarity had no effect on the varnish. Alternatives were tested, including solvent mixtures, aiming to differentiate between the solubility of varnish and paint layers. Alkaline solutions of ammonia were also tried, and found to be either ineffective (pH=9) or non-discriminating at higher pH.

Paint samples were taken at this stage to examine the nature of the materials present and the layer structure in the vulnerable areas of black. A sample taken from Tudway's black shoe was prepared as a cross-section and examined in incident tungsten and

ultraviolet light. The layer structure was found to be similar to that in the other black areas, from comparison of cross-sections from these sites. All samples comprised two layers of carbon black and brown ferric oxide pigments, bound in a drying oil (according to staining tests), with an intermediate layer of varnish, covered by a varnish layer of similar polarity. The similarity in the pigment composition of the two layers of black paint suggested that they were alterations made by the artist, using the same palette. Where it is common to find strengthening of worn areas of black paint, restorers repaints are usually different from the original in pigment composition, and tend to contain a greater variety of pigments in a struggle to match the exact tonality of the worn original.

A dilemma ensued: whether to proceed with varnish removal. Partial cleaning of the painting, which would involve removal of varnish except in the black areas would result in an image with increased contrast between the cleaned lighter areas and the black-painted parts. Leaving a unifying layer of varnish over the painting or, if practically feasible, thinning the layer evenly to reduce the yellowness were other alternatives which have been widely advocated (Hedley 1985). In this case, the potential for improvement in the appearance of the image which would be gained by removal of the varnish led to the decision to pursue this option further. Using free solvents, it was not possible to thin the varnish layer in a even controllable manner. The possibilities of using gelled formulations to remove the upper layer of varnish from the black parts of the painting was explored. The hypothesis is that by using gels, thinning of the varnish layer could be achieved by containing the activity of the solvent within a gel, which would remove varnish from the surface without affecting the varnish-paint interface. Based on empirical tests of solvent solubility and cross-section studies, a gel was formulated based on a microemulsion recipe suggested by Richard Wolbers (Wolbers 1989). A gel based on dimethylbenzene (xylene), with Ethomeen C-12® (a surfactant, cocobis[2-hydroxyethyl]amine) and thickened by neutralisation reaction initiated by a small volume of water with Carbopol 934® (a polyacrylic acid) was applied using a swab. Residual gel and varnish was cleared from the surface of the painting using a dry swab, followed by swabbing with generous amounts of xylene, to ensure removal of free surfactant in the gel formulation. While xylene applied as a free solvent barely swelled the varnish, the xylene gel removed

varnish at an appreciable rate. The use of non-volatile surfactants is integral to the microemulsion gel formulations, and although some studies have addressed the efficacy of various clearance procedures, the effects of residual surfactant on oil paint films has not been studied (Burnstock and Kieslich 1996).

The resolution of the cleaning problem was achieved by varnish removal using free solvents, with the exception of the black breeches, shoes and hat, where superficial varnish was reduced to a thin layer of a few microns using the xylene gel. Justification for the use of the solvent gel in this case was that it was used with awareness of the necessity for thorough clearance of the gel from the paint film, and because the thin layer of varnish remaining on the black painted areas after treatment may to some extent serve as a protective layer for the paint film.

The practical application of gelled cleaning systems for the removal of dirt, varnish and repaint is now well established, not as the primary means for cleaning, but as a last resort. An awareness of the problems associated with clearance of non-volatile components, particularly where they are used directly on the paint film are concerns which have been highlighted, largely by conservation scientists. The dangers of the use of gels, or any non-volatile cleaning systems is that in practice, they are often more effective, controllable and appealing to use than free solvents, and that residues, should they remain are not visible to the conservator. In the sort term, results achieved using gels may be preferable in terms of the resulting appearance of the paint film; where some solvents may leave the paint film looking slightly blanched, paintings cleaned using gelled formulations have been reported to have a saturated appearance (Stringari 1990). This effect has may be attributed to adsorption of residual surfactant on the paint surface, and it is therefore important that the appropriate clearance procedures be followed by the conservator and the concerns be considered in each case.

CONCLUSIONS

Investigation by the conservator of the materials and techniques of paintings using a range of analytical techniques plays a crucial part in decisions about the treatment procedure followed. An approach to technical study favoured by the Department of Conservation and Technology involves the conservator directing the investigation, based on the specific set of problems of each painting, as opposed

to routine analysis using all the available techniques. Stress is on defining the problem and deciding on the best approach for its investigation. An understanding of analytical processes and their limitations is necessary for maximising the value of information interpreted from technical data, particularly where analysis is carried out by experts outside the Institute.

While analytical information about the painting materials and layer structure of a painting is a pre-requisite for cleaning using gelled formulations, many decisions about aspects of conservation practice are taken on the basis of aesthetic criteria, and considerations relating to the age and history of a painting. One example discussed in this paper is the approach to the reintegration of well documented colour changes due to deterioration of pigments and pigment-binder interactions.

While science has a role to play in defining stable, reversible materials for use in the retouching stage of the conservation process, it is at this juncture, the re-presentation stage of treatment that the scientists role is least influential, and the conservator's decisions involve other principles.

It is hoped that by teaching some of the basic techniques and approaches to the scientific examination of paintings, students will be equipped to pursue the relevant technical studies themselves, where they can, and to evaluate the results. A high proportion of students follow up the course with an internship in the conservation department of a museum, where there may (or may not) be departments dedicated to technical analysis or scientific conservation research. Graduates should be able to ask relevant questions of the experts and to collaborate in the interpretation of the results. A small group of students (usually, but not exclusively those with scientific backgrounds) pursue careers in conservation science following their Diploma in the Conservation of Easel Paintings. With practical experience of conservation, these students are well placed to select crucial areas for study. For students destined for private conservation practice, the investigation of technical issues associated with the treatment of paintings takes on a new dimension, that of time, allocation of funds and access to the resources and expertise for the appropriate analysis. Although technical study may be limited, the skills for evaluating where scientific analysis is required may still be useful.

ACKNOWLEDGEMENTS

Many thanks to Annette King, Lesley Stevenson and Rachel North, who carried out the practical and technical studies described in this paper.

Thanks to Bill Luckhurst in the Department of Physics, Kings College, University of London for the use of the SEM/EDX equipment.

REFERENCES

Burnstock, A. and Kieslich, T. 1996. A study of the clearance of solvent gels used for varnish removal from paintings, in *11th Triennial Meeting, Edinburgh 1-6th September 1996* (ed J. Bridgland), ICOM-CC, vol. 1, 253-62, James & James, London.

Gettens, R.J., Feller, R.L. and Chase, W.T. 1993. Vermilion and cinnabar, in *Artists' Pigments: A Handbook of their History and Characteristics* (ed A. Roy), vol. 2, 159-82. National Gallery of Art, Washington.

Hedley, G. 1985. *On Humanism, Aesthetics and the Cleaning of Paintings.* Reprint of two lectures presented at the Canadian Conservation Institute. Courtauld Institute, London.

King, A. 1994. Unpublished report of a technical examination and treatment of *The Dream of the Virgin* by Simone dei Crocifissi of Bologna (poplar panel, rectangular 56.5cm (h) x 42.5cm (w) x 2.0cm (t), CIA No:1310, collection of the Society of Antiquaries of London) carried out in the Department of Conservation and Technology, Courtauld Institute of Art, forms the basis for this case study.

Kuhn. H. and Curran, M. 1986. Chrome yellow and other chromate pigments, in *Artists' Pigments: A Handbook of their History and Characteristics,* vol. I (ed R. Feller) Cambridge University Press, Cambridge.

Martin, E. 1977. Some improvements in techniques of analysis of paint media, *Studies in Conservation*, **22**, 63-7. (For a description of the use of Rhodamine B as an indicator for drying oils in paint cross-sections: See unpublished notes by Susan Buck on alternative methods for cleaning painted surfaces, for the Richard Wolbers Summer school course, organised by the Institute of Archaeology Summer schools programme, held at the Courtauld Institute of Art, July 1996.)

North, R. 1996. An unpublished report of a technical examination and treatment of a *Portrait of a Dutch Gentleman*, by Cornelius Johnson van Ceulen, dated 1657 (canvas, 92.5cm (h) x 73.0cm (w), CIA No:1336, collection of the Dulwich Picture Gallery) carried out in the Department of Conservation and Technology, Courtauld Institute of Art, forms the basis for this case study.

Personal Communication between Professor Robert Gibbs, University of Glasgow and Annette King, 1994, summarised in her report, op. cit.

Plesters, J. 1956. Cross sections and chemical analysis of paint samples, *Studies in Conservation*, **2**, 110-57.

Stevenson, L. 1993. An unpublished report of a technical examination and treatment of a *Portrait of Charles Tudway*, by Thomas Gainsborough *c.*1761 (canvas, 227cm (h) x 152cm (w), CIA No:1737, Lee Collection, Courtauld Institute Galleries) carried out in the Department of Conservation and Technology, Courtauld Institute of Art forms the basis for this case study.

Stringari, C. 1990. Vincent van Gogh's *Triptych of Trees in Blossom, Arles* (1888) Part I. Examination and treatment of the altered surface coatings, in *Cleaning, Retouching and Coatings* (eds J.S. Mills and P. Smith), IIC, 126-30, London.

Wolbers, R. 1989. *Notes for the workshop on new methods in the cleaning of paintings*, Getty Conservation Institute, Los Angeles, CA.

MATERIALS

Energy dispersive X-ray spectroscopy was carried out at Kings College, Department of Physics, using a Link/Oxford instruments AN1085 analyser with a Silicon/Be window detector attached to a JEOL T100 scanning electron microscope. Surface imaging and photography was carried out using a JEOL JSM-35c scanning electron microscope at the Courtauld Institute.

Paraloid B-72® from Rohm and Haas (UK) Ltd., Lenning House, 2 Masons Avenue, Croydon CR9 3NB, Tel: (0181) 686-8844.

Rhodamine B (Product No:R6626) and Amido Black (product No: N3005) from Sigma-Aldrich Company Ltd., Fancy Road, Poole, Dorset, BH12 4QH, Tel: 0800-373731.

Carbopol 934®, manufactured by B.F. Goodrich, and

Ethomeen C-12®, manufactured by Armak Chemicals.
Supplied by Fine Chemicals for Conservation, Newmans Lane, Surbiton, Surrey, KT6 4QQ, England, Tel: (0181) 390-6420.

Aviva Burnstock, Department of Conservation and Technology, Courtauld Institute of Art, Somerset House, London WC2R ORN

Figure 1 *The Dream of the Virgin* by Simone dei Crocifissi of Bologna, (collection Society of Antiquaries): photograph taken before treatment in 1994.

Figure 2 *The Dream of the Virgin* by Simone dei Crocifissi of Bologna: X-radiograph, taken before treatment in 1994.

Figure 3 left *The Dream of the Virgin* by Simone dei Crocifissi of Bologna, detail during 1994 treatment: varnish layers and repaints are removed, and part of the gesso and gold paint layers added in the nineteenth century, revealing the towers in the background.

Figure 4 *The Dream of the Virgin* by Simone dei Crocifissi of Bologna, detail of Christ's head during treatment. The original gilding and punching of the halo and background are revealed beneath layers of restoration.

Figure 5 *Portrait of a Dutch Gentleman*, by Cornelius Johnson van Ceulen, after cleaning, before restoration in 1996

Figure 6 Thin section of sample from the light-exposed area of the blue background from *Portrait of a Dutch Gentleman*, showing the fading of the blue pigment indigo, to a depth of about 3-4μ (x500)

Figure 7 *Portrait of Charles Tudway*, by Thomas Gainsborough *c.*1761, photographed before treatment in 1993

EFFECTS OF AQUEOUS TREATMENTS ON THE MECHANICAL PROPERTIES OF PAPER

Anthony W. Smith

ABSTRACT

This paper reports on a long-term research programme undertaken at Camberwell College of Arts, which aims to study in detail the effects of aqueous conservation treatments on the mechanical properties of paper. Consideration is given to the material nature of paper and the difficulties associated with paper testing. Emphasis is placed on the need for careful specimen preparation and the control of test conditions. The results of a preliminary study on the effects of 'washing' paper are reported. The main changes observed were a reduction in the elastic modulus, and an increase in the extensibility, compared to untreated paper. These changes were attributed to a relaxation of frozen-in strains and a reduction in the proportion of fibre bonding area of the paper sheet. No significant difference between the tensile strength of paper before and after washing was observed.

Key words

paper, mechanical, aqueous, water, tensile.

INTRODUCTION

Aqueous treatments have always held an important place in paper conservation. One of the principal properties of water in this context is its ability to penetrate and swell cellulose fibres. Being strongly polar in nature, water molecules are able to enter deeply into the microstructure of fibres, ultimately occupying the amorphous regions of the semicrystalline microfibrils (Corte 1980). Cellulose fibres are highly hygroscopic and will adsorb and desorb water vapour until they reach a state of equilibrium with the surrounding atmosphere. This adsorbed water has a profound influence on the physical properties of cellulose fibres. Increasing the moisture content increases the lateral swelling, tensile strength, plasticity, and elasticity (Casey 1960). When liquid water is being used for treating paper, it has the ability to transport chemical agents, such as ions, both in and out of the fibres. Hence, water, either in vapour or liquid form, may be employed to bring about significant changes in the mechanical properties, appearance, and chemical stability of paper, e.g. through relaxation of creases by humidification, through washing, deacidification and bleaching. There is an extensive literature on the 'beneficial' effects of aqueous treatments, where the focus is mainly on the enhanced chemical stability or 'improved' aesthetic appearance of the treated papers (Anon 1990). However, although it is widely appreciated that subjecting paper to dry-wet-dry cycles may also bring about profound, and often permanent, changes to both its structure and mechanical properties, far less attention has been paid to characterising and quantifying these influences, particularly with a view to modifying or improving paper conservation procedures. It is said, for instance, that old and embrittled paper is made 'stronger' and more 'flexible' by washing. With the exception of a small number of recent publications (Vitalie 1992, Hanus 1994) systematic and detailed studies are lacking in this area.

In order to control or predict the complicated behaviour of paper, we need a scientific understanding of the relationships which exist between paper structure, including microstructure, moisture content and mechanical stresses. This paper is intended to serve as an introduction to the first stage of a long-term, research programme whose main aims are:

- to study in detail the effects of aqueous treatments on the mechanical properties of paper, and to build a quantitative data base of the behaviour of both old and modern papers;
- to identify and understand the basic mechanisms and relationships that give rise to these changes;
- to evaluate and develop aqueous treatments in the light of the knowledge gained.

It is hoped that this research will be of direct relevance to the work of paper conservators and will, lead eventually to the development and refinement of conservation treatments. Current research concerns the effects of 'washing' on paper and this paper reports on the preliminary findings of this work. In order to establish the methodology and lay the foundation for future research, a decision was taken to begin the study with new, machine-made papers, one a high quality book paper, and the other a low quality newsprint.

OBSERVATIONS ON THE MECHANICAL TESTING OF PAPER

Paper is not the easiest of materials to study. It has been said that ' We know less about the basic strength and elastic properties of paper than almost any other common material' (Setterholm and Gunderson 1983). The mechanical testing of paper and the definition of its properties have several characteristic and peculiar features (Mark 1983, Caulfield and Gunderson 1988, Dwan 1987, Dodson and Herdman 1982).

Firstly, paper is an anisotropic, sheet or foil-like material. That is, two of its dimensions are larger than a third, its thickness. It is composed of ribbon-like elements, collapsed (or partially collapsed) plant fibres such as cotton, linen, hemp, or wood fibres. The fibres form a network structure in which segments of fibres are bonded to each other by hydrogen bonding. The continuous filtration process used in sheet formation results in a layered structure. That is, the fibres are laid down with their axes in the plane of the sheet, or nearly so. No fibre penetrates through the sheet more than a few fibre thicknesses. Consequently there is a vertical heterogeneity of paper which arises from its layered structure. Machine-made papers are manufactured in such a way that the axes of the fibres tend to be aligned parallel to the flow of the paper through the machine. This alignment of fibres in the so called 'machine direction', combined with the web tension and drying restraint imposed on the paper during the manufacturing process, results in an 'orthotropic' material. That is, a material in which three mutually perpendicular, principal response directions may be identified. These are referred to as:
- the machine-direction (MD);
- the cross-machine direction (CD);
- through-the-thickness direction (Z).

Hence, paper is often referred to as having a 'grain direction'. Handmade sheets of paper are said to be transversely isotropic. That is, the MD response is equivalent to the CD response but not the Z response.

Consequently, mechanical testing must take into account both the structural organisation of paper and the direction of the applied load. Precise sample alignment is essential if systematic errors are to be avoided.

Secondly, paper has a heterogeneous structure within the plane of the sheet, to a greater or lesser degree. If a sheet of thin paper is placed in front of a bright light source and observed closely, a certain 'cloudiness' may be detected due to a variation in sheet density. Such small scale variations in real density are often referred to as 'formation'. This means, in practice, that the results of paper tests are usually subject to appreciable variation. Thus, the number of specimens used and the number of tests performed has a significant bearing on the reliability of paper testing. Precision in testing is, therefore, dependent upon careful statistical analysis.

Thirdly, paper is hygroscopic and variations in its equilibrium moisture content (EMC) brings about almost immediate changes in structure and mechanical properties. Like all porous hygroscopic materials, paper exhibits a marked hysteresis effect. Consequently, particular attention has to be paid to humidity control, temperature control and sample conditioning. Even moisture on the hand can change the behaviour of the specimen.

Lastly, most of the important properties of paper are, in fact, not physical absolutes, but depend on the testing instruments and details of method used. For example, the tensile strength of paper depends on both the rate of load-application and the dimensions of the specimen. Hence, it is important to pay close attention to specimen preparation, testing procedures and testing conditions.

EXPERIMENTAL PROCEDURE

This paper reports on the tensile-elastic behaviour of uniaxially loaded paper strips. The use of constant width strips has been adopted as standard for paper and they are used in this work. Load-elongation curves are obtained by pulling the sample grips apart at a known rate and measuring the movement separating the grips. This measurement is not the true 'engineering strain'. The load is continually measured

through a load-cell attached to the moving grip. Since measurement of the thickness of paper has an uncertainty associated with it, the true stress (force per unit area) is not normally used in paper testing. In this article the load applied to the strip is reported.

The principal instrument being used in the testing programme is an Instron Model 4411 Materials Testing Instrument, fitted with a 500N load-cell. The Instron is computer controlled and uses Instron Series IX data acquisition and analysis software, version 7.0. Pneumatic vice-action grips and line contact jaw faces (25mm wide) are employed to avoid slippage and to ensure consistency in the grip pressure. Samples are rectangular in shape, 210mm long by 25mm wide, and the grip distance is set at 150mm.

Samples were precision cut and conditioned prior to testing. Conditioning conformed as close as possible to the recommendations set out in TAPPI Test Methods T402 (Anon 1987). Specimens were preconditioned for 24 hours at 20°C, 10-35% RH and then conditioned for 24 hours at 50±2% and 23±1°C. Care was taken not to handle the specimens with bare hands. Testing was undertaken in an air-conditioned booth to conform as closely as possible with TAPPI Test Method T402 of 23±1°C and 50±2% RH. However, RH control was more like ±3%.

The papers used for this investigation were the following. Hanemühle Book Wove: a mould-made, alpha cellulose paper (fibre furnish 100% soft-wood fibres), grammage 150 g/m2, gauge 0.23 mm. Newsprint: (fibre furnish 100% groundwood), grammage 48g/m2, gauge 0.08mm.

In order to prepare samples of 'washed' paper, the strips were wetted out and soaked in de-ionised water for 10 minutes. They were subsequently blotted and dried under light pressure to avoid cockling. After drying, the samples were preconditioned and conditioned as described above.

EXPERIMENTAL RESULTS

The results of the tensile tests are presented in Tables 1 and 2. Test A refers to untreated paper, while Test B refers to treated paper. The statistical analysis of the data followed the recommendation given in B.S. 2987: 1958 (Anon 1958).

Four parameters are presented in the results. *Load at break* - a measurement of the ultimate strength of the paper. *Slope* - a measurement of load/elongation in the initial, elastic region of the load/elongation curve (related to elastic modulus). *Displacement at Break* - a measurement of the extensibility of the paper. *Tensile Energy Absorption (TEA)* - a measurement of the area under the load-elongation curve, giving an indication of 'toughness'.

The observed difference between the mean values for the unwashed and washed samples may be summarised as follows:
a) load at break - the difference is insignificant for both papers;
b) slope - values reduced significantly after washing (Book 29%, Newsprint 24%) indicating a decrease in elastic modulus for both papers;
c) elongation at break - values are significantly increased after washing (Book 39%, Newsprint 44%) - indicating an increase in paper extensibility;
d) TEA - values are significantly increased after washing, indicating an increase in toughness.

The coefficient of variation for the TEA values are high. Therefore, caution should be exercised in reading too much into these results.

How may we interpret these changes in tensile properties? The strength of a sheet of paper with randomly oriented fibres has been shown both theoretically (Page 1969) and experimentally (Van den Akker *et al.* 1958) to depend on two factors. These are:
• the strength of the individual fibres;
• the strength and number of bonds between them.

It has been shown (Seth 1990) that:
• the tensile strength of a well-bonded, dry sheet at a given degree of fibre-fibre bonding is controlled by the strength of the fibres;
• the elastic modulus does not depend on fibre strength, as fibres are not stressed to that extent in the elastic region;
• the elastic modulus is determined by the relative proportion of bonded fibre area in the sheet;
• the extensibility of a sheet depends on the inherent stretch of the fibres, and the extent to which it is utilised depends on the degree of bonding in the fibre network and on the fibre strength, that is the tensile strength.

By bringing a paper sheet into contact with liquid water, we are creating conditions of saturation. Under these conditions, a number of changes will occur within the sheet. In liquid water, the glass transition temperature of cellulose is decreased to a value below room temperature (Kim 1977). That is, water acts as

a plasticiser. Hence, the transition dry paper-wet paper is of particular importance here. Wet cellulose is in a highly elastic state, whereas dry cellulose is in a glassy state. During paper manufacture, the removal of water by drainage and drying occurs under conditions of considerable shrinkage stress. In particular, during the drying stage, cellulose passes from a highly elastic state into a glassy state. The drying is so rapid that relaxation of the induced strains cannot take place on the machine, nor can relaxation occur later for the decreased plasticity of the dry sheet prevents this. Therefore machine-made paper contains dried-in strains. When paper is soaked in water, the frozen-in strains will be released and, if the sheet is then allowed to dry unrestrained it will shrink. Removal of these frozen-in strains may account, at least in part, for the increase in the extensibility values of the washed papers.

During the drying stage of paper manufacture, fibre-fibre bonds are formed owing to the formation of intermolecular bonds between the hydroxyl groups located on the surfaces of the fibres. A small percentage of these interfibre bonds are vulnerable to attack by water. Water molecules will compete for the hydroxyl groups at the fibre-fibre bonding sites, thereby reducing the proportion of fibre bonding area within the paper sheet. The interesting question then arises: will the hydrogen bonds between the hydroxyl groups of cellulose at these fibre-bonding sites be regenerated, or will their proportion be even increased, when the sheet is finally allowed to dry? Paper that has not been especially treated for wet strength shows a tensile strength value of between 4 to 8% of its dry strength (Britt 1964). Clearly, the fibre-fibre bonds are considerably weakened by the presence of liquid water and offer little resistance to the shearing forces imposed by a tensile force acting on the sheet. However, if care is taken not to overstress the fibre-fibre bonds while the sheet is wet, a high proportion of the original bonding area between fibres appears to be retained upon drying. This is reflected in the insignificant difference between the load at break values of the papers before and after washing. There is no direct evidence from these results of any increase in the proportion of bonding area as a result of washing. The elastic modulus is reduced after washing, which would indicate a reduction in bonding area rather than an increase. It would appear unlikely that washing would either enhance or diminish the inherent tensile strength of the paper fibres to any significant degree.

Changes in fibre strength may best be judged by measuring the zero-span tensile strength of paper. This method (TAPPI Method T231 and T481) provides a means for determining the average ultimate strength of individual fibres. It is hoped to undertake these tests in the future.

CONCLUSION

This paper reports on the preliminary findings of a long-term study of the effects of aqueous treatments on the mechanical properties of paper. The work presented here is concerned with the effects of washing on paper. The results obtained indicate that the tensile strengths of the papers tested were not altered significantly by washing. Clearly, the papers do not increase in tensile strength. On the other hand, the extensibility values of the papers were increased significantly. This probably reflects the relaxation of frozen-in strains within the sheets when in contact with liquid water and also, a possible reduction in the proportion of fibre bonding areas. The elastic modulus values of both papers decreased significantly after washing. That is both papers became more elastic in character. Again, this probably reflects the relaxation of fibre strain and reduction in the proportion of fibre bonding area within the paper sheets. There was no indication that the bonding area was increased by the washing treatment.

To sum up: washing new, machine-made papers makes them more elastic and extensible but does not appear to reduce or increase their tensile strength significantly.

These findings provide a better understanding of the type of changes that might be expected to occur when paper is 'washed'. When conservators report that paper is 'strengthened' by washing, the changes they are detecting are not so much to do with an increase in the ultimate strength (e.g. tensile strength) of the sheet but more to do with an increase in its flexibility. An increase in sheet flexibility may be seen as advantageous in certain circumstances.

Future research in this area will include investigating: the variation in the degree of fibre-fibre bonding in paper using optical methods; the effects of prolonged soaking and repeated washing; the washing of brittle paper; and the influence of drying methods.

ACKNOWLEDGEMENTS

This research is part of a long-term, conservation science project entitled 'Paper Substrates and Graphic Media' being funded by The London Institute. The author would like thank Nicholas Ardizzone for his technical expertise and help in establishing the testing methodology, and for running numerous tests with care and patience.

REFERENCES

Anon. 1958. *Application of Statistics to Paper Testing: B.S 2987*, BSI, London.

Anon. 1990. *Paper Conservation Catalog*. 7th. edn., AIC Book and Paper Group, Washington, D.C.

Anon. 1987. *TAPPI Test Methods*, 1988. TAPPI Press, Atlanta, Ga.

Britt, K.W. 1964. Properties and testing of paper, in *Handbook of Pulp and Paper Technology* (ed K.W. Britt) Reinhold Publishing Corporation, 443-79, New York.

Casey, J.P. 1960. *Pulp and Paper: Chemistry and Chemical Technology*, 2nd edn, Vol. 1, Interscience Publishing, London.

Caulfield, D.F. and Gunderson, D.E. 1988. Paper testing and strength characteristics, in *Paper Preservation: Current Issues and Recent Developments* (ed P. Luner), TAPPI Press, 43-52, Atlanta, Ga.

Corte, H. 1980. Cellulose-water interactions, in *Handbook of Paper Science* Vol.1 (ed H.F. Rance), Elsevier, 1-89, New York.

Dodson, C.T.J. and Herdman, P.T. 1982. Mechanical properties of paper, in *Handbook of Paper Science* Vol. 2, (ed H.F. Rance), Elsevier, 71-126, New York.

Dwan, A. 1987. Paper complexity and the interpretation of conservation research, *JAIC*, 26, 1-18.

Hanus, J. 1994. Changes in brittle paper during conservation treatment, *Restaurator*, 15, 46-54.

Kim, E.L. 1977. Changes in cellulose structure during manufacture and converting of paper, in *Cellulose Chemistry and Technology* (ed J.C. Arthur), 153-72, Washington, D.C.

Mark., R.E. 1983. *Handbook of Physical and Mechanical Testing of Paper and Paperboard*, Vol. 1, Marcel Dekker, New York.

Page, D.H. 1969. *Tappi*, 52, 674.

Seth, R.S. 1990. Fibre quality factors in papermaking I: The importance of fibre length and strength in materials interactions relevant to the pulp, in *Paper, and Wood Industries* (ed D.F. Caulfield et al.), Materials Research Society, Vol. 197, 25-141, Pittsburgh, PA.

Setterholm, V.C., and Gunderson, D.E. 1983. Observations on load-deformation testing, in *Handbook of Physical and Mechanical testing of Paper and Paperboard* (ed R.E. Mark), Marcel Dekker, 115-38, New York.

Van den Akker, J.A., Lathrop, A.L., Voelker, M.H. and Dearth, L.R. 1958. Importance of fibre strength to sheet strength, *Tappi*, 41(8), 416.

Vitalie, T.J. 1992. Effects of washing on the mechanical properties of paper and their relationship to the treatment of paper, in *Materials Issues in Art and Archaeology III* (eds P. Vandiver et al.) Materials Research Society, Vol. 267, 429, Pittsburgh, PA.

SUPPLIERS

Instron Model 4411 and accessories supplied by Instron Ltd., Coronation Road, High Wycombe, Buckinghamshire HP12 3SY. Tel. 01494-464646.

Hahnemühle Book Wove and Newsprint were supplied by R.K. Burt & Company Ltd., 57, Union Street, London SE1 1SG. Tel. 0171-407-6474

Anthony W. Smith, School of Art History and Conservation, Camberwell College of Arts, Wilson Road, London SE5 8LU

Book Paper Machine Direction	Load at Break (N)		Slope (N/mm)		Displacement at Break (mm)		TEA (N/mm)	
	Test A	Test B	Test A	Test B	Test A	Test B	Test A	Test B
Mean (n = 21)	82.4±3.8	80.5±4.1	45.5±6.5	32.5±5.0	6.15±0.67	8.52±1.0	0.096±0.013	0.12±0.03
Coefficient of Variation	4.6%	5.1%	14.3%	15.4%	10.9%	11.7%	13.5%	25%
95% Confidence Limits	±1.7	±1.8	±3.0	±2.2	±0.31	±0.44	±0.006	±0.01
Pooled Estimate of Standard Deviation	±4.0		±5.8		±0.86		±0.02	
Least Significant Difference Between Means	2.4		3.5		0.52		0.01	
Difference Between Means	1.9		-13.0		2.37		0.02	

Key: Test A - Untreated; Test B - Washed

Table 1 Results of Tensile Testing Measurements on Book Paper

Newsprint Machine Direction	Load at Break (N)		Slope (N/mm)		Displacement at Break (mm)		TEA (N/mm)	
	Test A	Test B	Test A	Test B	Test A	Test B	Test A	Test B
Mean (n = 24)	63.2±6.0	59.8±5.0	43.0±3.6	32.6±3.5	2.06±0.29	2.96±0.33	0.018±0.0004	0.026±0.00005
Coefficient of Variation	9.5%	8.4%	8.4%	10.7%	14.1%	11.2%	22.2%	24.3%
95% Confidence Limits	±2.5	±2.3	±1.5	±1.6	±0.12	±0.15	±0.002	±0.002
Pooled Estimate of Standard Deviation	5.5		3.6		0.31		0.005	
Least Significant Difference Between Means	3.3		2.2		0.19		0.003	
Difference Between Means	3.4		-10.4		0.9		0.008	

Key: Test A - Unwashed; Test B - Washed

Table 2 Results of Tensile Testing Measurements on Newsprint

65

THE ROLE OF SCIENTIFIC EXAMINATION IN THE PLANNING OF PRESERVATION STRATEGIES: CAVE 6 AT YUNGANG, CHINA

Francesca Piqué

ABSTRACT

The study of the sculptural polychrome of Cave 6 at Yungang was part of an overall program of investigation of the site by the Getty Conservation Institute (GCI) in its China Project.

In accordance with the overall philosophy of the China Project, the primary goal of the research work presented in this paper was to determine the nature of the original polychrome and its present condition. The information collected would provide the basis for designing a conservation treatment to preserve the cave and to prevent further deterioration.

The study showed that the surviving polychrome is extremely fragile, a result of both its original technique and deterioration. Failure of adhesion occurs at the various interfaces: between support and ground, ground and paint layer, and between subsequent phases of repainting. This has significant implications for its preservation since it is highly susceptible to mechanical damage. As a result, recommendations that the regular dusting methods be discontinued were adopted at the site.

Key Words

Yungang, scientific examination, atacamite, Prussian blue, lead-based pigments, Chinese polychrome sculpture, moisture problems.

INTRODUCTION

All painting conservation operations should be based upon the collection and integration of three types of information:

- nature of original and added materials;
- causes and rate of their deterioration;
- future role of the artefact.

In the case of the polychrome sculptures of Cave 6 at Yungang, historical research, site examination and sampling and analysis of pigments were carried out to ascertain the stratigraphy, the components and the condition of the various paint layers. This information, together with the study of the site history and of historical photographs, permitted identification of the main causes of, and rate of, decay.

This research work was part of the long-term project - involving research, conservation treatment and resource development which has been undertaken by The Getty Conservation Institute (GCI) at Yungang and Dunhuang. The overall project had the following objectives:

- to understand the deterioration processes through scientific research (study of site conditions, collection and interpretation of data);
- to prevent further deterioration and to solve existing conservation problems by using appropriate technology and materials;
- to enhance local expertise and technical resources, and to support conservation through training and collaboration.

HISTORY OF THE SITE

The caves at Yungang are one of the earliest surviving Chinese Buddhist grotto sites. Carved from the fifth century onwards, on the model of Indian Buddhist temples, they represent the introduction of Central Asian styles into China. The concept of cutting cave-temples into cliffs originates from India and spread from there to Afghanistan, Central Asia and China. The first major Chinese Buddhist temple was built in the fourth century at Dunhuang (Falco Howard 1983).

Yungang is located in northern China, in the Shaxi province, near the Great Wall and the Mongolian border. The Yungang caves were cut into sandstone cliff (Fig. 1) when in 460 AD the capital of the Northern Wei emperor was established at Pingcheng (modern Datong), about 15km east of Yungang.

Cave 6 was built between 465 and 494 by Emperor Xiao Wen in memory of his mother, and is one of the richest of the site. It is square in plan, with at the

centre an almost square tower which rises to the ceiling. The entire surface is carved and painted (Fig. 2). Altogether, given the three–dimensionality of the sculpture, Cave 6 has an estimated surface area of approximately 1,000m², and within this large area the differences in condition, number of apparent repainting schemes, and materials used is vast. During the visual examination and sample collection it was evident that there were at least three repainting phases, and that the polychromy was fragile and brittle, and tended to fracture between the paint layers and to separate from the support. It was later, during the analytical stages, that it became evident that there was a large number of repainting phases (up to twelve), each composed of at least two layers. For these reasons the identification of the original scheme and subsequent repainting phases was a difficult task. This was done by correlating the historical information and observation on site with the stratigraphic evidence from the samples and the analytical results.

The history of the condition of Cave 6 is largely dependent on the various events which occurred at Yungang over the centuries. While much more information is available for recent events than for earlier ones, it is possible to relate restoration of the site with the destruction and rebuilding episodes usually associated with power struggles and dynastic wars. However, dates for restoration and repainting in a specific cave are seldom recorded, and therefore the association of an historical event with a particular repainting phase in Cave 6 has been made as a hypothesis.

The Yungang caves were extensively studied during the years 1938–45 by two Japanese scholars, Mizuno and Nagahiro (1952–6), who published a detailed report of their archaeological survey in a series of 16 large volumes. These volumes are extremely valuable for their exhaustive written and photographic documentation of the site. In particular those documenting Cave 6 were useful, in comparison with the current condition of the caves, to determine the rate of decay.

In situ examination was coordinated with the overall GCI project, and involved collaboration with Chinese specialists in both the conservation and art history of Cave 6. Examination and sampling proformas were used to follow a coherent method of examination on site and collect all the information on the samples. Each sample taken was graphically and photographically documented.

CONSERVATION PROBLEMS

The conservation problems at Yungang are related to the deterioration and degradation of the carved stone by wind and water erosion, salt activity, atmospheric pollution, inappropriate conservation procedures, vandalism and theft. Due to these factors the caves are in a poor state of conservation. Most of the external carving has disappeared and many of the statues were removed at the beginning of this century. The surviving polychromy, largely repainted, generally shows widespread loss of adhesion and cohesion. These problems are common to the large number of grotto sites in China, all extremely large and difficult to manage.

At Yungang the sandstone rock of the caves is cross-bedded and varies in quality. In part it is fine-grained and compact but interspersed with lenses of soft, friable, easily weathered siltstone. Elsewhere it is coarser grained, containing nodules rich in pyrites (Kezhong and Tingfan 1990). The presence of different qualities of stone is partly responsible for the selective deterioration visible in various locations at Yungang (Fig. 1).

The present condition of the stone support varies considerably: all the lower parts of the Cave 6 are badly deteriorated with a deterioration level between 90-350cm above the ground (Fig. 2). During the year the air temperature at Yungang reaches between 37°C and -25°C. Cycles of freeze/thaw and crystallization/dissolution of salts are likely to be the cause of the stone disruption.

The origin and movement of water and salts occur through three different processes:

- ground water, which contains soluble salts, moves by capillary rise through the stone and causes salt crystallization at the surface of evaporation. This phenomenon occurs homogenously around the walls;
- rainwater accumulates on the top of the cliff and seeps through, dissolving and carrying soluble components of the sandstone and soil, which crystallize on the carved surface of the cave;
- condensation occurs in spring and summer when hot moist air from outside condenses onto the cold rock surface.

Although deterioration due to cycles of crystallization/dissolution of salts and freeze/thaw have occurred since antiquity, the industrialized city of Datong, with its severe pollution associated with coal mining and the burning of coal by the populace,

is now a major cause of further *new* deterioration of the stone. The resulting black dust is continuously deposited over all surfaces, particularly horizontal ones.

The study addressing the specific issues of Cave 6, Yungang, had as principal objective the determination of the nature and condition of the original and added materials of the paint layers and renders. The original materials of the polychrome sculpture were studied with optical and electron microscopy, microchemical tests, infrared microspectroscopy, X-ray diffraction (XRD), and energy dispersive X-ray micro-analysis. A summary of the results of the technical investigation of the painting is presented separately for the original scheme, the first repainting scheme and the later repainting schemes. For more information on this aspect of the research the reader may refer to the author's unpublished Master thesis (Piqué 1992).

ORIGINAL SCHEME

The original scheme was found to be characterized by a single clay-based preparation layer and a single paint layer. The preparation layer provides a smooth, compact surface as well as a background colour for the paint layer. Six pigments were identified and the resulting palette included a deep blue (natural ultramarine), a pale yellow (yellow earth), and several reds (vermilion, red lead and red earth). It is surprising, particularly in comparison to contemporary paintings in Central Asia, that there is apparently no green pigment used in the original scheme. It is possible that green does occur but was not sampled during the present study, and this should be borne in mind in any future studies of Cave 6.

The red pigments predominate, in variety and in use. Vermilion, red lead and red earth were identified and they are all common pigments used in Chinese polychromy. Vermilion and red lead were always applied over a red preparation. Red lead was found in all cases converted to plattnerite (PbO_2). Plattnerite is the oxidation product of lead-containing pigments and occurs frequently in both Asian and Western paintings. Although the conversion process of lead white $2PbCO_3 \cdot Pb(OH)_2$ has been well studied, that involving red lead (Pb_3O_4) has not been considered in detail. Studies of the alteration of lead pigments in western paintings indicate that three factors are necessary: alkalinity, moisture and an oxidizing agent (Matteini and Moles 1981). The oxidization of white

lead to plattnerite (Pb^{2+} to Pb^{4+}) occurs by the following equation:

$$2PbCO_3 \cdot Pb(OH)_2 + 2H_2O = 3PbO_2 + 2CO_2 + 6H^+ + 6e^-$$

It is generally assumed that red lead conversion to plattnerite occurs by a similar oxidation process.

In the original scheme the blue is a dark, natural ultramarine of high quality and large particle size. The use of natural ultramarine at this early date is interesting. Various sources in Persia, China and Tibet have been ascribed to the mineral. The best quality of lapis lazuli comes from Badakshan in north eastern Afghanistan. Gettens identified ultramarine in fifth-century wall paintings from Kizil in Chinese Turkestan (Gettens 1938). However, Kizil is located only miles from Badakshan and lapis lazuli would therefore have been much more easily available than at Yungang, several thousand miles away.

FIRST REPAINTING SCHEME

A possible date for the first repainting scheme is 640 AD (early Tang Dynasty) when Yungang was incorporated in the prefecture of Yunchung and works were resumed at the Buddhist site.

The first repainting scheme was found to be composed of only two colours: a green mainly composed of atacamite with some malachite and green earth, and red lead always converted to plattnerite (as for the original scheme).

Atacamite, one of three isomorphs (with paratacamite and botallackite) with the formula $Cu_2Cl(OH)_3$, was identified by XRD in six of the eight samples of the first repainting scheme, occasionally mixed with some malachite and possibly green earth. The optical characteristics of atacamite found in Cave 6, showing rounded, globular aspect, with the occasional presence of a central dark core, differ from those of the natural mineral and may indicate a synthetic origin (Fig. 3) (Naumova 1990). This type of mineral green pigment, is commonly found at Dunhuang in wall paintings of almost all dynasties including the Northern Wei (Moffatt *et al.* 1988).

LATER REPAINTING PHASES

As mentioned earlier, the substantial historical evidence indicating refurbishment, redecoration, and repainting at Yungang cannot be directly correlated with the scientific evidence of the stratigraphy. There are, however, several significant events which may have occasioned repainting in Cave 6. The general problems encountered for the determination of the early painting schemes, discontinuity due to partial repainting and/or partial loss, are compounded when trying to securely identify the successive repainting schemes. It was decided therefore to generally and collectively characterize the stratigraphies not attributable either to the original or to the first repainting scheme.

The technique of the various later repainting phases does not differ significantly from that of the two earliest schemes. The use of a ground and the tendency to apply paint in a single layer persist. The palette, comprising red, green, blue, yellow, black, and gold, is more extensive than that of the original and first repainting schemes.

There are three types of blue pigment: azurite, synthetic ultramarine, and an interesting early type of Prussian blue with physical appearance so similar to natural ultramarine and so different from the 'normal' Prussian blue. A similar type of Prussian blue (Fig. 3) has been found and discussed by Welsh (1988), and after comparing the eighteenth and twentieth-century recipes he concludes that the different particle size and shape is due to the preparation method. Although this is likely also to be the case at Yungang, it does not necessarily follow that a similar date can be assigned to the paint layer. A dating must be considered in the context of the history of Chinese alchemy and chemistry, and the date of discovery of a particular preparation method may well not coincide with that in the West.

The range of yellows is increased to include orpiment and massicot. Carbon black is also commonly found. An interesting addition is that of gold leaf. Gold leaf was probably used to imitate gilded bronze sculpture. It was used on flesh areas, and remnants of gilding can be found on all of the figures. In one sample, where gold is used for the flesh tone, there are four gold layers but no evidence of any other type of coloured paint layer, indicating that gold was used during the last four surviving repainting phases.

CONCLUSIONS

The present study of the polychromy of Cave 6 has provided significant information on the original and subsequent painting schemes of the sculptured decoration.

A conspicuous finding was the deterioration of lead containing pigments. All of the examples of red lead from the original scheme were found to be entirely altered to plattnerite (PbO_2), whereas in the later layers red lead is found unaltered, partially altered, and fully altered. Clearly, the mechanism of and conditions for the conversion of these lead-containing pigments to lead dioxide is of considerable interest, particularly with regard to the implications they may hold for conservation.

Another area which may prove fruitful for further investigation is the synthesis and use of atacamite (copper chloride green). The present study has demonstrated its extensive use in Cave 6 over a longer period of time.

An important factor which can be highlighted now is the development of the coal industry at adjacent Datong, where one of China's largest coal producers has become a serious threat. The industry results in a fine black dust being continuously and heavily deposited on the sculptures. Apart from the physical and chemical interaction this may cause, an immediate and serious danger is the dusting regularly undertaken to remove this deposit. Considering the extremely fragile condition of the surviving polychromy, with often tenuous adhesion between various layers of paint, and the widespread flaking evident, dusting is likely to be one of the major factors presently causing loss of the paint layers. It is therefore necessary first of all to try to reduce the amount of dust deposited, and secondly to improve the methods of dusting. Obviously the problem of flaking common to the entire site should also be resolved, however this would require further investigation both of the causes and of the most suitable conservation methods and materials.

ACKNOWLEDGEMENTS

The author wishes to thank the Courtauld Institute of Art for its support and guidance, especially Sharon Cather and Helen Howard (Conservation of Wall Paintings Department). The author is grateful for the support of Mr. Huang Kezhong (Deputy Director of the National Institute of Cultural Property in Beijing),

and at the Getty Conservation Institute, to Neville Agnew (GCI Associate Director, Programs) and Dusan Stulik (Senior Scientist of the GCI Scientific Program).

REFERENCES

Falco Howard, A. 1983. *Chinese Buddhist Sculpture from the Wei through the Tang Dynasties*, Chung-hua min kuo kuo li li shih po wu kuan, Taiwan.

Gettens, R.J. 1938. The materials in the wall paintings from Kizil in Chinese Turkestan, *Technical Studies in the Field of Fine Arts*, **6**, 281-94.

Huang Kezhong and Xie Tingfan. 1990. *The Weathering and the Conservation of the Stone Sculptures in Yungang Grottoes,* unpublished report.

Matteini, M. and Moles, A. 1981. The reconversion of oxidised white lead in mural painting: a control after a five year period, *in 6th Triennial Meeting, Ottawa, 1981*, ICOM-CC, vol. 3, 81/15/1, Paris.

Mizuno, S. and Nagahiro, T. 1952-56. *Yun-kang: the Buddhist Cave-temple of the Fifth Century A.D. in North China (Detailed Report of the Archaeological Survey Carried out by the Mission of the Toho Bunka Kenky'sho, 1938-1945)*, 16 vols, Jimbunkagaku Kenkyusho, Kyoto.

Moffat, E., Sirois, P.J., Wainright, I.N.M. and Young, G.S. 1988. *Contribution to the Analysis of Wall Painting Fragments and Related Materials from the Mogao Grottoes at Dunhuang, People's Republic of China*, unpublished report, Canadian Conservation Institute.

Naumova, M.M., Pisareva, S.A. and Nechiporenko, G.O. 1990. Green copper pigments of old Russian frescoes, *Studies in Conservation*, **35**, 81-8.

Piqué, F. 1992. *Scientific Examination of the Sculptural Polychromy of Cave 6, Yungang*, unpublished study undertaken as part of the Getty Conservation Institute programme of investigation of the site, and in partial fulfilment of the requirements for an Msc in Painting Conservation at the Courtauld Institute of Art, University of London.

Welsh, F.S. 1988. Particle characteristic of Prussian blue in an historical oil painting, *JAIC*, **27**, 55-63.

Francesca Piqué, The Getty Conservation Institute, 1200 Getty Centre Drive, suite 700, Los Angeles, California, USA.

E-mail FPique@getty.edu

All the illustrations are photographed by the author, copyright the Getty Conservation Institute.

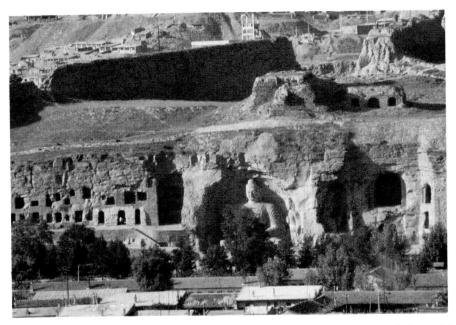

Figure 1 Yungang grottoes, general view of the western part of the south face of the sandstone cliff. The presence of different qualities of stone is partly responsible for the selective deterioration visible in various locations along the cliff face.

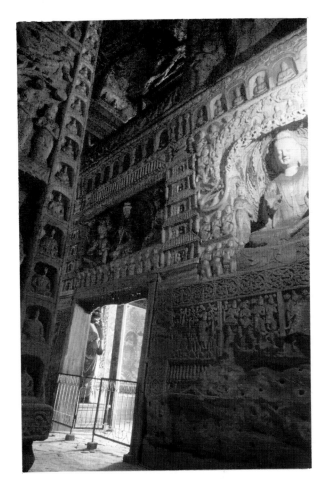

Figure 2 Yungang grottoes, interior of Cave 6. Cave 6 is square in plan, with at the centre an almost square tower or stupa pillar which rises to the ceiling. The entire surface is carved and painted. The lower parts of the Cave 6 are badly deteriorated with a deterioration level between 90–350cm above the ground.

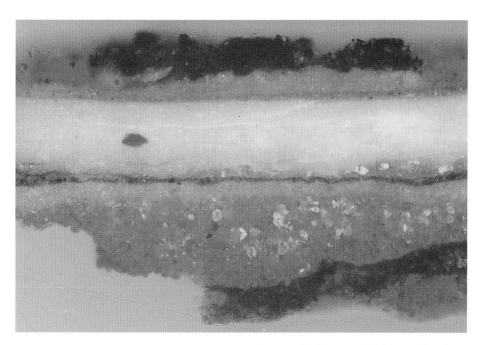

Figure 3 Yungang grottoes, cross-section (photographed at 200X) of a sample taken from the stupa pillar. The sample shows (starting from the lower part) a double black over white clay-based preparation, green paint layer (main component atacamite$Cu_2CI(OH)_3$; double gray over white preparation layer, Prussian blue paint layer (repainting phase). The black preparation layer applied just before the green paint layer probably had the function of increasing the colouring properties of the translucent green with poor covering power.

BOTANICAL AND ETHNOBOTANICAL KNOWLEDGE AND THE CONSERVATION OF ARTEFACTS

Mark Sandy

ABSTRACT

The usefulness of different types of botanical knowledge to artefact conservators is outlined. Plant morphology, anatomy, ultrastructure, biochemistry and ethnobotany are referred to. This body of knowledge can aid the conservator in the identification of materials. It can also help to understand the physical and chemical behaviour of plant based materials, the ways in which they deteriorate and the ways in which they respond to conservation procedures. Initial results of an examination of the leaves of Pandanus spiralis are discussed.

Key Words.

plants, artefacts, conservation, anatomy, ultrastructure, biochemistry, ethnobotany, Pandanus.

INTRODUCTION.

Plants have provided raw materials for the construction of artefacts, large and small, for many thousands of years. Plants can be used to form all or part of the structure of objects or buildings, and can provide useful extractives such as resins, oils, waxes, gums, starches and dyestuffs (Dimbleby 1978). There are many types of objects that are encountered by conservators made wholly or in part from plant materials. The focus of this paper is on plant materials used as 'whole tissue' to construct artefacts, for example timber or leaves.

Plants and therefore the objects derived from them can be studied on different levels which include morphology, anatomy, ultrastructure and biochemistry. These different aspects of plant structure should not be regarded as separate but as interrelated and overlapping parts of a whole. Plants can also be studied ethnobotanically in terms of their cultural and economic uses by different societies. All these approaches to understanding plants can be of value to

conservators and collection managers for the following reasons:

- they are of use in the identification of materials used in artefacts;
- they can aid in an understanding of the physical and chemical behaviour of artefacts as they age and as they undergo conservation procedures;
- they provide information about how artefacts were made and used (Florian 1977, Florian *et al.* 1990, Robbins 1980).

MORPHOLOGY

Plant morphology is the study of plant form in terms of external features (Bell 1991). An appreciation of plant morphology can enable the conservator to make an initial visual assessment of objects constructed from plant materials. This assessment will involve a recognition of the type of plant part or parts that have been used in construction such as leaves, bark, stems, roots etc. In some cases one may be able to make some progress towards an identification of the type of plant used.

ANATOMY

Plant anatomy is the study of the internal organisation of plants in terms of the size, shape, arrangement and interrelationship of the various different types of cells such as fibres, vessel elements, tracheids, parenchymal cells etc. (Esau 1977, Rudall 1992). Anatomy is of great importance for plant identification. Securely identified specimens of plants may be used to prepare sections (from more than one plane) for optical microscopy and these may be compared with sections prepared from unidentified specimens. There is a large body of literature dealing with the anatomy of different groups of plants, much of which deals with hard and softwoods (Gregory 1994, Wilson and White 1986). Details of the anatomy of some other important groups of plants often used in artefacts may

be found in the following references (Metcalfe 1960, Tomlinson 1961, Tomlinson 1990, Weiner and Liese 1993). In some cases sampling of plant tissues for section preparation from artefacts may be possible. Whether an artefact should be sampled, and the amount of material that can be taken for slide preparation will depend on several factors including the size of the object, condition, and the reasons why identification is desirable. If only a very small sample size is ethically justifiable (and it should always be kept to a minimum) an identification to species level may not be possible. It may be possible in such cases to extract some information that enables assignment of the plant to a broader taxonomic group, or to eliminate possibilities.

The physical behaviour of plant tissues incorporated into artefacts cannot be divorced from their anatomy. The different types of cells will make differing contributions to the mechanical behaviour of plant tissues because of variations in stiffness and strength. The location and orientation of those cells that have a mechanical function in the plant tissue, such as fibres and collenchyma is an important factor. Anatomical variation both between species and within different parts of the same species correlates with variation in mechanical behaviour (although this variability is intimately related to ultrastructure as well). For example hard and softwoods behave anisotropically in terms of their strength properties and their dimensional response to moisture changes in ways which correlate with anatomical direction, (radial, tangential and longitudinal). These factors will be influenced by the different anatomies of different taxonomic groups (Dinwoodie 1979, Hoadley 1978). The tensile, compressive, bending and fracture properties of rattan stems vary between species because of variability in anatomy. The behaviour of different sections of stem of the same species is also variable because the anatomy changes with stem position. Factors involved include fibre proportion, fibre wall thickness and metaxylem vessel diameter (Bhat *et al.* 1990, Bhat and Thulasidas 1992). Variability in this kind of behaviour is particularly important when considering questions of transport, storage and display of plant based objects.

The way in which fluids and gases flow through plant tissues is an important consideration where conservation procedures involve the application of liquids, for example during consolidation treatments or the use of vapour-phase treatments. The anatomical structure of the plant material, including cell wall pit types, will be one of the factors that will affect the penetration of liquids and vapours. Hardwoods for example show greater differences between species than softwoods in their ability to be penetrated by liquids because of their more variable anatomy. Penetration within a given plant tissue from one species may vary according to the distribution of cell types in that tissue. For example the treatability of the culm of the bamboo species *Dendrocalamus strictus Nees.* has been shown to be greater in the inner part of the culm wall than the outer part and to be greater in the higher internodes than the basal internodes because of anatomical variation. (Dinwoodie 1979, Florian and Renshaw-Beauchamp 1982, Greaves 1974, Kumar and Dobriyal 1992, Maturbongs and Schneider 1996).

ULTRASTRUCTURE

The study of plant ultrastructure involves examining 'structural details of cells below the limit of resolution of the light microscope and only revealed by the electron microscope' (Tootil 1984). An appreciation of ultrastructure aids an understanding of the physical behaviour of plant tissue and of the biological and non-biological mechanisms of deterioration of plant materials. The areas of ultrastructural investigation of most relevance for conservation are the middle lamella and the plant cell wall. The middle lamella is a layer present between adjacent cell walls and is deposited during cell division. It is an amorphous complex of materials which has as one of its functions the adhesion of adjacent cells. The cell wall may be regarded in simple terms as a two phase system consisting of a semi-crystalline phase made up of a polysaccharide of specific composition, which is cellulose in most plants, embedded in a broadly amorphous matrix made up of a wide variety of polysaccharides and other compounds. The semi-crystalline phase is organised in microfibrils which in higher plants are of the order of 10nm wide. The microfibrils are arranged in different ways depending on various factors including the stage of development of the cell and the area of the cell wall under consideration. Their disposition may be parallel to each other or more disorganised. The internal structure of the microfibril is partly crystalline and partly amorphous. Non-cellulosic materials may be present in the amorphous regions. Plant cells may have in addition to the first formed primary wall, a secondary wall consisting of distinct layers, usually labelled S1, the outermost secondary layer, S2, S3 etc.

and in some cases a tertiary wall. Usually the layer of greatest importance in terms of the mechanical behaviour of cells such as fibres and softwood tracheids that have a structural support function in the plant is the S2 layer. In some cells the secondary wall is polylamellate, as for example in bamboo fibres which may have eight layers (Brett and Waldron 1996, Higuchi 1989, Preston 1974).

The way in which microfibrils are arranged in the plant cell wall is a major determinant of the mechanical properties of the individual cells and thus of the tissues that they make up. For example there is a close correlation between the microfibril angle of the S2 layer and Young's modulus in plant fibres for tensile forces acting axially. Microfibril angle is the angle between the mean microfibril direction and the longitudinal axis of the cell. As microfibril angle increases, Young's modulus decreases. In the xylem of woody plants that have been investigated Young's modulus varies with microfibril angle in much the same way for the whole tissue. The longitudinal shrinkage of wood as moisture content is reduced has a positive (though non-linear) correlation with microfibril angle. The matrix phase also has an important effect on physical properties (Mark and Gillis 1973, Meylan 1972, Preston 1974).

Electron microscopy has proved to be a valuable tool for examining and comparing degraded and non-degraded wood and has demonstrated how different mechanisms of deterioration alter the fine structure of wood. For example the different types of fungi and bacteria that affect archaeological wood have been shown by electron microscopy to affect the cell wall and middle lamella in spatially different ways. When combined with chemical pretreatment of degraded samples, electron microscopy can provide information about the chemical nature of the remaining wood substance (Barbour 1984, Blanchette *et al.* 1994, Schniewind 1989).

BIOCHEMISTRY

Information concerning the biochemistry of plants is also helpful in understanding the way in which plant derived materials deteriorate and react to conservation treatments. Chemicals and biopolymers of interest to conservators include those which make up the plant cell wall, the middle lamella, the cuticle, and suberized areas. The cuticle, a waxy layer present on the surface of many of the aerial parts of plants such as leaves, is of importance because of its effect on the

appearance of the plant surface, on permeability and because of its protective function. Suberized areas in cell walls have an effect on the permeability of the tissue and also can have a protective function (Akai and Fukutomi 1980, Brett and Waldron 1996, Kolattukudy 1984, Martin and Juniper 1980).

In the cell wall the microfibrillar phase is mainly built up from chains of cellulose and the matrix phase consists of a complex network of polysaccharides such as hemicelluloses and pectins, lignins and other phenolic compounds and proteins. The middle lamella contains various substances including pectins and lignins. The interrelationship between these different materials in terms of spatial disposition and the chemical bonding involved is intricate and variable (Brett and Waldron 1996). Kronkright has discussed the potential complexity of the behaviour of the different biochemical components of the wall and lamella. This complexity is increased by the physical and chemical changes taking place as plant material ages. Different chemical species can be expected to deteriorate differently as they age and to react differently to conservation treatments. An example of this kind of change is the increased solubility of certain components as the degree of polymerisation decreases. Chemical changes will also alter mechanical behaviour (Kronkright 1981, Florian *et al.* 1990).

The use of solvents, aqueous or otherwise, in treatments should be considered with care as inappropriate treatments may remove non-structural chemicals to a greater or lesser degree. These chemicals may be important because they impart desirable properties to an artefact, such as flexibility or resistance to biodegradation and because they can affect appearance of an artefact as many of them are coloured (Blanchette and Briggs 1992, Florian *et al.* 1990). One must also consider a basic ethical question – if a treatment removes material of this kind from an artefact then its nature is being changed and information about the material is being lost.

Interesting examples of this type are the various barks used in artefacts. Those inner barks which have been used for manuscripts in India have been noted for their resistance to fungal and insect attack in storage and under experimental conditions (Agrawal 1984, Agrawal and Dhawan 1984). A reported chemical analysis of the bark of *Betula utilis*, one of the species used, has revealed the presence of small amounts of leucoanthcyanidin polymers in the inner bark that could contribute to this resistance (Chari *et al.* 1968). Chemical components of Indian birch-bark can be extracted with various organic solvents causing

colour change and delamination (Agrawal and Suryawanshi 1987).

The outer bark of the birch *Betula papyrifera* used in the construction of a variety of artefacts by indigenous cultures of North America is regarded as being very resistant to decay. Analysis of bark of this species has indicated the presence of various chemicals that may contribute to this resistance, such as phenols, tannins and terpenoids (including betulin, lupeol, acetyloleanolic acid and oleanolic acid). Exposure to some solvents has been shown to cause delamination and discolouration (Gilberg 1986, Seshadri and Vedantham 1971).

ETHNOBOTANY

The term 'ethnobotany' has had various definitions and interpretations since its first use in the late nineteenth century. It can be broadly defined as the study of the selection, propagation, processing and use of plants by traditional societies (Cotton 1996). In the context of artefact conservation it is important to bear in mind the distinction between the processing of plant materials and their subsequent use in artefacts. An understanding of the structure and behaviour of the materials in the context of the living plant is a starting point but it should wherever possible be allied to knowledge of the modification of the tissues to facilitate their use as a raw material. The processing will have the potential to introduce significant chemical and/or physical changes in the material. Such procedures can include the initial collection of the plant or plant material, removal of extraneous parts, drying, modification of flexibility, extraction of fibres and the application of coloured materials such as pigments and dyestuffs.

Once any processing has taken place the materials can be used to form artefacts or structures in a multiplicity of ways. The plant based material culture of many societies is both extensive, with a large number of species being used, and sophisticated, exhibiting a high degree of craftsmanship and awareness of the suitability of materials in terms of their mechanical utility and their resistance to biodegradation (Cotton 1996). For example some Semai communities of West Malaysia use 15 different species of rattan in the making of artefacts (Avé 1986, Avé 1988). Sometimes a large number of different plants may be incorporated in the same artefact. A study of ocean going canoes in Fiji by Banack and

Cox notes the use of 20 different plants in their construction (Banack and Cox 1987).

Ethnobotanical knowledge concerning artefacts is a crucial source of data for the conservator who must be able to distinguish between deterioration and changes caused by processing, construction and wear occurring in use, and changes occurring in storage. Indications and signs of processing, construction and wear constitute information that must not be jeopardised by conservation procedures. This information is important not just in an academic sense, but also because of the clues it can give to the conservator about the physical history of the artefact. This history in turn helps to determine any conservation procedures (Florian *et al.* 1990). An interesting area of ethnobotanical knowledge is the use of traditional techniques for the preservation of plant based objects (Agrawal 1981). An example of this is the use of juice from the fruit of the wild mangosteen (*Diospyros peregina*) in South Eastern Bangladesh as an antifungal and consolidating agent on household artefacts made from plant materials (Jahan 1987).

PANDANUS, BACKGROUND AND EXAMINATION OF LEAF MATERIAL.

The author is currently researching methods of analysis of plant materials used in artefacts in order to aid understanding of the responses of such artefacts to conservation treatments both passive and active. As part of this research leaves of Pandanus spiralis have been examined. This species has been used in the traditional material culture of Northern Australia (Smith 1991).

Pandanus is a genus containing approximately seven hundred species with a natural range including East Africa, South East Asia, parts of the Pacific and western Pacific rim. Many species are arborescent, some growing up to 30m high. Some species have substantial trunks and large prop roots. They have characteristic long stiff sword like leaves often with spiny midribs and margins. Various species of Pandanus have been used as sources of food, medicine and raw materials. Leaves have been the most extensively used part of Pandanus in material culture. After selection the spiny midribs and margins are usually removed if present and the leaves may then be further processed in a variety of ways (Purseglove 1972, Cox *et al.* 1995). Pandanus leaves are used to make many types of artefact including mats, baskets,

raincapes and sails (Banack and Cox 1987, Sillitoe 1988, Van der Grijp 1993, Whistler 1988).

Approaches being used in this research include an anatomical study of leaf material, Catling and Sandy - work in progress, an examination of the effect of different solvents on the leaf surface and the development of methodologies for the examination of the tensile properties of the prepared leaves.

Seen in transverse cross section the leaf of Pandanus spiralis can be seen to contain a significant amount of fibres. Sections were stained with safranin and alcian blue. Safranin stains lignified tissue red and alcian blue stains unlignified cellulose blue (Fig. 1). Lignified fibres are present in small bundles located below both surfaces of the leaf. There are also fibres associated with the vascular bundles (conducting tissue) which cross the leaf at regular intervals. Lignified parenchymal cells are present below the epidermis on both sides of the leaf. These features of the structure of the leaf make it a useful raw material. An understanding of the leaf anatomy is proving useful in developing tensile strength testing methodologies for such material. The cross sectional area of material is an important variable in these tests. Examination of the leaf makes it clear that the cross sectional area cannot be calculated by measuring the external dimensions of the material no matter how accurately because of the heterogeneous distribution of cell wall material across the leaf. Tensile strength testing of softwoods often involves approximations of cross sectional area based on external sample dimensions. Softwoods however have a much more homogeneous distribution of cell wall material and such approximations are considered reasonable (Dinwoodie 1979, Preston 1974).

The effect of three solvents on dried leaf material of Pandanus spiralis was investigated by the comparison of the wettability of samples immersed in the solvents with the wettability of untreated material. Wettability was assessed by measuring the exterior contact angle of small drops of distilled water applied to the surface of the leaf. A method described by Hollaway was

adapted for this purpose (Hollaway 1969a, Hollaway 1969b). Strips of leaf material about 2mm wide were cut with the long direction of the strips parallel to the long axis of the leaves. Strips were suspended in solvents contained in test tubes for five minutes. The solvents used were ethanol, acetone and hexane. These were chosen because of their different solubility parameters (Hedley 1980). Immediately after removal from the solvents the strips were lightly blotted with filter paper and allowed to dry.

The strips were attached to the surface of microscope slides (one slide per strip) with double sided adhesive tape. They were placed on the tape with their adaxial (towards the stem) sides uppermost. The slides were then gripped by the jaws of an microscope x-y stage screwed to a fibreboard platform. This platform was clamped to a laboratory jack enabling the platform to be raised or lowered into the line of sight of a microscope body held horizontally by a laboratory stand. This arrangement allowed the upper surface of the leaf to be brought into view and focussed on using the x-y jaws and the jack. Drops of deionised water approximately 1.5mm in diameter were applied to the surface of the samples using a hypodermic syringe. Each drop was applied to a different area of the sample. The exterior contact angle of the drop was measured immediately after application using a protractor graticule incorporated into the microscope eyepiece. The measurements were made to the nearest five degrees at a magnification of x40. This was the greatest level of accuracy possible with the samples as mounted because of their undulating surface. More precise measurements will be aimed at in further work by experimenting with different methods of mounting and illumination. The measurements were carried out in a controlled environment room at ie 50 \pm 1% relative humidity and 21 \pm 1°C. Twenty measurements were made in total on each of the pairs of treated strips and on three untreated strips. The results are recorded in Table 1.

Table 1

	No. of readings: untreated	No. of readings: ethanol treated	No of readings: acetone treated	No of readings: hexane treated
Contact angle (to nearest 5 degrees)				
75	3	0	0	0
80	11	4	1	0
85	5	6	11	0
90	1	9	6	10
95	0	0	0	6
100	0	1	2	3
105	0	0	0	1

The results suggest that of the three solvents, hexane had the greatest effect on the leaf surface. However a great deal of further work remains to be done as the sample size was small and this factor combined with the measurement of the wetting angle to the nearest five degrees only made statistical analysis problematic. Future studies will use larger sample sizes and a wider range of solvents and application times. The nature of the disturbance to the surface also needs to be investigated to ascertain whether cuticular material and/or other water repellent extractive material was removed or disturbed or if other factors were involved. Eventually it is hoped that the method can be developed so that it can be used to test small samples from artefacts as a way of assessing solvent treatments.

CONCLUDING REMARKS

Plant materials are amongst the most complex kinds of material encountered by conservators. Rational decisions concerning the conservation of objects constructed from these materials must be based on a thorough understanding of their structure, properties and uses. Continuing research efforts by conservators and scientists into these materials will lead to improvements in their storage, handling and treatment.

ACKNOWLEDGEMENTS

I would like to thank the following members of staff of Camberwell College of Arts for their help and advice: Anthony Smith, Aeli Clarke, Michael Yianni and Nicholas Ardizzone. I owe a particular debt of thanks to Dorothy Catling for preparing cross sections of Pandanus spiralis, supplying dried leaf material and for her patient guidance on matters of plant anatomy.

REFERENCES

Agrawal, O.P. 1981. 'Appropriate' Indian technology for the conservation of museum collections, in *'Appropriate Technologies' in the Conservation of Cultural Property*, The UNESCO press.

Agrawal, O.P. 1984. *Conservation of Manuscripts and Paintings of South East Asia*, Butterworths, London.

Agrawal, O.P. and Dhawan, S. 1984. Studies on fungal resistance of birch-bark, in *7th Triennial Meeting, Copenhagen 10-14 September 1984* (ed D. DeFroment), ICOM-CC, 84.25.1-2, ICOM, Paris.

Agrawal, O.P. and Suryawanshi, D.G. 1987. Further studies on the problems of conservation of birch bark, *in 8th Triennial Meeting, Sydney 6-11 September 1987* (ed K. Grimstad), ICOM-CC, vol. 2, 635-9, The Getty Conservation Institute, Los Angeles.

Akai, S. and Fukutomi, M. 1980. Preformed internal physical defences, in *Plant Disease. An Advanced Treatise. Volume 5, How Plants Defend Themselves* (ed J.G. Horsfall and E.B. Cowling), Academic Press, 139-59, London.

Ave, W. 1986. The use of rattan by a Semai community in West Malaysia, *Principes*, 30(4), 143- 50.

Avé, W. 1988. Small scale utilisation of rattan by a Semai community in West Malaysia, *Economic Botany*, **42**(1), 105- 19.

Banack, S.A. and Cox, P.A. 1987. Ethnobotany of ocean going canoes in Lau, Fiji, *Economic Botany*, **41**(2), 148-62.

Barbour, R.J. 1984. The condition and dimensional stability of highly deteriorated waterlogged hardwoods, in *Waterlogged Wood. Study and Conservation, ICOM-CC Waterlogged Wood Working Group 2nd Interim Meeting*, 23-37.

Bell, A.D. 1991. *An Illustrated Guide to Flowering Plant Morphology*, Oxford University Press, Oxford.

Bhat, K.M., Liese, W. and Schmitt, U. 1990. Structural variability of vascular bundles and cell wall in rattan stem, *Wood Science and Technology*, **24**, 211-24.

Bhat, K.M. and Thulasidas.1992. Strength properties of ten south Indian canes, *Journal of Tropical Forest Science*, **5**(1), 26-34.

Blanchette, R. and Briggs, A. (eds). 1992. *Defence Mechanisms of Woody Plants Against Fungi.* Springer-Verlag.

Blanchette, R.A., Haight, J.E., Koestler, R.J., Hatchfield, P.B. and Arnold, D. 1994. Assessment of deterioration in archaeological wood from ancient Egypt, *JAIC*, **33**, 55-70.

Brett, C. and Waldron, K. 1996. *Physiology and Biochemistry of Plant Cell Walls,* 2nd edn, Chapman and Hall, London.

Chari, V.M., Neelakantan, S. and Seshadri, T.R. 1968. Chemical components of Betula utilis and Celtis australis, *Indian Journal of Chemistry*, **6**, 231-4.

Cotton, C.M. 1996. *Ethnobotany: Principles and Applications.* John Wiley and Sons, .

Cox, P.A., Huynh, K. and Stone, B.C. 1995. Evolution and systematics of Pandanaceae, in *Monocotyledons: Systematics and Evolution* (ed P. Rudall *et al.*) 663-84, Royal Botanic Gardens, Kew.

Dimbleby, G. 1978. *Plants and Archaeology,* 2nd edn, John Baker (Publishers) Ltd.

Dinwoodie, J.M. 1979, *Timber. Its Nature and Behaviour,* Van Nostrand Reinhold Company.

Esau, K. 1977. *Anatomy of Seed Plants,* 2nd edn, John Wiley and Sons.

Florian, M. 1977. Plant material used in some ethnological artifacts, structure, fabrication and deterioration related to conservation treatment, *A.I.C. Preprints*, 51- 5.

Florian, M., Kronkright, D.P. and Norton R.E. 1990. *The Conservation of Artefacts Made from Plant Materials*, The Getty Conservation Institute, Los Angeles.

Florian, M. and Renshaw-Beauchamp, R. 1982. Anomalous wood structure: a reason for failure of PEG in freeze-drying treatments of some waterlogged wood from the Ozette site, in *Proceedings of the ICOM Waterlogged Wood Working Group Conference* (ed D.W. Grattan), 85-98.

Gregory, M, 1994. Bibliography of systematic wood anatomy of Dicotyledons, *Rijksherbarium/Hortus Botanicus/*International Association of Wood Anatomists.

Gilberg, M.R. 1986. Plasticization and forming of misshapen birch-bark artefacts using solvent vapours, *Studies in Conservation*, **31**, 177-84.

Greaves, H. 1974. A review of the influence of structural anatomy on liquid penetration into hardwoods, *Journal of the Institute of Wood Science*, **6**(6), 37-40.

Hedley, G. 1980. Solubility parameters and varnish removal: a survey, *The Conservator*, **4**, 12-18.

Higuchi, T. 1989. Bamboo, in *Concise Encyclopaedia of Wood Based Materials* (ed A.P. Schniewind), Pergamon, 19-26, Press, Oxford.

Hoadley, R.B. 1978. The dimensional response of wood to variation in relative humidity, in *Conservation of Wood in Painting and the Decorative Arts* (eds N.S. Bromelle *et al.*), IIC, 1-6, London.

Hollaway, P.J. 1969a. The chemistry of leaf waxes in relation to wetting, *Journal of the Science of Food and Agriculture*, **20**, 124-28.

Hollaway, P.J. 1969b. The effects of superficial wax on leaf wettability, *Annals of Applied Biology*, **63**, 145-53.

Jahan, S. 1987. Traditional techniques for the preservation of cellulosic ethnographic materials, *in 8th triennial meeting, Sydney 6-11 September 1987* (ed K. Grimstad), ICOM-CC, vol.1, 209-10, The Getty Conservation Institute, Los Angeles.

Kronkright, D.P. 1981. New directions in native American basketry conservation, in *A.I.C. Preprints* 9th Annual Meeting, 95-108.

Kolattukudy, P.E. 1984. Biochemistry and function of cutin and suberin, *Canadian Journal of Botany*, **62**, 2918-33.

Kumar, S and Dobriyal, P.B. 1992. Treatability and flow path studies in Bamboo, Pt 1, Dendrocalamus strictus Nees, *Wood and Fiber Science*, **24**(2), 113-17.

Mark, R.E. and Gillis P.P. 1973. The relationship between fiber modulus and S2 angle, *Tappi*, **56**(4), 164-67.

Martin, J.T. and Juniper, B.E. 1970. *The Cuticles of Plants,* Edward Arnold Ltd.

Maturbongs, L and Schneider, M.H. 1996. Treatability and CCA preservative distribution within ten Indonesian hardwoods, *Wood and Fiber Science*, **28**(2), 259-67.

Metcalfe, C.R. 1960. *Anatomy of the Monocotyledons. I. Graminae.* Clarendon Press, Oxford.

Meylan, B. 1972. The influence of microfibril angle on the longitudinal shrinkage-moisture content relationship, *Wood Science and Technology*, **6**, 293-301.

Preston, R.D. 1974. *The Physical Biology of Plant Cell Walls,* Chapman and Hall, London.

Purseglove, J.W. 1972. *Tropical Crops. Monocotyledons,* Longman, London.

Robbins, R.P. 1980. *Wood Identification of Spear Throwers in the Queensland Museum Ethnographic Collection, an*

Evaluation. Occasional Papers in Anthropology, 10, University of Queensland.

Rudall, P. 1992. *Anatomy of Flowering Plants. An Introduction to Structure and Development,* 2nd edn, Cambridge University Press, Cambridge.

Schniewind, A.P. 1989. Archaeological wood, in *Concise Encyclopaedia of Wood Based Materials* (ed A.P. Schniewind), Pergamon Press, 14-18 Oxford.

Seshadri, T.R. and Vedantham, T.N.C. 1971. Chemical examination of the barks and heartwoods of Betula species of American origin, *Phytochemistry*, **10**, 897-8.

Sillitoe, P. 1988. *Made in Niugini. Technology in the Highlands of Papua New Guinea*, BMP, London.

Smith, N.M. 1991. Ethnobotanical field notes from the Northern Territory, Australia, *Journal of the Adelaide Botanic Gardens*, **14**(1), 1-65.

Tomlinson, P.B. 1961. *Anatomy of the Monocotyledons*. II, Palmae.

Tomlinson, P.B. 1990. *The Structural Biology of Palms*, Oxford University Press, Oxford.

Tootil, E. (ed). 1984. *The Penguin Dictionary of Botany*. Penguin Books, Harmondsworth.

Van der Grijp, P. 1993. Women's handicrafts and men's arts. The production of material culture in the Polynesian kingdom of Tonga, *Journal de la Société des Océanistes*, **97**, 159-69.

Weiner, G. and Liese, W. 1993. Generic identification key to rattan palms based on stem anatomical characters, *I.A.W.A Journal*, **14**(1), 55-61.

Wilson, K. and White, D. 1986. *The Anatomy of Wood. It's Diversity and Variability*, Stobart and Son Ltd, London.

Whistler, W.A. 1988. Ethnobotany of Tokelau: their Tokelau names and their uses, *Economic Botany*, **42**(2), 155-76.

Mark Sandy, School of Art History and Conservation, Camberwell College of Arts. Wilson Road, London SE5 8LU

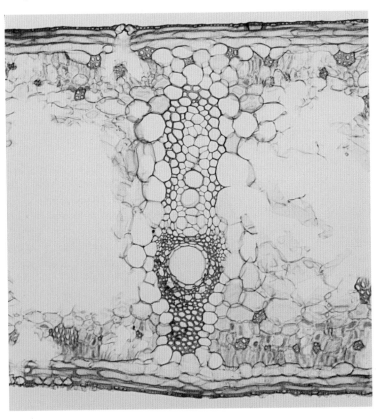

Figure 1 Transverse section of leaf of Pandanus spiralis. One vascular bundle can be seen can be seen extending across the section. Fibre bundles are visible below the epidermis of both leaf surfaces. Photograph taken on an Olympus CX40 optical microscope
(Note: Scale bar provided. One small division =10 microns.).

LASERS IN ART CONSERVATION

Costas Fotakis, Vassilis Zafiropulos, Demetrios Anglos, Savas Georgiou, Noni Maravelaki, Anna Fostiridou, Michalis Doulgeridis

ABSTRACT

Modern laser technology has been successfully employed in a variety of art conservation applications. For example, there have been several successful demonstrations of the use of lasers for the cleaning of sculpture and paintings, including the recovery of original paintings from overpaintings. The technique is based on the controllable removal of surface layers by laser ablation. In another type of application, lasers have been used as tools for the non destructive diagnosis of the chemical composition of surface constituents of artworks. Several of these analytical techniques can be applied in situ and can be also used for on-line control of the cleaning process safeguarding the object from any damage. Finally, modern imaging techniques can be used for the documentation of structural and color information with good contrast.

Key Words

painting laser cleaning, marble laser cleaning, artwork diagnostics, laser induced breakdown spectroscopy (LIBS), laser induced fluorescence (LIF).

INTRODUCTION

Modern laser and optical technologies are currently under active investigation with regard to their use in the field of artwork conservation and restoration, both for cleaning and diagnostic applications. For example, Nd:YAG lasers emitting in the infrared part of the spectrum have been extensively applied in the removal of black encrustations from stone including marble, (Asmus 1986, Watkins *et al.* 1996, Teppo and Calcagno 1995); while excimer lasers which emit in the ultraviolet have been used for the cleaning of painted artworks (Fotakis 1995, Fotakis *et al.* 1997). Besides laser cleaning, intense interest also exists for the development and application of laser based analytical techniques as tools for artwork diagnostics. Such techniques can be performed *in situ*, and are

essential to artwork conservation and restoration since they provide important information regarding the physical and chemical structure of artworks. In addition they can be used for the on-line monitoring of the cleaning process, safeguarding against potential damage (Fotakis 1995, Fotakis *et al.* 1997, Maravelaki *et al.* 1997, Gobernado-Mitre *et al.* 1977).

Over the last five years, the Laser and Applications Division of FO.R.T.H. together with the National Gallery of Athens have been involved in the investigations of a variety of painting conservation applications. These include:

- laser cleaning of surface layers and/or overpaint removal;
- *in situ* laser-based analysis of pigments and media;
- advanced imaging techniques for structural diagnostics;
- laser based authentication techniques.

A primary objective of this research has been the assessment of the prospects opened by the adaptation of laser technology in art conservation, and the determination of its limitations. Several of the corresponding techniques, together with selected examples will be presented here.

CLEANING PAINTINGS BY EXCIMER LASERS

Excimer lasers have been used in several delicate and demanding medical and material processing applications. These lasers emit light pulses of about 20×10^{-9} seconds duration, at several wavelengths in the ultraviolet (193, 248, 308nm), and are capable of removing materials in layer by layer increments of $0.1-1 \mu m$ ($1 \mu m$ is equal to 1×10^{-6} metres). This facilitates the surface cleaning of polluted surface layers of paintings, as for example dirty or aged layers of varnish, leaving the underlying material unaffected. Successful removal of overpaintings by excimer lasers has also been demonstrated. In this case overall material thicknesses of up to $300 \mu m$ have been

removed.

Traditional methods of conservation of paintings rely on mechanical or chemical techniques chosen by a conservator. Because these processes are difficult to control, extensive expertise is necessary to achieve an optimal result. Furthermore, in many cases chemical solvents may penetrate the painting and damage the pigments and media.

In contrast to these more traditional techniques, an excimer laser can be employed to remove unwanted surface layers in a controllable manner. With proper selection of laser parameters, detailed investigations have proved that material can be removed through the mechanism of photoablation with minimal thermal or photochemical effects to the underlying material. Furthermore, optical techniques can be applied on-line to evaluate the cleaning process and carefully monitor its progress, protecting from any damage (Fotakis 1995, Fotakis *et al.* 1997, Maravelaki *et al.* 1997, Gobernado-Mitre *et al.* 1977). An example of varnish removal by KrF excimer laser (248nm) is shown in Figure 1. In this case purposely only the top layers of varnish were removed leaving behind a thin protective layer of original varnish.

Generally, there are three types of cleaning applications for which excimer lasers are well suited. These include the removal of surface layers of varnish or contaminated regions from paintings, the cleaning of paintings' support material, usually canvas, wood or paper, and the removal of overpaintings. Recently we also found that the XeCl excimer laser (308nm) is suitable for the removal of certain types of encrustation from the surface of marble. Each of the above cases must be approached using a separate strategy to achieve optimum results. For instance, the laser surface cleaning of paintings ideally removes photodegraded varnish layers without any contamination or exposure of the underlying painted surface when fluence around 0.2-0.3 J/cm^2 is used.

Removal of unwanted overpainting can also be achieved in microscopic increments, avoiding labourious, risky procedures which employ mechanical means or strong solvents. In this case, however, laser fluence of about an order of magnitude higher than that used for surface cleaning must be employed.

For the cleaning of paintings using excimer lasers, we have developed a workstation comprised of:
a) an x-y-z stage, for properly mounting and moving the painting;
b) a set of suitable optics for the laser beam delivery and focusing;

c) several diagnostic modules for the on-line monitoring and control of the cleaning process.

More specifically the x-y-z stage is a computer controlled three-directional mechanical translator which is used for precisely moving the painting with respect to the laser beam. Image processing techniques or a module for broad band reflectography are used for on-line process control. As the dirt or debris is removed, a clean thin layer of overcoating is exposed which can be detected by means of diffuse reflectance measurements. Alternatively, laser based spectroscopic techniques, e.g. LIBS (see next section) can be incorporated for the on-line control. Furthermore, various diagnostic methods such as holography, optical microscopy, profilometry as well as gas chromatography combined with mass spectroscopy analysis have been used to assess the results of the cleaning process, (e.g. possible oxidation of the binding medium).

IMAGING AND ANALYTICAL APPLICATIONS OF LASER TECHNOLOGY

An effective application of any laser cleaning protocol depends on the availability of non-destructive diagnostic tools, which include imaging techniques to document macroscopic color and structural information, as well as analytical techniques to provide information about the chemical composition of the art object. Macroscopic observations are made by reflectography and can aid the on-line control of the cleaning process. Depending on the range of wavelengths used in the reflectographic observations different types of information can be obtained. Reflectance spectroscopy in the ultraviolet (200-350nm) provides information on the superficial varnished layers, while imaging in the near infrared (1.0-2.5μm) reveals underlying structure characteristics, particularly in the case of overpainting. Illumination by modern tunable lasers incorporating optical parametric oscillators (OPO) can be useful for the observation of pigment layers in this respect. Another laser spectroscopic technique called Laser Induced Fluorescence (LIF) can be used for *in situ* chemical analysis. Finally, Laser Induced Breakdown Spectroscopy (LIBS) has shown promise in elemental analysis of pigments and/or contaminants, as well as in assisting in the control of the laser cleaning process. Below some examples of the two latter techniques are presented.

LIF is a versatile, non-destructive analytical technique, which can be performed in-situ on the artwork itself and provides information which can be directly related to the molecular structure of pigments or binding media, both inorganic and organic. In a typical LIF experiment a low intensity continuous or pulsed laser beam is used to excite a small area on the surface of the sample. Following the excitation, organic or inorganic fluorescent substances in the sample emit broad band fluorescence with characteristic spectral features. Recently, LIF has been used for non destructive pigment and media analysis. Experimental work has shown that several commonly used pigments and even mixtures of them can be identified in model samples based on their characteristic fluorescence emission (Anglos *et al.* 1996, Miyoshi *et al.* 1982). Furthermore, LIF has been used to identify the presence of photochemical oxidation in varnishes. For example, Figure 2 shows fluorescence spectra of mastic varnish films before and after UV light ageing, obtained by using a frequency tripled Nd:YAG laser emitting at 355nm. A large spectral red shift (*c.* 100nm) is observed in the UV aged varnish.

LIBS is a well established, sensitive and highly selective analytical technique for performing elemental analysis of materials (Radziemski and Cremers 1989) which has found applications in industrial (Aguilera *et al.* 1992), geological (Grant *et al.* 1991) and environmental analyses (Casini *et al.* 1991). As a majority of pigments used in paintings from antiquity to modern times are metal containing substances, LIBS appears to be quite a suitable technique for elemental analysis of pigments. LIBS spectra have been collected from several commonly used pigments and their spectra exhibit characteristic atomic emission lines demonstrating the ability of the technique to identify and discriminate between different pigments. Figure 3, shows typical LIBS spectra obtained from model oil colour samples of cadmium yellow lemon and cadmium red. Also mixtures of two or three pigments were analysed and the individual components were identified on the basis of their characteristic emission spectral lines.

In a LIBS experiment, during the ablation process a microscopic crater of a few tenths of micrometers in diameter and 0.1 micrometers in depth can be created. As a result the extent of damage to the work is hardly visible by the naked eye, especially with the use of UV excimer lasers where only a tenth of a nanogram is taken off by laser ablation. The technique can thus be characterised as practically non-destructive. Furthermore, as the ablation depth reached by a single nanosecond laser pulse is very small, of the order of $0.1-2\mu m$ in the case of organic polymeric materials (Radziemski and Cremers 1989) in essence the LIBS technique can be used to perform cross sectional analysis of painted artworks, and obtain information regarding multiple pigment layers. Work is in progress to investigate the experimental parameters affecting the size of the crater in order to understand how it is possible to further minimise its diameter and control the depth especially when performing cross sectional analysis.

Summarizing, LIF is a rigorously non-destructive technique and although not as selective as LIBS, due to the broad band nature of molecular fluorescence spectra, has the ability to analyse both organic and inorganic materials and provide information that can be associated to their molecular structure and/or the extent of ageing. One obvious limitation of LIF is the analysis of pigments with extremely low fluorescence quantum yield values which are practically impossible to detect, especially in the presence of small quantities of fluorescent impurities. LIBS on the other hand offers exceptional selectivity as a result of the sharp line emission spectra obtained in the analysis. The individual frequencies and relative positions of the atomic emission lines provide characteristic fingerprints for most elements which lead to their unambiguous identification. Possible reasons for diminished selectivity can be interference from background emission from the organic matrix, the painting medium in which the pigment is dispersed, similar elemental compositions of different pigments, or even the poor detection sensitivity of some elements, mainly the non metals.

CONSERVATION OF MARBLE AND STONE

The formation of gypsum containing black crusts on natural stones of historic monuments is regarded as an important factor leading to their decay. The black crusts result from physicochemical processes occurring at the stone surface and/or between the stone surface and atmospheric pollutants, in most cases in the presence of water (Amoroso and Fassina 1983). Any exposure of the stone to open air conditions leads to deterioration. In the particular case of marble, air pollutants, especially high contents of SO_2 in the atmospheric aerosol are responsible for superficial sulphation (Fassina 1988, Camuffo *et al.* 1983). These black crusts possess an irregular thickness ranging from

20-600μm consisting of gypsum, black particles, iron oxides and iron oxide hydroxides, soot, residual calcite and fragments of limestone, mica flakes, quartz and numerous organic and inorganic constituents in low concentration. One type of black encrustation developed on marble has been observed in areas sheltered from rain, where dry decay phenomena prevail. Some of the crusts examined are very hard, as they have recrystallised, and consist of gypsum and deposits of soot and dust containing silica, aluminium, iron and magnesium. Mechanical cleaning, washing methods and poultices mixed with chemical agents are unable to remove such crusts without leading to substantial loss of decayed stone (Livingston 1992).

Removal of black encrustation from marble or stone is nowadays one of the most promising applications of laser technology in art conservation (Asmus 1986, Watkins *et al.* 1995, Teppo *et al.* 1995). An important issue in laser conservation of marble is the parallel monitoring and control of the cleaning process. In this respect, LIBS has been applied at the Laser Laboratory of FO.R.T.H. as a real time diagnostic technique for the laser cleaning of marble and stone (Maravelaki *et al.* 1997, Gobernado-Mitre *et al.* 1997). LIBS relies on the analysis of the emission spectra from excited species (atoms, ions, molecules and radicals) found in the laser induced plasma. Since these excited species are characteristic of the surface composition during the cleaning process by laser ablation, one laser is adequate both for the surface cleaning and as the LIBS source. Furthermore, it has also been demonstrated that LIBS can be used for the on-line control of the extent of laser cleaning in cases where the self limiting process does not apply. Besides the elemental composition, LIBS, if combined with an ablation rate study, provides information on the depth and morphology of the crust, thus facilitating the choice of the appropriate parameters for the cleaning process (Maravelaki *et al.* 1997). Typical LIBS spectra collected during the removal of encrustation from marble using a Q-switched Nd:YAG laser are shown in Figure 4. These spectra have been obtained from successive laser pulses and therefore provide an in depth profile of existing elements for a total depth of up to 150μm. For a better presentation of the spectra in Figure 4, the absolute intensities of the individual spectra have been normalised, so that the strongest peak has the same intensity in every spectrum.

Based on the above data the successful computer controlled removal of the outer layer of the

encrustation was achieved by monitoring the ratio of the emission of Fe, Si, or Al to the emission of Ca. More specifically, after each laser pulse this ratio was fed back as an input to the code that controlled the triggering of the laser and the steps of the x-y-z translator. When the emission ratio decreased to less than a certain value, the laser treatment ceased at that particular surface spot and the translator moved the sample to the next position. The stoichiometric information obtained from the cleaned surface by LIBS, is in perfect agreement with those obtained independently using the EDX technique (Maravelaki *et al.* 1997). LIBS could be additionally used *in situ* for providing indications of the in-depth characteristics of the encrustation before the cleaning. These characteristics, depth and composition of the encrustation, must be evaluated beforehand in order to select the appropriate parameters, such as energy fluence, approximate number of pulses and applied overlap between adjacent spots, for the removal of the polluted layers without damaging the substrate.

CONCLUSIONS

The implementation of modern laser technology in the field of art conservation has been proven to be quite promising both in cleaning as well as diagnostic applications. The successful cleaning of various types of artworks is dependent on the appropriate choice of laser parameters and on-line monitoring, and/or controlling techniques. Such techniques are also useful for the *in situ* and non-destructive analysis of pigments and media. Finally, it should be stressed that the successful implementation of lasers in art conservation is a strongly interdisciplinary field relying on collaboration between art historians, conservators and natural scientists.

ACKNOWLEDGEMENTS

This work is partially supported by the 'Laser Technology in the Conservation of Artworks' project N° 640 of the EPET II Programme (Greece) from the EU Structural Funds and by the Ultraviolet Laser Facility operating at FO.R.T.H. under the TMR Program (DGXII, ERBFMGECT 950021) of the EU. We would like to thank LAMBDA PHYSIK and QUANTEL for providing the lasers for this work.

REFERENCES

Aguilera, J.A., Aragon, C. and Campos, J. 1992. Determination of carbon content in steel using laser-induced breakdown spectroscopy, *Appl. Spectros.*, **46**, 1382-90.

Amoroso, G. and Fassina, V. 1983. *Stone Decay and Conservation*, Elsevier Science, 135-55, Amsterdam.

Anglos, D., Solomidou, M., Zergioti, I., Zafiropulos, V., Papazoglou, T.G. and Fotakis, C. 1996. Laser-induced fluorescence in artwork diagnostics: an application in pigment analysis, *Appl. Spectrosc.*, **50**.

Asmus, J.F. 1986. More light for art conservation, *IEEE Circuits and Devices Magazine,* June, 6-12.

Camuffo, D., Del Monte, M. and Sabbioni, C. 1983. Origin and growth mechanisms of the sulphated crusts on urban limestone, *Water Air and Soil Pollution*, **19**, 351-359.

Casini, M., Harith, M.A., Palleschi, V., Salvetti, A., Singh, D.P. and Vaselli, M. 1991. Time-resolved LIBS experiment for quantitative determination of pollutant concentrations in air, *Laser and Particle Beams*, **9**, 633-9.

Fassina, V. 1988. Environmental pollution in relation to stone decay, *Durability of Building Materials*, **5**, 317-358.

Fotakis, C., Anglos, D., Balas, C., Georgiou, S., Vainos, N.A., Zergioti, I. and Zafiropulos, V. 1997. Laser Technology in Art Conservation, *OSA Trends in Optics and Photonics Series*, Optical Society of America, Washington, DC, in press.

Fotakis, C. 1995. Lasers for art's sake!, *Optics and Photonics News*, **6**(5), 30-5.

Gobernado-Mitre, I., Prieto, A.C., Zafiropulos, V., Spetsidou, Y. and Fotakis, C. 1997. On-line monitoring of laser cleaning of limestone by laser induced breakdown spectroscopy, *Appl. Spectroscopy*, (in press).

Grant, K.J., Paul, G.L. and O'Neil J.A. 1991. Quantitative elemental analysis of iron ore by laser-induced breakdown spectroscopy, *Appl. Spectrosc.*, **45**, 701-5.

Livingston, R.A. 1992. Geochemical considerations in the cleaning of carbonate stone, in *Stone cleaning and the nature, soiling and decay mechanisms of stone, 7th International Conference* (ed R.G.A. Webster), Donhead, 166-80, London.

Maravelaki, P.V., Zafiropulos, V., Kylikoglou, V.,

Kalaitzaki, M. and Fotakis, C. 1997. Laser induced breakdown spectroscopy as a diagnostic technique for the laser cleaning of marble, *Spectrochimica Acta B.*

Miyoshi, T., Ikeya, M., Kinoshita S. and Kushida, T. 1982. Laser-induced fluorescence of oil colours and its application to the identification of pigments in oil paintings, *Jpn. J. Appl. Phys.* **21**, 1032-6.

Radziemski, L.J. and Cremers, D.A. (eds). 1989. *Laser-Induced Plasmas and Applications*, Marcel Dekker, New York.

Teppo, E. and Calcagno, G. 1995. Restoration with lasers halts decay of ancient artefacts, *Laser Focus World*, **31**(6), S5-S9.

Watkins, K.G., Larson, J.H., Emmony, DC, and Steen, W.M. 1996. Laser cleaning in art restoration: a review, in *Laser Processing: Surface Treatment and Film Deposition*, (eds J. Mazumder *et al.*), Kluwer Academic Publishing, 337-358, Dordecht

MATERIALS

The excimer laser (COMPEX 201) was provided by LAMBDA PHYSIK Gmgh, Hans-Boeckler-Strasse 12, D-37079 Göttingen, Germany
Tel: (0551)-6938-0, Fax (0551)-68651.

The Q-switched Nd:YAG laser (Brilliant) was provided by QUANTEL, Avenue de l'Atlantique - Z.A. de Courtaboeur - BP 23, 91941 Les Ulis Cedex, France
Tel: (1)-69291700, Fax: (1)-69291729.

Costas Fotakis,[a,c] Vassilis Zafiropulos, Demetrios Anglos,[a] Savas Georgiou, Noni Maravelaki, Anna Fostiridou,[b] Michalis Doulgeridis[b]

[a] Foundation for Research and Technology-Hellas (FO.R.T.H.), Laser and Applications Division, P.O. Box 1527, 71110 Heraklion, Greece

[b] National Gallery of Athens, Department of Conservation, 1 Michalakopoulou St., Athens, Greece

[c] Department of Physics, University of Crete, Heraklion, Greece

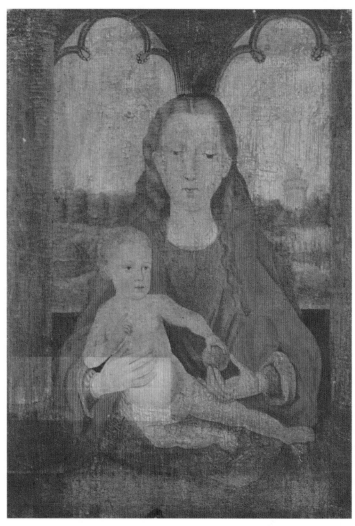

Figure 1 Detail of partial removal of varnish from a fifteenth-century Flemish oil painting

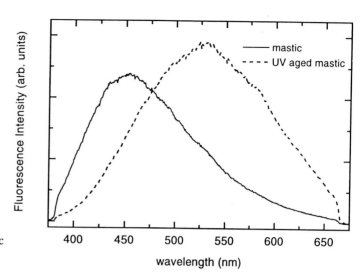

Figure 2 Fluorescence spectra from mastic varnish films (\ddot{I}_{laser}: 355nm)

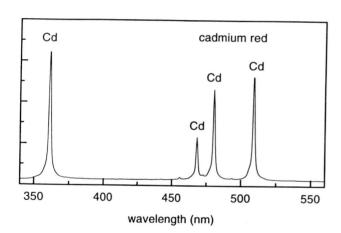

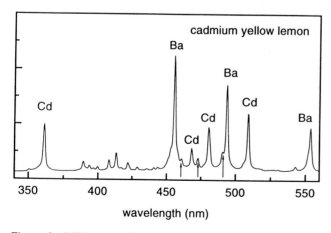

Figure 3 LIBS spectra from cadmium red ($CdSe_xS_{1-x}$) and cadmium yellow lemon ($Cd_{0.9}Zn_{0.1}S.BaSO_4$) pigments (\ddot{I}_{laser} : 1064nm).
In the bottom spectrum the arrows indicate the zinc emission lines.

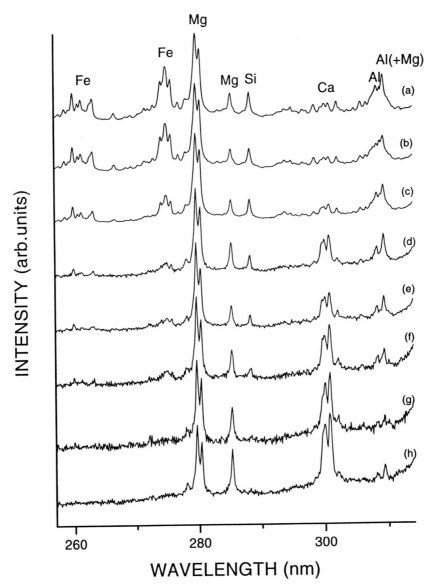

Figure 4 Successive LIBS spectra during the removal of black encrustation from Pentelic marble

ASSESSING AND MONITORING THE ENVIRONMENT OF CULTURAL PROPERTY

Graham Martin

ABSTRACT

This project was a joint European Union and Fraunhofer-Institut für Silicatforschung (ISC) funded programme to study the atmospheres in which cultural objects are displayed and stored. A range of sites across Europe were investigated for a number of potentially damaging factors including gaseous pollution (sulphur dioxide, nitrogen dioxide, acetaldehyde, formaldehyde, volatile organic compounds) temperature and relative humidity. A joint aim of the project was the development of a glass based dosimeter that has provided those responsible for cultural heritage with a tool to investigate the environments in which the collections are housed. It is this dosimeter that will become available to conservators for their use.

Key words

environment, dosimeter, pollution, glass

INTRODUCTION

In recent years there has been a growing concern about the environmental conditions under which museum objects or more general works of art are displayed or stored (Brimblecomb 1990, Baer and Banks 1985, Appelbaum 1991, Stolow 1966). However, damage of indoor art objects caused by environmental pollution is still difficult for most people to take as seriously as deterioration from other sources because it is seldom as easy to detect, and rarely an acute episode. Much of the research on air pollution relates to outdoor conditions, only recently has there been a growing interest in indoor pollution and the research on air quality in museums is at a rather low level compared to that of other conservation topics. The study of individual components of the environment such as temperature, relative humidity and other gases does not give any information on the synergetic impact of these parameters on cultural property.

To understand these queries, a programme of study was formulated under the title of Assessing and Monitoring the Environment of Cultural Property (AMECP). This project had dual objectives:
- to examine, characterise and quantify various typical environments of cultural property;
- to develop a glass based sensor to facilitate assessment of these environments.

A spread of project partners provided the basis for the environmental studies. The partners were from:
- southern Europe - Museu do Mosterio de Santa Maria da Vitória, Batalha, Portugal;
- central Europe - Fraunhofer-Institut für Silicatforschung (ISC), Würzburg, Germany;
- northern Europe - Victoria and Albert Museum, London, Great Britain.

Alongside the environmental studies, the development of a glass based dosimeter suitable for use indoors was investigated by one of the partners (FhG-ISC). It was an objective of this portion of the work to provide a robust dosimeter that could be used as first call for the general assessment of environmental risk to collections.

ENVIRONMENTS OF CULTURAL PROPERTY

As already stated a number of sites were chosen for in depth studies. This aspect of the work included examination of the external environment, the internal environment and the environment within display cases. The schema for this work is shown in Figure 1.

As an early decision in the project and for a variety of reasons, pollutants such as ammonia, ozone and nitrous oxide were not included in the study. This decision was largely led by the non-availability of dosimeters that were suitable for use in the study. Some of these dosimeters are now becoming available.

A range of pollutants and environmental parameters were studied. These are summarised below:

temperature;
relative humidity;
sulphur dioxide;
nitrogen dioxide;
formaldehyde and acetaldehyde;
volatile organic compounds (VOC).

A range of 28 VOC compounds were routinely analysed. These were:

methyl acetate;
hexane;
acetic acid;
1,1,1-trichloroethane;
benzene;
pentanal;
heptane;
toluene;
hexanal;
octane;
tetrachloroethylene;
ethyl benzene;
m-, p-xylene;
styrene;
o-xylene;
nonane;
α-pinene;
1,3,5-trimethylbenzene;
β-pinene;
1,2,4-trimethylbenzene;
decane;
3-carene;
limonene;
1,3-diethylbenzene;
1,4-diethylbenzene;
1,2-diethylbenzene;
undecane;
dodecane;

With all the analytes the preferred method of sample collection was by passive, diffusion controlled samplers whose *modus operandi* is described elsewhere (Moore 1987, Brown *et al.* 1992, Brown *et al.* 1993).

RESULTS

The reader is directed to the report held by the European Union for full details of the analysis results. Only a summary will be given here.

Temperature

Temperature readings were recorded at thirty minute intervals during the study. The results are not reported here.

Humidity

Relative humidity readings were recorded at thirty minute intervals during the study. The results are not reported here.

Nitrogen dioxide

The table below details the nitrogen dioxide concentrations as $\mu g \ m^{-3}$. A continuous monitoring programme over eighteen months, with sampler interval of 28 days (April 1994 to August 1995) is reported here.

	Minimum	Maximum	Range	Mean±Standard Deviation
P, Monastery				
Site II (roof)	11.0	27.6	16.6	15±4
Site III (Sacristy)	1.6	16.9	15.3	5±4
Site V (Gallery)	10.2	24.8	14.6	15±4
Site VI (Office)	2.3	11.0	8.7	4±2
Site VII (Studio)	3.4	17.5	14.1	8±4
GB, V&A Museum				
Roof	23.5	51.6	28.1	40±8
Gallery 131	27.8	47.5	19.7	39±5
Gallery 44	30.1	54.1	24.0	40±6
Gallery 44 Case 7	2.7	30.7	28.0	7±7
Gallery 44 Case 24	3.8	11.4	7.6	6±2
D, Residenz				
Balkon (external)	17.5	37.9	20.4	27±6
Blaues Vorzimmer	7.6	50.8	43.2	18±9
Kaisersaal	8.8	29.9	21.1	17±6
Spiegelkabinett	8.2	20.3	12.1	16±3
Weisser Saal	9.3	43.3	34.0	17±8

Comments

1. The lowest average nitrogen dioxide values of all the sites investigated was in Portugal at the Monastery site.
2. The Portugese site V had very similar nitrogen dioxide concentrations to the external site at around $15\mu g$ m^{-3}. Site V is essentially an open gallery with very little restriction to air flow between the external and 'internal' environment.
3. The other Portugese sites – all internal – show just over one half to one quarter of the value.
4. The Great Britain, V&A Museum site demonstrated the highest overall values of all the sites studied.
5. There was little difference between the Great Britain, V&A Museum roof and gallery sites.
6. Concentrations of nitrogen dioxide in the showcases is significantly lower than the surrounding gallery space for the Great Britain, V&A Museum.
7. The German, Residenz site was between the other sites for external nitrogen dioxide concentrations.
8. There is a reduction of nitrogen dixide levels in the gallery spaces of the German, Residenz site.

Interpretation

In the closed galleries there is a general decrease of nitrogen dioxide concentrations. This is commensurate with the predominant source being external to the galleries – as demonstrated by the high values in the gallery of the Portugese site V which has no windows.

Little date dependancy was evident from the results.

In summary the nitrogen dioxide concentrations follow the relationship of

showcase < gallery ≤ external.

Sulphur Dioxide

The table below details the sulphur dioxide concentrations as μg m^{-3}. A continuous monitoring programme over 18 months (April 1994 to August 1995) with a sampler interval of 42 days is reported here.

	Minimum	Maximum	Range	Mean±Standard Deviation
P, Monastery				
Site II (roof)	2.2	9.0	6.8	5±2
Site III (Sacristy)	0.3	10.6	10.3	2±3
Site V (Gallery)	0.7	8.7	8.0	4±2
Site VI (Office)	0.3	22.9	22.6	3±7
Site VII (Studio)	0.3	2.8	2.5	1±1
GB, V&A Museum				
Roof	12.4	37.9	25.5	22±9
Gallery 131	2.1	27.4	25.3	7±7
Gallery 44	0.4	21.2	20.8	8±6
Gallery 44 Case 7	0.3	11.3	11.0	3±3
Gallery 44 Case 24	0.4	7.9	7.5	2±2
D, Residenz				
Balkon (external)	0.4	14.4	14.0	8±4
Blaues Vorzimmer	0.4	7.0	6.6	2±2
Kaisersaal	0.4	21.1	20.7	4±6
Spiegelkabinett	0.4	10.9	10.5	3±3
Weisser Saal	0.4	12.7	12.3	3±4

Comments

1. The highest external concentration of sulphur dioxide is at Great Britain V&A external site.
2. Overall, the external sulphur dioxide concentrations were very much higher than internal.
3. Inside display cases there is a decrease in sulphur dioxide concentration.
4. Close examination of the data shows some evidence of escalation of sulphur dioxide levels in the months of July and August in Portugal and London. Further work is required to explore this using shorter sampling periods.

Interpretation

The showcases achieve a reduction in concentration of sulphur dioxide and a considerable reduction in concentration is found in the comparison of the external sites and the gallery spaces.

showcase < gallery « external

Total Volatile Organic Compounds (TVOC)

The use of diffusion controlled mixed bed polymeric and charcoal adsorption tubes provided the opportunity for remote sampling. Subsequent thermal desorption and gas chromatography (GC) analysis provided the analytical process. A continuous monitoring programme over eighteen months (April 1994 to August 1995) with sampler interval of 28 days is reported here. The results are reported as TVOC in μg m^{-3} (toluene equivalents).

	Minimum	Maximum	Range	Mean±Standard Deviation
P, Monastery				
Site II (roof)	3	25	22	11±7
Site III (Sacristy)	3	328	325	77±112
Site V (Gallery)	1	29	28	11±8
Site VI (Office)	30	1253	1223	172±301
Site VII (Studio)	8	1077	1069	167±253
GB, V&A Museum				
Roof	7	59	52	27±18
Gallery 131	20	322	302	99±94
Gallery 44	24	232	208	91±71
Gallery 44 Case 7	73	5421	5348	1222±165
Gallery 44 Case 24	36	700	664	310±205
D, Residenz				
Balkon (external)	2	55	53	21±14
Blaues Vorzimmer	7	488	481	137±171
Kaisersaal	10	1649	1639	310±428
Spiegelkabinett	18	3539	3521	1006±1095
Weisser Saal	5	3699	3694	665±196

Comments
1. The results are highly variable and it is felt demonstrate the wide range of sources.
2. The gallery spaces tend to have high TVOC and highest is in the cases.
3. There is little time dependence apparent.

Interpretation
Apart from identifying the local sources of each analyte, the general relationship can be summarised as

showcase » gallery > external

GLASS BASED SENSOR DEVELOPMENT

The other major section of the AMECP project was the study and development of a glass based sensor. This portion of the work was lead by the FhG-ISC. The rationale behind this work is the interpretation of the data generated in the previous section in terms of object based reactions. Studying the chemical composition of the atmospheres provides quantitative data but this is expensive, time consuming and cannot predict the synergistic effects.

It is well known that some compositions of glass (potassium lime silicate glass) corrode easily when exposed to air. This is the typical corrosion process that can be observed in medieval stained glass windows. Previously, the FhG-ISC has developed glasses for the study of corrosion rates of stained glass windows in the external environment. The potential to extend this study to the internal environment was possible through this project.

The corrosion process may be summarised as:

- leaching of potassium and calcium ions;
- formation of a gel layer;
- formation of a corrosion crust;

The degree and kinetics of these reactions correspond with the total stress level during exposure. Thus all environmental effects are integrated - including the synergetic effects. These reactions can be studied with several routine analytical techniques such as infra-red spectroscopy, H-profiling Rutherford Backscattering, X-ray photon spectroscopy and by simulation experiments. The two major corrosion effects, the leached gel layer and the increasing crystalline crust (potassium-calcium sulphate hydrates) cause an increase in the intensity of the OH stretching band in the infra-red region at $3300cm^{-1}$.

The strong infra-red absorption of the stretching bands of silicate glasses (at 3300-3800, 800-1200 and around $500cm^{-1}$) leads to a complete absorbence of radiation even for glasses of only a few millimetres in thickness. Therefore, the glasses must be prepared with a thickness of 0.7cm so that the infra-red spectrum can be recorded in the transmission mode. A typical infra-red absorption spectrum of an unexposed glass and the corresponding after exposure is shown in Figure 2.

To answer many of the most urgent questions conservators ask about the internal environment a basic knowledge of the corrosion potential of environments is sufficient. The in-depth studies reported earlier, are expensive and time consuming. An effective sensor such as the glass sensor, registers the combined impact, and not the effect of single parameters.

Such sensors should be unobtrusive, easy to handle and should require no maintenance or electric power. The glass sensor meets these requirements.

A variety of surface preparation techniques were studied including the sol-gel process (Thimme 1994).

CONCLUSION

The project has been completed and fully documented in the final project report cited below. The dual aims of the work have been fully addressed, in that the character of the gaseous content of a variety of atmospheres of relevance to the longevity of cultural heritage have been detailed, and a suitable glass sensor has been developed. Such a glass sensor allows the rapid study and survey of the environments of cultural property in a variety of situations. The cultural property may be on permanent display in a static gallery or part of a touring exhibition. The use of glass sensors will allow the study of the environment and provide an early warning of potential damage. It is appreciated that the glass sensor does not provide a tool for the specific identification of the cause of degradation, but it may be considered more as a sacrificial object whose sensitivity is greater than most objects of cultural property. If a detrimental environment is indicated, further studies beyond the exposure of the sensor are required to identify the root cause of the problem. The considerable benefit of the glass sensor approach is its broad sensitivity to a wide range of parameters - this will also include some evidence of the potential synergistic effects of the same environment.

ACKNOWLEDGEMENTS

This paper presents, in summary, the outcomes of the European Union (EU) Directorate General XII funded project entitled 'Assessing and Monitoring the Environment of Cultural Property'. Funding was secured under the EU's Environment Programme 1991-94, topic II.4: Environmental Protection and Conservation of Europe's Cultural Heritage. The Fraunhofer-Institut für Silicatforschung (ISC) (FhG-ISC) part funded the project. Access to the full reports is via the European Union, Directorate General XII D-1, Rue de Roi, Brussels, Belgium by quoting the full contract number CEC-Contract EV5V-CT92-0144 'AMECP'.

The author fully acknowledges the input of the co-workers in this project. Specially acknowledgement is given to:

Dr Johanna Leißner, AMECP Project co-ordinator, Fraunhofer Institut für Silicatforschung (ISC), Bronnbach 28, D-97877 Wertheim, Germany, E-mail leissner@isc.fhg.de;

Dr Nigel Blades, formerly at the V&A Museum and now at University of East Anglia, School of Environmental Sciences, Norwich NR4 7TJ, E-mail N.Blades@uea.ac.uk;

Dr Pedro Redol, AMECP Portuguese co-ordinator, Museu de Mosterio de Santa Maria da Vitória, P-2440 Batalha, Portugal

REFERENCES

Applebaum B., 1991. *Guide to Environmental Protection of Collections*, Sound View Press, Madison, Connecticut.

Baer, N.S. and Banks, P.N. 1985. Indoor air pollution: effects on cultural and historic materials, *The International Journal of Museum Management and Curatorship*, **4**, 9-20.

Brimblecomb, P. 1990. The composition of museum atmospheres, *Atmospheric Environment*, **24**, B(1), 1-8.

Brown, V.M., Crump, D.R., Gardiner, D. and Yu, C.W.F. 1993. Long term diffusive sampling of volatile organic compounds in indoor air, *Environmental Technology*, **14**, 771-7.

Brown, V.M., Crump, D.R. and Gardiner, D. 1992. Measurement of volatile organic compounds in indoor air by passive techniques, *Environmental Technology*, **13**, 367-75.

Moore, G. 1987. Diffusive sampling - a review of theoretical aspects and state of the art, in *Diffusive Sampling an Alternative Approach to Workplace Air Monitoring, International Symposium, Luxembourg 22-26 September 1986*, organised by the Commission of the European Communities and the United Kingdom Health and Safety Executive in co-operation with the United Kingdom Royal Society of Chemistry and the World Health Organisation (eds A. Berlin, R.H. Brown and K.J. Saunders), Royal Society of Chemistry, 1-13, London.

Stolow, N. 1966. The action of the environment on museum objects; Part 1: humidity, temperature, atmospheric pollution, *Curator*, **9**, 175-85.

Thimme, P. 1994. *Investigations for the Synthesis of Corrosion Sensitive Materials by sol-gel Method*, Unpublished masters thesis, University of Würzburg.

Graham Martin, Head of Conservation Research, The Victoria and Albert Museum, London, SW7 2RL. E-mail grahamm@vam.ac.uk

Figure 1 Environment sub-programme schema

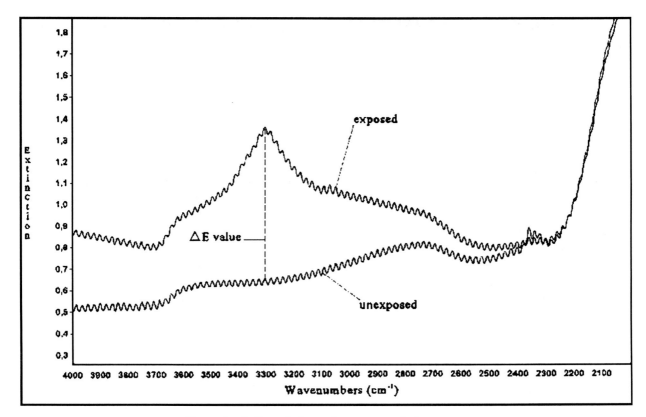

Figure 2 Infra-red absorption spectra of glass sensor

STICKY FINGERS – AN EVALUATION OF ADHESIVES COMMONLY USED IN TEXTILE CONSERVATION

Boris Pretzel

ABSTRACT

An evaluation of a set of ten thermoplastic adhesives, commonly used by textile conservators, is presented. Tests are adapted to mimic, as closely as possible, properties of the adhesives as used. Model 'objects', consisting of a polyester crepeline support attached to a silk 'artefact' by the adhesive film, are used for the evaluation. All samples were prepared by practised textile conservators at the Victoria and Albert Museum (V&A). The properties for evaluation were chosen in collaboration with the conservators and standard tests were adapted to model the desired properties. The ease of use and handling properties of the adhesive films were evaluated by the conservators and used together with results from the physical tests. The final results are scored and presented as a flexible matrix which can easily be tuned to the requirements of a particular treatment and/or preferences of a given conservator.

Key Words

adhesive, conservation, textile

INTRODUCTION

Communication between conservators and scientists is not always straightforward. Both professions have a specialised language, helping clear and concise communication within the profession but often forming a barrier to communication with others. For instance, conservators may ask scientists to 'test' a process or material to approve its use, without appreciating the information required to make the test meaningful. Conversely, scientists may not understand the issues most relevant to the conservator and may make inappropriate assumptions when choosing tests. Museums fortunate enough to employ both conservators and scientists are ideally placed to overcome such problems by fostering contact and collaboration. This paper describes the results of work

from such collaboration, between the Textile Conservation Section and the Science Group at the V&A, to evaluate the performance of ten thermoplastic adhesives commonly used in conserving textiles.

The use of thermoplastic adhesives for conserving textiles was pioneered at Delft University in Holland in the 1950s (Lodewijks 1964). The V&A was quick to try out such adhesives and used them routinely from the mid-1960s (Beecher 1964; Landi 1966). The Museum has built up a long history of their use in textile conservation in the intervening years. They are now used in about 3% of interventive treatments.

Although many early treatments were successful, some were not. Unsuccessful treatments can be traced back to unsympathetic application techniques (Marko 1978) or insufficient consideration of the environment to which the conserved object would be exposed (Hillyer 1990). Further, there was only a restricted choice of substrate material available and this was often inappropriate for supporting weave structures such as damasks, brocades, and tapestries. These early failures have generated a lot of criticism and concern over using adhesives (Keyserlingk 1990).

The adhesives available for use in conservation have been tested by a variety of institutions, for example at the Canadian Conservation Institute (Down *et al.* 1996). However, the influence of the application technique, support material, and object on the performance of an adhesive are not normally considered directly in these studies.

The experiences gained from unsuccessful early adhesive treatments show that there is a complicated interaction between adhesive, support and artefact that determines the success or failure of a treatment. Further, different artefacts will present different demands on the adhesive and support; there is no ideal adhesive which will be suitable for all applications!

The study presented here seeks to develop tests reflecting the way that the adhesives would be used in conservation treatments. Further, the ease of use and handling properties of the adhesives, as determined by conservators, are incorporated into the evaluation and

a weighting system is introduced to allow the evaluation to be tailored to different requirements.

PROPERTIES FOR EVALUATION

A manageable set of properties was chosen for evaluation by collaboration between Lynda Hillyer, Head of the Textile Conservation Section at the V&A, and the author. Factors reflecting the interaction of the adhesive, support, and artefact were chosen. These were:
- bond strength;
- ease of removal;
- reversibility;
- acidity;
- flexibility;
- corrosiveness, toxicity and staining; requirement for fume extraction;
- heat sealing temperature and glass transition temperature (T_g);
- handling and application properties;
- toughness.

ADHESIVES AND SAMPLE PREPARATION

A set of six poly(vinyl acetate) (PVAc) and four acrylic adhesives were chosen for evaluation. Each of the adhesives had been used successfully by textile conservators and must be considered suitable at least for some applications. The adhesives chosen are listed in Table 1. Adhesives which are not water soluble have an appropriate comment. The name of the manufacturer is given for each adhesive, together with the concentration of adhesive used to make the samples. Manufactures details are given at the end of the paper.

In order to make allowance for the way in which adhesives are used, model 'objects' were prepared for testing. Three sets of samples were prepared for different parts of the testing program (Table 2). Samples were made from new stocks of adhesives, diluted to the concentrations given in Table 1 and representative of the way they are used in practice.

Textile conservators at the V&A prepared the samples by brushing solutions of diluted adhesive onto an approximately $1m^2$ support on appropriate release material, polyethylene for water based solutions, silicone release paper for the three solvent based solutions. Excess adhesive was squeezed out using a second sheet of release material and a roller. The adhesive remaining on the support was then allowed to set before removing the original release material. Samples were treated as indicated in Table 2.

For mechanical tests, model 'objects' of jap silk were heat bonded to the adhesive by hand using a hot iron. To give an indication of the long term properties of the adhesives, the samples were aged for 35 days at 60°C and 70% rh (using a solution of NaCl as the humidity buffer).

Silk crepeline was used as the support material for samples for pH testing. It was chosen by the conservators in preference to the polyester support used for mechanical tests as it is more commonly used in textile conservation treatments and is considerably cheaper.

The application and handling properties of the adhesives were reviewed by the conservators while making the samples and used to grade the adhesives. Heat sealing temperatures were determined empirically using a hot spatula applied to the back of the support as this is the technique most likely to be used with fragile artefacts. Data supplied by the manufacturers for pH and T_g were also recorded.

Tests

Table 3 list the tests used to model each of the chosen properties. Mechanical and corrosion tests were performed under contract by the RAPRA Technology Ltd in 1992 (Hughes 1992). The extraction pH and acid value tests were performed under contract by RAPRA in 1996 (Kilgallon et al. 1996; Kilgallon and Bates 1996).

Five replicates were run for the peel and hot peel tests. Samples of jap silk on adhesive on polyester crepeline were cut from the $1m^2$ sheets provided by the V&A. Peel tests were run at ambient temperature (23 ± 2°C). Hot peel tests were determined using a hot air blower to soften the adhesive, a technique often used to reverse the adhesive bond.

A single determination was made of the tear strength samples of ten piles of the adhesive on paper, again cut from the $1m^2$ sheets supplied by the V&A. (Individual piles were too weak to allow the tear strength to be determined reliably.) Tests were performed at 23 ± 2°C.

Staining and corrosiveness properties were evaluated according to BS 903:Part A37 (1987). Duplicate samples of the jap silk on adhesive plus support were tested for staining with freshly prepared polished silver plates at 70 ± 1°C for 70 hours under

a load of 10 kg. After exposure, the extent (if any) of corrosion and discolouration of the silver plates and staining of the jap silk were noted.

The acid value and pH of extractions from samples on silk crepeline support were determined at 20°C. Small circular disks were cut from the sheets supplied and 1g of disks used for each of the tests. To allow for the properties of the adhesives as used, the area of the top surface of films corresponding to 1g of sample was also determined. The hydrogen ion concentration determinations were repeated from three to five times to determine variability. Acid values were determined with three to four replicates.

Results

Results of the tests and observations are summarized in Tables 4 (mechanical and staining tests, observations from the conservators) and 5 (acid value and pH tests), and in Figure 1 (extraction pH as a function of time).

EVALUATION AND SCORING

The interpretation for each of the tests is discussed in the subsections below. The performance against each property is given a score between 0 (good) and 10 (poor). The ranking of the adhesives can then be adjusted to any given situation by including relative weighting factors for the properties evaluated.

Bond Strength

The results from peel tests were used to represent bond strengths. The adhesives had peel strengths varying from 0.01 newton per mm width (N/mm width) and 0.32 N/mm width. Strengths less than 0.1 N/mm width are poor in general adhesion terms. The peel strengths were therefore evaluated as follows:

Peel strength	Score
> 0.1 N/mm width	0 (good)
< 0.05 N/mm width	10 (poor)
other	3

The surface from which the adhesive peels is significant when considering the reaction of the test object to unexpected stress. The adhesive should ideally always form the weaker bond to the object to avoid stress concentrations. Adhesive remaining visible on both the silk and the support can be considered as undesirable as this would not allow the object to break away from the adhesive as a result of unexpected sudden stresses. No adhesive remaining visible on either surface is interpreted as adhesive having been absorbed into the support and the object; this again is undesirable. Scores are as follows:

Surface with adhesive	Score
support only	0 (good)
none apparent (absorbed)	7 (undesirable)
both support and silk object	10 (undesirable)

The surfaces on which the adhesive remains only gives a very rough idea of the interaction between the object, adhesive and support. It is not as direct a measurement as the peel strength itself. The overall score for bond strength is therefore obtained from a combination of the peel strength score and the surface score but with a lower weighting given to the surface score. The formula used for the final score is:

$$bond\ strength\ score = \frac{(3 \times (peel\ score)) + (1 \times (surface\ score))}{4}$$

Ease of Removal/repositioning

The hot peel strengths were used to evaluate the ease of removal and repositioning of the silk on the adhesive. Hot peel strengths varied from 0.1 N/mm width to 0.003 N/mm width. A peel strength of 0.001 N/mm width signifies no effective bond while strengths greater than 0.1 N/mm width are significant. The lower the hot peel strength the better as this gives an indication of the ease of removal of the film. Hot peel strengths were evaluated as follows:

Hot peel strength	Score
> 0.001 N/mm width	0 (good)
< 0.05 N/mm width	10 (poor)
other	3

Reversibility

The reversibility was modelled by the reduction in peel strength on application of hot air. A reduction in strength of 100 fold effectively means complete breakdown of bond strength and a ten-fold reduction can be taken to be very significant. The reduction in peel strength from cold peel to hot peel was evaluated as follows:

Ration: peel strength / hot peel strength	Score
≥ 100	0 (good)
≤ 100	10 (poor)
other	3

Once again, the surface from which the adhesive peels is significant when considering the reversibility. Ideally, no adhesive would remain on the silk object after the hot peel. The surfaces on which adhesives remain are scored in the same way as those under the section on bond strength above. Other methods, apart from heating, are available for removing the adhesives; the surface scores are given a higher weighting than the score for reduction in strength. The final score for reversibility is given by the formula:

$$reversibility\ score = \frac{(3 \times (surface\ score)) + (1 \times (peel\ strength\ ratio\ score))}{4}$$

Acidity

Artefacts are composed of many different materials with varying degrees of tolerance to different pH. Most objects are sensitive to environments which have a low pH (less than 5), many are sensitive to high pH (greater than 9). Materials with a pH between 5.5 and 8.5 are generally considered acceptable for use with most organic artefacts (Blackshaw and Daniels, 1979). However, the hazard the extraction pH poses is dependent on the nature of the artefact and no universally tolerable range exists. The scoring system adopted for the pH is:

Extraction pH	Score
6 ≤ pH ≤ 7.5 (neutral)	0 (good)
pH < 5.5 or pH > 8.5 (caution)	10 (poor)
else	3

Aqueous extractions from all of the adhesives approached pH 7 (neutral) as the extraction time increased (Fig. 1). Even taking the first extraction pH (after 72 hours for Mowilith DMC2, 24 hours for the remaining adhesives) only Mowilith DMC2 (pH 5.4) and Beva 371 (pH 8.3) lie close to the limits generally accepted as safe.

The cold extraction pH of the silk crepeline determined by the V&A was near neutral, pH 7.2 (Ford 1995), although results from RAPRA with extended extraction times make it pH 8.2 after 24 hours, falling to pH 7.5 after 283 hours. The effects of the silk on the results must be considered.

The extraction pH of all samples is closer to neutral than the manufacturers' data for adhesives emulsions as supplied (not cast films). Extraction pH values of dry, dark aged cast films of six of the adhesives included in this study are published in the evaluation by Down et al. (1996). All the values reported are lower than those here and the differences are significant for three of the adhesives (Texicryl 13-002, difference of 2 pH, Vinnapas EP1, 0.9, and Paraloid F10, 0.6). Differences for the remaining three adhesives (Beva 371, Mowilith DMC2, and Mowilith DMC2 + DM5) are, however, less than 0.3. As the differences are dependent on the adhesive, they cannot solely be due to the influence of the silk crepeline.

The adhesives do not appear to release significant additional acidic components as the extraction time increases. The aqueous extract pH of the first extraction is therefore used for the evaluation to reduce as far as possible the influence of the silk crepeline support.

Acid Value

The acid value (AV, mg KOH required to neutralize the samples) was measured by dissolving 1g samples in mixtures of toluene, ethanol and acetone and then titrating against 0.1 M ethanolic KOH with thymol blue as indicator.

AV's are normally expressed per gram of sample. In Table 5 they are expressed per 100cm^2 (1dm^2) of top contact surface of the sample to take the thickness and density differences of the films into account.

AV's varied from 0.025 to 2.0 per dm^2 (0.14 to 4.8 per gram of sample). The spread of values from the set of adhesives can be grouped as follows: AV < 0.1 per dm^2 (good); AV > 0.5 per dm^2 (poor). A similar relative grouping is obtained from AV per gram by considering an AV < 0.5 per gram as good and an AV > 1 per gram as poor. The greater the AV, the greater the quantity of acid present. The speed at which the acid components are used up in reactions, however, depends on the local pH and will fall off sharply at a pH approaching neutral. The damaging potential of the adhesive films is therefore modelled from a combination of the AV and extraction pH:

Acid value (per dm^2)	Extraction pH	Score
AV < 0.1	any	0
AV > 0.5	pH < 5.5 or pH > 8.5	10
	otherwise	5
else	6 ≤ pH ≤ 7.5	0
	otherwise	3

The overall score for the acidity can then be represented by the average of the extraction pH and AV scores.

Corrosiveness and Staining

Staining of silver coupons or the silk by the adhesive indicates the potential for detrimental interactions with the object. Three different results were observed:

Observation	Score
no apparent staining or tarnishing	0 (good)
silver stained but silk not	5
both silk and silver stained	10

Fume Extraction

Solvent based adhesive require fume extraction for their preparation. This is not always available or appropriate and the limitation is therefore included in the evaluation. Preparations requiring fume extraction are given a score of 10 while those which can be prepared in the open laboratory are given 0.

Heat Sealing Temperature

Heat sealing temperatures between 70°C and 110°C were recorded for the adhesives. Higher heat sealing temperatures expose artefacts to higher temperatures during heat bonding to the adhesive. The heat sealing temperature is scored as follows:

Heat sealing temperature	Score
≤ 90°C	0 (good)
≥ 100°C	10
else	5

Glass Transition Temperature

The glass transition temperature is used to indicate the adhesive's tackiness and its tendency to pick up dirt. Adhesives used for objects on open display or with significant areas of loss should have a T_g higher than the room temperature. For objects housed in well sealed display cases or storage units, this consideration is less significant. The T_gs were evaluated as follows:

Glass transition temperature	Score
> 25°C	0 (good)
< 10°C	10
else	5

The tackiness of an adhesive at ambient temperature might be of advantage, for instance when it is necessary to piece an artefact together bit by bit. The initial position of any piece is likely to need adjusting as the object comes together and the ability temporarily to attach parts to the adhesive before forming the final bond would be desirable. In such a

case, the scores for T_g should be reversed for the evaluation. To a first approximation, this is achieved by using a negative weighting factor.

Handling and Application Properties

The handling and application properties determined for the adhesives by the conservators are grouped into three categories. They are scored as 0 (good), 5 (fair), and 10 (poor).

RELATIVE WEIGHTING FACTORS

Each property included in the evaluation is given a numerical score between 0 (good) and 10 (poor). Properties will be of varying significance for any given situation. The relative importance of the properties can be adjusted by applying different weighting factors to their scores. (A weighting factor of 0 indicates that the property should not be included in the evaluation.) The final score can be normalized to lie between 0 (good) and 10 by dividing each score by the sum of the weighting factors.

Two real treatments are used as examples of the considerations for weighting factors below. The result of the evaluation for the 10 adhesives is summarised in Table 6 and Figure 2.

Example 1

The conservation of an eighteenth-century silk theatre programme is described by Hillyer (1997). The programme was in very poor condition. It was split and fragmented into loosely connected sections and was very fragile. The artefact would need to be supported in stages and the ability to adjust parts of the programme after their initial attachment to the adhesive would be beneficial.

The main purpose of the adhesive was to consolidate the artefact. The fragile nature of the degraded silk would require an adhesive easy to apply but the handling properties would not be so critical as there were no large areas of loss. As the programme is not prohibitively large, the requirement for fume extraction would not be prohibitive. A glass transition temperature below room temperature would be desirable.

Example 2

The conservation of seventeenth-century Indian tent-hanging is described by Gentle (1993). This object is made of cotton and is quite large. Portions of the cotton had badly degraded as a result of damage from iron mordants used in the manufacture. There were large areas of loss and a non-tacky adhesive would be desirable, although the hanging would not be placed on open display.

In contrast to the theatre programme, the hanging is large and would need more support from the adhesive. The object would in any event be complicated to reverse and the inherent 'reversibility' of the adhesive would not be critical. A T_g higher than room temperature would be beneficial to prevent areas of loss picking up dirt unduly.

The relative weighting factors applicable to the two examples are shown in Table 6, together with the overall scores for each case. The relative scores are also shown in Figure 2. For the first set of factors, the lowest scoring adhesives are the two Vinamul products. (The treatment was undertaken using Vinamul 3252.) With the second set of factors, there is a cluster of adhesives with similar scores, consisting of the two Vinamul adhesive (with the lowest scores), the two Lascaux adhesives, and the two Mowilith preparations. (The treatment was undertaken using Mowilith DMC2.) The first set of scores are lower than the second set but the use of a negative factor for T_g in one of the sets makes their comparison meaningless. The scores indicate only the relative evaluation for a given set of weighting factors.

CONCLUSION

The paper presents a flexible method to compare the relative performance of adhesives under situations making different demands. Each property included is given one of three ratings (good, intermediate, and poor) and scored appropriately. The ease of application and ease of handling are determined with respect to only a single type of preparation and are somewhat subjective. Many properties are not included in the evaluation (such as discolouration) and the scoring technique is fairly coarse. The overall scores give only relative indications and further work would be needed to ascertain the significance of the absolute scores. Nevertheless, the approach is a useful guide when choosing between different adhesives. It is not meant to replace a conservators judgement.

The involvement of conservators in the choice of properties for evaluation and the preparation of the sample has allowed influence of the substrate, sample and preparation qualities to be taken into account. The influence, for instance, on extraction pH is significant and questions the value of data applying to dry films or base emulsions.

ACKNOWLEDGEMENTS

This project could not have proceeded without the collaboration of Lynda Hillyer, Head of the Textile Conservation Section, and her staff at the V&A. The financial support from the Conservation Department for the contracts for testing is gratefully acknowledged. Thanks, also, to my colleagues in the Science Group for their help and support.

REFERENCES

ASTM D 1583 – 91. 1992. *Standard Test Method for Hydrogen Ion Concentration of Dry Adhesive Films*, American Society for Testing and Materials, Philadelphia.

Beecher, E. 1964. Aspects of protection from light and methods of reinforcement, in *Delft Conference on the Conservation of Textiles* (2nd ed), IIC, 43-47, London.

Blackshaw, S.M. and Daniels, V.D. 1979. The testing of materials for use in the storage and display in museums. *The Conservator*, 3, 16-19.

BS 903:Part A37. 1987. *Determination of Adhesion and the Corrosion of Metals*, BSI London.

BS 2782:Part 3:Method 360A. 1991. *Determination of Tear Resistance of Plastic Film and Sheeting by the Elmendorf Method*, BSI, London. (ISO 6383:Part 2:1983).

Down, J.L., MacDonald, M.A., Tétrault, J. and Williams, R.S. 1996. Adhesive testing at the Canadian Conservation Institute – an evaluation of selected poly(vinyl acetate) and acrylic adhesives, *Studies in Conservation*, 41, 19-44.

Draft BS 5350:Part BXX:199X. 1994. *Methods of Test for Adhesives – Determination of Acid Value*, BSI, London. (pr EN 1241).

Ford, D.J. 1995. *Cold Extraction pH for Silk used in Textile Adhesives Project*, Internal V&A Science Group Report No. 95/15/DJF.

Gentle, N. 1993. The examination and conservation of two Indian textiles, *The Conservator*, 17, 19-25.

Hillyer, L. 1990. The conservation of a group of wall hangings at Ham House, Surrey, in *Conservation of furnishing textiles* (ed A. French), SSRC, 69-81, Edinburgh.

Hillyer, L. 1997. *The Conservation of an 18th-Century Theatre Programme*, in press.

Hughes, C. 1992. *Adhesive Evaluation. Confidential Technical Report 22001*, RAPRA Technology Ltd, Shrewsbury.

ISO 36. 1985. *Rubber, Vulcanised – Determination of Adhesion to Textile Fabric*, The International Organization for Standardisation, Geneva.

Keyserlingk, M. 1990. The use of adhesives in textile conservation, in *9th Triennial Meeting, Dresden 26-31 August 1990* (ed K. Grimstad), ICOM-CC, vol. 1, 307-12, Paris.

Kilgallon, Y. and Bates, I. 1996. *Adhesive Evaluation, Confidential Technical Report 28162*, RAPRA Technology Ltd, Shrewsbury.

Kilgallon, Y., Sidwell, J.A. and MacMillan, C. 1996. *Adhesive Evaluation. Confidential Technical Report 27697*, RAPRA Technology Ltd, Shrewsbury.

Landi, S. 1966. Three examples of textile conservation in the Victoria and Albert Museum, *Studies in Conservation*, 11, 143-59.

Lodewijks, J. 1964. The use of synthetic material for the conservation and restoration of ancient textiles, in *Delft Conference on the Conservation of Textiles* (2nd ed), IIC, 79-85, London.

Marko, K. 1978. Experiments in supporting a tapestry using the adhesive method, *The Conservator*, 2, 26-9.

MANUFACTURERS AND SUPPLIERS

Acrylic 360V & 498HV

Acrylic P550-40TB

Beva 371 (under license)
Lascaux Restauro, Alios K Diethelm AG, Farbenfabrik, CH 8306 Brüttisellen
+41 (0)1 – 833 0786
supplied by:
AP Fitzpatrick, 1 Barnabas Studios, 10 - 22 Barnabas, Road, London E9 5SB
Tel. +44 (0)181 – 985 7865)

Mowilith DMC2 & DM5
Hoechst Chemicals Ltd, Hoechst House, Salisbury Road, Hounslow, Middlesex TW4 6JH
Tel. +44 (0)181 – 570 7712

Paraloid F-10 Resin (no longer available)
Rohm and Haas (UK) Ltd, Lennig House, 2 Mason's, Avenue, Croydon CR9 3NB
Tel. +44 (0)181 – 686 8844

RAPRA
RAPRA Technology Ltd, Shawbury, Shrewsbury, Shropshire SY4 4NR
Tel. +44 (0)1939 – 250383

Silversafe
Atlantis Paper Company Ltd, 2 St Andrews Way, London E3 3PA
+44 (0)171 – 537 2727

Stabiltex
 Plastok Associates Ltd, 79 Market Street, Birkenhead, Wirral, Merseyside L41 6AN
 Tel. +44 (0)15 – 666 2056
Texicryl 13-002
 Scott Bader Company Ltd, Wollaston, Wellingborough
 Tel. +44 (0)1933 – 663 100
Vinamul 3252 & 3254
 Vinamul Ltd, Mill Lane, Carshalton, Surrey SM5 2IU
 Tel. +44 (0)181 – 669 4422

Vinnapas Dispersion EP1
 Wacker Chemicals Ltd, The Clock Tower, Mount Felix, Bridge Street, Walton-on-Thames, Surrey KT12 1AS
 Tel. +44 (0)1932 – 246111

Boris Pretzel
Science Group, The Victoria and Albert Museum, South Kensington, London, SW7 2RL

Adhesive	Manufacturer	Concentration, by volume	Comment
Acrylic Adhesives 360 + 498, 1:1	Lascaux Restauro	10%	acrylic
Acrylic Resin P550-40TB	Lascaux Restauro	10%	solvent based acrylic
Beva 371	Berger	supplied pre-diluted (20%)	solvent based PVAc
Mowilith DMC2 (renamed: Appretan MB Extra)	Hoechst	20 %	PVAc
Mowilith DMC2 + Mowilith DM5, 1:1	Hoechst	20%	PVAc
Paraloid F10	Rohm & Haas	10%	solvent based acrylic
Texicryl 13-002	Scott Bader	50% (& 25%)	acrylic
Vinamul 3252	Vinamul Ltd	20%	PVAc
Vinamul 3254	Vinamul Ltd	20%	PVAc
Vinnapas EP1	Wacker	25%	PVAc

Table 1 List of adhesives with brief comments.

Test type	Support	Model object	Ageing regime
Mechanical & corrosiveness	Polyester crepeline (Stabiltex ®)	jap silk heat bonded to adhesive	35 days at 60 °C, 70% rh
Toughness & flexibility	high α-cellulose paper (Silversafe®)	none	35 days at 60 °C. 35% rh
Acidity	silk crepeline	none	one year in dark at ambient

Table 2 Types of sample

Property	Test method	Comment
Bond strength	Peel test (ISO 36-1985)	
Ease of removal	Hot peel test (as above but using a hot air blower)	surface with adhesive evident after the peel were noted
Reversibility	not specifically tested	modelled by the ratio between the two peel tests
Flexibility	Bending stiffness	this test was omitted due to insufficient sample
Toughness	Tear test (BS 2782:1991)	tests on adhesives applied to α-cellulose paper[‡]
Staining and corrosiveness	Corrosion of metals (BS 903:Part A37:1987)	contact staining to silver plates at 70 °C and 10 kg load
Acidity	Aqueous extraction pH (ASTM D1583 :1991)	
	Acid value (Draft BS 5350:1994)	expressed per 100 cm^2 top surface contact area

Table 3 Tests

‡: results unrepresentative of adhesives as used and ignored for the evaluation

(For Tables 4 and 5 see following pages.)

Property	Weighting factor		Adhesive	Overall score	
	Example 1	Example 2		Example 1	Example 2
Bond strength	5	10	Acrylic Adhesive 360+498(1:1)	2.1	3.3
Removableness	10	10	Acrylic Resin P550-40TB	3.1	3.3
Reversibility	5	0	Beva 371	5.4	5.8
Acidity	8	8	Mowilith DMC2+DM5	2.0	3.0
Corrosiveness	10	10	Mowilith DMC2	3.4	3.4
Fume extraction	0	10	Paraloid F10	5.5	6.0
Heat sealing	10	10	Texicryl 13-002	6.5	4.6
Glass transition	–10 [‡]	5	Vinamul 3252	0.6	2.5
Application	10	10	Vinamul 3254	0.5	2.4
Handling	5	10	Vinnapas EP1	2.0	3.6

Table 6 Weighting factors and scores

Key: Shading: dark = good; light = acceptable; unshaded = poor
Scores are relative only; lowest values indicating mast appropriate adhesive
‡ negative factor approximates scores for this property being reversed

Adhesive	Peel Strength N/mm width	Surface p/a/s	Hot Peel N/mm width	Surface p/a/s	Tear Strength N/mm, 10 plies‡	Staining	Ease of Application	Ease of Handling	Data sheet pH	Data sheet T_g °C	Heat Seal, °C	Solvent based?
Acrylic Adhesive 360+498(1:1)	0.10 ± 0.01	p	0.011 ± 0.001	s	18	d	good	poor	8-9	-28	70	no
Acrylic Resin P550-40TB	0.01 ± 0.00	a	0.006 ± 0.003	a	30	p	good	good	n/a	34	100	yes
Beva 371	0.12 ± 0.01	s	0.003 ± 0.001	s	36	f	poor	poor	7.5	n/a	85	yes
Mowilith DMC2+DM5	0.06 ± 0.02	p	0.009 ± 0.003	p	14	d	good	good	4.5	2	110	no
Mowilith DMC2	0.05 ± 0.01	p	0.009 ± 0.002	p	16	d	good	good	5	10	100	no
Paraloid F10	0.01 ± 0.01	a	0.004 ± 0.002	a	28	p	poor	fair	7	20	110	yes
Texicryl 13-002	0.32 ± 0.02	s	0.100 ± 0.030	s	14	d	poor	good	9	10	90	no
Vinamul 3252	0.03 ± 0.01	p	0.017 ± 0.004	p	18	p	good	good	4.5	3	100	no
Vinamul 3254	0.05 ± 0.01	p	0.006 ± 0.002	p	16	p	good	fair	5	0	100	no
Vinnapas EP1	0.06 ± 0.01	p	0.016 ± 0.004	p	16	p	fair	poor	4	3	90	no

Table 4 Results of testing

Key: Shading: dark = good; light = acceptable (with care); unshaded = caution.

Peel surface: p = adhesive on backing only, a = no adhesive apparent (absorbed?), s = adhesive remains on backing and object.

Tear strength: 10 piles of uncoated paper = 46 N/mm width, all adhesives weaken paper (due to treatment with solution). This does not reflect a property of adhesives as used and is given 0 weighting for the evaluation.

Staining: p = no apparent staining (pass), d = silver stained but silk not stained, f = both silver and silk stained (fail) (no test showed corrosion).

T_g = glass transition temperature from manufacturer's data (above 25°C : desirable for artefacts on open display, below 10 °C, undesirable).

pH = pH from manufacturers data (5.5 ≤ pH ≤ 8, good).

Heat seal: experimentally determined using a hot spatula iron to activate adhesive film on polyester support.

Adhesive	g dm⁻²	Acid Value (per dm² contact)	First extraction		Final extraction	
			time, hours	pH	time, hours	pH
Acrylic Adhesive 360+498(1:1)	0.22	0.61 ± 0.03	24 hrs	7.08± 0.07	283 hrs	6.98 ± 0.05
Acrylic Resin P550-40TB	0.15	0.140 ± 0.008	24 hrs	6.63 ±0.07	283 hrs	7.20 ± 0.17
Beva 371	0.16	0.025 +0.003	24 hrs	8.4± 0.2	283 hrs	7.73 ± 0.40
Mowilith DMC2‡+DM5	0.25	0.110 ± 0.007	24 hrs	6.7± 0.1	283 hrs	7.22 ± 0.35
Mowilith DMC2‡	0.30	0.20 ± 0.05	72 hrs	5.4± 0.1	598 hrs	7.58 ± 0.17
Paraloid F10†	0.21	0.11 ± 0.01	24 hrs	6.83± 0.02	283 hrs	7.2± 0.4
Texicryl 13-002	0.43	2.04 + 0.06	24 hrs	5.88± 0.03	137 hrs	5.98 ± 0.05
Vinamul 3252	0.25	0.0471± 0.0003	24 hrs	7.67± 0.05	283 hrs	7.4± 0.2
Vinamul 3254	0.24	0.0330 ± 0.0002	24 hrs	6.7± 0.2	283 hrs	6.8± 0.3
Vinnapas EP1	0.45	0.08 ± 0.01	24 hrs	6.86 ± 0.06	283 hrs	7.2± 0.1
silk crepeline†			24 hrs	8.2 ± 0.1	283 hrs	7.50 ± 0.04

Table 5 Acid value and extraction pH

Key: Shading: dark = good; light = acceptable (with care); unshaded = caution.

‡ Mowilith DMC2 was repackaged as Appretan® MB Extra in the course of this work. Appretan MB Extra was used for the acidity samples but is referred to as Mowilith DMC2 for consistency.

† Paraloid F10 was withdrawn from sale in the course of this work. 3 year old stock was used to make the samples for acidity tests.

✝ Once it was realized that silk crepeline was being used as a support, it was examined at the V&A (Ford, 1995) before sending samples for pH testing to RAPRA. The cold extraction pH determined by the V&A with a short extraction time was near neutral (pH 7.2).

109

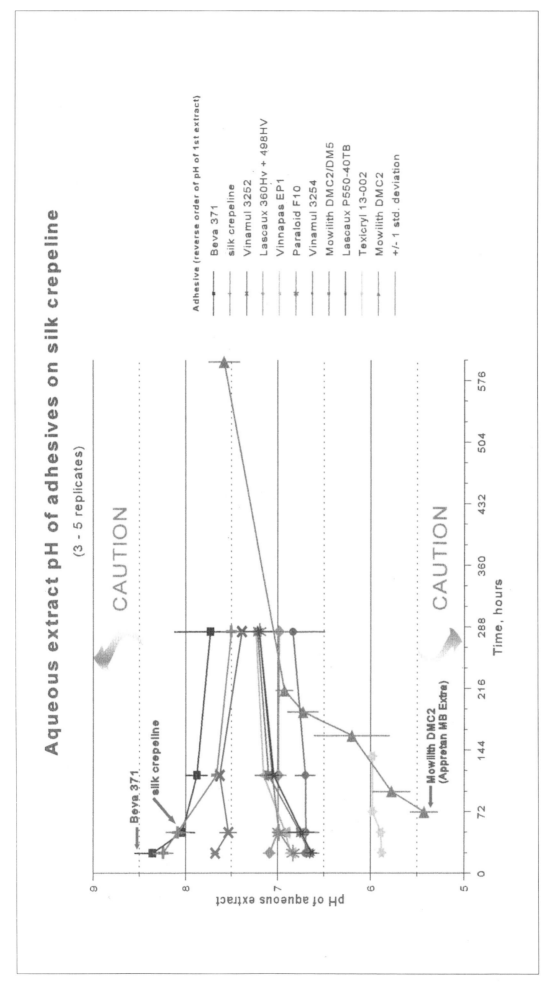

Figure 1 Graph of pH of adhesives on silk crepeline versus time of aqueous extract

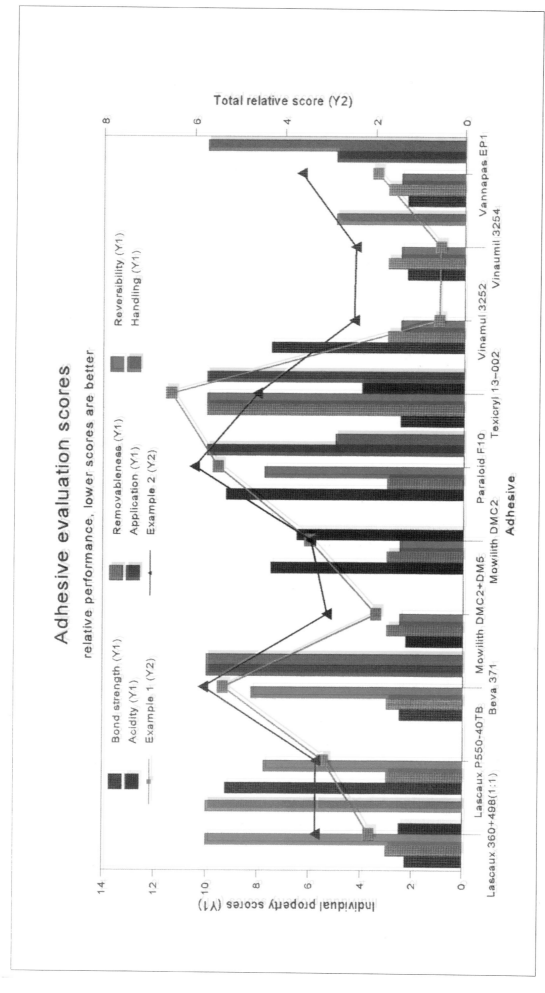

Figure 2 Graph of relative evaluation performance for two sets of weighting factors

THE SCIENTIFIC EVALUATION OF IMAGES

Michael Douma and Michael Henchman

ABSTRACT

In discussing art, we rely on image. and our discussions are only as good as the quality of those images. How is the quality to be evaluated? An image must represent its object faithfully - without distortion from lighting, etc., as it is acquired. Furthermore, to analyse an image quantitatively or to compare two images, color and brightness must be standardized, by introducing controls.

With such controls, brightness and color change can be analysed. Measurement of image brightness tests the cleaning of a fresco - suggesting, for a disputed ignudo *on the Sistine Chapel ceiling, the removal of more than dirt in the cleaning. Measurement of color changes on oil paintings quantifies the color shifts caused by discolored varnish - demonstrating marked color changes, in paintings by Raphael and Lely, especially for blue and purple hues. These results illustrate if computer simulation can effect the 'virtual' cleaning of oil paintings, by removing discolored varnish.*

Keywords

Adobe Photoshop, CIE L*a*b* color space, computer simulation, fresco restoration, image comparison, image evaluation, Sistine Chapel, varnish removal

INTRODUCTION

The use of images is fundamental to the study of art. For the most part, we acquire our knowledge of art from viewing not original artwork but images in slides or books. Scholarship in art is similarly referenced to images in articles and books. We examine individual paintings in galleries; but we must rely on images to make comparisons. How, then, may the *quality* of an image be assessed? How is it to be defined? How may it be measured?

For properties such as form, the quality of the image may be irrelevant: a poor slide may still reveal the design of the Parthenon. But if we are to judge Delacroix's qualities as a colorist, our image must faithfully represent the colors of Delacroix's painting. How may that be judged?

Similar questions arise in restoration. For example, to define the fading of Mark Rothko's Harvard murals, their state today has to be referenced to their original state, now only knowable through photographs taken 35 years ago. How reliable as a reference are those photographs today? Gross effects - the fading of the red in the murals to blue - are clear, but subtler questions of tone are precluded by the possible deterioration of the photographs. Restoration is evaluated by comparisons which involve images, comparisons between the restored object (or its image) and the image of that object before it was restored. To draw conclusions from comparisons, one must establish that the images are indeed comparable and, if so, how they are to be compared.

The range of images which a particular object can generate is limitless. The setting of the object has a dramatic effect upon the image. Exploring the limitless range of images is of course the province of the artist (as, for example, in Monet's 'series' paintings of Rouen cathedral, haystacks, etc.). From sunrise to sunset, a landscape creates a multitude of different images of the same fixed object, due to changes in the quality of the light and in the physical location of its source. In a photographic image, the variables are even more numerous and more complicated: the lighting, its location with respect to the object, the possible use of filters, the type of film used, its processing, the prints and their processing and their possible subsequent deterioration, and if digitized, modifications during image acquisition. Examples of this variability can be found in any slide collection, where duplicate slides of the same painting will differ significantly in coloring - and there is no basis for deciding which of them, if any, represents the original painting satisfactorily.

If images are to be compared, they must be produced under identical conditions. Even that requirement is insufficient. Truly comparable images will be viewed by different observers in different ways. Even though identical light signals would strike the retinas of all the observers, their responses would

differ because brains differ in their neurophysiological processing of the same optical signal. Thus the 'photopigments' in vision nerves have recently been found to have genetic variability throughout the human population (Mollon 1995). Even if we all see the same thing, our minds' readings of what we have seen may differ a little.

QUANTIFICATION OF IMAGES IS ONLY POSSIBLE WITH CALIBRATED IMAGES

Digital techniques represent a major advance over photographic ones, eliminating the need to consider film contrast, film sensitivity, colour temperature, film exposure, film processing, film printing and film degradation. Instead, when digital scans are made directly or scanned from a photograph, *an image must also be scanned for a color calibration chart under conditions identical to those used for the scanning of the object.*

A color calibration chart consists of standardized colors, such as a gray scale and certain typical colors. The imaging of the color calibration chart allows the image to be adjusted so that the image of the calibration chart is correct. Hence the image of the object is made correct. Thus the use of a color calibration chart allows images of two objects, taken under different conditions, to be adjusted to be as if they had been taken under identical conditions.

In the absence of a color calibration chart, only subjective procedures are possible and such qualitative measurements are invalid. In the scanning of old photographs, the exact colors cannot be ascertained. Analysis is possible in such cases, as in our discussion of the restoration of the Sistine Chapel ceiling below, but numerical values cannot be reported.

INCONSISTENT LIGHTING MISLEADS INTERPRETATION OF THE RESTORATION OF A FRA ANGELICO FRESCO

Our interest in comparing images derives from a remarkable fresco restoration by Dino Dini. Figures 1a and 1b show respectively a blistered head, before treatment, and the head transformed, after treatment (Ferroni 1982). Closer examination reveals the two images not to be comparable. The comparison is invalid because the circumstances of illumination differ significantly for the two cases. The damaged fresco has been photographed using raking light,

accentuating the disfiguring blisters; the restored fresco has been photographed with frontal illumination, minimizing surface irregularities. The two images, published together, were surely intended as a strong statement that the technique works well (which is correct); yet the two adjacent images invite the technique to be judged by comparing the images presented (which would not be correct). What should be done in such a case? Less is more. One compares two frontal shots or two raking shots or, if circumstances allow, both of them. By themselves, a raking shot and a frontal shot simply cannot be correlated, as comparable shots of paintings with a significant impasto show (Hours 1976).

IMPORTANT COMPARISONS: THE SISTINE CHAPEL CEILING.

Michelangelo's frescos in the Sistine Chapel rank among the world's most venerated artwork; their restoration is the largest such project ever undertaken; and no restoration has aroused more interest and debate. Evaluation must rely, here as elsewhere, on the comparison of images. A test case is the *ignudo* where, according to Beck, the restoration has removed part of Michelangelo's original painting (Beck 1989). Comparing 'before' and 'after' images (Figs. 2c and 2a) (Okamura 1980 and 1991) Beck has identified a flatness and a loss of modeling in the right shoulder due, possibly, to the removal by the restorers, of a glaze or surface layer originally applied by Michelangelo to the surface of the fresco.

How is this controversy to be assessed? What is the real difference between the 'before' and 'after' images? Were they recorded under identical conditions? Since ten years interposed, that seems a difficult condition to have met. Have records been kept and are they accessible? What evidence can show that they have not been retouched?

If we accept the images as being comparable, how should the images be compared? Ideally we would wish to compare the 'after' image with Michelangelo's original or an image of the same; but neither are available. To make our images, we scanned slide reproductions of printed photographs (Okamura 1980 and 1991). We then obtain a 'difference' image between the 'before' and the 'after' (Fig. 2b), after adjusting the luminosity of the two images to be equivalent. The dirt layer reduces the luminosity of the image on average by about 90%, as shown for another *ignudo,* partly dirty and partly clean

(Fig. 2d). The difference in brightness can be seen in Figure 2d to cover about half the tonal range of the image (from an ~25% shade to an ~80% shade on the arm). As slide film has a range of about 6 f-stops, the brightness difference is 3 f-stops, or roughly $2^3 = 8$ times or nearly 90% different. Admittedly the dirt layer may be heterogeneous but by comparing the brightness of the *ignudo* recorded on the film, we can measure experimentally the uniformity of the dirt layer.

When this 'difference' analysis is applied to the *ignudo* (Fig. 2b), a uniform match is not found. Note that on the shoulder, the 'difference' is not a neutral gray as it is on the face. On the face, the dirt layer was uniform, but on the shoulder, the dirt layer was not. Either the dirt layer on the shoulder was not uniform, or more was removed from the shoulder than just dirt. This is qualitative evidence consistent with Beck's claim that more than dirt was removed in the restoration of this particular *ignudo*. As a calibration, the same procedure, repeated for the *Delphic Sybil* (where the cleaning is not in dispute) (Okamura 1980 and 1991) shows that a convincing match is found - the 'difference' producing a reasonably homogeneous neutral gray.

In summary, this use of a non-quantitative 'differencing' test identifies one site on the ceiling where more than dirt may have been removed. But, given the size of the ceiling, this observation by itself, is neither statistically significant nor does it question the overall restoration.

THE REPRESENTATION OF COLOR CHANGE USING MATHEMATICAL 'COLOR SPACE'

The optical properties of a dirt layer - for example on the Sistine Chapel ceiling - are complicated. Its action can be formally categorized as follows:
- components of the dirt which absorb uniformly at all wavelengths will darken the image.
- components of the dirt which absorb non-uniformly at different wavelengths will darken and color the image.
- components of the dirt which scatter the light will cloud the image.
- the distribution of the dirt will be heterogeneous.

To simplify the problem, we have examined a more restricted system of a painting covered with a uniform layer of discolored varnish. To introduce our discussion of color change in paintings with discolored varnish, we describe briefly some biological aspects of vision to explain the quantitative measures of color we will use and the limitations of those measurements.

All color images - whether print, photographic, painted, television, computer monitor, or theatrical lighting - depend on the physiological nature of color perception in the eye and brain. Most higher mammals experience the sensation of color through the cumulative biological currents of visual nerves. All but the purest colors contain mixtures of all the wavelengths; in our mind, complex connections amongst visual nerves allow our mind's computer to compute the 'color' of these wavelength mixtures. Normal humans have three species of color vision nerves: one type responds to the wavelengths purple-blue-green, another to green-yellow-orange, and the third to yellow-orange-red. Color-blind individuals have only one or two of these three nerve types.

Just as different ratios of sweet and sour stimulation to taste nerves are interpreted to reveal the flavor of a fruit, different ratios of purple-blue-green, green-yellow-orange, and yellow-orange-red wavelength stimulations to visual nerves are interpreted to reveal the color of a fruit - whether the color is pale or vibrant, yellow-hued or red, light or dark (Asenjo *et al.* 1994).

Taste is possible because fruit juice spreads over the tongue covering the sweet, sour, salty and bitter taste nerves. Similarly, light from an object is focused onto more than one type of microscopic vision nerve (a large object will illuminate millions of visual nerves). The nerve cells are very closely packed on the retina, so light from an orange tangerine will reach many purple-blue-green, green-yellow-orange, and yellow-orange-red vision nerves. An orange tangerine reflects all wavelengths of light; but since it reflects more orange than any of the other wavelengths, the green-yellow-orange and yellow-orange-red nerves will be stimulated more than the purple-blue-green nerves - and the brain concludes that the tangerine is orange.

How does the brain make that conclusion? Nerves release different types of neurotransmitting chemicals when communicating, and can perform a sort of biological computation. This allows the stimulation of a purple-blue-green nerve to be compared with the stimulation of a green-yellow-orange nerve, and so on. The brain performs a number of biological calculations, adding and subtracting signals from each of the three vision nerves. These calculations culminate in two measures of color: a red-to-green

axis and a yellow-to-blue axis. These 'axes' of color are independent of each other - one might speak of a 'reddish-yellow' or a 'bluish-green', but never a 'bluish-yellow' or a 'reddish-green'. It is along these axes (Table 1) that we subconsciously experience color; and it is along these axes that colors are best quantified (Jameson and Hurvich 1989).

Table 1. Construction of the CIE L\stara\starb\star color space

L\stara\starb\star AXIS	COLOR AXIS	CONSTRUCTION
a\star	red-to-green =	*(yellow-orange-red)* − *(green-yellow-orange)*
b\star	yellow-to-blue =	*(green-yellow-orange)* + *(yellow-orange-red)* − *(purple-blue-green)*

Understanding the biology has allowed mathematical representations of color to be developed. A mathematical representation of physiologically perceived colors defines colors in a so-called 'color space' with red-to-green and yellow-to-blue axes (Figs. 3b and 4b). It is called the CIE L\stara\starb\star color space, which is a more modern implementation of the more familiar CIE x-y-z color space, replotted using coordinates that correspond to the calculations of nerve cells and adjusted for the spectral sensitivity of the human eye (Hunt 1992). The older system was developed before more recent neurobiological studies. These color spaces separate the hue of a color from its brightness. Any color can be represented along the blue-yellow and red-green axes of the L\stara\starb\star system.

With colors thus mathematically defined, the difference between colors can be measured. We have used this technique to measure the color change in paintings where photo-oxidized varnish has discolored the appearance.

ASSESSING COLOR CHANGE: THE EFFECTS OF PHOTO-OXIDIZED VARNISH

Of key importance to conservators and the viewing public alike, the effects of discolored varnish on the appearance of a painting may be quantitatively defined. When a painting's varnish photo-oxidizes, it begins to block ultra-violet, purple, blue, and green wavelengths. By blocking these wavelengths, the purple-blue-green nerves receive no stimulation and the green-yellow-orange nerves are understimulated. This alters the brain's interpretation of the painting's colors: it effectively nullifies the yellow-to-blue color axis because there is virtually no stimulation of its purple-blue-green vision nerves (note in Table 1 how the yellow-to-blue color axis depends on input from

the purple-blue-green vision nerves). Additionally, the absorption of the varnish hampers the red-to-green axis because the green-yellow-orange vision nerve is under stimulated. It is important to realize that blocking *all* the wavelengths which stimulate the purple-blue-green vision nerves is a worse problem than just blocking a few of the wavelengths which stimulate the green-yellow-orange nerves. In cases of extremely photo-oxidized varnish, the colors white, purple, blue, magenta, and even some greens cannot be experienced; and only reds, oranges and yellows can. We measure color changes of this type in two different cases below.

In our first case, we measured the color changes in Raphael's portrait of Agnolo Doni due to its 1985 restoration. As controls we used high-quality 'before' and 'after' images, photographed by the same agency (Saskia), under nearly the same conditions and including standard color samples as color references within the photograph. The color calibration bars allowed the slight tonal differences between the two photographs (having been made a few years apart) to be eliminated. The images were scanned and, using Adobe Photoshop, were re-equalized based on their known color samples, digitally modifying the color cast, contrast, and peak light and dark values to equalize the images and to eliminate differences in their quality.

The a\star and b\star color axis values for a number of samples in each image were calculated and plotted on the color space (Fig. 3b). A particular hue on the surface of the painting is transformed by the action of the varnish layer to a different hue, now represented by a second point on the color space. An arrow, linking the first point to the second on the color space, depicts vectorially the action of the varnish on the painting, transforming one hue into another. This transformation is the 'Color absorbed by the Varnish'

and the change depends on the original color. Six arrows on Figure 3b represent the effect of varnish on six representative hues (Fig. 3a) and they are all directed to the upper right quadrant, where orange/red hues are located. The arrow numbered ① is the simplest to follow, showing how discolored varnish makes white appear as yellow. The arrow corresponds to the difference between the two colors, following the equation:

'Clean' = 'Dirty' + 'Color absorbed by the Varnish'

'Clean' and 'dirty' refer to the images 'after' and 'before'; and the 'Color absorbed by the Varnish' is the color of the light which we do not see in the dirty image because it is blocked by the discolored varnish. It is *not* the color of the varnish, which may only be measured by comparing the color of a white sample before and after.

Using this technique to compare colors 'before' and 'after' demonstrates quantitatively the experience of conservators that photo-oxidized varnish does not merely 'yellow' a painting but dramatically alters original colors. Notice how the arrows, as vectors, differ. Colors initially spread throughout three quadrants, are focused into one. Arrows ②, ④, and ⑤ in Figure 3b transform very different hues into the same small area of the color space. In painterly terms, blues and greens look orange under discolored varnish. Where a varnished painting appears orange, there is no way of predicting whether the responsible hue, lying underneath the varnish, is blue or green. The color-space analysis reveals how our simulated cleaning (Fig. 3c) fails for this particular painting. The painting contains blues and greens which the simulated cleaning cannot reconstitute. To be able to predict the effect of removing discolored varnish - reversing the direction of the arrows in Fig. 3b - points on the color space representing the hues before varnish removal must show a unique one-to-one correlation with points defining the state after varnish removal.

Our second example treats a painting where purples and blues are absent and demonstrates the success of a simulated cleaning. The item in question is a portrait by Lely which we followed during the course of its restoration. Figure 4a shows the face, with a clean half and a dirty half in the same photograph. Obviously both 'clean' and 'dirty' were acquired under identical conditions.

Comparison of the clean and dirty halves of the face (Fig. 4a) reveals clearly the optical properties of the discolored varnish. It acts as a light brown filter absorbing the blue, muting the pink, dirtying the white but also introducing, as filters do, accents and contrasts not present in the original, especially here for the pearl necklace, which becomes more lustrous under the discolored varnish than without it. Here, as indicated, the color change is measured for three points in the painting and plotted again on the color space (Fig. 4b). Notice the difference in the vectors between Figures 3b and 4b, because the absence of purple, blue, or green in the original painting greatly reduces the variability of the 'Color absorbed by the Varnish.'

Since this value for 'Color absorbed by the Varnish' was reasonably constant, we tried to 'clean' the painting by subtracting an average value (we chose the value of 'Color absorbed by the Varnish' on the subject's cheek). By adding the 'Color absorbed by the Varnish' to the dirty half, the appearance of the fully cleaned portrait could be simulated (before it was completely cleaned). The result is shown in Figure 4c. It is impressively successful, only the vestige of a seam between the cleaned halves, distinguishing the actual from the simulated. This case, where, with a limited palate, we could quantitatively measure and nullify the effects of the varnish, contrasts with our unsuccessful attempt with the Raphael (Fig. 3c).

Future developments suggest that we should escape the confines of physiological color space of traditional film and computer imaging and directly measure the intensities of the various wavelengths. A purple-blue-green nerve does not distinguish which wavelength is stimulating it, but a spectrophotometer detector can. Or perhaps more simply, as the absorption spectra of the photo-oxidized varnish appears to be quite reproducible and hence generally applicable (de la Rie 1989), the use of an optical filter with the opposite absorbence of varnish - letting though the violet, blue, and falling away to nothing in the green - may allow the lost light to be recovered and then added to the dirty image.

CONCLUSIONS

- Digital techniques offer powerful applications to art but it is critical that standardized color calibration bars be imaged under the same conditions as the art object.
- If two images are to be compared, they must be acquired under identical circumstances, e.g. of lighting. Where this does not hold, the validity of the comparison is indeterminate.

- Documentation has to be available to validate experimental controls, e.g. for photographic comparison over extended periods, calibrating shots of a fixed standard. The aim has to be to introduce the same standards to which scientists are held. Scientific results are validated through their repeatability: repeatability cannot be tested with inadequate reporting.
- Without publication there can be no evaluation. We cannot evaluate restorations until the technical volumes are published (four technical volumes on the Sistine Chapel and one on the Brancacci Chapel have been promised years ago).
- We have used two digital techniques. The first involves 'differencing,' wherein image intensity values are compared between two images. In the second, by quantifying image hues into the CIE L*a*b* color space, we were able to compare changes in image colors as mathematical vectors.
- There is a future for the virtual cleaning of paintings. The present study analyzes the 'color absorbed by the varnish' for both richly and narrowly hued paintings. Alternative approaches, combining digital imaging with blue-purple optical filters to measure the 'color absorbed by the varnish,' may possibly simulate a cleaned painting.

Note added in proof

Dr Andreas Burmester has kindly drawn our attention to an exciting initiative – the MARC project – mounted at the Doerner Institute to publish digital images of the highest quality (Burmester, et al. 1996). The introductory essay gives an interesting account of the technical procedures and an assessment of the quality of the reproduction one may hope to get.

One of us (M. Henchman) had an hour to 'eyeball' the printed images in the volume alongside the actual paintings. For cases where the range of hue was limited, as in the Rubens *Medici Cycle*, this crude test could identify no detectable difference. This could be a case where, as outlined above, a 'difference' image obtained on the same scanner could provide a quantitative measure of the success of the undertaking: Difference = [digital image of painting] – [digital image of print from digital image of painting].

ACKNOWLEDGMENTS

Michael Douma thanks the Richter and Sachar Prize Funds of Brandeis University for awards. Michael Henchman thanks Professor Zdenek Herman (chemical physicist/sculptor) for provoking this study, and thanks Professor Robin Clark and University College, London, for sabbatical hospitality. This project was supported by grants from the National Science Foundation (#9254291) and the Dreyfus Foundation (# SG-96-159).

REFERENCES

Asenjo, A. B., Rim, J. and Oprian, D. D. 1994. Molecular determinants of human red/green color discrimination, *Neuron*, **12**, 1131-8.

Beck, J. 1989. Can the Vatican Save the Sistine Chapel Ceiling? *NOVA* Program videocasette #1515.

Burmester, A., Raffelt, L., Renger, K., Robinson, G. and Wagini, S. 1996. *Flemish Baroque Painting - Masterpieces of the Alte Pinakothek München*, Hirmer Verlag, Munich.

Ferroni, E. 1982. Restauro chimico-strutturale di affreschi solfatati, in *Metodo e scienza operativa'e ricerca nel restauro* (ed U. Baldini), Sansoni Editore, 265-9, Florence.

Hours, M. 1976. *Conservation and Scientific Analysis of Painting*, van Nostrand, Reinhold, 18-19, New York.

Hunt, R.W.G. 1992. *Measuring Color*, 2nd edn, Ellis Horwood, New York.

Jameson, D. and Hurvich, L.M. 1989. Essay concerning color constancy, *Annual Reviews of Psychology*, **40**, 1-22.

Mollon, J. 1995. Seeing colour, in *Colour: Art and Science* (eds T. Lamb and J. Bourriau), 127-50, Cambridge University Press, Cambridge.

Okamura, T. 1980. in *The Vatican Frescos of Michelangelo* (ed A. Chastel), Abbeville, vol.1 pl. 76, New York.

Okamura, T. 1991. in *The Sistine Chapel* (ed F. Hartt), A.A. Knopf, vol. 1, 80, New York.

de la Rie, E.R. 1989. Old master paintings: a study of the varnish problem, *Analytical Chemistry*, **61**, 1228A-40A.

Michael Douma and Michael Henchman, Department of Chemistry, Brandeis University, Waltham, MA 02254-9110, USA

Figure 1a Fra Angelico, *Christ on the Cross, adored by St
Dominic,* Convent of San Marco, Florence, detail of the head
of St Dominic, before restoration

Figure 1b Fra Angelico, *Christ on the Cross, adored by St
Dominic,* detail of the head of St Dominic after restoration

Figure 2a Michelangelo, Sistine Chapel ceiling, detail of *ignudo*, between the prophets Joel and Zechariah, after cleaning.

Figure 2b Difference image between Figs 2a and 2c, after normalization to a constant luminosity

Figure 2c Detail of *ignudo*, as above in Fig. 2a, before cleaning

Figure 2d Detail of another *ignudo*, showing the increase of luminosity on cleaning.

Figure 3a Raphael, *Agnolo Doni*, Pitti Palace, Florence, location of the hues sampled in Fig. 3b.

Figure 3b Representation in CIE L★a★b★ color space of the effect of discolored varnish on the hues located in Fig. 3a.

Figure 3c Simulated cleaning of Raphael, *Agnolo Doni*.

Figure 4a Sir Peter Lely, *Barbara Palmer, later Duchess of Cleveland,* private collection, detail in process of cleaning, showing location of hues sampled in Fig. 4b.

Figure 4b Representation in CIE L⋆a⋆b⋆ color space of the effect of discolored varnish on the hues located in Fig. 4a.

Figure 4c Simulated cleaning of Fig. 4a (right half) compared to actual cleaning (left half).

RISK ANALYSIS

Jonathan Ashley-Smith

ABSTRACT

In the context of the conservation of objects, 'Risk Analysis' describes the evaluation of predictions about the decay of objects and the change in value that results from such deterioration. The products of the analysis can be used to aid decision-making in collections management and conservation treatment. Risk can be seen as one of the factors to be considered along with other costs and potential benefits that will dictate which option should be chosen. Scientists and conservators routinely collect information that could be used in risk analysis but little relevant data is published. The published interpretations of degrees of risk are disputed by conservators and scientists, one group often in opposition to the other. Models devised for financial decision-making can be used to indicate the types of information that are needed to help guide museum strategies.

Key Words

risk, cost-benefit analysis, damage function, collections management, prediction.

INTRODUCTION

The word 'risk' is used loosely in everyday language and with several slightly different definitions in the technical literature. It relates to events in the future that are unwanted but not unforeseen. Phrases such as 'risk assessment' and 'risk analysis' are used to describe systematic approaches to identifying, quantifying and evaluating the relative importance of the risks associated with proposed activities. Quantification of risk involves predicting the probability of future one-off events or extrapolating current rates of change to predict future states. It also entails making estimates of the change in value or utility as the unwanted events occur. The use of risk assessment as a technique to aid conservation decisions was probably pioneered by Baer (1991). It has been given recent impetus in the area of collections management by Waller (1994) and Michalski (1994).

It is necessary to make assessments of risk in order to manage risk. Managing risk means taking steps to prevent or minimise the possibility of undesirable future states. Managing risk must also include devising procedures to deal with the effects of unwanted events that cannot be prevented. The various stages of risk analysis provide information for the decision-making necessary for risk management (Fig. 1) (Covello and Merkhofer 1993). This risk information is moderated by constraints such as budget priorities, the single-mindedness of museum directors and the stupidity of politicians.

Traditional interventive conservation/restoration has dealt with salvage following the absence or failure of risk management strategies in the past. Preventive conservation through environmental control and disaster mitigation involves developing and implementing successful risk management strategies.

Potentially, the risk information needed to drive these strategies comes from two sources, scientists and conservators. Scientists, working inside and outside the conservation milieu, study the relationships of variables such as light intensity, temperature, and concentrations of moisture and acid gases on a variety of materials and constructions. These investigations can be used to derive 'damage functions', mathematical relationships that define the rate of deterioration under specific conditions. Conservators are repeatedly confronted by damaged objects and are in a position to build a formal or anecdotal database relating condition and probable cause of deterioration. They are also in a position to relate construction type to frequency of failure. Unfortunately the potential of these two groups is not fully realised and the information that is fed into the decision-making process is partial (in both senses of the word).

If the task in hand is solely to manage risk, then decisions can be based solely on risk assessments. Most conservators believe that this concentration on the down-side of any proposal is an appropriate professional attitude as they see themselves as the sole advocates of the welfare of the collections.

Viewed holistically, the task of management is to accomplish the success of a venture rather than

control the factors that would lead to undesirable outcomes. The formal definitions of museums provided by international bodies such as ICOM (Anon 1990) or by Parliament (Anon 1983) give weight to increased utility of the objects through increased access to collections. Thus museum management decisions are likely to be about putting on a successful exhibition or arranging a successful loan, rather than specifically reducing damage to objects. The stages of option generation, evaluation, selection and implementation are likely to be influenced by the benefits that reward a successful decision. An assessment of the costs of achieving success is needed in addition to prediction of the costs of failure. This evaluation based on a balanced view of both the up-side and the down-side is a part of cost-benefit analysis (CBA). If risks are still the main subject of interest this balanced evaluation can be called risk-benefit analysis.

Cost-benefit analysis and risk-benefit analysis are expressions that are used loosely in non-technical speech and with a range of meanings in technical writings. Historically CBA has been used to inform decisions that would have a long-term impact on the welfare of large numbers of people not directly associated with the design or implementation of a scheme such as the building of a dam or a bridge (Zerbe and Dively 1994). The benefits considered are those to society as a whole in the long-term, rather than the rewards to the decision-maker in the short-term. However CBA can be used to describe any comparison of options based on calculation of costs and evaluation of rewards. It is often used when only costs are being compared, although this is more correctly described as cost effectiveness analysis. It is profitable to think that decisions taken in board-rooms and conservation laboratories within museums will have long-term outcomes beneficial to members of society outside the museum. CBA is therefore an appropriate, but by no means simple, adjunct to conservation decision-making.

The study of risk allows a change of attitude from 'the safer the better' to 'how much can I achieve without causing damage?' which might be translated as 'how close can I approach damage without actually getting there?'. 'Testing the envelope' of risk, which may have positive advantages in terms of display and interpretation, requires a trustworthy evaluation by conservators of their own observations and the observations of scientists who have studied related materials.

DECISION ANALYSIS

It is possible to analyse the decision-making process by using diagrams called decision trees (Moore and Thomas 1988). The simplest decision consists of selecting one option from two. For either option the outcome may be what was hoped for, but there is a certain probability that it will be somewhat worse. A simple decision consists of consideration of four potential outcomes (Fig. 2). The 'payoff', N_{1-4}, for each outcome is the difference between the sum of the benefits and the sum of the costs. (All the following equations will be written as though costs, benefits and values could be measured using the same units although no such units will be defined.)

$$N = B - C$$

The difference in payoff between the good outcome and the less good outcome will usually result from a difference in the benefits. The costs are likely to be a function of the option and will be fixed irrespective of the outcome. The estimated value (EV) of each option is the average of the good and less good outcomes weighted by the probabilities of each. (If the probability of one outcome is the fraction P, the probability of the alternative is, by definition, 1-P.)

$$EV = N_1(1-P) + N_2 P$$

In general, if the costs and the benefits are of the same order and P is small then the option of choice will be the one with the highest EV. In the following discussion it will be assumed that these conditions are met. High EV will not always be the appropriate deciding factor in museums where risk aversion is part of the job description. If P is large and the benefits in the event of the poor outcome are considerably less than those for success, the option is only for risk lovers.

If one of the two options is 'doing nothing', that is failing to make a decision or to take any action, then we can define the value of doing nothing as EV_0 without considering in detail the possible outcomes that lead to this value. Any decision will then have a net estimated value (NEV) which is the difference between the EV of this option and EV_0 the estimated value of the status quo.

$$NEV = EV - EV_0$$

It is then possible to compare a number of different options by comparing their NEVs. (This has some advantages over comparing the EVs of all the options, one of which is doing nothing). In CBA it is conventional to discount future costs and benefits,

that is give them lower values the further into the future they arise. A simple way of understanding why this is done is to ask yourself whether you would rather have £100 now or £105 in a year's time. It is assumed that most people would take the money now because they could do more with the cash than they could with just a promise of money. £100 now has greater present value than £105 later. There is considerable debate about an appropriate discount rate for CBA in the areas of health and ecology (Soby and Ball 1992, Hanley and Spash 1993) and one can imagine the same would be true for museum decisions. In the following discussion the symbols used to show future cost and benefit streams will be assumed to be suitably discounted at an undefined rate (which could be zero). The resulting NEV is then comparable to the more widely used Net Present Value (NPV). NEV looks at a position at a fixed time in the future, NPV looks at the present value of future flows of costs and benefits.

DECISIONS INVOLVING THE CONSERVATION OF OBJECTS

It is arguable that the purpose of preventive conservation (passive or interventive) is to maintain the value of an object and that the purpose of restoration is to restore value (add value to a devalued object). It is also arguable that the purpose of new galleries, exhibitions and loans is to increase the value of collections. If there is no aversion to considering museum collections as investments which provide a flow of benefits, then it could be argued that once the value of an object or collection has been increased it will continue to provide a higher rate of return. The words value, return and investment do not have to be interpreted in money terms. For instance, once an object has been made more famous by an exhibition more people will want to see it in the future. Its 'cultural' value is increased.

Adding Value

Figure 3 shows a simple decision tree used to decide whether to go ahead with a treatment or event that should raise the value of an object. This could be a decision to send a collection of ceramics to an exhibition in Japan, to restore a painting or mass deacidify a library full of brittle books. The benefits of

a good outcome will be the increase in value V_1-V_0, immediate benefits B_1 such as a loan fee or entrance charges for an exhibition, and the long term return R_1 (net of maintenance costs) over a specified number of years. The costs C are the immediate costs of the treatment or event. There is a probability P that the operation will not be as successful as intended. In that case there will be a new lower value V_2 which could be less than V_0, or even zero if something goes disastrously wrong. The NEV for this operation is composed of the immediate and long-term net benefits $(V_1-V_0) +B_1+R_1- C$ plus a number of terms that relate to possible losses of value and opportunity, $-P(V_2-V_1)-P(B_2-B_1)-P(R_2-R_1)$. These terms represent the risk, that is the probability of failure multiplied by differences in return and value between success and failure.

The key lesson this simplistic model teaches is that it is imperative to understand what the consequences of success or failure are and to have a clear idea of the chances of failure. The definitions of success and failure are for discussion amongst groups from the different disciplines within the Museum profession. Determination of the value of P, the probability that something will go wrong, comes from a scientific approach to the documentation and evaluation of unplanned occurrences. This puts a pressure on conservators to document failures, truthfully and retrievably. It also directs scientists to research mechanisms of failure to help quantify the risk.

Estimates of the various quantities can be put into a computer spreadsheet. Different assumptions can be tested and the sensitivity of certain changes on the NEV can be evaluated. Figure 4 shows a graph extracted from such a spreadsheet exercise. This shows the change in NEV for different values of P. A negative NEV indicates an unsound decision. In this case the largest probability of failure that is acceptable is 0.3, the value of P when NEV is zero, ie no net gain. Suppose it is not known what your chances of success are but you think they are between 90 and 95% (P= 0.05-0.1) then you know you have a considerable margin of 'safety'. The value of 0.3 is shown for graphical clarity, in many cases the critical value of P will be a very much smaller fraction and the actual probability smaller still. For example the probability of a road accident causing damage to an art object is considerably below 10^{-4} .

Maintaining Value

The type of tree shown in Figure 3 can be used as a model for a spreadsheet to investigate proposals to increase capital and/or operation costs to maintain the state of a collection. For example, is it a wise decision to install air-conditioning to prevent deterioration? In this simple model it is assumed that there is a known relationship between deterioration and change in value, this may be linear, although I have argued elsewhere that this is often not the case (Ashley-Smith 1995). Table 1 shows typical values used in the calculations. The variables k_0, k_1 and k_2 are the annual fractional losses in value in different environments. A figure of -0.00001 indicates complete loss of value in 100,000 years, ie slow deterioration. Silk deterioration might have a value around -0.002 y^{-1}, decay of cellulose acetate negatives might be of the order of -0.02 y^{-1}.

The model does not give a straight 'yes or no' but it does indicate what values of which variables make an expensive investment in plant seem a sensible option. The aim is to radically decrease the rate of deterioration, however this may not be achieved. The risk depends on the value of P and on the difference between k_1 and k_2, the difference between the hoped for rate of deterioration and the rate achieved if something goes wrong in the planning or execution.

Using realistically large values for capital and running costs the NEV only becomes positive if the present rate of deterioration is greater than about 0.001y^{-1}, greater than 10% loss in value per century. More important, the certainty that intervention is going to cause a significant improvement in stability has to be about 90% or better. Thus low temperature storage for photographic materials is easy to justify, an air-conditioned gallery for stone sculpture might be more debatable. The conservator's desire to create clean stable conditions has to be supported by an accurate scientific appraisal of rates of deterioration.

Such a scientific appraisal put in the form of an equation linking the rate of damage to variations in concentration or intensity of damaging agents is known as a damage function. Robert Koestler has summarised the different types of damage function (Koestler 1994). Relatively few have been derived and even fewer are published in the conservation literature (Lipfert 1988, Mirabelli and Massa 1991, Ware 1996).

Conservators who have seen damage caused by wrong environments might argue that such damage is not the result of slow progressive deterioration but of catastrophic failure. Mathematically the two mechanisms can be treated as the same. A catastrophic loss of 50% value with an annual probability of 0.001 can be modelled as a deterioration rate of 0.0005y^{-1} (Fig. 4). Benarie has demonstrated the relationship between supposedly random isolated catastrophes and the first order rate law which determines many deterioration reactions (Benarie 1991).

Table I. Typical input to spreadsheet analysis to determine NEV. (Investing 1 million units of value in the environmental control of a collection worth 100 million.)

benefit (interest on investment)		k	0.05
original investment		Vo	100,000,000
present rate of deterioration		ko	-0.000100
proposed rate of deterioration		k1	-0.000010
possible rate of deterioration		k2	-0.00005
probability of ill fate		p	0.05
capital outlay		c	1,000,000
present maintenance	costs	mo	20,000
proposed maintenance	costs	m	60,000
discount rate		r	0.05
year of first capital	outlay		0 (1-50)
frequency of repeat			25 years

USES OF RISK INFORMATION

The examples above place risk in the area of general decision-making. In that context risk is the danger that a prediction will be wrong as a result of incomplete information. Most published work concentrates solely on risk as potential damage to objects.

Collections Management

Waller (1994) has assessed the risk (probability of damage x change in utility resulting from damage) posed by each of a large number of agents of deterioration to different types of natural history collections. The results give differing risk profiles for different sorts of material, some being more prone to damage by light, others by physical forces or by changes in temperature. The profiles do not indicate what should be done next, but the implication is that effort would be directed to areas of high risk. The cost-effectiveness of risk reduction measures is then assessed. To minimise the dangers of giving absolute values to priceless or worthless objects Waller works only with proportional changes in value or utility.

A number of other tools devised to direct collections management decisions have used approximations of the probability/ value estimation of risk. Most rely on construction of a matrix of importance versus condition. An object's priority for action or treatment is judged by its coordinates in the matrix. The Delta project in the Netherlands (Krikken 1996) used relevance to the collection as the measure of value. The assessment of damage, measured as conservation need, can be seen as a *post hoc* measure of probability.

Prediction and Study

One area where scientists and conservators can work together for mutual benefit is in the design and interpretation of collection condition surveys. Full conservation surveys to a standard format are the potential basis for epidemiological studies of deterioration. If there are enough similar objects with the same environmental history then information about susceptibilities to particular agents can be derived from the survey data. If objects have entered a specific environment at known times there is the possibility of using survey data to derive a form of damage function. This can be used to predict future states of the collection. The methodology used by Mirwald and Buschmann (1991) in work on deterioration of gravestones can be extended to other collections such as libraries where there are large numbers of similar objects whose date of acquisition is known.

The survey places each object in a condition category. The percentage of objects in each category is plotted against the year of acquisition. The percentage of objects in the worst state will increase the older the objects are, as shown by the solid black line in Figure 6. To predict the state of the collection in say 50 years time the line can be shifted horizontally to the right by 50 years. To predict the effect of improving the environmental factors the new line can be shifted vertically downwards. The damage function derived from the survey only includes the variables time and damage. To determine future states in future environments requires damage functions that include variables such as pollution levels. However the method described above gives an indication of the possible effects of improvement.

CONCLUSION

The main users of risk information will be conservators advising other museum professionals. The information used to assess risk is unnecessarily inexact and would be improved by more systematic studies leading to derived relationships between the progress of time and the progress of damage. In scientific experiments it is necessary to limit the number of variables so that interpretable and reproducible data can be collected. What has been studied is not directly related to the real world (Fig. 7).

In the real world, and even in museums, the number of variables is large and uncontrolled. Most real world observers do not make enough observations to form statistically valid conclusions, but this does not make the information they provide invalid. Nor does it stop them forming opinions which turn out to be correct.

There need to be people who operate at the interface between science and conservation acting as interpreters. The scientists need someone to explain what it is in the real world that actually matters, so that they can design their experiments more meaningfully. The conservators need someone to interpret the results of scientific experiment in the light of their experience of reality. There is a special need to explain that when two scientists disagree this does not mean that either or both are wrong, but merely that their experiments were different.

In other more mature areas of the study of risk, it has been noted that there are three stages in the dissemination and acceptance of risk assessments (Fig. 8), (Funtowitz and Rautz 1985).

The boundaries between the three are determined by degrees of uncertainty about the methodology and information (systems uncertainty) and the importance

of the outcome of decisions (decision stakes). At one end is 'consensual science' where there are reliable databases and there is agreement because there is no advantage in disagreement. At the other end is a system (total environmental assessment) which is permeated by qualitative judgements and value commitments. In the middle is an area termed 'clinical consultancy' which is determined by the use of quantitative tools supplemented explicitly by qualitative judgement based on experience. This reliance on personal judgement tends to accentuate differences of interpretation arising from competing institutional, educational and disciplinary cultures. It also leads to an unbalanced state where views on risk can oscillate wildly.

There can be no doubt that the conservation profession is at the stage of clinical consultancy. Unfortunately the profession is small and there are not enough clinical consultants.

REFERENCES

Anon, *National Heritage Act. 1983*. chapter 47, HMSO, London.

Anon, 1990. *Statutes: Code of Professional Ethics*, ICOM, Paris.

Ashley-Smith, J. 1995. *Definitions of damage*, AAH Conference, London. Text on the Internet at http://palimpsest.stanford.edu/.

Baer, N.S. 1991. Assessment and management of risks to cultural property, in *Science, Technology and European Cultural Heritage. Proceedings of the European Symposium, Bologna, Italy, 13-16 June 1989* (eds N.S. Baer, *et al.*), Butterworth-Heinemann for the Commission of the European Communities, 27, London.

Benarie, M. 1991. The establishment and use of damage functions, in *Science, Technology and European Cultural Heritage, Proceedings of the European Symposium, Bologna, Italy, 13-16 June 1989* (eds N.S. Baer *et al.*), Butterworth-Heinemann for the Commission of the European Communities, 214, London.

Covello, V.T. and Merkhofer, M.W. 1993. *Risk Assessment Methods: Approaches for Assessing Health and Environmental Risks*, Plenum Press.

Funtowitz and Rautz, 1985. Three types of risk assessment: A methodological analysis, in *The Social and Cultural Construction of Risk* (eds Covello and Johnson), D. Reidel, Dordrecht, Holland.

Hanley, N. and Spash, C.L. 1993. *Cost-Benefit Analysis and the Environment*, Edward Elgar Publishing, Aldershot.

Koestler, R.J. 1994. How do external environmental factors accelerate change? in *Durability and Change* (eds W.E. Krumbein *et al.*), Wiley, 149-64, Chichester.

Krikken, J. 1996. A Dutch exercise in the valuation of natural history collections, in *International Conference on the Value and Valuation of Natural Science Collections*, Manchester, (A conference held in April 1995), forthcoming.

Lipfert, F.W. 1988. Atmospheric damage to calcareous stones: Comparison and reconciliation of recent experimental findings, *Atmospheric Environment*, **23**, 415.

Michalski, S. 1994. A systematic approach to preservation: description and integration with other museum activities, in *Preventive Conservation: Practice, Theory and Research* (eds A. Roy and P. Smith), IIC, 8-11, London.

Mirabelli, M. and Massa S. 1991. Ancient metal objects in outdoor exposure: Causes, mechanisms and measurements of damage. in *Science, Technology and European Cultural Heritage*, Proceedings of the European Symposium, Bologna, Italy, 13-16 June 1989 (eds N.S. Baer, *et al.*), Butterworth-Heinemann for the Commission of the European Communities, 190, London.

Mirwald, P.W. and Buschmann, H. 1991. Assessment of the stone inventory and weathering state of the tombstones of the old cemetery of Bonn FRG as a constraint for urban planning, in *Science, Technology and European Cultural Heritage*, Proceedings of the European Symposium, Bologna, Italy, 13-16 June 1989, (eds N.S. Baer *et al.*), Butterworth-Heinemann for the Commission of the European Communities, 881, London.

Moore, P.G. and Thomas, H. 1988. *The Anatomy of Decisions*, 2nd edn, Penguin Books, Harmondsworth.

Soby, B.A. and Ball, D.J. 1992. *Consumer Safety and the Valuation of Life and Injury*, Research Report No.9, Environmental Risk Assessment Unit, School of Environmental Sciences, UEA, Norwich, NR4 7TJ.

Waller, R. 1994. Conservation risk assessment: A strategy for managing resources for preventive conservation, in *Preventive Conservation Practice, Theory and Research* (eds A. Roy and P. Smith), IIC, 12-17, London.

Ware, M.J. 1996. Quantifying the vulnerability of photogenic drawings, in *Research Techniques in Photographic Conservation* (eds M.S. Koch *et al.*), Royal Danish Academy of Fine Arts, 23, Copenhagen.

Zerbe, R.O. and Dively D.D. 1994. *Benefit-Cost Analysis in Theory and Practice*, Harper Collins, New York.

Jonathan Ashley-Smith, Conservation department, Victoria and Albert Museum, South Kensington, London SW7 2RL
E-mail: jonathan @jonsmith.demon.co.uk.

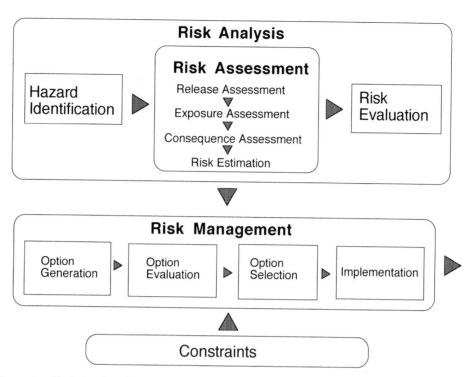

Figure 1 Relationship between risk assessment and risk management (after Covello and Merkhofer)

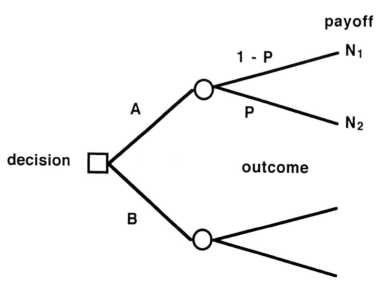

Figure 2 Decision tree showing a choice between two options, each of which has two possible outcomes

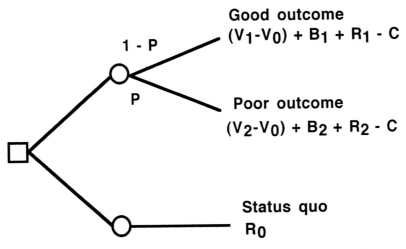

Figure 3 Decision tree showing the payoffs for a good outcome and a poor outcome of a decision compared with the option of doing nothing

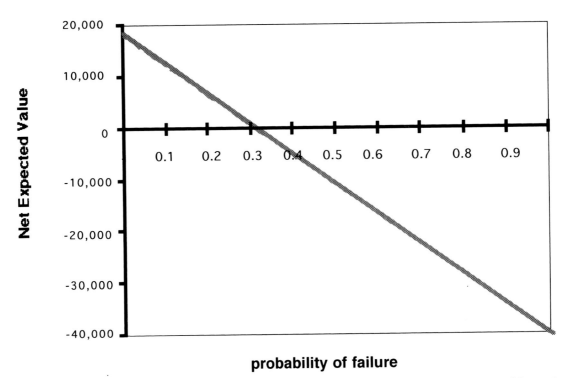

probability of failure

Figure 4 Graphic output from a specific spreadsheet scenario. The plot shows how the NEV of the option varies with the possibility of things going wrong. In this case NEV ceases to be positive when P is greater than 0.3.

Figure 5 Graphical representation of the idea that a catastrophic loss in value at some unspecified point within 1000 years can be thought of as equivalent to a constant fractional loss.

Figure 6 Data from a condition survey about categories of damage is plotted against the year that each object entered the specific environment. The resulting curve can be manipulated to give predictions about future states of the collection. (After Mirwald)

Figure 7 The more a scientific experiment is designed to be reproducible and scientifically valid the less it resembles what is observed in the real world.

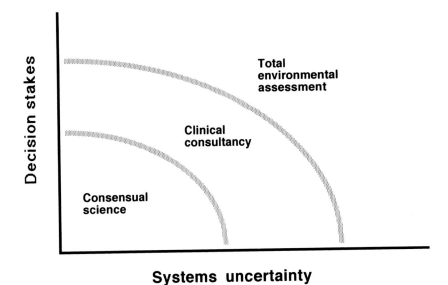

Figure 8 Three types of risk assessment determined by the state of knowledge and the personal or societal rewards of a particular viewpoint. (After Funtowitz and Rautz).

THE USE OF GASEOUS POLLUTION MONITORING IN DETERMINING AIR HANDLING SYSTEM FILTRATION AND MANAGEMENT REQUIREMENTS: A CASE STUDY

Paul Wilthew

ABSTRACT

A project to assess the risk from the pollutants nitrogen dioxide, sulphur dioxide, chloride and hydrogen sulphide to objects kept in a newly built store housing collections of the National Museums of Scotland is described. Results of measurements are given and their implications for the decision as to whether the use of chemical filtration in the air handling systems was justified are discussed. The importance of obtaining scientific data to allow an informed assessment of the relative risk to objects from different environmental factors, in particular atmospheric pollutants, before specifying costly preventive conservation measures when limited resources are available for such measures is emphasised.

Key Words

pollutants, monitoring, nitrogen dioxide, hydrogen sulphide, sulphur dioxide, chloride.

INTRODUCTION

When, in 1990, the National Museums of Scotland (NMS) learned that leases on two existing storage sites would not be renewed an appraisal of options for developing alternative storage facilities was carried out. As a result it was decided to construct a new storage facility, including conservation workshops and laboratories, on a site at West Granton Road in the north-west of Edinburgh. The NMS was already using buildings on the site for storage and to house conservation and laboratory facilities.

A new building with a floor area of 8,600m^2 was designed. Construction began in 1993. The first phase was completed in early 1995 and the second in 1996. Construction of the building has been described by Anthony *et al.* (1996). The building (Fig. 1) is known as Building 14 (B14) and includes storage areas for the collections of the Natural History and Geology; Science, Technology and Working Life; and History

and Applied Art departments. It also houses the Engineering conservation section and laboratories for artefact and textile conservation.

The original proposal for the building specified full air conditioning with filtration for chemical pollutants throughout the storage areas in order to maintain acceptable environmental conditions.

However the cost effectiveness of this approach, both in terms of capital and operating costs, was subsequently reviewed and the decision taken to try to maintain conditions, where possible, through more passive means. The behaviour of the building in practice was to be evaluated before decisions were taken about whether to install within the modular air handling system units to control humidity or filters for chemical pollutants.

The building was designed to provide a well-insulated envelope minimising interaction between internal and external conditions. The storage areas are entered through loading bays maintained at a negative pressure relative to the stores and which act as an air lock between the stores and the outside. The air handling units (AHUs) were chosen to allow a flexible approach to be taken without punitive additional costs should it be found that in practice additional plant was required. Each storage area has a separate AHU providing heating. Dust filtration is, of course, included, but additional environmental controls are only provided in those specific storage areas which require them. The design of the AHUs is modular, allowing units for control of humidity and chemical filtration to be retro-fitted easily if necessary. The proportions of recycled and fresh air circulated can be adjusted, with 100% recycled air used if required. Only two stores containing geological samples sensitive to high relative humidity have air conditioning, which maintains RH below 40%.

The policy of minimising the use of active systems to control environmental conditions has been applied to both humidity and pollutant control in the development of the Granton facility. The performance of the building in both respects is still

being evaluated. In this paper the approach taken to determine the need for pollutant filtration is described, and the results obtained and conclusions drawn to date are presented.

When it was decided to evaluate the requirement for chemical filtration in the air handling systems for the storage areas advice was sought from Dr Peter Brimblecombe (School of Environmental Studies, University of East Anglia). Based on his comments and data from monitoring stations in and around Edinburgh obtained from City of Edinburgh District Council it was concluded that the pollutants sulphur dioxide, nitrogen dioxide and ozone were not likely to be present at high levels on the Granton site.

However no data was available to indicate the likely levels of two pollutants about which we were particularly concerned. The area in which the building was located was well known to experience 'rotten egg' smells raising questions about levels of hydrogen sulphide, although no analysis had been carried out (despite newspaper reports and even a video on the 'Granton smell'!). Chloride was also a potential problem because the site is located close to the Firth of Forth.

Discussions with the Environmental Health Department of City of Edinburgh District Council revealed that the hydrogen sulphide odour in the Granton area was thought to be due to leakage of solvents from drains at a local company. Sulphate reducing bacteria were active in the contaminated ground below the drains, producing hydrogen sulphide. According to the council action had recently been taken to ensure that the drains were sealed and the problem should diminish with time.

In the absence of analytical data and in view of the possibility that the sulphide levels might be lower than they had been in the past it was decided to measure levels of the pollutants of concern before taking a decision about whether to install chemical filtration in the storage AHUs, rather than to assume a problem existed. It was decided to measure the levels of hydrogen sulphide, chloride, nitrogen dioxide and sulphur dioxide at intervals over a period of one year immediately following installation of objects in phase 1 of the building.

MONITORING METHODS

The extent and type of monitoring carried out was constrained by both financial and technical factors. Although passive sampling involving the exposure of diffusion tubes over a period of time, typically several weeks, was the preferred method of analysis no sufficiently sensitive tubes were available for hydrogen sulphide or chloride at the start of the project, although a passive sampler for hydrogen sulphide did become available towards the end of the project.

Sampling was initially carried out in a storage area containing large industrial and technological objects known as 'STWL1', regarded as typical of the storage areas in the building. It later became apparent that conditions in this store were being affected by short term factors which influenced the results, particular for hydrogen sulphide, and subsequent measurements were made in a store known as 'HAA' containing artefacts from the History and Applied Art department's collections.

For comparison, external measurements were taken close to the intakes for the fresh air for the AHUs for the stores, and to a limited extent in galleries and stores at the Royal Museum of Scotland, Chambers Street in central Edinburgh.

Commercially available diffusion tubes supplied and analysed by Gradko International Ltd were used to sample nitrogen dioxide and sulphur dioxide. Nitrogen dioxide tubes were exposed for four periods of between three and six weeks and for three of these periods sulphur dioxide tubes were also exposed.

In the absence of a passive sampling method, the Centre for Environmental Waste Management (CEWM), Paisley University was contracted to carry out measurements of hydrogen sulphide and chloride. Hydrogen sulphide was measured by a method based on that of Natusch et al. (1972) with sampling carried out over a period of three to four hours. Chloride was analysed using a method based on NIOSH S246 Method with sampling for 15 minutes. Initially an ion selective electrode technique was used to determine the mass of chloride collected, but this proved insufficiently sensitive for the levels found and an ion chromatography method was used instead for the later measurements (Mitchell 1996). Further details of the analytical methods are published elsewhere (Eremin et al. forthcoming).

At the end of the project hydrogen sulphide was monitored for a period of six weeks using passive diffusion tubes supplied and analysed by Simon Watts, using a method described in Shooter et al. (1995).

RESULTS AND DISCUSSION

The monitoring results are summarised in Figures 2-8. A full report on the hydrogen sulphide and chloride measurements by CEWM was produced (Mitchell 1996). The passive hydrogen sulphide, nitrogen dioxide and sulphur dioxide results were reported as concentrations by the analysts without comment.

Sulphur Dioxide

On all three occasions on which sulphur dioxide was measured levels were substantially lower within the store, Building 14, than they were outside, indeed they were close to or below (the one measurement of the HAA store), the detection limit for the analytical method used (Fig. 2). The building was found to be providing effective buffering of this gas, which is known to be effectively removed by indoor surfaces (Brimblecombe 1990), and levels were within those recommended by Thomson (1986) and Cassar (1995). Gallery 2.8 of the Royal Museum of Scotland, without air-conditioning, measured concurrently with one of the sampling periods gave similar, low levels although external levels at the museum were higher, probably because of its city centre location.

Nitrogen Dioxide

Unlike sulphur dioxide, nitrogen dioxide levels inside STWL 1 were not significantly different from those outside (Fig. 3). The building did not appear to be buffering concentrations of nitrogen dioxide significantly. Nevertheless the levels detected were not high, although they did exceed Thomson's recommendation, and confirmed the initial belief that nitrogen dioxide would not present a major problem. Results from Gallery 2.8 of the Royal Museum of Scotland, Chambers Street indicated similar levels to those in the store over the same period (Fig. 4).

Hydrogen Sulphide

The results of hydrogen sulphide sampling at Granton are summarised graphically in Figure 5. The site initially chosen to represent a relatively undisturbed storage area was STWL 1. This site was used for preliminary tests in April and May 1995. However it became clear during sampling on 21 April 1995 that ongoing building work on the site, particularly arc-welding in the vicinity of the air intake for the store's AHU, was probably affecting the results and could explain the high hydrogen sulphide levels detected.

Sampling restarted in October once all building work which could affect the store had been completed. The levels detected between 18 October and 9 November were both variable and high, giving cause for concern and were higher inside the building than externally. However investigation of activities on the site revealed that there had been considerable use of vehicles during this period both in the loading bay adjacent to the store and within the store itself because of installation of objects in other storage areas. Vehicle exhaust fumes are a source of hydrogen sulphide and almost certainly affected the results significantly.

Subsequently sampling was carried out in the HAA store which was not adjacent to a loading bay and which we could be certain would not be disturbed during the sampling period. The data obtained from the sampling on 14 February 1996 and 12 March 1996 was considered to be the most reliable. This confirmed, as previous results had indicated, that there was no significant buffering effect of the building with respect to hydrogen sulphide. Values within the building were not significantly different from those on the roof, close to the air intake for the store (although in practice the intake was closed). The actual values indicated hydrogen sulphide concentrations in the range 140 - 220 ppt (parts per trillion). Earlier sampling of STWL1 gave concentrations 2 - 5 times this level, but these samples were almost certainly affected by the local hydrogen sulphide sources discussed above.

In the absence of any generally accepted specification for hydrogen sulphide levels in museums measurements were taken at the Royal Museum of Scotland for comparison. Figure 6 shows that levels at Granton were comparable to those on the same day in gallery G.8, which is not air-conditioned but which has no obvious local source of hydrogen sulphide. Levels were substantially lower than in gallery 1.17 in which silver is known to tarnish fairly rapidly. Readings from an air-conditioned cellar store (cellar 2) which has chemical filtration chemical filtration, ranged from 64 - 169 ppt, although they were not taken on the same date.

Towards the end of the project a passive sampler for hydrogen sulphide became available from Oxford Brookes University. The samplers were exposed between 28 March 1996 and 9 May 1996 at Granton,

and in gallery 1.17, providing a measure of the average concentration over a long period. Because of the quite different exposure periods, the active sampling for example took place only during working hours, and the different analytical method used the values obtained are not directly comparable to the active sampling method. However the pattern of results from Granton and from gallery 1.17, (Fig. 7), was similar to that found with the active sampling. Values at Granton were a factor of 3-5 lower than in the gallery, and comparable to levels found by Shooter et al. (1995) inside the Dreadnought Study Centre of the Horniman Museum.

The data obtained indicated that there was a measurable level of hydrogen sulphide at Granton, and that the level could vary significantly over short periods of time. However the variations observed may have been more associated with internal factors than external ones. Levels were higher than in an air-conditioned cellar at the Royal Museum of Scotland but were similar to those in a gallery and lower than in those galleries with known silver tarnishing problems. The level could be reduced by chemical filtration but is probably not high enough to pose sufficient risk to most objects to justify it. It would be more cost effective to protect any objects at particular risk by taking measures to protect them individually.

However in view of the small number of results which were not thought to be affected by special factors further monitoring is planned using passive methods and the conclusions reached will be revised in the light of further data.

Chloride

The measurements of chloride levels obtained after the ion chromatography was introduced are summarised in Figure 8.

The results do not suggest that the building is buffering significantly against chloride. There are no generally accepted recommended levels for chloride, but the actual levels detected were considered to be fairly low, 31-121 ppb (parts per billion) internally. It was concluded that they did not suggest that there was a major problem with chloride pollution from the Firth of Forth or elsewhere. However the samples were not taken during severe weather and exceptional conditions might create an occasional problem. The fact that the samples were 15 minute averages may be a particular problem with chloride measurement, since it is possible that levels will be very dependent on

wind strength and direction. Although no further active sampling is planned, metal coupons are being exposed on the site to monitor passively for the corrosive effects of chloride, or other corrosive agents.

CONCLUSIONS

Sulphur dioxide and nitrogen dioxide were not present at high enough levels within the store to justify chemical filtration within the air handling systems. Sulphur dioxide levels were significantly lower within the building than externally, suggesting that the building buffered the gas significantly, but there was no significant difference between internal and external nitrogen dioxide levels.

The 15 minute average method used to analyse for chloride was not ideal, as the concentration might be expected to vary considerably with differing weather conditions. It was concluded that despite the proximity of the Firth of Forth, there was no evidence that chloride levels were a significant risk to objects, but that metal coupons should be exposed over an indefinite period to confirm this.

Hydrogen sulphide was the pollutant of greatest concern, but the atmosphere is probably no more aggressive than that experienced by many objects on display at the Royal Museum of Scotland, Chambers Street. The concentration could be reduced by chemical filtration but almost certainly not to a level which would prevent corrosion altogether and local protection of individual objects may be more appropriate.

High hydrogen sulphide levels may occur occasionally in the Granton area but the high levels measured on some occasions during this study could be explained by temporary sources on site, such as building work or vehicle use. In general, despite the reputation of the area for sulphide smells hydrogen sulphide levels were not exceptionally high. In normal operation these factors would be controlled by procedures for managing the store which are now in place. Spot measurements are not ideal for assessing gases, the concentration of which may vary greatly, and further passive monitoring would be desirable.

It was originally thought that the use of a high proportion of recycled air might be a significant factor in reducing internal pollutant levels. In practice the results suggested that only sulphur dioxide of the gases investigated would be significantly affected by this procedure.

Without scientific data on pollutant levels at Granton the natural assumption was that chemical filtration would be required within the air handling systems. Further monitoring is desirable but the conclusion to date is that despite the initial concerns, chemical filtration is not a necessary preventative conservation measure in this case, demonstrating the need for conservators to use science to provide the information needed to enable the best decisions to be taken. The resources available could be better employed addressing other more serious risk factors, with individual corrosion prevention measures taken for particularly sensitive objects.

ACKNOWLEDGEMENTS

The author would like to acknowledge Dr Peter Brimblecombe, University of East Anglia for valuable advice, Dr Simon Watts, Oxford Brookes University for providing and analysing passive sampling tubes for hydrogen sulphide analysis, Professor Roger Willey and Martin Mitchell, Paisley University, for carrying out active sampling of hydrogen sulphide and chloride, and his colleagues Alistair Cunningham, Dr Katherine Eremin and Dr James Tate for their help and advice during the project.

REFERENCES

Anthony, W.B., and Clancey, R. 1996. Museum Store, National Museums of Scotland, West Granton, *Museum Practice*, **1**, 1.

Brimblecombe, P. 1990. The composition of museum atmospheres, *Atmospheric Environment*, **24**, B 1, 1-8.

Cassar, M. 1995. *Environmental Management*, Routledge, London.

Eremin, K., Wilthew, P., Breeze, J. and Mitchell, M. (forthcoming). Monitoring pollutants and particulates within the National Museums of Scotland, in *Conservation Science in the UK - II* (ed N.H. Tennent).

Mitchell, M. 1996. *Investigation of Airborne Hydrogen Sulphide and Chloride for National Museums of Scotland*, The Centre for Environment and Waste Management, Paisley University, unpublished report.

Natusch, D.F.S., Klonis, H.B., Axelrod, H.D., Teck, R.J. and Lodge Jr, J.P. 1972. Sensitive method for the measurement of atmospheric hydrogen sulphide, *Analytical Chemistry*, **44**, 2067-70.

Shooter, D., Watts, S.F. and Hayes, A.J. 1995. A passive sampler for hydrogen sulphide, *Environmental Monitoring and Assessment*, **38**, 11-23.

Thomson, G. 1986. *The Museum Environment*, 2nd edn, Butterworth, Oxford.

SUPPLIERS

Nitrogen dioxide and sulphur dioxide passive diffusion tubes:
Gradko International Ltd, St. Martins House, 77, Wales Street, Winchester, Hampshire SO23 7RH, UK
Tel: 01962 860331

Hydrogen sulphide passive diffusion tubes:
Dr Simon Watts, School of Biological and Molecular Sciences, Oxford Brookes University, Headington, Oxford, OX3 0BP, UK
Tel: 01865 483613

Active hydrogen sulphide and chloride sampling:
Centre for Environmental and Waste Management Ltd., University of Paisley, Westerfield House, 25 High Calside, Paisley PA2 6BY, UK
Tel: 0141 8483146

Paul Wilthew, Conservation and Analytical Research, National Museums of Scotland, Chambers Street, Edinburgh, EH1 1J

Figure 1 The new storage facility of the National Museums of Scotland at Granton, Edinburgh

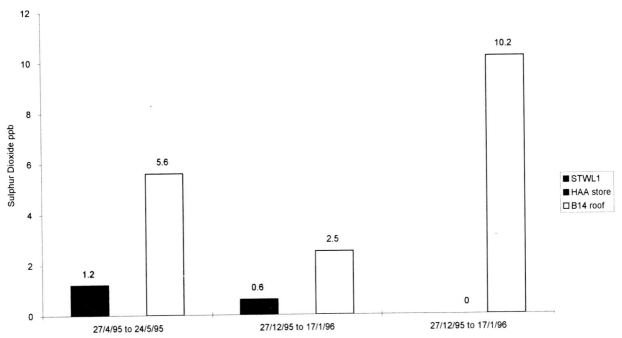

Figure 2 Sulphur dioxide concentrations in parts per billion measured in two stores and externally at Granton (HAA store result was below the detection limit and recorded as zero)

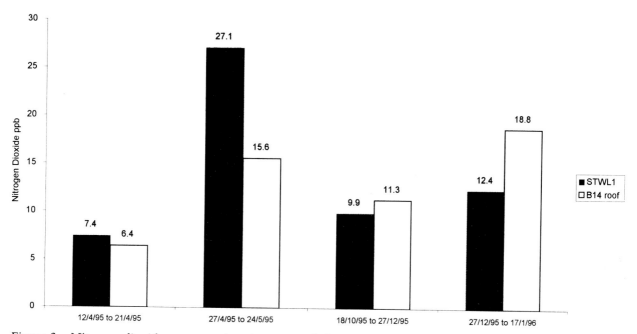

Figure 3 Nitrogen dioxide concentrations in parts per billion measured in a store and externally at Granton

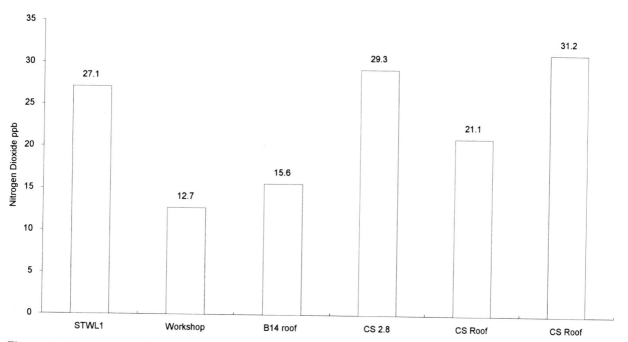

Figure 4 Comparison of internal and external nitrogen dioxide levels, in parts per billion, at Granton and at the Royal Museum of Scotland, Chambers Street (CS) over the period 27 April to 24 May 1995

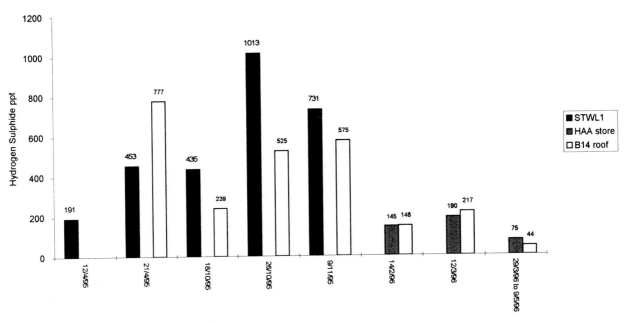

Figure 5 Hydrogen sulphide concentrations in parts per trillion measured in a store and externally at Granton

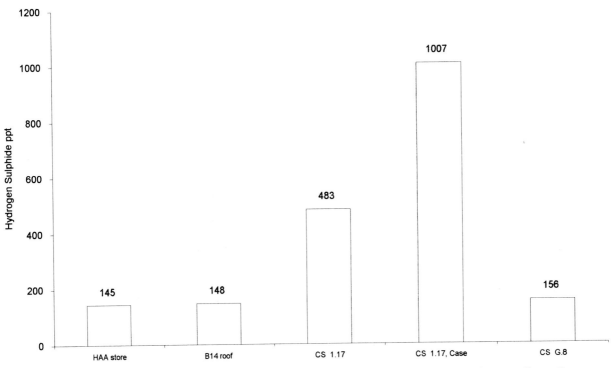

Figure 6 Hydrogen sulphide concentrations in parts per trillion measured in a store and externally at Granton and in galleries 1.17 and G.8 in the Royal Museum of Scotland (CS) on 14 February 1996

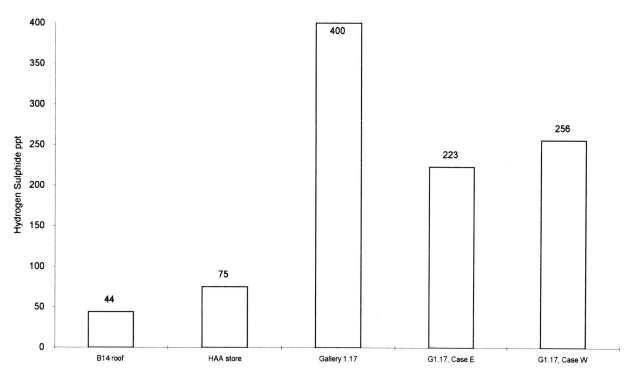

Figure 7 Comparison of average hydrogen sulphide concentrations in parts per trillion at Granton and in Royal Museum of Scotland gallery 1.17 during the period 28 March to 9 May 1996

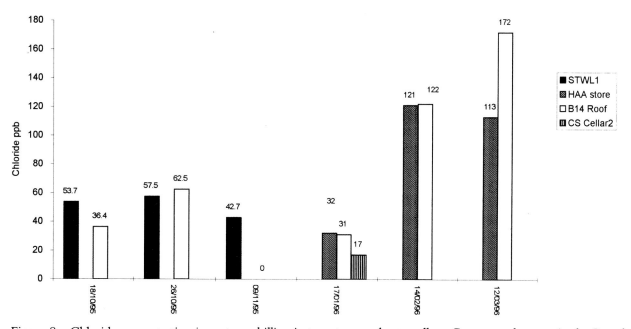

Figure 8 Chloride concentration in parts per billion in two stores and externally at Granton and a store in the Royal Museum of Scotland (CS Cellar 2)

DECISION SUPPORT MODELS FOR PREVENTIVE CONSERVATION

Paul J. Marcon

ABSTRACT

A computer-based, preventive conservation decision support model is being developed for museum professionals. Its main applications include building surveys and planning exercises where it is necessary to make choices from a wide range of design features that control nine agents that cause material damage in museum collections. The basic components of the decision support model include an audit of building features and a collections damage model. The audit assesses control features and generates sequences of control feature improvements derived from expert judgement. The collections damage model ranks control measures by accounting for the nature and susceptibility of the collections to each agent of deterioration. The preservation feature audit and the method by which expert judgement is incorporated into the audit and collections damage model is described in this paper.

Key Words

preventive conservation, computers, decision support, model, collections management, planning, surveys, preservation

INTRODUCTION

Incorporating appropriate design elements into museum buildings has an important influence on the buildings' effectiveness for preserving collections. These design elements are important because they form part of a control sequence that limits the incidence and intensity of nine agents that cause material damage in artifacts: physical forces, thieves, fire, water, pests, contaminants, light, incorrect temperature and incorrect humidity. When building assessments and planning exercises are carried out, efficient controls toward all of these agents is often desired, but resource limitations usually restrict the number of beneficial features that can be implemented at any given time. As a result, it is often necessary to make choices. The key to maximizing preservation effectiveness with available resources is to rank the importance of control features for each agent by considering the nature and susceptibility of a collection. This leads to an effective control strategy that allocates resources to controlling of agents that pose the greatest risk of damaging a collection.

The decision model, currently under development, is intended to assist museum professionals with this risk assessment process. Its consists of an audit for analyzing control features and a collections damage model. The audit assesses control features and allows improved control strategies to be realized in an organized sequence that is derived from expert judgement. The collections damage component will provide a means of ranking control deficiencies in order to allocate resources where they are most needed. This paper discusses the development of the audit and how expert knowledge on design elements is incorporated into this audit. Collections damage models are briefly discussed.

Background

In 1987, a systematic approach for conserving museum collections was developed by Stefan Michalski (1994, 8-11). One product of this approach was a detailed wallchart of favourable design features for controlling the nine agents of deterioration that cause damage in museum artefacts. The general form of the wallchart is illustrated in Figure 1. It lists the nine agents of deterioration and a structured framework of features for controlling their incidence and intensity. The control framework addresses three typical types of location found in a cultural facility: storage areas, display areas and transit areas (loading bays). Individual features for each of these locations are listed under five stages of control; avoid, block, detect, respond and recover. This control stage sequence is repeated for each agent under three means by which the controls can be implemented: building design elements, hardware items and museum procedures. Each successive control stage is intended to be the next line of defence if the preceding stage fails.

143

The wallchart, which contains over 900 features, has provided a useful reference and mnemonic device when conducting surveys and organizing survey reports. Writing survey reports has also been simplified by entering the information from the wallchart into a word-processing program. For example, reports have been formatted according to the divisions of the wallchart and preceded with a list of wallchart features identified as either assets or liabilities. This approach provided clients with an informative summary on the relative strengths or weakness of a particular control strategy, in any given location, for each agent of deterioration.

The presentation of control assets and liabilities described above led to an interest in presenting graphical summaries of control features on a larger scale. This type of summary was produced by a basic quantification of the chart features using a computer spreadsheet program. In this application, the chart features were simply assigned a score of either 1 (when assessed as adequate) or 0 (when considered inadequate). This enabled an overview of the control features in a museum relative to those of the wallchart to be presented. Although this type of overview is informative, it does not indicate control efficiency because the importance of each feature is not assessed. This difficulty can be appreciated by considering the difference between 'smooth soft wall finishes' and 'adequate floor strength', and the influence they have on preventing physical damage to collections. This problem provided the incentive to seek numerical weight factors to quantify the relative importance of the wallchart features. By applying numerical weights to the wallchart features, its utility can be extended from a knowledge base to a decision support resource.

Multicriteria Decision Methods – The Analytic Hierarchy Process

The Analytic Hierarchy Process (AHP) is currently being used to apply weights to the wallchart structure and features (Saaty 1990). The AHP approach begins by representing the system under study as a hierarchial structure (described in the following section). Numerical weights (or priorities) for the individual elements of this structure are then assigned by individuals who understand the system using a numerical algorithm. The technique used for quantifying these weights allows a simultaneous inclusion of judgements involving criteria for which

there are known measures, and of judgements involving intangible criteria for which known measures are not available.

The AHP technique has been applied to a wide variety of problems including those concerning complex social phenomena that defy quantification by using the usual economic monetary scales of measurement. Considerable literature is available on the applied and theoretical aspects of the AHP. The Analytic Hierarchy Process (second edition) by Thomas Saaty contains an appendix of 15 papers and includes some of the work mentioned here. Publications concerning the AHP are also available in seven languages (see Appendix 1).

Hierarchies

The first requirement for the AHP is a hierarchy that represents the structure and function of the system under study. In a hierarchial representation, importance is distributed from an objective located at the top level, down through a number of intermediate levels and finally to a set of alternatives on the base level. The base level alternatives, the most controllable elements of the hierarchy, are where choices are made in decision problems.

The Framework for Preservation of Museum Collections wallchart is based on a well-defined structure. This structure is illustrated in hierarchial form in Figure 2a. Preservation, the main objective, is located at the top level. Meeting this objective depends on controlling the nine agents of deterioration on level 2. These agents are further divided into subclasses, or types, on level 3. For example, physical forces is divided into the subclasses of earthquakes, floor collapse, impact and strain/abrasion in Figure 2b. In the hierarchy for physical forces, controlling earthquake damage can be seen to depend on the buildings, hardware items, and museum procedures on level 4. Finally, on level 5 in Figure 2b are individual control features that appear under the avoid, block, detect and respond control stages on the wallchart. The features, which identify important design elements, form alternatives in survey report recommendations. The base level of the hierarchy in Figure 2b further divides each feature into categories. These categories are discussed in further detail in a section to follow.

Pairwise Comparisons

The second component of the AHP is a procedure for quantifying judgements on how strongly a set of alternatives meets a given objective. This involves comparing alternatives in pairs and using an algorithm to normalize judgements expressed on a scale of 1 to 9. A measure of the relative importance of the alternatives is then provided as a ratio scale. The basis for this algorithm is the reciprocal property of comparison which can be illustrated by an example that involves comparing the weight of two different objects (A and B). If A is judged to be four times heavier than B, it follows that B is one quarter the weight of A. In this case, both items factor into the judgement, and the lighter item provides the basis for comparison. Saaty and Vargas have stated that, regarding perceptions of sensory information as in the preceding example involving weight, our minds also make these types of comparisons when abstract ideas are compared to common properties. Reciprocal comparison is considered an inherent human ability that enables us to scale the things we encounter in practice (Saaty and Vargas 1987).

For an example on how judgements are quantified using the AHP method, assume that A, B, C and D represent four different objects and that the objective of an experiment is to create a scale comparing the weight of each object relative to the others. A participant in the experiment would be asked to compare two objects at a time by holding one in each hand and judging their difference in weight. The participant would then choose the number in Table 1 that most closely describes this weight difference. For example, if object A is considered slightly heavier than B, they might choose 2. If A is considered very heavy compared to B, the number 7 would be chosen. With four objects, all of the possible pairwise combinations can be represented by a 4x4 (4 row by 4 column) matrix. A typical comparison sequence is AB, AC, AD, BC, BD and CD. Because AA is equally heavy when compared to itself, 1 is entered in position AA. Elements BB, CC and DD are also 1s. Matrix elements BA, CA, DA, CB, DB and DC are reciprocal comparisons that are automatically placed in the appropriate positions when the initial comparison sequence AB to CD is made.

	A	B	C	D
A	1	3	2	7
B	1/3	1	1	3
C	½	1/7	1	3
D	1/7	1/3	1/3	1

Once a decision matrix is constructed, a matrix normalization procedure is used to yield a vector of priorities (a vector is a matrix consisting of only one row or column of entries). This vector expresses the relative weights of the objects that have been compared. A reasonably accurate method for calculating this vector is to divide the elements in each column by the sum of that column, add the elements in each resulting row and divide this sum by the number of elements in the row. The resulting priority vector expresses the strength of the activities, or of a quantity, as a ratio scale. The priority vector for objects A, B, C and D obtained from the matrix above, using the calculation procedure that has been described above, is (0.54, 0.21, 0.18, 0.07). In addition to the normalization procedure that yields this priority matrix, a calculation of consistency is performed to identify possible errors in judgement. Consistency measures the ability to logically deduce all other data from a basic amount of raw data. As a general rule, the more a person knows about a situation, the more consistently they will represent it. Consistency is expressed as a consistency ratio (C.R.), and values of 0.10 or less are the desired objective (Saaty 1987).

An example described by Saaty on the use of judgement matrices provides an insight on the extent that meaningful measures can be derived from judgements by the AHP method (Saaty 1990, 38-9). The example involves two trials in which four identical chairs were arranged in a straight line at distances of 8, 14, 19 and 26 metres leading away from a light source. In two separate trials, observers were asked to stand next to the light source and judge the relative brightness of the chairs by comparing them pairwise. The first trial group were two children age 5 and 7. The second trial was performed by an adult. The relative brightness values obtained from the trial observations were then compared to calculated values based on the distance between the chairs using the inverse square law of optics. An impressive correlation appears between the trial results and the calculated values, see Table 2. It indicates that the judgements have successfully captured a natural law: that brightness varies inversely with the square of the distance from a light source.

The AHP method can also provide meaningful measures in other areas of thought and perception. Detailed explanations of the mathematical reasoning underlying the AHP method and the justifications for the use of an intensity scale of 1 to 9 for quantifying judgement, is provided by Saaty (1990).

Wallchart Feature Weights and Descriptions Control Audit Model

An example follows that demonstrates how the wallchart forms the basis for an audit when numerical weights are applied to its features and the elements of its structure. A control audit is used in surveys to evaluate existing control strategies and to guide their improvement.

For an audit application, it is necessary to describe the wallchart features in an easily recognizable way. This allows expert knowledge on details to be presented in a manner that helps a non-expert during the evaluation process. For example, a wallchart feature for blocking the entry of insect pests is generally stated as:'pay attention to seal details'. In order to expand on the meaning of this feature and make its significance recognizable to a non-expert, Tom Strang of the Canadian Conservation Institute, who specializes in pest control, has provided the following example of three categories of seal effectiveness for blocking the entry of insects:

Optimum no holes or gaps greater than 0.3mm;
Fair holes and gaps within a range of 0.3mm to 1.0mm;
Poor holes or gaps in excess of 1mm.

The hole and gap sizes in these categories allow straightforward observations to be made by users of the audit. The true significance of the classifications, however, is a matter of expert judgement. It is partly based on the fact that many insect species important to museums will pass through gaps that are about 10% larger than their body width, a range between 0.3mm to 1.7mm in size (Michalski 1992). In addition to this criteria, the fair category reflects the compromise between the dimensions of the best seal that is practical to achieve in practice (e.g., on a building scale) and insect exclusion. Many other tangible and intangible criteria can underlie this and similar classifications. The priority values for the three seal categories of optimum, fair and poor are (0.78, 0.16, 0.06). The descriptions of these categories would be located on level 6 of the hierarchy that appears in Fig. 2(b), and would be presented as options to the audit user.

An expanded portion of the preservation hierarchy for physical forces appears in Figure 2b. It includes four types of physical forces on level 3: earthquakes, floor collapse, impact (due to handling) and long-term effects such as strain and abrasion. In the same figure, the hierarchy under earthquake is presented in further detail. This hierarchy describes earthquake damage control as being influenced by the building, hardware items and procedures and each of these means of control is made possible by the features on level 5. The elements of the hierarchy in Figure 2b have been assigned sample priority ratings according to the strength of their contributions to objectives on the next higher level by using the judgement matrices and the normalization procedure that has been previously described.

If three similar categories were defined for features of the earthquake damage control hierarchy in Figure 2b (e.g, $F_{Category}$) the overall control rating would be calculated as follows:

Earthquake Control =
Building Controls+Hardware Controls+Procedure Controls

Earthquake Control =
$0.701(F_S)+0.213[0.667(F_{Sh})+0.333(F_I)] +0.086(F_P)$

Where F_S = F Structure
F_{Sh} = F Shelving
F_I = F Immobilization
F_P = F Procedures

Depending on the degree of seismic risk, the audit would seek a control rating equal to, or greater than, some acceptable bench-mark value. The priority values for building, hardware items and procedures would determine the sequence of improvements. As in the pest control example, categories can be defined for the degree of urgency with which a detailed seismic investigation of the structure is advised. The appropriate category for the structure could be determined by a reasonably straightforward procedure. One such procedure that is adapted to Canadian seismicity and building practice enables structures to be quickly classified as high, medium or low priority candidates for more detailed seismic investigation (Anon 1992). Descriptive categories and screening procedures can also be developed for evaluating hardware and procedural details for mitigating seismic hazards.

For a museum located in a region of low seismic risk, a satisfactory rating can be achieved without elaborate seismic control features. Although the control features are no longer important to protect against seismic disturbances, the importance of stable shelving and artifact immobilization would re-emerge as priority issues for protection against impact and long-term strain, but only after satisfactory performance is confirmed for floor strength due to its

higher priority rating of 0.440 versus 0.051 for impact and abrasion/strain.

A working audit model would address control features for all nine agents of deterioration. If three categories of feature descriptions were provided for each agent, the audit would incorporate over 6,000 individual feature categories (based on 20 agent types, an average of 100 features per agent, three categories per feature). In order to avoid entering numerous observations, features that influence more than one agent can be linked internally. For example, maintaining an open perimeter space along storage area walls can improve the control of a number of agents: physical forces (ease of access and inspection), thieves (visibility), fire (space maintains wall fire ratings), water (leaks often travel along walls), pests (ease of housekeeping and detection), incorrect temperature (avoids extremes of temperature near wall surfaces), and incorrect humidity (avoids humidity extremes caused temperature extremes near walls). In a working audit, several categories of perimeter space can be presented to the user. The extent to which the space is sufficient for controlling all of the relevant agents can be evaluated by the software. Further to combining observations pertaining to different features, the user input portion of the program can be designed in a way that is compatible with the way surveys are conducted (e.g. beginning with an exterior walk around a facility) while internally retaining the structure of the wallchart.

Rank-ordering Priorities

A control audit provides a means of assessing and developing efficient control strategies. Attempting to optimize controls for all agents of deterioration, however, is often not possible because of resource limitations. Furthermore, it may not always be necessary to achieve optimum control levels for every agent of deterioration depending on the nature and susceptibility of a collection. In order to allocate available resources as effectively as possible, it is necessary to address control issues in terms of the risks or rates of occurrence associated with each agent and the potential damage they may cause to a given collection. Research is in progress to develop collections damage models for this purpose. An example of such a model for non-recoverable object damage appears below (Michalski 1994, 9). In addition to non-recoverable damage, collections can also accumulate recoverable damage (recoverable by

conservation treatment) due to a lack of control measures for slower acting agents of deterioration, such as humidity extremes or humidity fluctuations in excess of critical thresholds. Additional models are under development to assess these losses. The AHP approach provides a means for developing these collections damage models by enabling some of their difficult parameters to be quantified. These parameters include estimates of object value, rates of deterioration, and estimates of proportional loss of value.

Non-recoverable object damage rate/risk for each agent = {Non-recoverable deterioration rate/risk (as a % of the maximum possible for an agent)} x {Proportional loss of value (due to maximum possible for that agent)}

CONCLUSION

The framework for preservation of museum collections wallchart provides a knowledge resource built on a well-defined structure that describes preservation activity of a cultural facility. By applying numerical weights to the individual chart features and expanding the features into categories of performance, this knowledge resource is being developed into a computer-based decision support model for museum professionals. The AHP technique, described herein, provides a method for obtaining meaningful measures of the relative importance of the wallchart features based on the tangible and intangible criteria that underlie expert judgement.

The outcome of applying numerical weights to the wallchart features will be a control feature audit that seeks to maximize control efficiency for all agents of deterioration. By combining the control feature audit with a collections damage model, it will be possible to rank-order the importance of controlling each agent of deterioration. The AHP technique appears to provide a means of evaluating some parameters of the collections damage models that are required for this purpose.

ACKNOWLEDGEMENTS

The author wishes to thank his colleagues for their interest in this area of research and their helpful contributions, and comments as the approaches described in this paper were being investigated. In

particular, the author gratefully acknowledges the helpful discussions and contributions of Charlie Costain, Stefan Michalski and Tom Strang of the Canadian Conservation Institute, and Rob Waller and Sylvie Marcil of the Canadian Museum of Nature. The author would also like to convey his sincere thanks to Caroline Tom of the Canadian Department of National Defence through whom he first became aware of the Analytic Hierarchy Process.

REFERENCES

Anon. 1992. *Institute for Research in Construction, Manual for Screening Buildings for Seismic Investigation, IRC/NRC,* Ottawa, Canada.

Michalski, S. 1992. A systematic approach to the conservation (care) of museum collections with technical appendices, *Museum Pest Management,* technical appendix by T. Strang, 10-11.

Michalski, S. 1994. A systematic approach to preservation: description and integration with other museum activities, in *Preventive Conservation, Practice, Theory and Research* (eds A. Roy and P. Smith), IIC, London.

Saaty T.L, 1987. Rank Generation, Preservation and Reversal in the Analytic Hierarchy Process, *Decision Sciences,* Volume **18**(2), (also in addendum to Saaty 1990, A-54).

Saaty T.L. 1990. *The Analytic Hierarchy Process - Planning, Priority Setting and Resource Allocation,* 2nd edn., RWS Publications, Pittsburgh, PA.

Saaty T.L. and Vargas L.G. 1987. Stimulus-Response with Reciprocal Kernels: The Rise and Fall of Sensation, *Journal of Mathematical Psychology,* **13**(1), (also in addendum to Saaty 1990, A-54).

APPENDIX 1

Papers On The Analytical Hierarchy Process In Seven Languages

CHINESE
Analytic Hierarchy Process - Applications to Resource Allocation, Management and Conflict Resolution, Thomas L. Saaty, trans. Shubo Xu, 1989, Press of Coal Industry, China.
Applied Decision Making Methods - Analytic Hierarchy Process, Shubo Xu. 1988, Press of Tianjin University, Tianjin, China.

FRENCH
La prise de décision en management, D. Merunka, 1987, Vuibert Gestion, 63 Bd. St Germain, Paris.
Décider face à la complexité, Thomas L. Saaty, 1984, Enterprise moderne d'édition, 17 Rue Viete, 75017 Paris.

GERMAN
Haben Sie heute richtig ent-scheiden?, Knut Richter and Gisela Reinhardt, 1990, Verlag Die Wirtschaft Berlin.

INDONESIAN
Pengambilan Keputusan, Bagi Para Pemimpin, Cetakan Pertama, 1991. Jakarta, Indonesia.

JAPANESE
The Analytic Hierarchy Process - Decision Making, Kaoru Tone, 1986, Japanese Scientific and Technical Press, Tokyo.
AHP Applications, Kaoru Tone and Ryutaro Manabe, June 1990, Japanese Science and Technology Press, Tokyo. Like or Dislike Mathematics: Decision Making with Mathematics, Eizo Kinoshita. Denkishoin, 1991, Tokyo.

PORTUGUESE
Metodo de Analise Hierarquica, Thomas L. Saaty, trans. Wainer Da Silveira E Silva, Ph.D., 1991, McGraw-Hill, Ltda. e Makron Books, Brasil.

RUSSIAN
Analytical Planning: The Organization of Systems, Kevin P. Kearns and Thomas L. Saaty, trans. Revaz Vachnadze, 1991, Radio Moscow, Moscow.
The Analytic Hierarchy Process, Thomas L. Saaty, trans. Revaz Vachnadze, 1992, Radio Moscow, Moscow.

Paul J Marcon
Canadian Conservation Institute, 1030 Innes, Ottawa, Ontario, Canada

Table 1

Intensity of Importance	Definition	Explanation
1	Equal importance	Two activities contribute equally to the objective
3	Weak importance of one over another	Experience and judgement slightly favour one activity over another
5	Essential or strong importance	Experience and judgement strongly favour one activity over another
7	Strong importance	An activity is favoured very strongly over another; its dominance is demonstrated in practice
9	Absolute importance	The evidence favouring one activity over another is of the highest order of affirmation
2,4,6,8	Intermediate values between adjacent scale values	When compromise is needed

Table 2

Observed Intensities Trial 1 C.R. = 0.13	Observed Intensities Trial 2 C.R. = 0.03	Calculated Intensities Calculated using inverse square law of optics
0.61	0.62	0.61
0.24	0.22	0.22
0.10	0.10	0.10
0.05	0.06	0.06

Framework for Preservation of Museum Collections

Agents Control Level → Location →	Building			Hardware			Procedures
	Storage	Display	Transit	Storage	Display	Transit	
Physical Forces	▓						
Thieves, Vandals, Displacers							
Fire							
Water							
Pests							
Contaminants							
Radiation (UV, Visible)							
Incorrect Temperature							
Incorrect Humidity							

Stages	Building Features
Avoid	Avoid areas of high seismic activity Avoid building on soft, loose soils Ensure adequate floor strength Ensure smooth, soft interior finish Ensure adequate access
Block	Construct earthquake resistant buildings Ensure adequate space for collections storage
Detect	Leave adequate space for inspection of artifacts
Respond	n/a

Figure 1 Framework for Preservation of Museum Collections wallchart

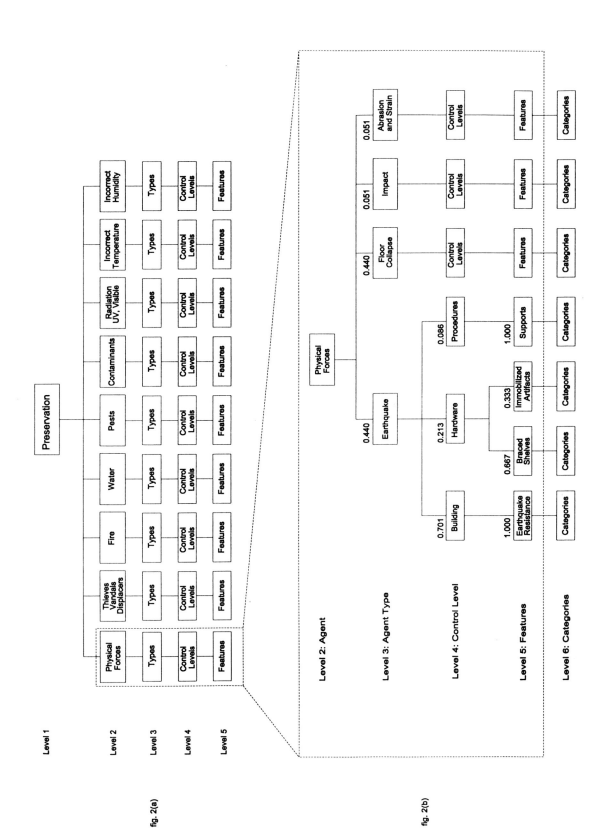

Figure 2 a) Hierarchial form of the Framework for Museum Collections wallchart; b) expanded section for physical forces

THE DETERMINATION OF APPROPRIATE MUSEUM ENVIRONMENTS

David Erhardt, Marion F. Mecklenburg, Charles S. Tumosa, and Mark McCormick-Goodhart

ABSTRACT

The choice of a range of temperature and relative humidity for the general museum environment must consider a number of factors related to the materials and construction of objects in the collection. These include critical transitions of the materials (such as glass transition and deliquescence points), physical and mechanical properties, chemical reactivity, and the effects of environmental changes within the allowed range. Changes caused by environmental fluctuations can be shown to be generally reversible (non-damaging) within a relatively wide (± 10 to 15%) range in the moderate RH region. A range that is safe for the general collections and minimizes the number of inevitable exceptions can be determined. Other factors such as building design and construction, local climate, energy costs, and available funds and time then can be considered to develop a climate control strategy that maintains the climate within the 'safe' range while conserving energy, funds, and effort.

Key Words

environment, temperature, relative humidity, materials, physical, mechanical, chemical, properties

INTRODUCTION

The museum environment has a number of components, including temperature, relative humidity, light, vibration, pollutants, and particulates. Of these factors, the optimal value for vibration, pollutants, and particulates is zero. If objects are light sensitive, then light should be reduced to the minimum amount of visible light required for proper viewing (and preferably only during viewing). Temperature and relative humidity (RH) differ from the other environmental factors in that they are interdependent, and their effects are much more varied and complex. A temperature or relative humidity acceptable for one object may be disastrous for another. Since temperature and relative humidity must be optimized rather than eliminated, satisfactory values or ranges must be determined and maintained.

Values for temperature in the general museum area (as opposed to storage) are restricted to the relatively narrow range in which people are comfortable. Thus relative humidity is the major variable of the general museum environment for which there is no obvious optimal value or range.

Relative humidity affects the preservation of objects in many ways. It affects physical, chemical, structural, and optical properties, and even the physical state of materials. It is a factor in many chemical reactions, and determines whether biological attack might occur. It affects the rate at which pollutants or contaminants can attack a material. It even affects the building structure itself if temperature differences cause condensation within the external fabric of the building. Changes in relative humidity also have effects, producing dimensional changes in hygroscopic materials that can result in strains, stresses, plastic deformation, or fracture.

Each of these factors may be more or less important for a specific type of material, and each material will be affected differently. As a result, considerations of different individual factors may suggest different optimal values or ranges of relative humidity, even for the same material. Research into the different effects of relative humidity leads not to an ever more accurate determination of the one optimal value, but to more or less overlapping, or even conflicting, recommendations (Erhardt and Mecklenburg 1994). Thus, no matter what value or range of relative humidity is chosen for the general museum environment, there will always be some objects that require either tighter control or separate and different conditions. Conditions other than those of the general environment can be provided through the maintenance of appropriate microenvironments.

This paper discusses considerations relating to the determination of suitable conditions of relative humidity in the general museum environment, with an emphasis on hygroscopic organic materials. In addition, some considerations relating to specialized storage environments also are presented.

153

CLASSES OF MATERIALS

Materials in the museum can be roughly separated into four different classes: those that are insensitive to relative humidity, those that require low relative humidity (possibly below a critical value), those that require RH values within a specific range, and those that respond to differences in RH throughout the RH range.

Materials Insensitive to RH

The class of materials that are insensitive to RH includes many inorganic materials: most ceramics and glasses and some metals and minerals. These materials are dimensionally stable with changes in RH, and are either chemically unreactive under any reasonable conditions or reaction is so slow as to be negligible. For example, some ceramics theoretically can re-hydrate, but do so very slowly so that changes can be ignored.

Materials Requiring Low RH

The degradation processes of a number of materials start or speed up as the RH is raised. Such processes include the corrosion of metals such as iron and bronze, and the oxidation or hydrolysis of minerals such as pyrite. In some cases, reaction stops or is negligible below certain values of RH. The corrosion of chloride contaminated bronze ('bronze disease') (Scott 1990) and the oxidation of pyrite (Waller 1989) both slow or stop at low RH.

Many materials contain or are contaminated with deliquescent salts. If the RH is above the value at which such salts deliquesce, they absorb water vapour from the air to form mobile electrolytic solutions. Such solutions can contribute to reactions such as corrosion (Evans 1960) or hydrolysis, or increase the susceptibility to pollutants (Padfield and Erhardt 1987).

For materials described in this section, low RH is required. Some materials require an environment as dry as possible, while others are unreactive and insensitive to RH and dimensionally stable if the RH is below a certain value. Many such materials require drier conditions than are suitable for general collections. Such materials are best kept in separate low RH areas, or in dry microenvironments.

In addition to exhibited and stored objects, the museum building itself may require an RH below a certain value. If the outside temperature is below the dewpoint of the interior air, then condensation may occur in the exterior fabric of the building. This can result in rotting, staining, rusting, spalling, dripping, and other problems. Ideally, the dewpoint of the interior air should be below the temperature of the exterior air. This may result in extremely low interior RH values during cold weather in temperate and cold climates, however. Approaches to the problem include strategies such as vapour barriers, reduced interior temperatures and pressures, and other measures to minimize problems while still maintaining acceptable interior humidities.

Another factor, mould growth, places an upper boundary on RH. Mould growth is likely above about 75% RH, but ceases to be a factor below about 60% RH (Michalski 1993). Factors such as air flow and circulation also affect mould growth.

Materials Requiring a Specific RH Range

The number of materials requiring a specific RH range is quite small, restricted mainly to mineral hydrates that incorporate water into their crystalline lattice. These minerals are stable only within certain compound-specific RH ranges, losing water and powdering at lower RH, or gaining water and decomposing or dissolving at higher RH. The stability ranges for a number of minerals has been compiled (Waller 1980). Such materials must be kept in separate microenvironments if the overall RH is not maintained within their range of stability.

Materials Responsive to RH throughout the RH Range

Most organic materials are sensitive to differences in RH throughout the RH range. This can be illustrated by a typical moisture absorption isotherm for cellulose shown in Figure 1. There is no range over which the moisture content remains constant. Any change in RH produces a change in moisture content. This leads to changes in chemical reactivity, structural and physical properties, and dimension. Differences in dimensional responsiveness to RH changes within an object can result in stresses that, if large enough, cause plastic deformation or fracture. Any attempt to determine an optimal value or range for such a

material (or composites that incorporate it) must allow for all of these factors. The choice is complicated by the fact that some deterioration processes of these materials speed up or occur only at low RH. The RH range chosen is often a compromise.

Cellulose, which is the structural component of many museum objects, provides an example of the way these factors can be taken into account in determining an appropriate or optimal range for hygroscopic materials. The first step is considering the nature of absorbed water in hygroscopic materials.

Water in Cellulose

Cellulose contains many polar, reactive groups, specifically the hydroxyl groups of the glucose molecules that are the building blocks of cellulose. These groups can form hydrogen bonds to, and bind very tightly with, water molecules. Cellulose at very low RH contains little or no water, but as the RH is raised cellulose rapidly picks up water. This accounts for the steep curve of the isotherm at low RH in Figure 1. This 'bound' water absorbed at low RH is held very tightly by the reactive groups, and in fact can be regarded as part of the structure of the cellulose 'matrix'. The isotherm curve flattens out once the reactive sites are covered, and cellulose absorbs water at a much slower rate as the RH is raised through the middle range, i.e., cellulose is less responsive to RH change in this region. As the RH is raised further, capillary absorption increases and the rate of absorption with RH change increases. Capillary absorption in fact occurs throughout the RH range, but is most important at higher RH (above about 50%). Water absorbed through capillary action, so-called 'free' water, is not tightly bound, is mobile, reactive, and behaves much more like liquid water. Bound and free water can be differentiated by methods such as thermodynamic studies of the heat of absorption of water. Figure 2 separates the isotherm of Figure 1 into bound and free water.

Reactivity of Cellulose vs. RH

The main reaction of cellulose under 'normal' conditions is hydrolytic cleavage of the cellulose chain. This type of reaction is dependent on RH. Figure 3 plots the rates of hydrolysis at different points along the cellulose chain vs. RH, along with curves fit to the data (Erhardt and Mecklenburg 1995). The rates of the reactions correlate with the amount of free water from Figure 2, also plotted. The hydrolysis of cellulose can be reduced to minimal levels by reducing the relative humidity.

At low RH, crosslinking of cellulose occurs. This is due in part to the uncovering of the reactive groups with the loss of bound water. In addition, the loss of bound or structural water can lead to collapse of the pore structure and inter-fibrillar interstices of materials such as paper and wood, along with reductions in reactivity as access to the cellulose molecules is reduced. Changes induced by severe drying are only partly reversible, and are less so if crosslinking is allowed to continue for a long time.

Thus, the reactivity of cellulose is minimized by reducing the RH to the point at which most of the free, reactive water is removed, but enough bound water remains to cover the reactive groups and prevent crosslinking and structural collapse. This minimum occurs somewhere around 30% RH, (isotherms vary depending on factors such as percent crystallinity and processing of the cellulose). Since the isotherm is relatively flat just above this point, though, the RH can be raised up to 50% or 60% without significantly increasing the reactivity of the cellulose, ('significantly' being a relative term, in this case a factor of two or three, as compared to the large increases that occur at very high RH).

Physical Properties of Cellulose Versus RH

Of the basic physical properties that are important in determining the ease with which damage occurs at constant RH, three can vary with changes in RH. These are the modulus (stiffness), strain-to-yield (deformation required to cause permanent distortion), and strain-to-failure (deformation required to cause fracture or breakage). Absorbed water affects these properties by acting as a plasticizer. Figure 4 plots the modulus of cottonwood in the cross-grain (primarily tangential) direction. The modulus is relatively constant up to about 50% RH, then falls off rapidly, losing two-thirds of its maximum value by 100% RH. This behaviour indicates that it is primarily the free absorbed water that acts as a plasticizer and affects the stiffness. This material exhibits little change in stiffness in the range below 50% RH, which includes the 30-50% RH range suggested from the considerations of chemical reactivity. In this relatively flat portion of the isotherm, there is little change in water content, thus little change in these properties.

Similar conclusions result from a consideration of the strain required for failure. Figure 5 plots both the strain-to-failure and strain-to-yield of cottonwood in the (primarily) tangential direction. The strain-to-failure (amount of stretching required to cause fracture) is relatively constant (between 1 and 2%) up

to about 80% RH, above which it increases dramatically. Again, there is little difference in a wide range that includes the 30-50% RH range. However, the prevention of total failure is not stringent enough a goal. Permanent distortion can be avoided by not exceeding the strain-to-yield, which is relatively constant at about 0.004, (0.4%). Deformations less than this are elastic, with the material returning to its original shape and size once the deforming force is released. Absorbed water does not seem to affect this property.

These data dispel the myth that materials are necessarily brittle and/or stiff at all low RH values. This idea may have resulted from the fact that the crosslinking of materials stored at very low RH (less than 20-30%) can result in reduced strain-to-break, which can be interpreted as brittleness. In fact, if very low RH is avoided, important physical properties are relatively insensitive to RH within the flat portion of the isotherm.

Similar results have been found (Tumosa 1996) for the properties of a number of materials, including samples of paper from a book published in 1804. Such results, combined with those of a study that showed that paper loses strength with little change in modulus during aging (Erhardt and Mecklenburg 1995), indicate that while paper may become weaker on aging, its stiffness and response to RH changes do not change significantly.

Effects of RH Fluctuations on Hygroscopic Materials

Cellulosic materials absorb and desorb water and consequently change dimension as the relative humidity changes. If a material is unrestrained, this absorption and desorption is reversible in a quite wide range of relative humidity, and a material simply expands and contracts with changes in relative humidity. It is only when a material is restrained, either internally or externally, that this tendency to change dimension can cause stresses and resulting damage. If the relative humidity is reduced, wood will try to shrink. If it is held rigidly and prevented from shrinking, stresses develop. If these stresses are large enough, they result in permanent deformation or fracture.

Figure 6 shows stress-strain curves for a piece of cottonwood at various relative humidities. The horizontal axis is displacement, and the vertical axis is the stress, or force per cross-sectional area, corresponding to that displacement. Changes in dimension produced by changing the RH are also

represented. This is shown by moving along the horizontal (zero stress) axis, and is why the stress-strain curves for different values of RH start at different positions along the horizontal axis. The curves are separated by the change in length due solely to changes in RH. Each curve is linear and reversible in the initial stage, but then becomes nonlinear and non-reversible as permanent deformation occurs.

How do these tests, conducted at constant RH, relate to effects caused by changes in RH? Figure 7 is a detail of Figure 6. The worst case assumption is that a sample is fully restrained and not allowed to change dimension or respond to changes in RH. If the RH is reduced from 48%, the sample tries to shrink, but cannot, and stress develops. This is equivalent to moving vertically, staying the same length but with increasing stress. If the RH is reduced to 23%, the plot ends at a point on the 23% RH stress-strain curve. This demonstrates a fundamental principle found to be true for all of the materials tested (Mecklenburg et al. 1995a). The stress in a sample is a function of the final conditions of strain and RH; the path to a specific condition does not matter. Keeping the dimension constant and lowering the RH results in the same stress as allowing the sample to shrink freely as the RH is lowered, and then stretching it to the original length. This means that the effects of RH changes can be calculated from a series of stress-strain tests conducted at constant, but different, values of RH.

The only additional information required is the change in dimension caused by changes in RH. Measurements of the changes in dimension caused by RH changes, as well as the amount a material can be reversibly stretched, allow the calculation of the minimum safe RH fluctuations that can be allowed without irreversible deformation or fracture (Erhardt et al. 1995, Erhardt et al. 1996, Erlebacher et al. 1992, Mecklenburg 1991, Mecklenburg et al. 1992, Mecklenburg et al. 1994, Mecklenburg et al. 1995a, Mecklenburg et al. 1995b, Mecklenburg et al. in press, Mecklenburg and Tumosa 1991a, Mecklenburg and Tumosa 1991b, Mecklenburg and Tumosa 1996, Richard et al. in press). Figure 8 shows the result of such calculations for cottonwood. Larger fluctuations than those shown are safe if the worst case conditions (total restraint, long exposure and full response to the extreme RH values) are not met. The rate of the change in RH does not affect these allowable fluctuations. An interesting feature of the calculations is that the allowable fluctuations are not uniform, but depend on the starting relative humidity. Not

surprisingly, the greatest allowable fluctuations for most organic materials are in the 30-60% RH range, the flat portion of the isotherm where they are least responsive to changes in relative humidity. If there is no response, there is no mechanism for environmental mechanical damage.

Similar measurements and calculations for a wide range of materials (not just cellulose) yield similar results, with allowable fluctuations of at least ±10 to 15% or more in the moderate RH range. For example, comparisons of new and seventeenth-century samples of *Pinus sylvestris* L. (Scots pine) showed that wood in an uncontrolled environment exposed to centuries of wide variations in temperature and relative humidity can survive with no significant change in physical properties, and only minor indications of chemical deterioration (Erhardt *et al.* 1996).

Such calculations refute another myth, that objects at high RH can more readily 'equilibrate' to RH changes. In fact, allowable fluctuations are small at high RH because hygroscopic materials are very responsive to RH changes in that region. Any so-called 'equilibration' of restrained materials at high RH to other than small changes involves irreversible plastic deformation (damage).

Effects of RH Changes on Composite Materials
If the material properties of the components of a composite structure are known, similar calculations of the overall response of the composite, and the strains and stresses induced at each point, can be made (Erhardt *et al.* 1995, Mecklenburg *et al.* 1994, Mecklenburg and Tumosa 1991a, Mecklenburg and Tumosa 1991b, Mecklenburg and Tumosa 1996, Mecklenburg *et al.* in press, Richard *et al.* in press). Figure 9 shows the swelling isotherms of a number of materials, including the components of a typical panel painting. In the moderate (30-60% RH) range, such materials in a composite object respond to RH changes similarly, and the materials shrink or swell together, producing little or no stress in the individual layers. At low (below 30%) or high (above 70%) RH, the differences in response start to exceed safe values. Wood and glue respond much more to changes in RH than, for instance, oil paint. In an oil on wood panel painting, the massive wood layer controls the response of the composite. At high RH, the wood swells and stretches the paint layer, while at low RH the wood shrinks and compresses the paint. Thus, RH-induced cracking of the paint, if it occurs at all, is caused not by low RH, but by high RH,

while low RH can result in buckling and cupping of the paint layer. A more detailed discussion of such calculations can be found in the references (Erhardt *et al.*1995, Mecklenburg *et al.* in press, Richard *et al.* in press).

It is possible to calculate the stresses and strains generated throughout an object by RH changes if the appropriate properties (stiffness, yield points, dimensional RH isotherm) are known, and to determine if safe values are exceeded anywhere in an object. It is obviously impractical to do this for every object. To set limits for the general museum environment, however, it is only necessary to consider the worst cases. In general, the allowable fluctuation for a composite is at least as great as that for the most RH-responsive component. Most materials have at least a ±10 to 15% RH allowable fluctuation when equilibrated to moderate RH. It can be seen in Figure 9 that even a material such as ivory that is generally considered especially 'sensitive' to RH changes is really no more sensitive than tangential wood. For most materials and collections, environmentally-induced mechanical damage can be avoided if the RH is kept between 35 and 60% RH. Other considerations, such as chemical stability, favour keeping the RH at the low end of this range. Again, it must be emphasized that these calculations of allowable fluctuations are based on worst case considerations, and many materials and objects can be subjected to even greater fluctuations without sustaining mechanical damage.

As discussed in previous sections, no general environment will be suitable for all objects. Unless these exceptions form an unusually large percentage of the collection, however, maintaining separate microenvironments usually requires less trouble and expense than basing the general environment on the requirements of only a few objects.

CONDITIONS OTHER THAN ROOM TEMPERATURE

An underlying assumption is that museum collections, with few exceptions, are stored, exhibited, and studied at room temperature. This is unfortunate, because the increases in the chemical stability of most organic materials possible with cold storage are much greater than those that can be achieved by modifying the relative humidity within a reasonable range. For instance, Figure 3 shows that lowering the RH from 60 to 30% can reduce the rate of degradation of paper

by a factor of three to five times. In the same study, a determination of the activation energies of these reactions showed that their rates could be approximately halved by each 5 °C reduction in temperature (Erhardt and Mecklenburg 1995). Lowering the storage temperature from room temperature (20 °C) to -15 °C (a temperature achievable with standard single-stage mechanical refrigeration) produces over a hundredfold increase in expected chemical stability.

Physical considerations are the main factor in determining whether a material or object can safely be stored at low temperature. Temperature changes produce dimensional changes, and therefore can produce strains and stresses much as changes in RH. An approach similar to that used in determining the mechanical and physical effects of changing the relative humidity can be used to evaluate the effects of temperature (Erlebacher *et al.* 1992, Mecklenburg *et al.* 1994, Mecklenburg and Tumosa 1991b, Mecklenburg and Tumosa 1996, Mecklenburg *et al.* 1992, Richard *et al.* in press). Measurements of properties such as the thermal expansion coefficient, and the modulus, strain-to-break, and strain-to-yield as a function of temperature can be used to calculate the effects of temperature changes. Other subtle factors also must be considered. These include glass transitions that can change physical properties, and shifts in the isotherm that can change the equilibrium moisture content even at constant RH.

Figure 11 illustrates the results of a comprehensive approach to the determination of safe conditions for the cold storage of photographs that takes into account chemical, physical, and mechanical properties. Photographs, especially those produced by some colour processes, are inherently unstable enough that noticeable degradation of image quality can occur in as little as thirty to fifty years at room temperature. Cold storage is the only practical preservation approach. The recommended environmental range in Figure 10, is based on an analysis of a number of factors, including the complex relationship between temperature, pressure, relative humidity, and moisture content, and the behavior of photographic gelatin (McCormick-Goodhart 1995). At room temperature (20 to 25 °C), photographs are mechanically stable in the 35 to 60% RH range (line AB). Above this range, there is a risk of crossing the glass transition boundary (the dotted line). Beyond this line, gelatin softens and photographs stick together. The numbered contour lines are lines of equal permanence. The lifetime of a photograph in the conditions along Line 10 will be

approximately ten times that for the same photograph in the conditions defined by Line 1. These values are based on data for the temperature and RH dependence of a number of important chemical reactions of photographic materials. The shift of the safe region to a lower RH range at lower temperatures takes into account the fact that the moisture content of gelatin and other organic materials such as those used in film bases is a function of both temperature and relative humidity. A photograph in an airtight enclosure with a minimal airspace goes directly from Point B to Point C with no change in moisture content if cooled from 25 °C to -25 °C. Such conditions, attainable with simple packaging and standard freezers, extend the predicted lifetime of photographs to many thousands of years.

Such deviations from 'room temperature' are practical only in storage areas or specialized microclimate exhibit cases. Cold storage also presents challenges of design and access. Nevertheless, cold storage for suitable collections can be integrated effectively with overall museum energy cost objectives and reasonable policies that balance the conflict between preservation and access.

CONCLUSIONS: GENERAL RECOMMENDATIONS FOR RH SETTINGS

Clearly, there is no one ideal RH for the general museum environment. This is made clear in Figure 10, adapted and updated from Erhardt and Mecklenburg (1994), which provides a comparison of the ranges suggested by various factors. An environment maintained between 35-60% RH may be the best general compromise. The RH can be allowed to vary (at any rate) within this region with little risk of mechanical damage. However, any overall setting must be a compromise, and there will always be exceptions that will have to be treated separately, either buffered to maintain a specific RH range or housed in a microenvironment with a different RH. As shown in the section on RH fluctuations, objects conditioned to high RH are susceptible to damage if exposed to low (or even moderate) RH environments. Metals such as bronze and iron should be kept in the dry end of the 35-60% RH range, if not drier.

The combined costs of maintaining both the general and specialized environments also must be considered and balanced. The installation and running costs of equipment and facilities designed to maintain

'constant' conditions can be prohibitive. Allowing both short-term and seasonal fluctuations in the environment can greatly reduce costs. For example, allowing the RH to drop to 35% in the winter and rise to 50% or 60% in the summer may reduce the running costs of humidification and dehumidification, and may even eliminate the need for large capacity or multiple stage systems.

Setting the RH range and determining the exceptions requires an understanding of the effects of RH as well as a thorough knowledge of the materials in a collection, the ability to determine which objects and materials must be treated differently, and an understanding of the costs and problems involved in maintaining specific environments.

REFERENCES

Erhardt, D. and Mecklenburg, M. 1994. Relative humidity re-examined, in *Preventive Conservation: Practice, Theory and Research* (eds A. Roy and P. Smith), IIC, 32-8, London.

Erhardt, D. and Mecklenburg, M. 1995. Accelerated vs natural aging: Effect of aging conditions on the aging process of paper, in *Materials Issues in Art and Archaeology IV* (eds P. Vandiver *et al.*), Materials Research Society, Vol. 352, 247-70, Pittsburgh, PA.

Erhardt, D., Mecklenburg, M.F., Tumosa, C.S. and McCormick-Goodhart, M. 1995. The determination of allowable RH fluctuations. *Western Association for Art Conservation Newsletter*, **17**(1), 19-23.

Erhardt, D., Mecklenburg, M.F., Tumosa, C.S. and Olstad, T.M. 1996. New versus old wood: Differences and similarities in physical, mechanical, and chemical properties, in *11th Triennial Meeting, Edinburgh 1-6 September 1996* (ed J. Bridgland), ICOM-CC, vol. 2, 903-10, James and James, London.

Erlebacher, J.D., Brown, E., Tumosa, C.S. and Mecklenburg, M.F. 1992. The effects of temperature and relative humidity on the rapidly loaded mechanical properties of artists' acrylic paints, in *Materials Issues in Art and Archaeology III*, (eds P. Vandiver *et al.*), Materials Research Society, Vol. 267, 359-70, Pittsburgh, PA.

Evans, U.R. 1960. *The Corrosion and Oxidation of Metals: Scientific Principles and Practical Applications*, Edward Arnold Ltd, London.

McCormick-Goodhart, M.H. 1995. Moisture content isolines of gelatin and the implications for accelerated aging tests and long term storage of photographic materials, *Journal of Imaging Science and Technology*, **39**(2), 157-62.

Mecklenburg, M.F. 1991. Some mechanical and physical properties of gilding gesso, in *Gilded Wood Conservation and History* (eds D. Bigelow *et al.*), 163-70, Sound View Press, Madison, Connecticut.

Mecklenburg, M.F., McCormick-Goodhart, M. and Tumosa, C.S. 1994. Investigation into the Deterioration of Paintings and Photographs Using Computerized Modeling of Stress Development, *JAIC*, **33**(2), 153-70.

Mecklenburg, M.F. and Tumosa, C.S. 1991a. An introduction into the mechanical behaviour of paintings under rapid loading conditions, in *Art in Transit: Studies in the Transport of Paintings* (ed M.F. Mecklenburg), National Gallery of Art, 137-72, Washington, DC.

Mecklenburg, M.F. and Tumosa, C.S. 1991b. Mechanical behaviour of paintings subjected to changes in temperature and relative humidity, in *Art in Transit: Studies in the Transport of Paintings* (ed M.F. Mecklenburg), National Gallery of Art, 173-216, Washington, DC.

Mecklenburg, M.F. and Tumosa, C.S. 1996. The relationship of externally applied stresses to environmentally induced stresses, in fiber: *Proceedings of the First International Conference on Composites in Infrastructure* (eds H. Saadatmanesh and M.R. Ehsani), 956-71, University of Arizona, Tucson.

Mecklenburg, M.F., Tumosa, C.S. and Erhardt, D. In press. Structural Response of Wood Panel Paintings to Changes in Ambient Relative Humidity, in *Painted Wood: History and Conservation*, AIC, Washington.

Mecklenburg, M.F., Tumosa, C.S. and McCormick-Goodhart, M.H. 1992. A general method for determining the mechanical properties needed for the computer analysis of polymeric structures subjected to changes in temperature and relative humidity, in *Materials Issues in Art and Archaeology III* (eds P. Vandiver *et al.*), Materials Research Society, Vol. 267, 337-58. Pittsburgh, PA..

Mecklenburg, M.F., Tumosa, C.S. and McCormick-Goodhart, M.H. 1995a. A General Model Relating Externally Applied Forces to Environmentally Induced Stresses in Materials, in *Materials Issues in Art and Archaeology IV* (eds P. Vandiver *et al.*), Materials Research Society Vol. 352, 285-92, Pittsburgh, PA.

Mecklenburg, M.F., Tumosa, C.S. and Wyplosz, N. 1995b. The effects of relative humidity on the structural response of selected wood samples in the cross-grained direction, in *Materials Issues in Art and Archaeology IV* (eds P. Vandiver *et al.*), Materials Research Society, Vol. 352, 305-24, Pittsburgh, PA.

Michalski, S. 1993. Relative humidity: A discussion of correct/incorrect values, in *10th Triennial Meeting, Washington 22-27 August 1993* (ed J. Bridgland), ICOM-CC, vol. 2, 624-9, Paris.

Padfield, T. and Erhardt, D. 1987. The spontaneous transfer to glass of a image of Joan of Arc, in *8th Triennial Meeting, Sydney* 6-11 September 1987 (ed K. Grimstad), ICOM-CC, vol. 3, 909-13, Getty Conservation Institute, Los Angeles.

Richard, M., Mecklenburg, M.F. and Tumosa, C.S. In press. Technical considerations for the transport of panel paintings, in *The Structural Conservation of Panel Paintings*, Getty Conservation Institute, Los Angeles.

Scott, D. 1990. Bronze disease: A review of some chemical problems and the role of relative humidity, *JAIC*, **29**, 193-206.

Tumosa, C.S. 1996. Unpublished results.

Urquhart, A.R. 1960. Sorption isotherms, in *Moisture in Textiles* (eds J.W.S. Hearle and R.H. Peters), Textile Book Publishers, Inc., 14-32, New York.

Waller, R. 1980. The preservation of mineral specimens, in *8th annual meeting, San Francisco 22-25 May 1980, AIC*, 116-28, Washington, DC.

Waller, R. 1989. Pyrite oxidation studies. *CCI Newsletter*, Spring/Summer 1989, 10.

David Erhardt, Marion F. Mecklenburg, Charles S. Tumosa, and Mark McCormick-Goodhart, Conservation Analytical Laboratory, Smithsonian Institution, Washington, DC 20560, USA

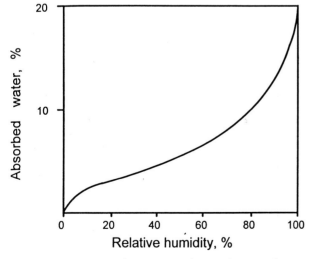

Figure 1 Moisture absorption isotherm of cotton. (From Urquhart 1960)

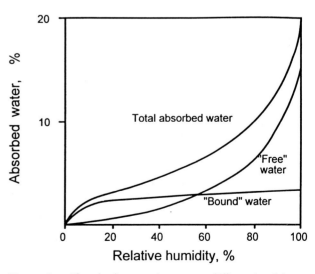

Figure 2 Absorbed water in cotton differentiated into 'bound' and 'free' water. Bound water is absorbed and held tightly starting at low RH. Free, or capillary, water is less tightly bound and absorbed primarily at high RH. (From Urquhart 1960)

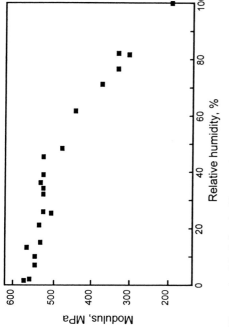

Figure 4 Modulus (stiffness) of cottonwood as a function of relative humidity

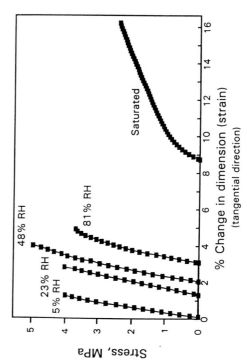

Figure 6 Stress-strain curves for cottonwood at various relative humidities. The curves are displaced on the X axis by changes in dimension due solely to changes in RH. (From Erhardt *et al.* 1995)

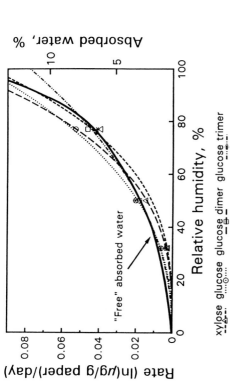

Figure 3 Hydrolysis of cellulose produces glucose and glucose oligomers. The rates at 80°C of the reactions that yield each product correlate with the amount of free absorbed water. (Reaction rate data from Erhardt and Mecklenburg 1995, absorbed water curve from Urquhart 1960)

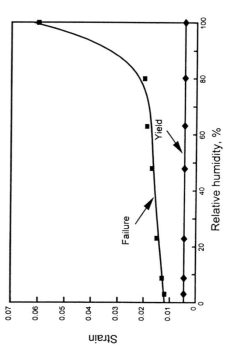

Figure 5 Strain-to-yield and strain-to-failure for cottonwood in the tangential direction as a function of relative humidity.

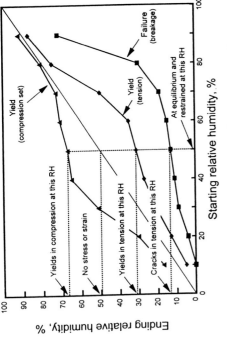

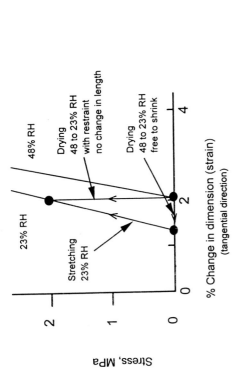

Figure 7 Detail of Figure 6. Drying while held at constant length produces the same stress as when allowed to shrink during drying and then stretched to the original length. (From Erhardt *et al.* 1995)

Figure 8 Allowable fluctuations for cottonwood as a function of starting relative humidity. A stress-free sample restrained at 50% RH can be raised or lowered to 68 or 31% RH without permanent deformation, and lowered to 13% RH before failure. These values are for the tangential direction. Allowable fluctuations in the radial and longitudinal directions are much larger. Larger changes also are possible if the sample is not restrained, or is not exposed to the RH extremes long enough to fully respond.

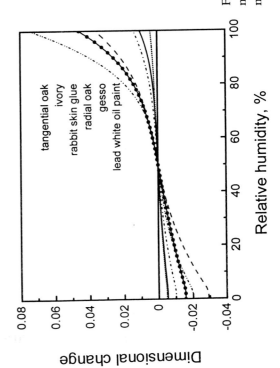

Figure 9 Dimensional moisture isotherms for some materials typically found in museum objects. Most materials are relatively insensitive to RH changes in the moderate RH range. Moisture isotherms for most other materials fall within the range seen here.

RELATIVE HUMIDITY STABILITY ZONES

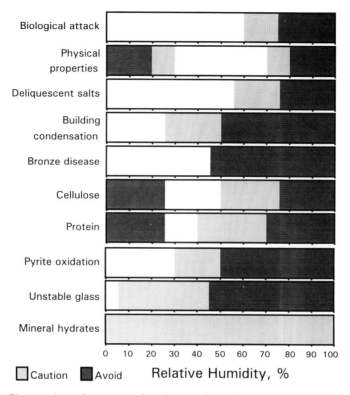

Figure 10 Ranges of relative humidity suggested by consideration of various factors. No value or range is suitable for all objects, but a relatively wide range is safe for many types of objects. Adapted from Erhardt and Mecklenburg (1994).

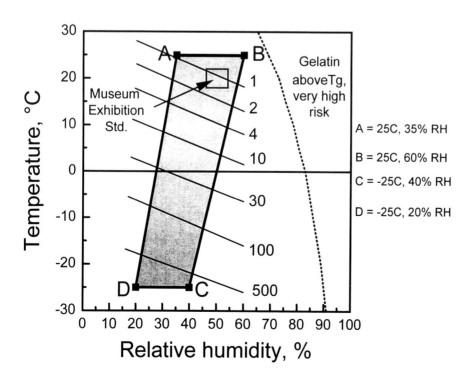

A = 25C, 35% RH

B = 25C, 60% RH

C = -25C, 40% RH

D = -25C, 20% RH

Figure 11 Factors involved in determining environmental ranges that are safe for the storage of photographs. With suitable packaging, photographs can move freely within the shaded area without generating damaging stresses or crossing the glass transition (T_g) boundary. Relative chemical stability (indicated by the numbered lines) is greatest in the lower left section of the mechanically safe region.

163

LABORATORY TESTING OF NEW CLEANING TECHNIQUES FOR STAINED GLASS AND THEIR APPLICATION IN THE WORKSHOP

Hannelore Römich

ABSTRACT

The surface of corroded historic glass often consists of a leached layer, adjacent to the bulk glass and a crust of corrosion products on top. The gel layer, somehow acting as a protective 'skin' for the sensitive glass, should not be removed or damaged. The crust, however, is in some cases very dense and disfiguring, for example on the outside of stained glass windows. It needs to be removed in order to regain transparency. The most striking examples of these corrosion phenomena are medieval windows in the St Mariendom Cathedral in Erfurt, which appear dark, even in transmitted light (Fig. 1).

As systematic investigations on the evaluation of cleaning techniques cannot be carried out on original glasses, simulation materials were designed having a very high sensitivity to corrosion (high potassium-lime-silicate glasses). The glasses were corroded by accelerated weathering to produce a surface similar to degraded medieval stained glass. After the samples were cleaned with different methods, the degree of cleaning and the damage to the glasses were characterised.

This paper describes the procedure for the laboratory testing of different cleaning techniques and the selection of cleaning methods to be applied on original glasses from Erfurt cathedral. The results, both of the laboratory testing and of the field applications were evaluated by a board of scientists, conservators and art historians, an excellent example of interdisciplinary co-operation.

Key Words

stained glass windows, glass corrosion, simulation materials, accelerated weathering, cleaning, ion exchanger.

INTRODUCTION

A stained glass window is made of coloured glass segments with the main outlines or trace lines executed in opaque black or dark brown enamel followed by heat treatment. The subsequently applied lead frame not only holds the pieces of glass together but should also be considered as part of the artistic composition (Newton and Davison 1989). This general description, still valid for modern art objects, dates back to manufacturing techniques in medieval times (Blondel 1993).

Contemporary architectural glass is considered to be quite stable against chemical attack. However, due to their chemical composition, medieval glasses are much more sensitive to atmospheric corrosion processes (Newton 1985). In former times, glass-melting technology allowed only rather low temperatures, so that large quantities of alkalines and alkaline earths had to be added. As soda resources were restricted, potash was used instead. This resulted in glasses which were low in silica and high in potassium and calcium, thus having structures susceptible to corrosion (Newton 1985, Scholze 1988).

The chemical reactions of glass surfaces interacting with aqueous solutions, with a moist atmosphere or with air pollutants are described in the literature (Newton 1985, Scholze 1988, Fuchs 1994).

Acidic conditions favour an ion exchange between sodium, potassium or calcium ions from the glass and hydrogen ions from the environment. Additional water molecules are incorporated into the altered surface of the glass, and a so-called 'gel layer' is built up. In a moist atmosphere the ions which have leached out from the glass can react with air pollutants to form a crust of corrosion products, consisting mainly of gypsum($CaSO_4.2H_2O$) and syngenite ($K_2Ca(SO_4)_2.H_2O$) (Fuchs *et al.* 1989, Geilmann 1960).

For the interaction of glass with alkaline media, a different reaction path occurs. The breaking up of the Si-O-Si bridges of the glass network results in the dissolution of the surface layers of the glass (Scholze 1988).

As described above, the degradation of medieval glass is strongly influenced by its chemical composition and by the environmental conditions to

which it is exposed. Another parameter which will direct the future corrosion process of the glass is the surface condition of the object. Severe abrasive cleaning techniques will lead to a 'clean' surface, which is much more sensitive to corrosion than before. For some examples corrosion on medieval glass can be correlated directly to a former cleaning process (Fig. 2). This explains the importance of the decision on how and to what extent the glass should be cleaned.

This publication reports on a research project aimed at evaluating cleaning procedures for stained glass windows from Erfurt cathedral. As conventional cleaning techniques were not acceptable for this special problem, new methods were tested in the laboratory and applied to selected originals in co-operation with glass conservators in their workshop.

CLEANING OF STAINED GLASS

Encrustations of dirt and gypsum or syngenite have to be removed from the surface to regain the colourful transparency of the glass and to prepare the surface for conservation. Any cleaning procedure for sensitive glasses should remove the corrosion crust only as far as necessary to improve the transparency, without damaging the gel layer or the bulk glass. The gel layer is considered to stabilise the bulk glass and protect it from further corrosive attack (Müller, et al. 1995). A variety of cleaning methods including 'dry' (e.g. bristle brushes, glass fibre brushes, scalpel, airbrasive) and 'wet' (e.g. organic solvents, water, complexing agents) techniques are used in workshops in Europe for different cleaning problems on stained glass (Newton and Davison, 1989).

For the removal of porous corrosion layers a bristle brush may be sufficient. However, encrustations of gypsum adhere so well, and can be so dense, that no mechanical technique can be applied without taking the risk of damaging the bulk glass or the gel layer. Medieval glasses from Erfurt cathedral are the most striking examples of such a case.

Gypsum can be removed from glass quite effectively by using chemical cleaning methods, e.g. complexing agents like ethylene diamino-tetra-acetic-acid (EDTA) or its sodium salts (Bettembourg 1974, Müller et al. 1996), or special gels containing ammonium bicarbonate (Valentin 1996). The potential risk of treatments with complexing agents is a matter of debate, as it can be assumed that the chemical attack, e.g. from EDTA, not only dissolves calcium ions from the crust but also from the bulk glass. Cleaning with EDTA has to be controlled carefully to reduce the risk of damage as far as possible (Müller et al. 1996).

Encrustations of gypsum on wall paintings are treated, for example, with ammonium carbonate, NH_4CO_3, (Fritz 1996), or by an ion exchange method (Böhme and Wölker 1994). As encrustations on stained glass have a similar composition the application of those methods for cleaning glasses from Erfurt cathedral was considered.

CO-OPERATION BETWEEN CONSERVATORS AND SCIENTISTS ON THE EVALUATION OF CLEANING TECHNIQUES

Outline of the project

In a research project funded by the German Federal Ministry for Education, Science, Research and Technology (Bundesministerium für Bildung, Wissenschaft, Forschung und Technologie - BMBF) a team of scientists, conservators and art historians was formed to evaluate cleaning techniques for glasses from Erfurt cathedral.

Different institutions shared the tasks of the work programme: scientists from the Fachhochschule Köln, the Bundesanstalt für Materialforschung und -prüfung, Berlin, and from the Fraunhofer-Institut für Silicatforschung (ISC), Würzburg/Bronnbach, oversaw the selection of cleaning treatments and were responsible for their application and evaluation in the laboratory; glass conservators and art historians from the Glasrestaurierungswerkstatt der Dombauhütte Köln and the Dombauverwaltung Erfurt carried out pilot applications on original glass segments. A glass conservator from Cologne, who was seconded to work with the ISC in Würzburg for one year, has turned out to be the ideal link for this multidisciplinary team.

Work programme in the laboratory

Studies of the effects of cleaning on original glass samples are limited for various reasons. Corrosion phenomena due to cleaning can be compared only on similar samples providing a reproducible starting point for all of the experiments. Model glasses, as prepared by the ISC, present a practicable alternative to replace

the originals in cleaning experiments (Fuchs *et al.* 1991, Römich and Fuchs, 1992). The corrosion behaviour of model glasses is similar to that of the originals, but they can be made even more sensitive to corrosion by increasing the potassium content in order to detect the risk potential of a cleaning medium within a relatively limited observation time.

For the experiments described in this publication, one of the most sensitive ISC model glasses (glass type MI) was chosen with the nominal composition (weight -%):

48% SiO_2, 3% Na_2O, 25,5% K_2O, 3% MgO, 15% CaO, 1,5% Al_2O_3, 4% P_2O_5 (Fuchs *et al.* 1991).

Model glasses can be used without pre-treatment or after simulation of cracked gel layers and encrustations.

Due to their standardised preparation technique, the corrosion of each sample can be quantified by IR-measurements. The difference in intensity (ΔE) of the OH-absorption band at $3300cm^{-1}$ before and after treatment indicates the degree of corrosion of the glass (Fuchs *et al.* 1991).

In a sequence of eight steps of the work programme a total number of 47 treatments were tested on model glasses. These involved solutions or compresses of EDTA or NH_4CO_3 at different concentrations and exposure times; anion exchange resin charged with carbonate, nitrate, and acetate, additives to improve the effectiveness of the ion exchanger; NH_4CO_3 thickened as a gel or with whitening to a paste, etc. (Römich and Fuchs, 1991 and 1996).

Figure 3 shows a series of model glasses exposed to different cleaning media. In Figure 4 the results of such treatments are demonstrated by light microscopy. The corrosion crust produced on the sample by accelerated weathering could be removed by chemical cleaning.

Some recipes, e.g. liquid/ion xchange resin, caused damage to model glasses, so that there was no need to test them on originals. Other experiments in the laboratory, e.g. involving additives, showed no difference in damage potential. In these cases the most promising version was selected for further testing on originals.

Within this work programme consisting of eight series of experiments on model glasses the number of treatments applied to original glass samples could be reduced considerably. The results of each step were discussed with the other members of the team to optimise the research strategy. One set of experiments is described in detail below.

Cleaning experiments on model glasses

Based on previous investigations seven recipes were selected to be evaluated in this test series including the anion exchange resin Amberlite IRA 416. This was compared with ammoniumcarbonate, applied as a paste.

The treatments were:

II Amberlite IRA 416, charged with carbonate, ammoniumcarbonate (10%) in water, as wetting media;

XI Amberlite IRA 416, charged with nitrate, ammoniumnitrate (10%) in water, as wetting media;

XIV Ammoniumcarbonate (10% in water);

XVII Ammoniumcarbonate (5%) in water, thickened to a paste with MH 4000, a methyl hydroxyethyl-cellulose;

XVIII as XVII, with 2% solution;

XIX Ammoniumcarbonate (5%) in water, thickened with whitening;

XX water, applied on a cellulose poultice.

For each treatment two uncorroded MI-glasses were used, exposed to the cleaning agent for 3 hours or 24 hours, respectively.

In Figure 5 the ΔE-values of the samples indicating the corrosive potential of the cleaning treatments are summarised. The corrosion rate of samples exposed to the different cleaning media for 24 hours was always higher than the corresponding samples after 3 hours treatment, as expected.

According to these results the cleaning methods XIX and XX (ammoniumcarbonate with whiting and water) had the lowest, and XIV, XVII and XVIII the highest potential to damage sensitive glasses. Water (XX) showing the lowest corrosion values in this series is not appropriate for cleaning encrustations of gypsum on glass and was used only as a reference. In conclusion, treatment II, XI (both ion exchange formulations) and XIX, (ammoniumcarbonate thickened with whitening) were recommended for further testing on originals from Erfurt cathedral.

Transfer into conservation practice

On original glasses not only the effectiveness of the cleaning procedure had to be checked. An equally important role was subscribed to the feasibility of use of the treatment in the workshop. Many aspects, including advantages and disadvantages of different methods had to be discussed by the project team. Ion exchange resin formulations and ammonium-carbonate pastes caused similar results on model glasses. However, the application of ion exchange resin is far more complicated since they need careful preparation, and a time consuming recycling-process is necessary to lower the costs of restoration.

Ion exchange resin charged with nitrate might enhance growth of microorganisms as a long-term effect which is a disadvantage compared to ion exchange resin charged with carbonate. Any exchange of sulfate from the gypsum containing crust with carbonate might transform part of the gypsum into calcite, which should be avoided, as this would form a non-transparent crust.

For any chemical treatment two main problems have to be solved for cleaning original stained glass panels. Old lead profiles with old putty are never sealed completely against moisture, bearing the risk that cleaning solutions will migrate to the interior side of the panel where they can damage the paint or react with already applied conservation materials, such as wax. The other problem concerns inhomogeneous cleaning on a glass segment due to an irregular thickness of the corrosion crust. A second application of a cleaning paste on an area which is partly cleaned carries the risk of damaging areas where the corrosion crust has already been removed, and the cleaning agents can react with the unprotected surface of the glass. All chemicals have to be removed from the surface by washing carefully to avoid accelerated corrosion caused by residual cleaning products.

CONCLUSIONS

Sensitive model glasses are an important tool in the evaluation of risk potential of cleaning methods for stained glass windows. According to promising results from laboratory experiments ion exchange resin and ammonium carbonate paste will be considered for use in the removal of dense encrustations from medieval glass from Erfurt cathedral. Besides the effectiveness and the potential damage of a cleaning method, which can be partly assessed in the laboratory, a number of practical aspects have to be addressed before introducing the routine application of any treatment into conservation practice. Cleaning of medieval glass is certainly one of those conservation problems where no general recommendations can be made, but careful investigation should be made, where scientists and conservators are involved as partners in a close co-operation.

ACKNOWLEDGEMENTS

The author wishes to thank the other partners in this project team for their friendly co-operation: Dr W. Müller and Dr M. Torge (Bundesanstalt für Materialforschung und -prüfung, Berlin), Dr Forberg, Dr Bornschein, M. Jähn and T. Glass (Dombauverwaltung Erfurt), Prof. Dr E. Jägers (Fachhochschule Köln), Dr U. Brinkmann, P. Berkenkopf and their colleagues (Glasrestaurierungswerkstatt der Dombauhütte Köln) and especially C. Mueller-Weinitschke (glass conservator from Cologne) who stayed in our research institute for one year and managed to connect theoretical and practical aspects of glass conservation in a remarkable way.

This project was funded by the Bundesministerium für Bildung, Wissenschaft, Forschung und Technologie (Germany).

REFERENCES

Bettembourg, J.M. 1974. Chemical cleaning of medieval glass. *CVMA News Letter* 7, 3.

Blondel, N. 1993. Le Vitrail, *Imprimerie nationale Editions - Inventaire général*, Paris.

Böhme, D. und Wölker, G. 1994. Chemische entfernung von kalkschleiern und -krusten auf wandmalereien, *Kunsttechnologie und Konservierung* 8/1, 78-85.

Fritz, E. 1996. Gipsumwandlungs-und reinigungsverfahren an wandmalereien, *Kunsttechnologie und Konservierung* 2, 366-76.

Fuchs, D.R. 1994. The effects of air pollutants on glass, in *The effects of air pollutants on materials* (eds D.S. Lee and T.A. McMullen), Proceedings of the AEA workshop, 29-32, London.

Fuchs, D.R., Patzelt H. and Schmidt H. 1989. Umweltbedingte Schädigungen an historischen Glasfenstern - Phänomene, mechanismen, konservierungskonzepte, in *Umwelteinflüsse auf Oberflächen. Kontakt & Studium.* 282, 174-92, Expert-Verlag.

Fuchs, D.R., Römich, H. and Schmidt, H. 1991. Glass sensors: Assessment of complex corrosive stresses in conservation research, in *Materials Issues in Art and Archaeology II* (eds P. Vandiver *et al.*), Materials Research Society, vol. 185, 239-51, Pittsburgh, PA.

Geilmann, W. 1960. Beiträge zur Kenntnis alter Gläser - Die Verwitterungsprodukte auf Fensterscheiben, *Glastechn. Ber.* **33**, 213-19.

Müller, W., Torge, M. and Adam, K. 1995. Primary stabilization factor of the corrosion of historical glasses: the gel layer, *Glastechn. Ber. Glass Sci. Technol.* **68**, 286-92.

Müller, W., Torge, M., Kruschke, D. und Adam, K. 1996. *Sicherung, Konservierung und Restaurierung historischer Glasmalereien.* Forschungsbericht Förderkennzeichen Bau 5026 G5.

Newton, R.G. 1985. The durability of glass - a review. *Glass Technol.* **26**, 21-38.

Newton, R.G. and Davison, S. 1989. *Conservation of Glass.* Butterworths, London.

Römich, H. and Fuchs, D.R. 1992. Evaluation of the effectiveness and the potential damage of cleaning methods for the restoration of stained glass windows. in *Materials Issues in Art and Archaeology III* (eds P. Vandiver *et al.*), Materials Research Society, vol. 267, 1039-44, Pittsburgh, PA.

Römich, H. and Fuchs, D.R. 1991, 1996. *Untersuchungen zum einfluss von restaurierungsmassnahmen auf das korrosionsverhalten der glasoberflächen,* BMBF-Forschungsbericht. Förderkennzeichen BAU 5026/C4. Teil 1 und Teil 2.

Scholze, H. 1988. *Glas - Natur, Struktur, Eigenschaften,* Springer Verlag, Berlin.

Valentin, N., Sanchez, A. and Herräz, I. 1996. Analyses of deteriorated Spanish glass windows; Cleaning methods using gel systems, in *11th Triennial Meeting, Edinburgh 1-6 September 1996* (ed J. Bridgland), ICOM-CC, vol. 2, 851-6, James and James, London.

MATERIALS

Tylose MH 4000®
Methyl-hydroxyethyl-cellulose,
 Fa. Hoechst (Frankfurt, Germany)
Amberlite® IRA 416
Anion exchanger (type 15262),
 Merck Laborprodukte (Darmstadt, Germany)

Hannelore Römich, Fraunhofer-Institut für Silicatforschung (ISC), Bronnbach Branch, Bronnbach 28, D-97877 Wertheim, Germany.
E-mail: roemich@isc.fhg.de

Figure 1 Part of a stained glass panel from Erfurt Cathedral (fourteenth century)

Figure 2 Corrosion on a glass segment from Altenberg (fourteenth century) - probably due to harsh mechanical cleaning

Figure 3 Model glasses during (left) and after (right) exposure to a variety of chemical cleaning methods

Figure 4 Light microscopy (40fold magnification) on a sample after cleaning: residual corrosion products (left) compared to an area where all crystals were removed completely, to show the gel layer with its typical crack pattern (right)

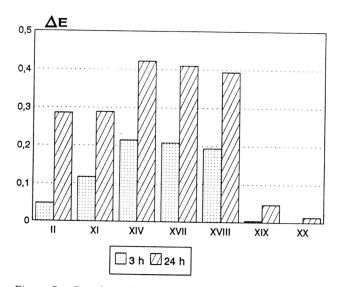

Figure 5 Results of IR-measurements on MI-glasses (uncorroded) after treatment with different cleaning methods for 3 hours or for 24 hours

TEXTILE SCIENCE INTERFACES WITH TEXTILE CONSERVATION AT THE UNIVERSITY OF ALBERTA

N. Kerr,★ S. Lemiski, Y. Olivotto

ABSTRACT

This paper will show how textile conservation practice informs textile science research by describing two recent projects at the University of Alberta. The inspiration for Lemiski's research on the identification, characterization and photodegradation of weighted silk came from her experiences as a conservation intern working with very degraded silk artefacts. In response to a need for simple but reliable techniques for identifying weighted silk, three methods are described as well as typical patterns of degradation found in weighted silk. Olivotto's research evolved from difficulties we encountered in the identification of highly degraded rope and cordage specimens associated with Sir John Franklin's expeditions in the Canadian arctic. To help conservators identify highly degraded bast fibers, Olivotto evaluated various methods for isolating phytoliths (silica bodies and calcium oxalate crystals). The phytoliths found in abaca, ramie, jute and hemp are described. The isolation of phytoliths offers another means of identifying highly degraded bast fibers.

Key Words

weighted silk, fiber identification, bast fibers, phytoliths, silica, calcium oxalate

INTRODUCTION

The close relationship between textile science research and textile conservation at the University of Alberta is evident from the research which graduate students conduct. The purpose of this paper is to show how ideas for textile science research come from practical conservation work with historic textiles in our Clothing and Textiles Collection. Two recent research projects by Lemiski and Olivotto, Case study 1 and 2, will be described briefly, including inspiration for the research and findings that are of immediate use to textile conservators.

CASE STUDY 1. WEIGHTED SILK: IDENTIFICATION, CHARACTERIZATION AND PHOTODEGRADATION.

While Lemiski was a conservation intern working with textiles at the Museum of American Textile History in Lowell, Massachusetts, and the Clothing and Textile Collection at the University of Alberta, she encountered a number of highly degraded silk artefacts and saw a need for research on the effects of weighting on the properties of silk fabrics. A survey of silk artefacts dating from 1880 to 1920 in the Clothing and Textiles Collection revealed that many, but not all, were in rather poor condition. Given the extremely fragile condition of some garments, options for handling, storage and treatment were limited. Since not all conservators are able to identify weighted silk with certainty, one of the objectives for phase 1 of her research was to test the validity of three simple non-instrumental techniques for identifying the presence of metallic weighting agents on silk. The second objective was to characterize the visual appearance of weighted silk degradation and to identify patterns of damage common to historic weighted silks (Lemiski 1996).

Methods

Fabrics
Eighteen historic silk samples were collected from textile conservators in Canada and the United States. These samples were not part of museum collections and were offered for research, and thus, were used for the identification tests described below.

Identification Tests for the Presence of Weighting Agents on Silk
a) **Burning test** A few silk fibres, held in metal forceps, were slowly moved toward the upper part of the blue flame of a Bunsen burner, then left in the flame for approximately ten seconds. The test was

considered positive for the presence of metal weighting agents if a crisp skeleton in the shape of the original yarn or fibres remained and glowed red when held in the flame.

b) **Flame Colour Test for Tin** A 1cm square of silk fabric was placed in a 50 ml beaker with about 10ml of concentrated hydrochloric acid (12N), then five to seven small pieces (~ 0.0005-0.01g) of zinc metal gratings were added. The solution was stirred with a test tube filled with cold water and held with a test tube clamp. The lower end of the test tube was then held in the upper portion of a blue Bunsen flame for 20-30 seconds. If tin was present, a bright blue flame formed around the test tube where it was immersed in the test solution. The blue flame is the result of combustion of the rapidly evaporating solution containing tin ions. If the amount of silk for testing is limited, the ash of a sample which has been used for the burning test may be subjected to the flame colour test. The test is extremely sensitive for as little as 0.03μg of tin will give a positive test (Hoffman 1984).

c) **Spot Test for Iron** The potassium ferrocyanide spot test for iron was selected to identify the presence of iron (III) cations, a component of some weighting formulations. Ferric salts react with potassium ferrocyanide to form a distinct blue compound called Prussian blue (Feigl 1958). A small sample (5mm square of silk or a few fibres) is placed on a watch glass. One drop of 1N hydrochloric acid is placed on the fabric then one drop of 5% (W/V) potassium ferrocyanide is added. If the Prussian blue colour forms, iron (III) cations are present. The identification limit is 0.1μg iron.

In order to check the validity of the three identification tests, energy dispersive x-ray analysis (EDXA), a procedure for identifying elements with atomic numbers greater than eleven, was performed on the 18 unknown silk samples. A JEOL XVision field emission scanning electron microscope was used to take readings at 15 KV from several locations on a 2 x 5mm sample of each fabric. The metallic elements identified were compared with the results of the burning test, flame test for tin and spot test for iron.

Appearance and Patterns of Degradation in Weighted Silks

Lemiski wanted to characterize the appearance of degradation in weighted silk fabrics and try to identify patterns of damage. Forty-seven silk dresses and ensembles from the University of Alberta's Clothing and Textile Collection were examined. The garments dated from 1880 to 1920, a time period chosen because tin weighting was first patented in the mid 1880s and continued with few changes until the 1920s. A report form containing a deterioration rating scale and descriptors of damage was developed for recording the condition of the silk garments. With the standardized report form, quantitative and qualitative data could be collected. The deterioration rating scale was adapted from Horswill (1992). To determine whether each fabric was weighted, small yarn samples from each garment (taken with permission of the curator and conservator of the Clothing and Textiles Collection) were subjected to a burning test.

Results

The results of the burning test for metallic weighting, the flame test for tin, the potassium ferrocyanide spot test for iron III and EDXA are shown in Table 1. Eight of the 18 donated silks were weighted. When a burning test indicated the presence of weighting on the silk, EDXA in all cases confirmed that metallic elements were present in more than a trace amount. All of the weighted silks gave a positive test for tin that was confirmed by EDXA. The prevalence of tin is not surprising since tin chloride was the most important weighting agent used by the beginning of the twentieth century (Scott 1931). The EDXA findings were also consistent with the results of the iron spot test which showed that iron was not present in more than a trace amount in any of the silks. Lemiski concluded that the simplest identification test for silk weighting is the burning test. With experience, it is possible to recognize the characteristic red glow of the metallic coating even when a very small yarn sample is used; in addition, the ash residue can be used for the flame colour test for tin, if desired.

Figure 1 shows the evaluation form Lemiski developed for recording the condition of silk artefacts. Of the 47 women's silk dresses (*c.*1880-1920) examined for condition, none was rated 5 (fabric no longer intact), but 40% had a rating of 4 (extensive deterioration throughout). Seventeen of these 19 garments had slits and cracks throughout the fabric, the tears occurring not only in areas of strain, but also in areas not strained during wear. Given the severity of deterioration, one might expect all of the 17 fabrics to be weighted, but 4 were not. Of the 27 garments given a rating of 2 (minor deterioration) or 3 (deterioration in areas of mechanical stress or

perspiration) only 6 garments (22%) were weighted. Although weighted silk was not restricted to the groups with the highest deterioration ratings, it was more prevalent in those groups. The characteristic cracks and slits found in deteriorated silk garments are shown in Figure 2, a photograph of the silk lining of a woman's bodice, *c.*1904. This lining is weighted, however, the presence of the cracks in a silk fabric is not sufficient evidence of weighting. An additional test is necessary to confirm the presence of weighting salts.

Table I Results of tests for the presence of weighting agents on 18 donated silk fabrics

Sample	Date	Item	Colour	Burning[a]	Tin[b]	Iron[c]	EDXA[d]
A	1903	yardage	brown	+	+	−	+
B	1912	slip	cream	+	+	−	+
C	−	yardage	pink	−	−	−	−
D	−	blouse	grey	+	+	−	+
E	1906	flag	white	−	−	−	−
F	1906	flag	red	−	−	−	−
G	1906	flag	blue	−	−	−	−
H	−	purse	purple	+	+	−	+
E	−	dress	bl/wh	+	+	−	+
J	−	dress	cream	+	+	−	+
K	−	dress	cream	+	+	−	+
L	−	dress	cream	+	+	−	+
M	1865	flag	brown	−	−	−	−
N	1865	flag	red	−	−	−	−
O	1865	flag	cream	−	−	−	−
P	1865	flag	cream	−	−	−	−
Q	1865	flag	cream	−	−	−	−
R	1865	flag	blue	−	−	−	−

[a] The burning test was considered positive (+) when the ash retained the shape of the fibres and glowed red when held in the flame
[b] The flame colour test for tin was considered positive when a blue glow was observed encircling the test tube when held in the Bunsen flame
[c] The spot test for iron (III) was considered positive when a blue colour was produced on the silk specimen
[d] EDXA was considered positive for weighting when a weighting metal, especially tin or iron was present in more than a trace amount

CASE STUDY 2 PHYTOLITH ANALYSIS FOR THE IDENTIFICATION OF DEGRADED FIBRES

The conservation and interpretation of artefacts begins with description, including the identification of various materials in the artefact. Although the specific identification of fibres is not always essential, sometimes a curator or conservator wants to know whether the artefact is made from hemp, flax or some other material. The identification of highly degraded cellulosic materials is not always possible using conventional methods because characteristic features such as response to identification stains or swelling agents is masked by deterioration or soils. A search for characteristics which persist even when fibres are

highly deteriorated led to us to consider phytoliths (literally plant stones), residual mineralized inclusions from plant tissues. These have been studied and characterized by botanists, archaeologists and others, but have not been considered a tool for textile conservators to use in identifying degraded fibers. Marshall (1992) developed a test protocol for identifying flax, ramie, hemp and jute fibres. It worked well when fibres were in good condition, but a number of highly degraded rope and cordage specimens from Sir John Franklin's expeditions to the Canadian arctic could not be identified using the test protocol. Marshall's thesis provided the point of departure for Olivotto's research on the separation and description of phytoliths in ramie, jute and hemp as well as other bast and leaf fibres.

Methods

Materials
Olivotto distilled phytoliths from five plant materials, four of which are described here because they relate directly to Marshall's test protocol for identifying the bast fibres, flax, ramie, jute and hemp (Marshall 1992). Flax fibres were not examined because they do not have phytoliths. The plant materials included *Musa textilis* Née (abaca or Manila hemp) - leaf sheaths, various grades of bast fibres, paper and woven textiles; 77 samples examined;

- *Boehmeria nivea* L. (Gaud.) (ramie) - rove of processed fibres; 17 samples examined;
- *Corchorus capsularis* L. (jute) - rove of fibres with varying amounts of adhering parenchymous tissue and uneven texture; 17 samples examined;
- *Cannabis sativa* L. (hemp) - whole stems of Kompolti variety, low THC hemp grown in Alberta, and fiber from fabric imported from Asia.

Separation of Phytoliths
Olivotto experimented with and perfected the following methods for distilling phytoliths from plant parts: mechanical separation by hand sectioning, chemical digestion with hydrogen peroxide and potassium dichromate, dry thermal ashing at 400°C in a crucible or between glass plates and cold oxygen plasma ashing at 25.3°C for 5-18 hours (Jones 1988, Lanning *et al.* 1958, Olivotto 1996, 45-51). On most plant specimens, at least four distillation methods were used.

Results

The various forms of silica and calcium oxalate phytoliths found by Olivotto are shown in Figure 3. The specific crystals, as well as their description and location in *Musa textilis* Née (abaca), *Boehmeria nivea* L. (Gaud.) (ramie), *Corchorus capsularis* L. (jute) and *Cannabis sativa* L. (hemp) are summarized in Table 2. *Musa textilis* Née (abaca) contained files or chains of silica bodies adjacent to the fibre bundles, thus, if a conservator were examining processed fibres, single crystals like those in Figure 3f, or short chains of crystals like those in Figure 4a might be found. The silica files shown in Figure 4a were isolated by oxygen plasma ashing. The scanning electron micrographs in Figure 4b and 4c show in more detail the characteristic shape of the silica bodies in abaca. In Figure 4c, the file of four silica bodies is associated with the fibre bundle, not the epidermal tissue above. Below the file adhering to the fibre bundle is some parenchyma. The leaf sheath of abaca contained sacs of calcium oxalate raphide crystals (Figs 3b and 5a). The sac with the needle-shaped raphide crystals was manually separated from the leaf sheath. Textile fibres are not made from leaf sheath components, thus, raphide crystals would not normally be found with abaca fibers in textile remains.

In *Boehmeria nivea* (ramie) fibres, druse or cluster crystals and crystal sand particles were found (Fig. 3a and 3c). Since the fibre ultimates from which the crystals were isolated were taken from a ramie fabric, phytoliths survive the processing of bast fibre bundles into individual fibres and yarns.

Cannabis sativa (hemp) also had files of druse crystals and the occasional rhomboid aligned parallel to the fibre bundles in the primary phloem. Three calcium oxalate crystals found on a fibre bundle are shown in Figure 5b. When a whole *Cannabis* stem was sectioned, the epidermis contained silica bodies in the form of trichome bases (Fig. 3g), confirming the findings of Dayanadan and Kaufman (1976).

In *Corchorus capsularis* (jute), files of calcium oxalate rhomboid crystals (Fig. 3d) were abundant and appeared to be associated with the fibre bundles. In Figure 5c, for example, it is possible to see the close association of the rhomboid crystals with a node as reported by Jarman and Kirby (1955).

How useful would phytolith analysis be to a conservator? This technique would be very useful if it was essential to know the specific identification of the material being examined, and other identification methods could not be used or were inconclusive. In

addition to the availability of the equipment for distilling the crystals, some of which is not costly, the conservator would need good microscopy skills. A knowledge of plant morphology would be helpful.

One of the advantages of phytolith analysis as a tool for identifying fibres is the resistance to degradation of the crystals. When a bast fibre is severely degraded, many characteristics useful in identifying the fibre disappear. The response of fibres to various identification tests such as the twist test or Schweitzer's reagent (Marshall 1992) may be impossible to see. Ideally, phytolith analysis would be combined with other identification tests such as those in Marshall's test protocol (Marshall 1992) for identifying flax, ramie, jute, and hemp fibres.

The purpose of this paper was to show how ideas for textile science research come from practical conservation work. Although Lemiski's research on degraded silk and Olivotto's research on phytolith analysis were quite different, they both addressed a need that was identified by conservators. The information these researchers have learned will now be available to conservators and the cycle will be complete. Not only does practice inform research, but research informs practice.

Table 2 Description and location of phytoliths found in *Musa textilis* Née (abaca, Manila hemp), *Boehmeria nivea* (L.) (ramie), *Corchorus capsularis* (jute) and *Cannabis sativa* L. (hemp)

Material & number of samples examined	Phytolith character	Location & description	Found with processed fibers?
Musa textilis Née (abaca or Manila hemp) 77 samples	silica files, individual silica bodies	-adjacent to fibro-vascular bundles -files disaggregate during chemical digestion	yes
	calcium oxalate raphide crystals	-in sacs or single crystals -sacs located on aerenchyma surface spanning abaxial & adaxial surfaces of leaf sheath	no
	magnesium phosphate (possibly) rhomboid crystals	-abundant -in or near epidermis in all Musa plant parts examined	possibly
Boehmeria nivea (L.) Gaud. (ramie) 17 samples	calcium oxalate druse or cluster crystals	-occasional crystals & crystal fragments isolated from processed fibers (fiber ultimates)	yes
Corchorus capsularis L. (jute) 17 samples	calcium oxalate rhomboid crystals	-abundant -attached to fiber bundles; appear to be contained in sacs near nodes in some cases. -files of crystals adjacent to fiber bundles	yes
Cannabis sativa L. (hemp) 17 samples	calcium oxalate druse & rhomboid crystals	-files of druse crystals with occasional rhomboid forms, adjacent to primary phloem fiber bundles and individual druse crystals to perifery of the pith parenchyma, concentrated close to xylary elements	yes
	silica body	-silicified trichome base from epidermis	possibly

ACKNOWLEDGMENTS

The authors wish to thank the Alberta Museums Association for contributing research funds for the weighted silk study. We are grateful to a number of individuals and institutions for contributing silk and bast fibre samples for each project; in particular, we thank the Philippine Fibre Development Authority for generously sending specimens of various grades of fibre as well as plant parts, textiles and pulp and paper items made from *Musa textilis* Née (abaca).

REFERENCES

Dayanandan, P. and Kaufman, P.B. 1976. Trichomes of *Cannabis sativa* L. (Cannabaceae), *American Journal of Botany*, **63**, 587-91.

Feigl, F. 1958. *Spot Tests in Inorganic Analysis*, (trans R.E. Oesper), Elsevier, Amsterdam.

Hoffman, J.H. 1984. Qualitative spot tests, in *Analytical Methods for a Textile Laboratory* (ed J.W. Weaver), American Association of Textile Chemists and Colorists, 174, Research Triangle Park, NC.

Horswill, M.T. 1992. *Characterization and Preservation of Weighted Silk*, Ph.D dissertation, University of Wisconsin, Madison.

Jarman, C.G. and Kirby, R.H. 1955. The differentiation of jute and some jute substitute fibres based on the type of crystals present in the ash, in *Colonial Plant and Animal Products*, 281-5.

Jones, G.J. 1988. A simplified procedure for the extraction of silica and calcium oxalate phytoliths from plant tissue, *Phytolitharien Newsletter*, **5**, 9-10.

Lanning, F.C., Ponnaiya, B.W.X. and Crumpton, C.F. 1958. The chemical nature of silica in plants, *Plant Physiology*, **33**, 339-43.

Lemiski, S.L. 1996. *Weighted Silk: Identification, Characterization, and Photodegradation*, Unpublished masters thesis, University of Alberta.

Marshall, J. 1992. *The Identification of Flax, Hemp. Jute and Ramie in textile artifacts*. Unpublished masters thesis, University of Alberta.

Olivotto, Y. M. D. 1996. *Phytolith Analysis as a Means of Cellulosic Fibre Identification: Silica Bodies and Calcium Oxalate Crystals in Agave genera (cantala, maguey and sisalana, sisal), Boehmeria nivea (L.) Gaud. (ramie), Cannabis sativa L. (hemp), Corchorus capsularis L. (jute), and Musa textilis Née (abaca, or Manila hemp)*. Unpublished masters thesis, University of Alberta.

Scott, W.M. 1931. The weighting of silk, Chapter 1, Historical, *American Dyestuff Reporter*, **20**, 517-18, 539-40 and 543.

N Kerr,★ S Lemiski, Olivotto Y, Department of Human Ecology, 301 Printing Services Bldg., University of Alberta, Edmonton, Alberta, Canada, T6G 2N1

★ author to whom correspondence should be addressed.

EVALUATION OF SILK DEGRADATION

Acc. #_____
Location_____

ARTIFACT INFORMATION:

Category:_____ Colour:_____ Date:_____

ARTIFACT CONDITION:

DETERIORATION RATING SCALE*

1	2	3	4	5
No visible deterioration	Minor deterioration	Deterioration in areas of mechanical stress or perspiration	Extensive deterioration throughout fabric	Fabric in pieces, no longer intact

Rating scale adapted from Horswill, M.T. (1982). Characterization and preservation of weighted silk. PhD dissertation, University of Wisconsin, Madison.

DETAILS OF CONDITION (check all that apply)

all-over soiling	_____	holes/loss	_____
stains	_____	tears	_____
discolouration	_____	slits/cracks	_____
distortions	_____	creases	_____
abrasion	_____	powdering	_____
fraying	_____	previous repair	_____

Comments:

MICROSCOPE OBSERVATIONS BURNING OBSERVATIONS

RECOMMENDATIONS:

REPORT BY:_____ DATE:_____

Figure 1 Report form developed for recording the condition of silk artefacts using standard terminology and a deterioration rating scale

Figure 2 Detail of cracks and slits in the severely degraded weighted silk lining of a woman's bodice, *c.*1904. University of Alberta Clothing and Textiles Collection, acc. # 87.69.1a, reproduced by permission, photograph by S. Lemiski

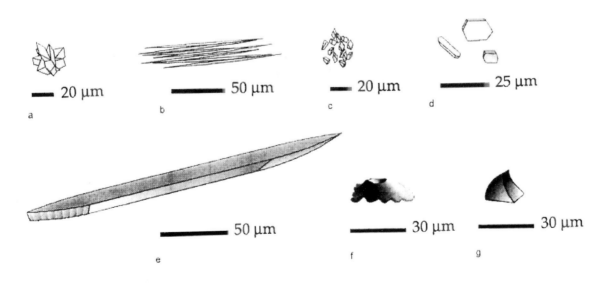

Figure 3 The unit forms of silica and calcium oxalate phytoliths observed: a) calcium oxalate druse crystal in *Musa* and *Cannabis;* b) calcium oxalate raphide crystals in *Musa* and *Agave;* c) calcium oxalate crystal sand in *Musa* and *Cannabis;* d) calcium oxalate (and possibly magnesium phosphate in *Musa*) rhomboid crystals in *Musa, Cannabis,* and *Corchorus;* e) calcium oxalate styloid crystal in *Agave;* f) silicon dioxide body in *Musa* and g) silicon dioxide trichome base in *Cannabis*. Illustration by Y. Olivotto

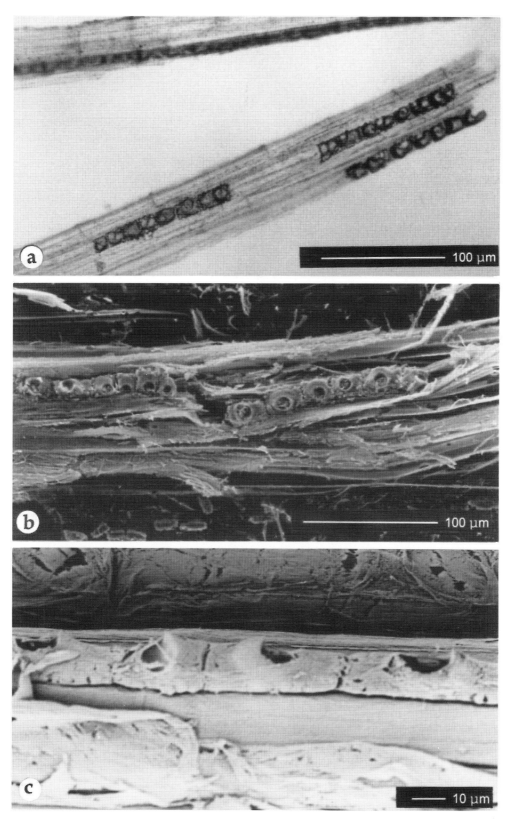

Figure 4 *Musa textilis* Née (abaca or Manilla hemp). a) Photomicrograph of silica files associated with a fiber bundle after fiber was ashed in a cold oxygen plasma; b) SEM photo of silica files shows more detail than a), but also shows the disruption of the sample that can occur during oxygen plasma ashing; c) detail of four silica bodies in a file. Sample has been treated with chloral hydrate and critical-point dried. Silica file is associated with a fiber bundle to which some parenchyma (bottom) adheres; it is not part of the epidermis (above).

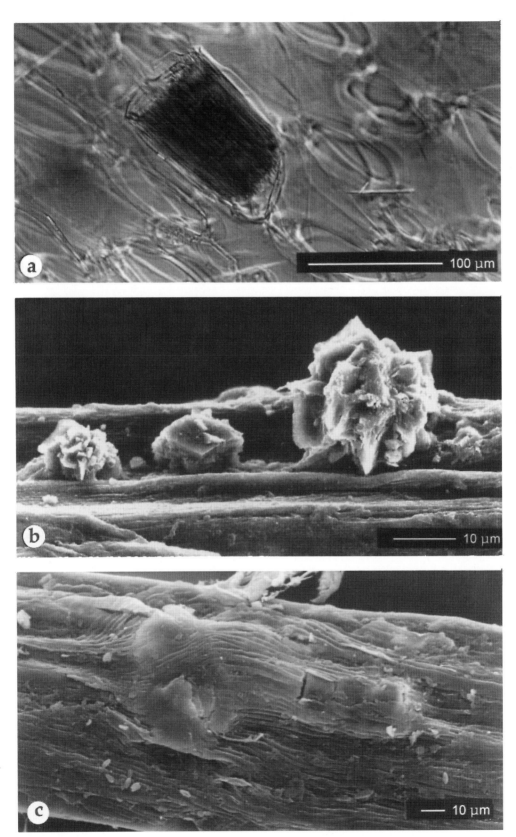

Figure 5 a) *Musa textilis* Née (abaca) leaf sheath contains sacs of calcium oxalate raphide (needle-shaped) crystals that may be extracted manually for microscopic viewing; b) *Cannabis sativa* L. (hemp) contains calcium oxalate crystals associated with the fiber bundles. Druse (cluster) crystals predominate but occasionally rhombohedral-shaped crystals (centre) are found; c) *Corchorus capsularis* L. (jute) may have rhomboid crystals that are often located near a node as in this SEM photo.

THE CLEANING OF COIN HOARDS:
THE BENEFITS OF A COLLABORATIVE APPROACH

David Thickett and Celestine Enderly

ABSTRACT

Coins hoards may contain several hundred coins, often corroded together to form a solid mass. In order to reveal the legends for identification of the coins, chemical methods are used to break down the corrosion. The effects of a range of chemical treatments on coupons of copper and silver and on actual coins have been investigated. These included alkaline Rochelle salt, alkaline Rochelle salt and aluminium (electrochemical reduction), alkaline glycerol, alkaline dithionite, formic acid, and alternate washes of sulphuric acid and sodium carbonate. The effects of each treatment have been determined on both metal coupons and archaeological coins using a variety of analytical techniques. The treatments using alkaline Rochelle salt were found to cause the least 'damage'. Alkaline dithionite was found to be the most aggressive, although in all cases the affects were small. Alkaline glycerol solution and formic acid treatments adversely affected coins containing lead, This investigation has been undertaken as a joint project between a conservator and conservation scientist; the benefits of this collaborative approach are illustrated in this paper.

Key Words

coins, hoards, chemical treatments, collaboration

INTRODUCTION

Coin hoards can contain many hundreds or thousands of corroded coins which need to be identified by numismatists. The legends of the coins are often obscured by corrosion products and in extreme cases the coins may be corroded together as a solid lump, (Fig. 1). However, the coins have usually been buried in a vessel, most often ceramic, and generally have a sound metal core. Coin hoards require processing in an efficient and non-damaging way, to reveal the surface legends and produce coins that are stable in the museum environment. Although many conservators consider chemical treatments to be aggressive, the very large amount of material involved in a coin hoard often precludes individual treatment by hand. Acid–based chemical immersion treatments have been used in the British Museum since the turn of the century. Alkali treatments were introduced in the 1920s as they were thought to be less aggressive towards alloys with a high copper content (Scott 1923) and a range of treatments are now available to the conservator. A literature search has shown that little scientific investigation has been carried out on this subject (Merk 1978, Pollard *et al.* 1990, Wellman 1995).

The composition of coins has been extensively studied (Cowell 1986, Ponting 1994) and conclusions about the method of manufacture, provenance, and authenticity of coins can be drawn from analysis. It is, therefore, important that conservation treatments now should not affect analysis in the future.

The aim of this research project was to investigate the effects of the various cleaning agents on copper and silver coins in order that the conservator can make an informed choice of reagent for conserving a particular hoard. The comparison of different treatments is a common theme in conservation research and one with an obvious impact on the work of the conservator. Research is time consuming and needs to be closely focused to ensure it provides the necessary information. This project has been a collaboration between a conservation scientist and a conservator at all stages, and the questions of interest were as follows.

- Do the treatments etch or otherwise damage the coin surfaces?
- Are any elements leached out of the coins during the treatments?
- Do the treatments leave any contamination on the coins?

Five methods are commonly used in The British Museum for treating copper and silver alloy coins (Watkins and Enderly, in press) and have been investigated. Another method has been reported to give satisfactory results by other institutions; this

utilizes alkaline dithionite (MacLeod and North 1979, Ganiaris in press).

CONSERVATION PRACTICE

In practice, the choice of treatment is determined by the visual assessment of the amount and type of corrosion present on the coin hoard. The coins are immersed in the chosen treatment solution and are regularly checked and removed from the solution as soon as the desired level of cleaning or softening of the corrosion has occurred. A washing procedure is then carried out, usually in running tap water, followed by immersion in two washes of distilled water. If small groups of coins are being treated, the washing procedure would consist of immersion in three washes of tap water and two of distilled water, each for 20 minutes. The coins are then allowed to dry and, in some cases, given a light mechanical clean. Coins may also be given protective coating with a solution of 3% of Paraloid B72 dissolved in acetone.

EXPERIMENTAL WORK

For each process, two treatment times were chosen: (a) to represent an average treatment; and (b) a longer time to represent the maximum time that the coin would be left in the reagent. The choice of treatment times relied on the experience of the conservator. In this work the effects of the treatments on the metal substrate were of interest rather than the relative efficiencies of the treatments at removing corrosion. Hence the treatments were carried out for the two time periods and were not stopped when the desired level of cleaning or softening was reached. Each treatment was followed by immersion in three washes of tap water and two of distilled water, each lasting for 20 minutes.

The effects of each treatment have been assessed using metal alloy coupons of three compositions and also copper alloy coins and debased silver coins, both from hoards. The metal alloy coupons were investigated to provide a homogeneous substrate on which surface changes after treatment would be easily recognised using reflectance microscopy or scanning electron microscopy with energy dispersive x-ray analysis (SEM-EDXA). The question of removal of elements from the coupons by the treatments was investigated by analysis of the reagent solutions by atomic absorption spectrophotometry (AAS). Coins are a very different substrate from metal coupons as they are much more porous. They contain many trace elements not present in the metal alloys, and hence the effects of the conservation treatments on the results of future analysis were determined on the actual coins. The coins were examined visually and using SEM-EDXA, before and after treatment. The EDXA analyses were found to be very variable and therefore the coins were analysed by the method used by the Department of Scientific Research at The British Museum. Drillings were taken from the coins before and after treatments and analysed using x-ray fluorescence spectroscopy (XRF) (Cowell 1986). AAS was not carried out on the reagent solutions after treatment of the coins as the concentrations of copper and silver in the solutions would arise predominantly from the corrosion products on the coins and not from the base metal.

Metal Alloy Coupons

Metals coupons (10x15mm) were cut from sheets of Analar copper (99.9%), sterling silver (9.5% silver, 7.5% copper) and a 40% silver, 60% copper alloy. Each coupon was abraded with a glass bristle brush, degreased in propanone (acetone) and allowed to dry. Coupons of each type of metal were treated separately by immersion in each of the reagents for the two time periods (a) and (b) as described earlier. The time periods represented by (a) and (b) for each treatment are given in Table 1. Control treatments were carried out by immersing sample coupons prepared as above in distilled water for 48 hours.

REAGENTS	COMPOSITION OF REAGENT	USED FOR REMOVING OR SOFTENING	TIME a: average treatment time b: maximum treatment time
alkaline Rochelle salt	50g sodium hydroxide 150g potassium sodium tartrate 1000ml distilled water	general corrosion, copper or silver coins	a: 10 min b: 30 min
alkaline Rochelle salt + aluminium	as above, but coin placed in contact with piece of aluminium foil. Foil replaced when effervescence halts (after 12 minutes)	general corrosion, copper or silver coins	a: 12 min b: 36 min
alkaline glycerol	120g sodium hydroxide 40ml glycerol 1000ml distilled water	general corrosion, copper or silver coins	a: 20 min b: 60 min
alkaline dithionite	40g sodium hydroxide 59g sodium hydrosulphite 1000ml distilled water	general corrosion, copper or silver coins	a: 2 h b: 48 h
30% formic acid	-	cuprite corrosion, debased silver coins	a: 5 min b: 15 min
alternate washes of 5% sulphuric acid & 5% sodium carbonate	-	heavy cuprite corrosion, debased silver coins	a: 3x1 min in each b: 5x1 min in each

Table 1 Treatment Reagents and Times

Loss of Metal into Reagent Solutions

The aggressiveness of each treatment was examined by measuring how much metal had been taken into solution. Each of the reagent solutions was retained after the longer treatment of the coupons and its silver and copper concentration determined using a Pye Unicam SP9 atomic absorption spectrophotometer. Separate treatments with sulphuric acid and sodium carbonate were carried out. The measured copper concentrations are shown in Figure 2. The amount of material removed from the metal coupons by the treatment is extremely small. The highest concentration, 32ppm of copper is equivalent to a 0.01% weight loss from the coupon. There is no consistent pattern in the susceptibility of the different metal alloys used, but the overall apparent order of copper removal of the treatments is:

alkaline dithionite > alkaline rochelle and aluminium > alkaline rochelle > formic acid > sulphuric acid \simeq alkaline glycerol > sodium carbonate

As expected, copper shows greater solubility in the reagent solutions than silver. Silver was removed by four of the treatments. The equivalent losses in silver concentration of the coupons were:

- 0.00002%, from silver/copper alloy coupon treated with sulphuric acid/sodium carbonate;
- 0.00005%, from silver/copper alloy coupon treated both alkaline Rochelle and alkaline Rochelle and aluminium;
- 0.00074%, from silver/copper alloy coupon treated with alkaline dithionite;
- 0.00315%, from sterling silver coupon treated with alkaline dithionite.

Examination of Coupons

After treatment, each of the coupons was examined using a Joel JSM 840 scanning electron microscope with energy dispersive X-ray analysis SEM-EDXA (Thickett and Enderly 1996). Results and a summary of the atomic absorption results are presented in Table 2.

Treatment	Analar Copper			40% silver/copper alloy			Sterling silver	
	Visible changes	Damage	Copper Concentration	Visible changes	Damage	Copper Concentration	Damage	Copper Concentration
alkaline Rochelle – a	orange/red iridescence	N	-	N	N	-	L	-
alkaline Rochelle – b	orange/red iridescence	N	M	N	L	M	L	M
alkaline Rochelle + aluminium – a	N	N	-	N	N	-	L	-
alkaline Rochelle + aluminium – b	orange/red iridescence	N	M	N	L	M	L	H
alkaline glycerol – a	two dark patchs	N	-	N	N	-	N	-
alkaline glycerol – b	orange/red irredescence	N	M	N	N	M	N	L
alkaline dithionite – a	whole surface dark brown/grey	N	-	N	M	-	H	-
alkaline dithionite – b	whole surface dark brown/grey	N	H	N	H	H	H	H
sulphuric acid/sodium carbonate – a	N	L	-	N	M	-	L	-
sulphuric acid/sodium carbonate – b	N	M	M	N	H	L	L	L
formic acid – a	N	L	-	one dark area	L	-	L	-
formic acid – b	N	L	M	N	M	M	L	L

Key

- not determined

N no change compared to control

L low level of damage/Copper concentration (0–5ppm in solution)

M medium level of damage/Copper concentration (5–10ppm in solution)

H high level of damage/Copper concentration (>10ppm in solution)

Table 2 Summarised Results of Treatments of Metal Alloy Coupons

In the SEM where iridescent areas were present on the Analar copper coupons, no differences could be determined between these and the rest of surface. Any damage observed had occurred to the edges of coupons. The coupon treated with alkaline glycerol for 5 minutes was noticed to have two dark brown patches. When viewed under magnification these appeared banded and they were found to be high in carbon. This material was probably a residue of glycerol that had not been fully removed by the washing.

The 40% silver/60% copper alloy was found to have a dendritic structure with a few small, approximately 10μm diameter, pores. After treatment, an increase in porosity was observed, especially within the copper rich dendrites. Aluminium was detected in some of the pits in the surface of the coupon treated with alkaline Rochelle and aluminium.

Surface pitting was observed on some of the treated sterling silver coupons. The alkaline dithionite treatments caused extensive surface pitting (Fig. 3).

Calcium rich particles were present on the surface of all of the coupons, (Fig. 3) which were probably calcite, $CaCO_3$, deposited from the tap water used for washing.

Copper Alloy Coins

The next stage was to examine and compare the effects of the treatments on coins (Thickett and Enderly 1997). Nine copper alloy Roman coins from a hoard found in the Essex area were obtained for experimental purposes. Prior to treatment, x-ray diffraction (XRD) was used to identify the corrosion products on the coins. The corrosion from all of the coins was found to be a mixture of malachite, $Cu_2(CO_3)(OH)_2$, copper phosphate hydrate, $Cu_3(PO_3)_6.14H_2O$, and calcite, $CaCO_3$ a deposit from burial. The presence of a phosphate corrosion product is unusual and is probably due to fertiliser in the soil, or to the residues of habitation. A metal sample was taken from the core of each of the coins using a 0.8mm drill bit, and analysed using x-ray fluorescence spectroscopy (XRF). This indicated that the coins contained 74-91% copper, 7-16% lead, and up to 6% tin, with traces of silver, iron, nickel, antimony and arsenic. A piece was cut from each coin and a polished cross section was prepared in an epoxy block. The surface and cross section of each of the coins was examined in the SEM. The coins were very heterogeneous and the microstructure and composition varied greatly both between the coins and between different areas of the same coin. The degree of porosity also varied, but in the majority of cases the pores were of even size, being around 20μm diameter. The examination of the cross sections was deemed to be extremely useful by the conservator as variations such as very different degrees of corrosion were observed, and several 'hairline' cracks were noticed. Elemental analysis of the surfaces of the coins detected large concentrations of calcium and phosphorus in confirmation of the XRD analysis results.

The six most similar coins were chosen for experimental treatments. Each of the selected coins was cut into three pieces, one of the pieces was retained as a control, and the other two pieces were subjected to treatments (a) and (b) as previously described, followed by washes in tap water and distilled water.

The coin pieces were examined and analysed after treatment. The washing solutions were retained and analysed for the presence of various ions from the treatment solutions using ion chromatography, to follow the removal of the reagents from the coins during the washing process.

No changes were visible on the surfaces of the coins when examined in the SEM after treatment. However the EDXA analysis did show a decrease in the concentrations of calcium and phosphorus at the surface, consistent with removal of corrosion products. The treatments using alkaline Rochelle salt gave the best removal of the corrosion and burial deposits on these coins; the alkaline glycerol and sulphuric acid/sodium carbonate treatments were least effective. Examination of the cross sections revealed that the alkaline dithionite and formic acid treatments had the most severe effect on the coins, causing increased porosity and loss of lead from the lead rich areas. This resulted in a decrease in lead concentration as determined by XRF from approximately 16 to 10%. Lead is reported to be susceptible to attack by formic acid (Uhlig 1948). The 48-hour treatment with alkaline dithionite appeared to have totally removed the lead rich areas throughout the coin (Fig. 4). The alkaline glycerol and sulphuric acid/sodium carbonate treatments were less severe but still caused loss of lead with increased porosity. The treatments based on alkaline Rochelle salt treatments may have had some slight effect, but differences could not be confirmed due to the variations in microstructure shown by the coins.

In all cases, sodium, potassium, sulphate or formate ions from the treatments were not detected after three washes in tap water.

Debased Silver Coins

Originally, it was intended to carry out the treatment on a hoard of freshly excavated silver alloy coins. However, no such hoard could be purchased and it became apparent that any excavated hoard would probably have had some kind of treatment before becoming available. Therefore, four debased silver alloy coins from an hoard were kindly provided by the Department of Coins and Medals of the British Museum for experimental purposes. Visual examination by the conservator confirmed that they had probably been treated prior to acquisition by the Museum. However, deposits of corrosion or dirt were still visible on their surfaces and since the aim of the project was to examine effects of the cleaning agents on the coin substrates these coins were considered suitable.

The coins were examined as before. Silver chloride was identified by XRD as the major corrosion product on the surface of the coins. The coins contained over 90% silver, with copper and traces of gold and lead. The surface analyses did not differ significantly from the bulk analyses carried out by XRF on samples obtained by drilling.

Since the number of coins was limited, only long-term treatments were carried out, as these would show the most effect. The three most similar coins were selected and treated and examined as before. The coin surfaces were quite heterogeneous with areas of original surface separated by rough corroded areas. Only the coin treated with alkaline dithionite showed any definite change, with the surface becoming rougher (Fig. 5).

SUMMARY OF RESULTS

None of the treatments caused extensive damage to the coins. After all treatments, the coins were basically sound and even in the worse cases only a very small amount of material was removed from them. The relative effects of the treatments on each metal are summarised in Table 3 from both the work on the metal coupons and on the coins.

Treatment	Effect on		
	Copper	Silver	Lead
alkaline Rochelle	M	M	M
alkaline Rochelle + aluminium	M	M	M
alkaline glycerol	L	L	H★
alkaline dithionite	H	H	H★
formic acid	M	L	H★
sulphuric acid/sodium carbonate	M	M	L

Key

L low effect
M medium effect
H high effect
★ loss of lead could be detected from the core analysis (XRF on drilled sample)

Table 3 Effects of Treatments on Different Metals

All of the treatments resulted in some deposition of particulate matter but the particles were only visible under high magnification. The particles are calcium rich and are most likely to be calcite ($CaCO_3$) deposited from the tap water used for washing. If this is the case then they are inert and pose no risk to the future stability of the coins. Light mechanical cleaning, if carried out is likely to remove these particles.

Two of the treatments left residues on the metal surfaces, even after washing. The alkaline glycerol treatment left a carbon rich deposit on the copper coupon. This is probably glycerol, which has not been fully washed away. The presence of a hygroscopic material on the surface of a coin will attract moisture from the air and accelerate corrosion. The alkaline Rochelle salt plus aluminium treatment did deposit some aluminium into the existing porosity of the 40% silver/copper alloy coupon. However the aluminium concentration is not useful in archaeometric studies of coins from an archaeological context.

The long term effects of the treatments on the stability of the coins have not been evaluated in this work. The treated coin pieces have been returned to the normal storage and will be monitored periodically to determine any changes. Thousands of coins from the Museum's collections have been treated with the methods described over the past 40 years. These coins are in good condition and are apparently stable.

The alkaline Rochelle based treatments would appear to be the least damaging for general use in removing common corrosion products and burial deposits on coin hoards. These treatments were also the ones favoured by the conservator.

If the alkaline glycerol treatment is to be used then it would be prudent to analyse the coins first to determine if any lead is present. The apparent deposition of glycerol by this treatment raises concerns about the long-term stability of coins.

Alkaline dithionite was the most aggressive treatment evaluated and there would seem to be little justification for the use of this treatment as less aggressive treatments are available. However, alkaline dithionite is reported to be effective at removing waxy types of silver corrosion that are resistant to some methods of treatment and may have an application in such cases.

Considering the treatments for cuprite corrosion on silver alloy coins, formic acid treatments are less aggressive than sulphuric acid/sodium carbonate treatments, unless lead is present.

DISCUSSION

This work has illustrated the benefits of careful experimental design. The two approaches, with metal alloy coupon and coins, complemented each other to give a fuller picture of the effects of the treatments. The work with metal alloy coupons yielded an important comparison of the treatments and allowed quite small differences between treatments to be determined. The work on coins provided useful additional information about effects on lead, which although not usually present in European copper alloy coins, is very common in oriental coins of which the British Museum has a large collection.

One of the important aspects of this type of research project is the interpretation of the results. As scientific techniques are becoming more and more sensitive, very minor changes can be detected and these can be greeted with some consternation by the conservation profession. In this case, the changes were certainly not visible to the naked eye and would probably be very difficult to detect with a conventional microscope.

Working together has allowed both partners to share their experience and knowledge, and involvement in the scientific aspects of the work has allowed the conservator to have an in depth appreciation of the conclusions of the project and how they should affect the conservation of this type of material in the future.

A collaborative approach has produced a piece of work that has more fully addressed the needs of the conservator and the collections of The British Museum.

ACKNOWLEDGMENTS

The authors would like to thank Andrew Burnett, Keeper of the Department of Coins and Medals for the provision of coins for experimental work, Michael Cowell, Department of Scientific Research, for his advice on coin analysis, and their colleague Lorna Lee for ion chromatography and much useful discussion and guidance.

REFERENCES

Cowell, M.R. 1986. The application of chemical, spectroscopic and statistical methods of analysis, in *A Survey of Numismatic Research, 1978-1984* (eds M. Price et al.), IAPN Special Publication, No. 9, 2:1022-40.

Ganiaris, H. In press. Reduction with gain: the treatment of excavated silver coins with alkaline dithionite, in *Looking After The Pennies*, proceedings of a conference at the Museum of London, 1994, London.

Merck, L.E. 1978. A study of reagents used in the stripping of bronzes, *Studies in Conservation*, **23**, 15-22

MacLeod, I.D. and North, N.A. 1979. Conservation of corroded silver, *Studies in Conservation*, **24**, 165-71.

Pollard, A.M., Thomas, R.G. and Williams, P.A. 1990. Mineralogical changes arising from the use of aqueous sodium carbonate solutions for the treatment of archaeological copper objects, *Studies in Conservation*, **35**, 148-53.

Ponting, M.J. 1994. *Folles and forgeries: an appraisal of the composition of Roman copper-alloy coinage of the mid-third to mid-fourth centuries A.D. from Britain*, Ph.D. Thesis, University College, London

Scott, A. 1923. *The cleaning and restoration of museum exhibits*, Second report upon investigations conducted at the British Museum, HMSO, London.

Thickett, D. and Enderly, C. 1996. The effects of cleaning agents on coins, *British Museum, Department of Conservation, Conservation Research Group Internal Report*, No. 1996/14.

Thickett, D. and Enderly, C. 1997 . The effects of cleaning agents on coins part II – Work on coins from hoards, *British Museum, Department of Conservation, Conservation Research Group Internal Report*, No. 1997/2.

Uhlig, H.H. 1948. *The Corrosion Handbook*, Chapman & Hall, London, 212.

Watkins, S. and Enderly, C. In press. Processing coin hoards at the British Museum, in *Looking After The Pennies*, proceedings of a conference at the Museum of London, 1994, London.

Wellman, H. 1995. *The effects of alkaline dithionite treatment on silver-copper alloys*. Report submitted for B.Sc to Institute of Archaeology, University College London.

David Thickett and Celestine Enderly, Department of Conservation, The British Museum, London, WC1B 3DG

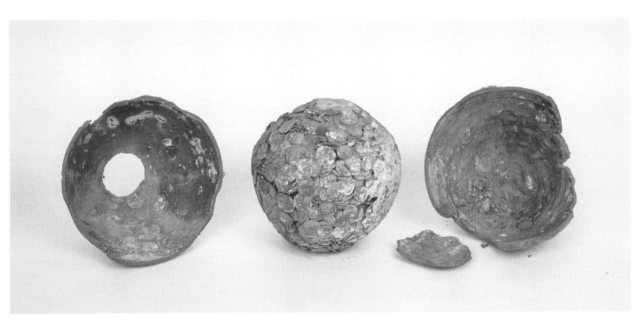

Figure 1 Silver coin hoard found at Chalfont St Peter in 1992

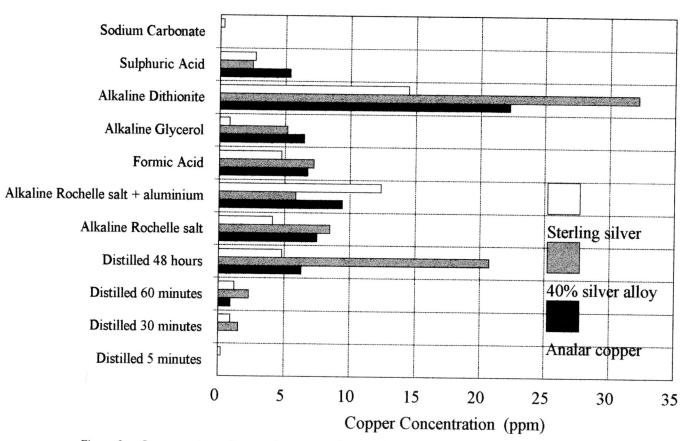

Figure 2 Concentrations of copper in reagent solutions after treatments of metal coupons. scale bar – 5μm

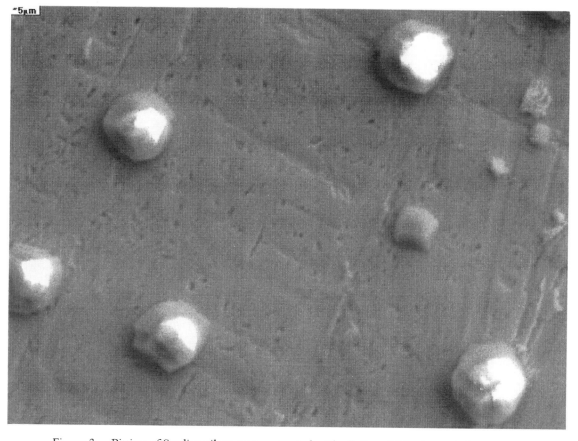

Figure 3 Pitting of Sterling silver coupon treated with alkaline dithionite. scale bars – 20μm

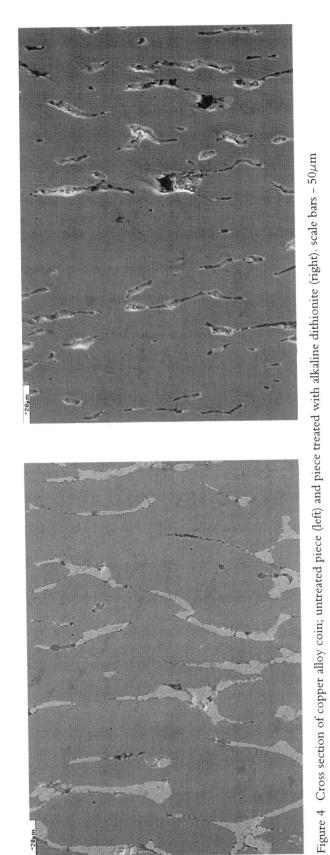

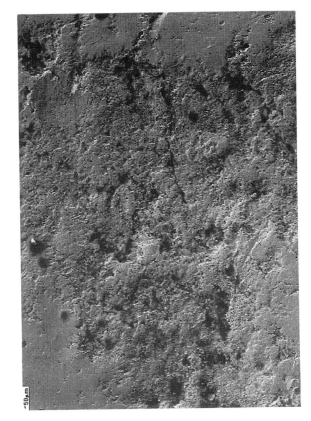

Figure 4 Cross section of copper alloy coin; untreated piece (left) and piece treated with alkaline dithionite (right). scale bars – 50μm

Figure 5 Surface of silver coin; untreated piece (left) and piece treated with alkaline dithionite (right)

SIMULATION OF GOLD ENAMEL DEGRADATION

Monika Pilz and Carola Troll

ABSTRACT

The degradation of coloured gold enamels from the late eighteenth century has been observed to a considerable extent in museum environments during the last twenty years. This damage is caused by microclimatic stresses although displayed in 'safe' show cases.

In a case study 'Investigations on Indoor Environmental Influences on Gold Enamels at the Gruenes Gewoelbe' (funded by Deutsche Bundesstiftung Umwelt) an interdisciplinary team of conservators, materials scientists and chemists examined the dramatic deterioration of golden enamel figures from the main collection of the Saxon Court, dating from the baroque period, at the museum 'Gruenes Gewoelbe' (Green Dome) in Dresden, Germany.

This co-operation was aimed at explaining the effects of indoor pollutants on the corrosion processes of the enamels. The collaborative research is important as the first step towards effective preservation, including the development of conservation methods specifically for these art objects, in order to maintain their integrity for the future.

Key Words

enamel, degradation, micro-environment, model substrate, accelerated ageing, conservation

INTRODUCTION

Works of art in general are endangered worldwide by microclimatic environmental stresses occurring in museum showcases. Recently there was a growing concern that the outstanding examples of ancient coloured enamels which are displayed for visitors, or stored for ongoing restoration work would soon be lost. Investigations in the laboratory were concentrated on sensitive enamels either applied on silver ('émail en ronde-bosse') from the late Gothic period (Zamora *et al.* 1995) or painted on copper from the early Renaissance at Limoges (Perez 1993). However, gold is the most precious substrate for these enamelled works of art.

An example of this increasing degradation is in the museum 'Gruenes Gewoelbe' in Dresden, where unique precious objects in gold from the eighteenth century, part of the extensive historical collection of King '*August der Starke*' of Saxony, are endangered by a gradual loss of the enamel layers (Figs. 1, 2).

From the chemical point of view enamels can be compared to coloured glass (Scholze 1988) since the main component of enamel is also silica modified by different alkaline and alkaline earth oxides, and minor amounts of colouring compounds of manganese, cobalt, nickel, iron or copper. Enamels are considered to be a composite material of a glass melted onto a metal substrate (Dietzel 1981). The tensile stress within the glass, and therefore its tendency to crack, is strongly influenced by the thermal coefficient of expansion of both the glass and the metal substrate.

In addition to external environmental influences, the composition of the glass itself and its contact to the metallic substrate, are obviously important factors in the susceptibility of enamels to chemical and mechanical degradation processes. This paper reports the systematic research into the corrosion phenomena of gold enamels carried out in the study: '*Investigations on Indoor Environmental Influences on Gold Enamels at the Gruenes Gewoelbe*' (Mueller 1995). Possible parameters influencing the degradation of the originals were simulated on model enamels of different compositions, using different accelerated weathering conditions in climatic chambers.

THE COLLABORATIVE TEAM

The members of the collaborative team involved in the fifteen-months research project were scientists and conservators from the Federal Institute for Materials Testing (Bundesanstalt für Materialforschung und -prüfung BAM, Berlin), from an institute for applied materials research (Fraunhofer-Institut für Silicatforschung ISC, Würzburg) and from the museum 'Gruenes Gewoelbe' in Dresden. Wuerzburg) and from the museum 'Gruenes

Gewoelbe' in Dresden. The tasks were divided amongst the members of the team as described below, and diagrammatically (Fig. 3).

The conservators had access to historical scripts recording the origin of the raw materials, formulations, the technique of manufacture of these prestigious objects, and their case histories up to and including recent treatments. This information was indispensable in determining the composition of the original enamels in conjunction with the chemical analysis of splinters of enamels carried out at BAM; and in explaining the corrosion phenomena. The contribution of both research institutions to the work programme included the preparation of appropriate specimen model enamels using historically documented techniques. After an exchange of samples, artificial climatic conditions were selected for accelerated weathering. The subsequent characterisation of the aged samples was carried out at ISC and BAM. During the project period the partners met every three months to discuss the results obtained from the measurements and to direct further research.

SPECIFIC PHENOMENA OF ENAMEL DEGRADATION IN 'GRUENES GEWOELBE'

The present alarming condition of the gold enamels in 'Gruenes Gewoelbe' is concentrated on the coloured translucent enamels which showed the most severe damage. Opaque white and flesh tone enamels proved to be less susceptible to degradation. The main collection had been stored and displayed at a controlled temperature and humidity for more than ten years in the same show cases constructed of security glass with composite boards covered by a damask textile, or in a wooden safe.

Photodocumentation

The deterioration of the coloured translucent enamels is characterised by a decrease in their former glossiness, the formation of a milky film on the surface and an increased growth of cracks within the enamel layer comparable to the phenomena of glass disease. In some cases the phenomena lead to a complete loss of adhesion of the enamel to the gold substrate. In other cases it is observed that an extremely unstable top layer of enamel is separated from the underlying enamel which remains relatively firmly attached to the gold metal base. Splinters of enamel falling down on the shelves could be seen nearly every day in the display cases or in the safe.

The conservators from the 'Gruenes Gewoelbe' took macro photographs of the deteriorated objects for damage characterisation while obvious damage was additionally documented by examination using a microscope (Figs. 2, 4 and 5). According to the statistical evaluation of the observed corrosion phenomena, two types of damage could be distinguished (Mueller 1995):

- the blue and red enamels showed mainly a milky surface layer with crizzling structure and crystalline white corrosion products;
- the green coloured enamels exhibited splintering with splinters flaking off the objects.

Environmental Influence

It was assumed that the degradation processes observed were caused by the aggressive attack of gaseous pollutants and humidity on the enamel, with the synergistic effect of the different parameters enhancing the alteration process.

The examination of the micro-environment in the display cases was carried out within the EC project *'Assessment and Monitoring the Environment of Cultural Property'* (Leissner 1996). The routine monitoring programme, recording gaseous compounds by passive samplers, humidity and temperature by data loggers, was combined with a glass sensor study (Fuchs and Leissner 1995) to detect the overall corrosive potential. The latter showed that a corrosive atmosphere existed in the show cases, and in storage. It originated from a combination of volatile organic compounds, mainly formaldehyde and acetic acid, released by the construction materials of the display case itself, and sulphur dioxide which entered the cases via an inadequate air filter system.

In general the levels of SO_2 and NO_x in Dresden have been drastically decreased during the last 20 years due to changes in the heating systems and types of motor vehicles. However, the air pollutants transported from outdoors into the showcases were not decreased by the air conditioning system, but were concentrated by the air flow exchange.

194

Chemical Analyses of the Original Enamels

Analysis of original enamel splinters was carried out at BAM using a scanning electron microscope in combination with an energy dispersive X-ray analyser (SEM-EDXA). The analyses showed that the translucent enamels were made from an alkaline-rich silicate glass (soda-lime glass). They exhibited the characteristic phenomena of glass degradation:

- leaching out of alkaline and alkaline earth ions at the enamel surface resulted in a soft gel layer;
- sodium and calcium sulphate and carbonate crystals were formed on the surface and along the cracks by reaction with pollutants.

On the back surface of the splinters, the former enamel/metal interface, a similar gel layer, poor in alkaline, could be found.

The chemical composition of splinters from a green (GM 2) and a blue (DS 8) enamelled figure displayed in the show cases 'Großmogul (GM)' and 'Dinglinger Schale (DS)' were determined by non-destructive electron scanning micro-elemental analysis (ESMA) (Mueller 1995) (Table 1).

The original gold substrates were analysed to be an alloy of gold with silver and copper, 70-85 weight% Au, 10-25 weight% Ag, 4-5 weight% Cu.

Table 1 Composition (in weight%) of the original (GM, DS) and the corresponding model enamels (MGM, MDS) used for the case study (2: a green coloured enamel, 8: a blue coloured enamel)

Enamel	SiO_2	Al_2O_3	Na_2O	K_2O	CaO	MgO	SO_3	Cl	MnO	Fe_2O_3	CuO	NiO	P_2O_5
GM 2	61.6	0.8	18.9	2.9	2.6	0.5	0.7	0.6	0.3	3.9	7.8	0.1	0.1
MGM 2	61.1	0.8	18.8	2.9	2.6	0.5	0.7	0.6	0.3	3.9	7.8	-	-
												CoO	As_2O_3
DS 8	67.2	0.7	21.6	2.7	0.6	-	0.9	0.8	-	0.7	2.7	0.7	1.4
MDS 8	68.2	0.7	21.9	2.7	0.6	-	0.9	0.8	-	0.7	2.7	0.7	-

SIMULATION OF ENAMEL DEGRADATION IN THE LABORATORY

Preparation of Simulation Substrates

Model enamel substrates with a composition corresponding to the originals, (MGM 2 and MDS 8, in Table 1), were prepared for use in the laboratory experiments. Carbonates, sulphates and chlorides as well as oxides were used for the glass melt at approximately 1300°C. A defined amount of the powdered glass obtained by grinding and screening was applied to square gold substrates, 1.5cm x 1.5cm x 0.05cm thick, in order to prepare a reproducible thickness of the enamel layer of 0.05cm or 0.025cm. The composition of the gold used was (by weight) 75% gold, 20% silver and 5% copper. The substrates were heated to approximately 850°C to prepare the enamels. Some of the enamels were pre-damaged by cracks carefully produced through specific cooling conditions, which caused mechanical stresses within the glass.

Conditions for Accelerated Ageing

The typical corrosion reactions of glass are well known (Scholze 1988). A high relative humidity should cause degradation of the enamel layer, starting with an ion exchange reaction on the surface. On the resulting gel layer crystals of alkaline and alkaline earth compounds are expected to form depending on the pollution level in the atmosphere. Great differences in humidity and temperature should cause additional stress leading to an increased growth of cracks within the enamel layer. Therefore extreme climatic conditions, pollutant levels, and changes in relative humidity and temperature, for indoor environments, were selected in order to reproduce damage to the model enamels within an acceptable exposure time (Table 2). The combination of parameters in the climates A-D was chosen to estimate the influence of each factor in the deterioration process by direct comparison of their effects on the enamels.

Table 2 Climate conditions for accelerated weathering

Climates	Conditions		Dose of pollutants	Time of exposure	carried out at
A	temp. rel. humidity	45°C 80%	---	21 d	BAM
B	temp. rel. humidity	45°C 80%	5 ppm SO_2 5 ppm NO_2	21 d	BAM
C	cyclic temp. cyclic rel. humidity	-10 to 50°C 30 to 90%	---	6.5 d and 14.5 d	ISC
D	cyclic temp. cyclic rel. humidity	-10 to 50°C 30 to 90%	2 ppm SO_2 0.3 ppm NO_2	6.5 d	ISC

Characterisation of the Degradation Progress

The many corrosion processes cannot be assessed separately due to the synergistic effect of the different parameters influencing the reaction progress. The degradation of the model enamel samples exposed to the various accelerated weathering conditions was documented by light microscopy and in some cases by scanning electron microscopy (SEM). A semi-quantitative determination of the corrosion process was obtained using infrared (IR) spectroscopy coupled with a microscope, in reflection mode.

Exposure to a Constant Temperature and Relative Humidity (climate A)

After 21 days of exposure to climate A simulating relatively humid storage conditions, the difference between the green and the blue model enamels became obvious. The blue enamel (MDS 8) showed a more significant change in appearance, seen in the central area of Figure 6, due to leaching of alkaline and alkaline earth metal ions from a thin surface layer. This was observed by line scan measurements along a cross section. Through this ion exchange, water diffused into the top layer of the enamel, while white salt crystals of the leached calcium and sodium covered the surface of the enamels reducing their former bright glossy appearance. These corrosion products were identified as carbonates and sulphates by ESMA measurements (Mueller 1995). The concentration of SO_2 in the atmosphere taken from outdoors, which was humidified and used for climate A appeared to be sufficiently high to form crystalline sulphates on the whole of the enamel layer.

Exposure to a Constant Temperature and Relative Humidity at a High Level of Pollutants (climate B)

The specimen of MDS 8 exposed to climate B clearly showed a gel layer, typical of ion leaching at high relative humidities, in areas near the surface. In contrast to samples exposed to climate A, crystals of sodium and calcium sulphates formed a dense crust as a consequence of the high levels of pollutants (Fig. 7). Pollutants in combination with a humid and warm atmosphere caused severe corrosion. These reactions were enhanced as the pH of the water in the cracks decreased due to the high SO_2 and NO_2 concentrations. Along these cracks corrosion could even be found in the more stable model enamel MGM 2. Nevertheless, both enamels seemed to still resist permanent humidity, and occasional direct water contact to a certain extent, so that the corrosion processes remained limited to a micro-scale within the cracks.

Exposure to a Cyclic Temperature and Relative Humidity (climate C)

Cycling of humidity and temperature accelerated the corrosion processes, causing additional stress, resulting in an increased growth of cracks within the enamel layer, compared to climate A. The blue as well as the less sensitive green enamels were badly attacked by these cyclic climate conditions (Figs. 8 and 9). The chemical conversion, once it has occurred at the surface, in the cracks and at the interface of metal and enamel, is irreversible. The thickness of the gel layers can only be estimated roughly by line-scan measurement. The surface alterations were more or less visible, at least where cracks in the enamels had

been observed by light microscopy. Therefore it can be assumed that each drastic or long-term change in environmental conditions can cause damage to the enamel (Fig. 8).

The advanced corrosion process could also be confirmed by IR spectroscopy, using reflection mode because of the non-transparent samples. In contrast to the spectrum of MGM 2 (Fig. 10), a definite change in the intensity of absorptions in the range from $800cm^{-1}$ to $1250cm^{-1}$ after exposure to accelerated weathering for 6.5 and 14.5 days was detected in the spectrum of MDS8 (Fig. 11). A decrease of Si-OM valence vibrations at $980cm^{-1}$ and its shift to lower wave numbers, (M = alkaline or alkaline earth ion), combined with an increase of Si-O-Si deformation vibrations at $1060cm^{-1}$ indicates ion exchange resulting in a change to the structural environment at the enamel surface after weathering.

Exposure to a Cyclic Temperature and Relative Humidity at a High Level of Pollutants (climate D)

Climate D caused the most corrosive attack on the blue enamel surfaces (Fig. 12). The corrosion progress can be confirmed by IR spectroscopy, (Fig. 13). Heavy corrosion is indicated by a decisive decrease in absorption at about $980cm^{-1}$ and its shifting to lower wave numbers. The green enamels proved to be more resistant to the climatic conditions since there were no definite changes in the IR spectrum after this short weathering period.

The growth of corrosion products on the weathered blue enamel surface and along the cracks led to the lifting of enamel flakes from the residual enamel mass (Figs. 14 and 15). In many areas the enamel cracked down to the metal base thus providing the aqueous, acidic medium with access to the enamel-metal interface, which is highly sensitive to chemical attack. It seems that further degradation occurred along this interface because this was the weakest area of the composite material. The adhesion of the enamel to the metallic substrate varied significantly over the area of these samples.

SUMMARY AND CONCLUSIONS

The influence of the indoor environment and changing microclimatic conditions on the deterioration of gold enamels from the museum 'Gruenes Gewoelbe' were investigated. Measurement of environmental stresses, based on glass sensors and passive samplers, in the 'Gruenes Gewoelbe', as well as simulation experiments on model enamels proved that air pollutants are a cause of the degradation of the enamel objects.

In collaboration with conservators who carefully documented the degradation phenomena of sensitive objects in the museum 'Gruenes Gewoelbe', two model enamel types were prepared by scientists. Corrosion phenomena similar to those of the originals, formation of a gel layer and corrosion products, cracks in the enamel mass and splinters flaking off, could be reproduced by accelerated weathering.

The influence of temperature and humidity changes and levels of SO_2 and NO_2 pollutants on the corrosion of enamels were estimated by the systematic variation of four sets of parameters in climatic chambers. The chemical composition influences the sensitivity of the enamels to reactions with aqueous solutions, especially when the acidity of the media is increased by gaseous pollutants. Chemical attack is induced on the enamel surface and on areas along the cracks formed in the substrate. This results in noticeable zones of reaction forming gel layers. In addition, the combination of glass and metal does not have a great ability to withstand corrosive attack. There are high stresses within the materials themselves, as well as in the composite structure due to the difference between the coefficients of expansion of the enamel and the metal substrate.

In some showcases and storage areas, other aggressive pollutants were measured which were evolved by the construction materials. These were formaldehyde, acetic acid and volatile organic compounds. They probably also play a role in increasing the corrosion rate. Further investigations are necessary to study these influences.

Based on the mechanisms presented here, it can be assumed that all objects in which damage is not yet visible, as well as the areas of already partly degraded pieces of gold enamels, have already been subjected to the initial stages of degradation and the visual effects of damage will occur at some time. How long this will take depends on the environmental conditions to which these art object are exposed in the future. In

addition to the general environmental stress, even higher pollution levels may occur locally causing an additional risk to some objects. Any direct conservation and restoration measures for enamels should include efforts to optimise the micro-environment in the museum and in the show case.

Mechanical vibration and drastic changes in temperature may also cause increased cracking of enamels. Because of past or current corrosion processes, the enamels are at a stage where, on the one hand, rapid conservation measures are needed, but on the other hand all conservation measures should be considered thoroughly and only be put into effect with great care. The analysis of the corrosion mechanisms shows that the influence of air pollutants combined with existing mechanical damage results in a high damage potential.

The results of this case study are considered to be the initial step for further research on long-term preservation procedures which will be carried out through a continued co-operation aiming at the development of appropriate conservation techniques and materials in order to meet the special requirements of these unique works of art.

ACKNOWLEDGEMENTS

The authors would like to thank their partners at BAM, Berlin (Wolfgang Mueller, Detlef Kruschke and Karin Adam) and 'Gruenes Gewoelbe', Dresden (Christine Wendt and Rainer Richter) for their friendly and co-operative collaboration and the *Deutsche Bundesstiftung Umwelt* (DBU), Osnabrueck for the funding of this case study.

REFERENCES

Dietzel A.H. 1981. *Emaillierung - wissenschaftliche Grundlagen und Grundzüge der Technologie*, Springer Verlag, Berlin.

Fuchs D.R. and Leissner J. 1995. Glassensoren erfassen das Schadensrisiko an Kunstobjekten, *Restauro* **3**, 170-3.

Leissner J. (ed) 1996. *Assessment and Monitoring the Environment of Cultural Property, Final Report: CEC-Contract EV5V-CT92-0144"AMECP"*, Wuerzburg.

Mueller W. (ed.). 1995. *Modellhafte Untersuchungen zu Umweltschaedigungen in Innenraeumen anhand des Gruenen Gewoelbes*, Final report: Forschungsbericht 215, Verlag für neue Wissenschaft GmbH, Bremerhaven

Perez y Jorba M., Rommeluere M. and Mazerolles L. 1993. Etude de la détérioration d'une plaque d'émail peint de Limoges, *Studies in Conservation* **38**, 206-12.

Scholze H. 1988. *Glas - Natur, Struktur und Eigenschaften. 3 Auflage,* Springer Verlag, Berlin.

Zamora Campos B., Schmitz J., Clark A. and Schreiner M. 1995. Transluzides burgundisches Email auf Silber - *Teil II, Restauro* **6**, 418-21.

Monika Pilz and Carola Troll, Fraunhofer-Institut für Silicatforschung (ISC), Bronnbach Branch, Bronnbach 28, D-97877 Wertheim, Germany
E-mail: pilz@isc.fhg.de

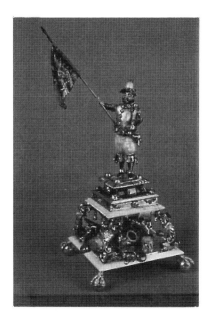

Figures 1 and 2 left: endangered enamelled gold object selected from the 'Gruenes Gewoelbe' (original height 15.2cm); right: the flag showing the loss of enamel in detail

Collaborative tasks

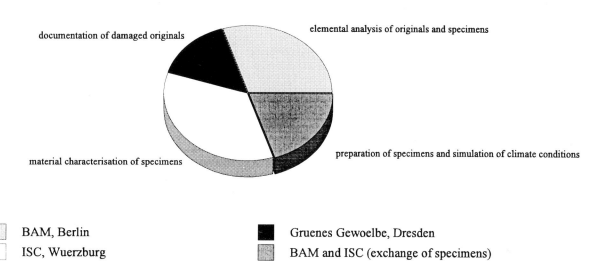

Figure 3 Involvement of the project partners (shares of funding)

Figures 4 and 5 Details of corroded enamel layers which are partly separated from the substrate surface by flaking off

Figures 6 and 7 Microphotographs of model enamel MDS 8: a specimen exposed to climate A (21 d, left) and a specimen exposed to climate B (21 d, right)

Figures 8 and 9 Macrophotographs of model enamels exposed to climate C (6.5 d): a MGM 2 specimen (left) and a MDS 8 specimen (right).

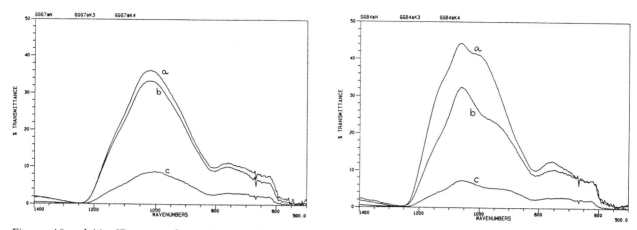

Figures 10 and 11 IR spectra for specimens of model enamels exposed to climate C (a: before exposition, b: after 6.5 d exposure, c: after 14.5 d exposure): a MGM 2 specimen (left) and a MDS 8 specimen (right)

Figures 12 and 13 Photograph (left) and IR spectrum (right, a: before exposure, b: after 6.5 d exposure) of model enamel MDS 8 exposed to climate D

Figures 14 and 15: SEM-micrographs of model enamel surface MDS 8 exposed to climate D (2 d): corroded area where an enamel splinter flaked off (left) and area with gel layer (after removal of crystalline corrosion products, right)

201

THE CONSERVATION OF AN INDIAN POLYCHROME FIGURE OF THE INDIAN GOD, BAL KRISHNA

Rachel Kilgallon and Susan Thomas

ABSTRACT

The paper presents an account of the research, analysis and conservation carried out on a complex ethnographic artefact. Treatment was accompanied by an investigation into the method of manufacture, the original materials and those added in later unrecorded restoration. Experiments were undertaken to test materials to be used in the conservation process. As a case study, the work illustrates use of a range of scientific analysis available to the practising bench conservator, and also the importance of findings from such investigations in the decision making process which underpins all treatment. Finally the treatment involved various ethical dilemmas and the use of aesthetic judgements but was primarily determined by the findings of scientific investigation.

Key Words

ethnographic, clay, polychrome, treatment, investigation, analysis.

INTRODUCTION

In 1994, an Indian polychrome figure belonging to the Hancock Museum in Newcastle was transferred to the Conservation Section, De Montfort University, Lincoln, for treatment assessment. The aim of the assessment was to establish conservation requirements in terms of investigation, cleaning and stabilisation, with the possibility of reconstruction and sympathetic restoration.

Proposals for treatment were subsequently approved by the Hancock Museum and a programme for the conservation of the figure was initiated in March 1995.

This paper presents a short account of the research, analysis and conservation treatment. This was accompanied by an investigation into the manufacture of the original materials and experiments to test the suitability of materials to be used in the conservation process.

HISTORY

Few details as to the provenance or condition of the figure prior to its donation to the Hancock Museum in 1858 have been established. The accession register described it as 'a cloaked model of Bal Krishna'. However, the figure is now naked but for the moulded bands of gold jewellery, inset with glass or mica gems, which encircle his neck, waist and limbs, (Fig. 1).

Such figures and others representative of the divine personalities of *Brahma*, *Siva* and *Vishnu* are prominent in the rituals of Hindu worship. Krishna is depicted in various stages of the human lifecycle, from infancy to manhood. To distinguish him from ordinary mortals, his skin is always rendered in blue (Gombrich 1989).

This figure is realistically sculpted in the form of a well proportioned, crawling infant. The facial features are naturalistic, the lustrous appearance of the inset glass eyes adding to the lifelike effect. A hole has been pierced in each ear to accept an earring (Fig. 2). The palms and soles of the feet are decorated in gilt with religious symbols, similar to the hennaed patterns applied by Hindu women. The marks on the upper arms and forehead denote social caste.

During its history, the figure had been subjected to inappropriate environmental conditions. This had resulted in mechanical damage to the moulded and painted decoration and extensive dirt accumulation. Earlier attempts to replace a detached arm had been unsuccessful and prevented the figure from being displayed in its original posture. A handwritten museum label, adhering to the back of the figure, was overpainted at the edges indicating that these repairs were carried out subsequent to its arrival at the museum (Fig. 3). Unfortunately, this work is undocumented.

GENERAL CONDITION

Preliminary inspection of the figure revealed it to be an elaborate construction of unfired clay decorated with paints, gold leaf and inlays. Microscopical examination of a sample of detached material revealed this decorative layer to comprise a red textile overlaid with what appeared to be a gesso ground.

The object was poorly preserved and had suffered extensive cracking and loss. The worst damage had occurred to the neck, the groin, legs and feet, the left side of the body at shoulder level and the arm, which was detached. Where cracking had occurred, limbs were loose and the head was misaligned. Some attempt had been made to repair or disguise the cracks with a dark blue/black pigmented filler. Examination of the detached arm, feet and other areas revealed these crude fillings and repairs to be extensive. Previous attempts at restoration were also evident where the arm had become detached exposing the pale yellow body. Here, successive repairs were apparent: dark brown, semi-opaque, brittle animal glue, and paler yellow, more recent, translucent adhesive. Large areas of the torso and face had been liberally overpainted with a variety of pigmented mediums, ranging from a dark blue/black wash to a thickly applied pale blue layer. These had been applied where the original paint layer had been lost; more recent areas of loss appearing white. In some areas, the decorative layer had been lost completely or worn away.

The surface of the figure was very soiled and had suffered considerable dirt accumulation which was obscuring finer details on the hands and feet. The paint layer was degraded and discoloured and, in places, fine white particles were visible within the decorative layer giving a whitish, mottled appearance.

The tip of the penis and several fingers and toes were missing. In these places, a coarse textile was visible within the clay body. This material was also found within the torso, the detached arm and decorative mouldings. It appeared to have been used as a support around which to mould various parts of the body and decorative details.

Areas of the moulded jewellery were loose or missing and some of the gems were detached. Where the gilding was missing, the underlying composition had a pale yellow, shiny appearance, suggesting use of a size prior to gilding.

EXAMINATION AND ANALYSIS

To assess specific conservation requirements of the figure, more thorough examination was necessary, to establish both the type and extent of damage and the nature of the materials and methods used in its construction.

X-Radiography

X-radiography provided valuable information about the structure and presence of internal supports within the fabric.

Visual examination had revealed a metal rod protruding from the foot suggesting the presence of a metal armature. In fact, this was a repair and the internal support faintly evident on the radiograph was later identified as wooden and similar to the stake found in the detached arm.

The 'Clay' Body

Small samples of the body were removed from the detached arm for examination. Tests were qualitative and intended to give an indication of the properties of the substance rather than definitive identification.

1. A small sample was placed in a test tube and de-ionized water added. The sample dissolved, indicating that the 'clay' was unfired.
2. A second sample was mounted in Canada Balsam and examined microscopically (x10 mag). In addition to the clay particles, large amounts of vegetable/bast fibres were evident.
3. A third sample was ground to a fine powder. Equal amounts of this were placed in metal crucibles and weighed. These were then repeatedly heated over a Bunsen burner to reduce the organic material and re-weighed until no further modification was observed. The mean percentage of organic material was approximately 4%.

Two conclusions could be drawn from this:
1. the sample comprised unfired clay mixed with some form of fibrous waste, e.g. cotton or kapok, to improve its working properties and/or;
2. it contained some form of animal dung including undigested cellulosic material. In which case, given the religious status of the cow in India, the most likely identification was cow dung.

The Internal Support Material

The rolls of support textile were stable and in relatively good condition. Generally pale yellow to brown in colour, this appeared darker in places, perhaps due to an animal glue or resin used to hold it in shape before clay was applied. Although several different widths of fabric had been used as supports, all were made of the same rather coarse, thick fibre in a fairly close, plain tabby weave (Hodges 1989).

The textile support for the gesso ground was quite distinct from that used to form the mouldings. This material was considerably finer in texture and appearance and was of a loose, open, irregular tabby weave (op. cit.).

Samples of fibres were taken with tweezers from a piece of the textile ground and the internal support. Viewed under transmitted light at a magnification range of 5-150x, these were identified respectively as silk and bast fibres probably obtained from the species *Boehemaria nivea*, commonly known as ramie (Figs 4, 5) (Anon. 1975).

The Gesso

This was in the form of a fine, white plaster, applied directly over the fabric support to obscure the weave of the cloth and act as a ground for the pigments. It had been carved or moulded in low relief before gilding. Where exposed due to paint loss, the surface appeared friable and was discoloured: areas of recent paint loss appeared white. Samples of the gesso were taken from a detached piece of the decorative layer. A flame test proved these to be calcium salts. A ground sample, placed in a test tube, effervesced when nitric acid was added. The white ground therefore contained calcium carbonate and was probably a lime plaster.

The Paint Layer

This had originally been applied to the gesso surface with considerable care and skill. Predominant pigments were blue, pink, orange, black, red/dark red and gold. Their age and appearance indicated a natural origin (Lucas 1962).

The blue, pink and orange had been applied in a thick layer, suggesting that a viscous medium had been used. Conversely, the black and dark red pigments were thinly applied, indicating use of a thin size or water. Hence some areas appear glossy and others matt.

Three distinct forms of medium are known to have been widely used: pigments were either mixed with water and then with a gum, with an animal glue or size, or with egg to form a sort of tempera. However, glue size or egg white used alone would also have given a translucent, glossy sheen to the surface (Gettens and Stout 1966).

Although the paint layer was generally very dirty and discoloured, the individual pigments showed varying levels of degradation and loss. Preliminary testing proved all the pigments, including the restorations, to be soluble in water.

TREATMENT ASSESSMENT

The aim of conservation was to stabilise the object for storage and display. As a religious relic, this treatment should not interfere with the integrity of the object and any restoration was to be carried out as sympathetically as possible (Anon. 1984). There were two important aesthetic considerations; that the colour and detail of the painting be revealed where possible, and that repairs to the structure should allow for the object to be displayed in its correct orientation.

The figure presented four main conservation problems:
- the decorative surface of the figure required cleaning;
- the gesso ground, the areas of exposed clay body and the pigment layer were in need of consolidation;
- the cracks in the fabric of the figure required repair and detached flakes needed to be relaid;
- the detached arm needed replacing with a repair strong enough to support the weight of the figure. This would require an internal support and a decision needed to be taken as to how this was to be done.

Conservation treatment was anticipated as listed below. Of these, the first five processes were considered essential and the last two desirable:
1. construction of a support;
2. removal of previous restorations;
3. cleaning;
4. consolidation;
5. repair of damaged limbs and torso;
6. gap-filling and reconstruction of areas of loss;

7. replacement of missing surface detail.

CONSERVATION TREATMENT

As the figure was unstable when laid on its back, a Plastozote 'nest', lined with acid free tissue, was made to support and protect the figure during treatment. This fitted inside the carton in which the figure was stored and could also be used for protection during storage and transportation.

Removal of the Previous Restorations

Only the dark blue/black overpaint was removed completely. The other areas of overpaint, although in a variety of hues, could, conceivably, have been applied as part of a regular maintenance program during its ritual and ceremonial use. As these areas appeared stable and not obtrusive they were left in situ. If, in the future, this were found not to be the case they could always be removed.

The overpaint was removed by swabbing with de-ionized water applied on cotton wool swabs. The difference in colour between the overpaint and the original pigment meant that depth of cleaning was easily controlled and could be halted when the original surface was reached.

The old filler and adhesive were removed mechanically using a scalpel, working through an illuminated magnifier. In some places, it was necessary to soften the area surrounding the filler moistening with de-ionized water.

Removal of the filler from the right foot further revealed the metal pin that had been used in repair. Testing with a magnet identified this as a ferrous metal.

When the filler was removed from the inner surface of the detached arm, a dark brown wooden 'dowel' was exposed, embedded within the clay. Reference to the radiograph suggested this was part of the armature from the original construction. The wooden dowel was deteriorated and had split and cracked along the grain of the wood, (Fig. 6).

Removal of the filler from the outer surface of the detached arm revealed that it had been fragmented and repaired several times. These repairs were removed by softening the adhesive, identified as animal glue, with warm water and then carefully prising the pieces apart.

Cleaning

The aim of testing to devise a suitable cleaning technique was to establish the composition and solubility of the component materials and the susceptibility of the painted decoration to damage by mechanical and chemical action.

The white particles adhering to the surface came away readily with a water dampened swab. However, as there was no varnish between the paint layer and the deposited dirt, the solubility of the binding medium was particularly important. It seemed probable that the other dirt deposits were, by now, chemically bonded with the original paint layer (Borov 1990). It was decided that only superficial cleaning should be attempted.

Preliminary testing, conducted on discrete areas of decorative layer and clay body, had indicated that each of the latter was differentially fugitive. Further testing proved de-ionised water to be an effective cleaner on all the pigments. However, the unfired clay deteriorated to a sticky mud on contact and prolonged contact with the dampened swabs left the gesso tacky.

Some of the pigments became progressively more fugitive with cleaning and although the binding medium appeared denatured it had not been rendered fully insoluble. The use of a purely aqueous solution was ruled out.

A range of organic solvents were tested both alone and in various percentage solutions with de-ionized water. None of the solvents alone was effective on the dirt layer which had accumulated on the pigments. A 20% solution of IMS in de-ionized water proved to be the safest, effective cleaner on all but the blue pigments. Here, a 30% solution was required to prevent loss of the pigment.

Robust areas of the surface were first vacuumed through nylon to remove dust and loose debris before cleaning. Only a small area, approximately 3cm x 3cm, was cleaned at a time and each area was allowed to dry before progressing to the next.

The cleaning solution was applied on cotton wool swabs which were blotted with tissue to remove excess moisture before application. The deposits became soft after a few seconds and were removed with clean swabs dampened with further cleaning solution.

The decorative layer was so degraded in places, that even the subtle action of a cotton swab tended to disrupt the paint surface and detach tiny fragments of the surface layer. There was also a tendency for the

cotton fibres to adhere to the roughened surfaces of the pigments. In these areas swabs made from Japanese tissue proved generally less damaging than the cotton wool.

Although cleaning was effective in revealing the painted detail, there was no dramatic improvement in terms of the hues of the colours. The most noticeable changes were in the blue pigment and the gilding which appeared substantially fresher and brighter after treatment.

Consolidation

The choice of a consolidant both for the clay body and the decorative layer was somewhat empirical. Those available have already been subjected to extensive testing and widespread support for their use for these purposes is well documented in current conservation literature (Horton-James *et al.* 1991).

The aim of consolidation was not only to improve adhesion between the gesso and the fabric support and between the gesso and the paint layer but also to increase cohesion within the paint layer itself. The consolidant had to fulfil several functions:

- it had to remain flexible because of the underlying textile support;
- it should not change the appearance of the original surface;
- it should have good ageing properties and remain soluble for an indefinite period of time. However, it is doubtful whether any consolidant could be entirely removed from such a porous object if it was subsequently found to be unsuitable (op. cit.).

Water-based emulsions such as methyl cellulose were inappropriate and from those remaining, three were selected as possibilities: Paraloid B67 (acrylic resin), Paraloid B72 (acrylic copolymer) and Beva 371 (ethyl-vinyl acetate copolymer). The consolidants were prepared for testing in a 2% solution in toluene. Acetone and Industrial Methylated Spirits (IMS) were considered as diluents, being less hazardous for the conservator but discounted as high evaporation would not have allowed sufficient penetration.

Of the three consolidants, the Paraloid B67 produced a slight, but unacceptable colour change. The Beva 371 and the Paraloid B72 were both effective and produced little change in the paint layer. However, the aging properties of Beva 371 are inferior to those of Paraloid B72. Paraloid B72 was therefore selected as the only consolidant which

fulfilled the criteria. Although at this concentration it gave the surface of the clay body improved cohesion, it did not impart the strength or depth of consolidation considered necessary.

The consolidant was most effective for this purpose in a 10% solution. This caused considerable darkening of the clay body and left a slightly shiny residue upon drying. However, this was considered acceptable as replacement of the arm meant this area would not be visible.

The consolidant was applied in successive coats with a sable paintbrush. Treatment was discontinued when the consolidant began to reappear on the surface. Any excess consolidant was then removed by swabbing.

After consolidation, the areas which had been loose and powdery became quite firm and the overall strength of the figure was visibly improved. There was no obvious change in the appearance of the painted surface.

Repair

The repair of the damaged limbs demanded an adhesive which could be injected into the gaps and cracks. This also had to fulfil certain criteria:

- it had to be viscous enough to prevent seepage which might discolour or stain the painted plaster;
- it had to form a good bond but remain flexible and not shrink or become insoluble upon ageing.

Paraloid B72 had already proved successful as a consolidant and fulfilled the criteria for the adhesive. Although it was realised that reversal at a later stage might threaten the consolidant, it was decided to use this for the repairs. Experimentation proved a 30% solution in acetone to be most effective. This solution remained fluid long enough to be injected with the hypodermic syringe, whilst the rapid evaporation of the solvent, once injected, prevented seepage onto the decorative layer.

The exposed wooden stake in the detached arm was consolidated using a 10% solution of the adhesive in acetone before reassembly. Here, the weight of the structure necessitated more than an adhesive repair and the arm was then dowelled into position using a medium gauge steel rod set into the wooden armatures.

Gap-Filling and Retouching

There were many areas of loss which required filling. The gap-filler had to be lightweight and flexible and it was decided to use a filled adhesive consisting of Phyllite (glass micro-balloons) in Paraloid B72. At a 20% v/w dilution in acetone, even with a substantial addition of Phillite, this was still fluid enough to be applied to the cracks from a pipette. The cracks and other areas of loss were slightly under-filled and finished with Fine Surface Polyfilla (cellulosic filler) to the level of the original gesso layer.

In replacing the surface details a simple tonal colour match was considered most appropriate. Powder pigments in Maimeri Matt Medium (aqueous acrylic emulsion) were used to achieve a texture and appearance sympathetic with the original surface. Where necessary, Cab-O-Sil (fumed silica) was used to further reduce the sheen of the acrylic medium. Gilded decoration was then replaced using one hour size and transfer gold.

ACKNOWLEDGEMENTS

The authors would like to acknowledge the help and co-operation provided by Alec Coles (Hancock Museum, Newcastle), Chris Robinson (De Montfort University Lincoln) and Rob White (Lincoln City and County Museum Archaeological Conservation Laboratory) for access to X-ray facilities.

REFERENCES

Anon. 1975. *The Identification of Textile Materials*, Textile Institute, Manchester.

Anon. 1984. *Guidance for Conservation Practice*, UKIC, London.

Barov, Z. 1990. Removal of inorganic deposits from Egyptian painted wooden objects, in *Cleaning, Retouching and Coatings* (eds J.S. Mills and P. Smith), IIC, 19-22, London.

Gettens, R. and Stout, G. 1966. *Painting Materials: A Short Encyclopaedia*, Dover Publications, Inc., New York.

Gombrich, E.H. 1989. *The Story of Art*, The Phaidon Press, Oxford.

Hodges, H. 1989. *Artefacts - An introduction to early materials and technology*, 3rd edn, Gerald Duckworth and Company Ltd, 133-47, London.

Horton-James, D., Walston, S. and Zounis, S. 1991. Evaluation of the stability, appearance and performance of resins for the adhesion of flaking paint on ethnographic objects, *Studies in Conservation*, **36**, 203-21.

Lucas, A. 1962. *Ancient Egyptian Materials and Industries*, 4th edn, Edward Arnold Publishers Ltd, London.

MATERIALS

Paraloid B72
Ethylacrylate/Methylacrylate co-polymer
 Arcesso Conservation Materials, Insta Business Services, PO Box 41, Hillbro Road, Liss, Hampshire, GU33 7PT

Plastazote
Expanded polyethylene foam
 Kewell Converters Ltd., 60A Holmethorpe Avenue, Holmethorpe Industrial Estate, Redhill, Surrey RH1 2NL

Phillite
Glass micro-balloons
 Phillite Corporation

Maimeri Matt Medium
Acrylic water based emulsion with 70% fumed silica
 Maimeri S.p.a., Strada Vecchia Paullese, 20060 Rettolino DI, Mediglia, Milan Italy

Cab-O-Sil
Fumed silica matting agent
 BDH Merck

Polyfilla Fine Surface Filler
Cellulose spackle
 Polycell Products Ltd., Broadwater Road, Welwyn Garden City, Herts. AL7 3AZ

Rachel Kilgallon and Susan Thomas, School of Applied Arts & Design, De Montfort University, Lindum Road, Lincoln, Lincolnshire, LN2 1PF

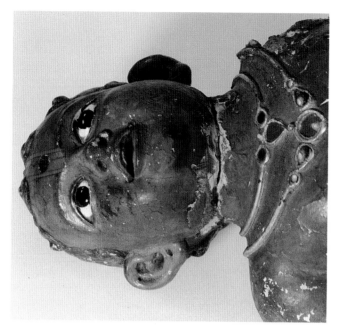

Figure 2 Detail of face before conservation

Figure 6 Detail of the detached arm

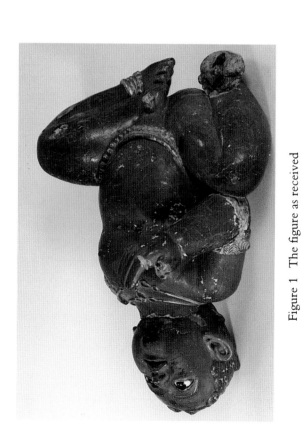

Figure 1 The figure as received

Figure 3 Rear view of figure before conservation showing the original museum label

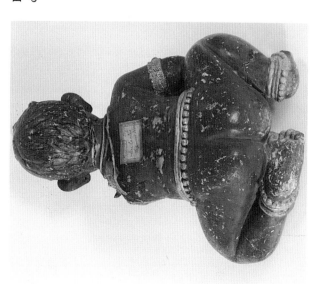

Figure 4 Fibres from the fabric ground (x10 mag.)

Figure 5 Fibres from the internal support fabric (x10 mag.)

LOOKING THROUGH BOTH SIDES OF THE LENS: WHY SCIENTISTS AND CONSERVATORS SHOULD KNOW EACH OTHER'S BUSINESS

Jerry Podany and David Scott

ABSTRACT

The work of the conservation scientist and that of the conservator are intimately linked. Productive and accurate results are only gained through the combination of both analytical skills and empirical knowledge of materials and their history. When these aspects are not combined or when the expectations held by one group of the other are unrealistic, misinterpretations abound. Clarifying the limitations of both empirical knowledge and that of analytical techniques is paramount in any collaborative venture between a scientist and a conservator. This paper presents a number of case studies where such limitations were not recognized and illustrate the often complex discussions that are required to assure accurate results and sound interpretations of those results.

Key Words

conservation, conservation science, authenticity, analysis

THE DIFFERENCE IN APPROACH

For any conservator who has worked with a scientist to solve a particular treatment problem or to answer a particular archaeometric question it is clear that the viewpoint of the scientist is often considerably different from that of the conservator. It can also be said that for any scientist who has enlisted the aid of a conservator, or joined with one toward a common goal, the same revelation can hold true. Sitting side by side, the two may be looking at the same object and may indeed be working toward the same objective, but the lens that each peers through is often cut and polished quite differently. Indeed the very way in which each first approaches the problem at hand can be essentially disparate. Those differences are not often sufficiently appreciated and both the conservator and scientist too often fail to look up from their particular view and glance in the other's direction, where both inspiration and common support can be found.

While these are clearly quite generalized statements and there can be found many examples of both extraordinary collaboration between scientists and conservators as well as individuals who are interchangeably competent in either arena, it is perhaps an appropriate time to examine our assumptions about the relationship between scientists and conservators. How 'scientific' is conservation and how directly applicable can 'analytical science' be to its efforts?

As scientific principles were introduced into the craft of restoration there was little communication, indeed even minimal desire for contact, between the two worlds. The extraordinarily positive aspects of interdisciplinary dimensions within projects and the absolute necessity for those dimensions, both of which we increasingly enjoy today, were not yet realized. The introduction of the 'scientific method' was made by exceptional individual scientists who found themselves serving enlightened institutions or collections with vast needs. But the service was often isolated. Scientists often simply applied what they already knew, as Giorgio Torracca has pointed out (de Guichen 1991). They transferred familiar techniques to the problems at hand and assumed that their limited exposure to the aesthetic issues or their lack of understanding of artists' materials, were not of immediate consequence. Some would argue that this has not changed. What has certainly changed however is the scientists' appreciation of the complexity contained within any conservation problem or question.

At the introduction of scientific thought to restoration the challenges were seen as straightforward and solvable in the light of the impressive developments within science and scientific methodology of the nineteenth century. After all, there had been little application of proven laboratory techniques and scientific method to works of art or artifacts when Friedrich Rathgen first began his considerable influence upon the field of conservation

(Rathgen 1898, Giberg 1987). Whatever he brought to the task, whether innovative or already well known in the scientific world, was seen as revolutionary in the academic and non-academic branches of the arts. But the nuances which the craftsman/restorer knew all too well had escaped many of the scientists. Perhaps largely because of this, the weaknesses of their scientific contributions soon revealed themselves in the form of alkali silicates, soluble nylon and extensive electrochemical stripping of ancient metals. Restorers for their part were soon to become conservators, studios soon became laboratories, and armed with basic chemistry courses and an often inadequate understanding of analytical results, conservators donned white laboratory coats, mixed their consolidates in expensive laboratory glassware and proceeded to take on the aura of 'science'. Despite this new-found image however they continued, often without any realistic choice, to make decisions based on less than the desired amount of evidence and support. Empirically based decisions, often the only kind possible as any conservator will attest to, were given a 'scientific spin' but not necessarily good scientific grounding. Such superficial joining of the two approaches was doomed at the start and has increasingly revealed itself as misdirected.

And so we have arrived at a point where there is a perceived reciprocity between conservators and scientists, and yet an increasing awareness of a widening division.

Perhaps more than any of the other factors forming this division are the assumptions that each of the parties maintains about the other. Scientists often assume that the information which a conservator might have about the particular technique being applied, or scientific principle being utilized, is limited, which indeed is often the case. Scientists also at times believe that the conservators' capacity for that information is limited. That, in fact, is rarely the case.

The conservators for their part will far too often look upon the scientist as the source of all that is... well... scientific. By this is meant both our modern and our historic (nineteenth-century) view of science, defining it as all that is sure, proven, measurable and concrete. One need only ask the question and, irrespective of its formulation or complexity, an objective and final answer, a scientific answer, will be provided. That belief is as much a reflection of our love affair with science and our general assumption that scientists can, with ever increasing accuracy and speed, find the answer to all our questions and to all our needs. One can hardly fault

the conservator for falling prey to one of our great modern myths. It is interesting however that one approach is unduly negative (conservators have limited capacity to understand the complexities of science) while the other is unduly positive (scientists can explain and solve anything). Perhaps this reflects the early history of each profession and our shared assumptions about the differences between those involved in scientific pursuits and those who have followed the path of the arts. It is also worth noting that these assumptions have spread internationally and have affected the very structure within which both professionals work. In many institutions around the world the term 'conservator' is granted exclusively to scientists. They are not required to have any practical training in conservation practice. Indeed they may have little interest at all in the areas of intervention, treatment or stabilization and no background in understanding the artisan's intentions or techniques. The restorers in these institutions are often kept in the manner of the nineteenth century, down in the basement workshop repairing the damage that seems to have eluded their more worthy counterparts in the upper laboratories.

In part because of the lack of scientific support or small number of available scientists who work exclusively within conservation (in the US only 78 of the almost 2000 members listed in the 1996 AIC membership directory define themselves as 'scientists') the conservator often applies a material or technique and evaluates its performance without a full understanding of the physical and chemical interactions which are occurring. Such evaluations are not necessarily less valuable however. Indeed many of the most useful advances in the field have come from direct experimentation and with limited (if any) analytical support. Like the empirically based exploration of the technologist, which Giorgio Torracca refers to as equally important in the development of industrial ideas, the conservator is often a 'tinkerer' and in that role is often responsible for some of the most significant advances in conservation (Torracca 1982) Nonetheless these advances can only have long term positive effects upon the field if they are passed through the scrutiny of scientific inquiry.

Despite the fact that the partnership of conservator and scientist is clearly valuable, many conservators are forced to work without the advice of a scientist. They are asked to maintain the same level of productivity, to make the same decisions and to take the same actions that they would if they had the service of a

scientific colleague. Scientists on the other hand, the few that work in institutions and museums, are contracted for a specific purpose and are rarely dependent upon the presence of a conservator. Such imbalance only widens the divisions and misunderstandings.

But the responsibility of preserving the past is not a competition of 'patentable' ideas or schemes. The conservator and the scientist have as much to gain from their interaction as from their individual expertise and strengths. One cannot always answer the other's questions, but may ask questions which lead both to solutions. It is in this dialogue that the approach and understanding of a scientist meets the empirical knowledge and skill of the conservator.

It is perhaps also true that as the analytical aspects of science become more specialized they, in a manner of speaking, become antithetical to modern science since accuracy of the analysis is almost fully dependent upon the skill of the operator. Rarely do any conservators, let alone all scientists, have such a sufficiently broad degree of interpretive and operative skill. As a result, the data and the interpretation of the data, are often less than clear.

What is clear however, is that there are not enough scientists fully dedicated to conservation efforts to go around. Equally there are certainly not a large number of scientific generalists who feel both fully comfortable and fully capable analysing pigments from a Rembrandt, evaluating a stone consolidant, developing a treatment for bronze disease, authenticating an ancient wooden artifact and determining the sizing in a paper. Perhaps there never were these 'generalists', perhaps conservators just thought they existed and scientists attempted to fill the bill.

Scientific research has become more and more specialized as it has become more informed and more demanding in its complexity and precision. While the number of analytical techniques has increased and their exactness has been dramatically enhanced, the answers are less clear, less certain. What conservators must learn to appreciate is that this lack of clarity is, in many cases, a reflection of inherent accuracy. When the use of carbon and oxygen stable isotope analysis was first applied to provenancing marbles, the data bases were too small to make much headway. As the available data increased, a wonderfully structured, clear and definitive view came into focus. Clusters of data were clearly defined and the occasional rogue was tolerable and eventually either solved by other means or relegated to the then rather thin file labelled with

a question mark. As the data bases grew so did the number of rogues and so did the overlap between those once clearly defined clusters. And so grew the file labelled with a question mark.

It can also be said that as we begin to apply analytical techniques to a larger number of materials originating from a broader range of time periods, more results appear less definitive. As an example, thermoluminescence has been quite an important dating technique for most ancient fired clay vessels and sculptures. However the technique's accuracy is dramatically reduced when looking at eighteenth-century French terracottas (from a 38% to an 18% range for error), due to the characteristics of the clay body (Considine, personal communication). These difficulties also apply to ceramics where the body is deficient in quartz content and high in feldspars. Limitations abound elsewhere as well. Recent developments in Carbon 14 dating, while increasing accuracy and decreasing the size of sample required, have often resulted in disappointing results. A recent sample submitted by our laboratory could provide only the possible choice between two equally likely broad ranges of time: 260-192 BC or 362-278 B.C., (Fig. 1) (Anon 1996). Improvements in the calibration curve left our sample on an odd 'bump' in the curve and our ability to place the object in time rather vague.

In the face of all these complexities and traps (not all at the molecular dimensions!) the conservator and the scientist must stay clearly aware of each other's limitations and strengths. To illustrate this precept the following brief series of case studies is provided. All four reflect the particularly difficult problems of dating and authenticity, an area where the limitations of both connoisseurship, science and technological expertise become quickly apparent.

CASE STUDIES

A copper alloy goat

Of all the problems faced by the conservator and the scientist alike issues of authenticity can be the most complex. Determining whether an object is what it is said to be, completely or in part, requires both an expertise in scientific inquiry and a familiarity with the technology and approach of the particular period during which the object is reported to have been made. Leaving out one of those elements can often lead to incorrect assumptions about the findings of the

other approaches. Figure 2 shows an example of such an instance. This solid cast copper alloy goat, lent to the museum for an exhibition, was reported to date from 500-480 B.C.

During its installation the object's appearance was called into question. It was, by any measure, a very subjective question. The patina did not present what the conservator felt was the representative colour, texture or characteristic of an ancient patina. Possible explanations for this, of course, vary from a treatment which may have altered the patination to the possibility that this particular patina is unique. Nonetheless the conservator felt sufficiently strong about the issue and called upon the scientist to examine the casting. X-ray fluorescence showed an unusually high tin content, sufficiently high to support the doubts raised. The owners were informed that the object was under question and agreed, given the initial scientific probe, to continue the investigation. Several days later however it was discovered that faulty calibration of the fluorescence unit had caused the high tin reading and indeed ICP-MS analysis revealed an alloy that was perfectly consistent with ancient compositions. The owners were again called and told that further scientific evidence now supported the antiquity of the object. The conservator was not content however. Upon close technical examination of the rear left leg of the goat, which appeared broken and bent to meet the body where it had evidently been cemented by corrosion, a telling feature was discovered. The leg was in fact cast in that broken state and position. While it is possible that such a casting might have occurred in antiquity the scant likelihood of that event increased the doubts of the object's authenticity. Clearly a copy of some artifact had been made and a cast produced. This finding once again brought the object into question and with the generous agreement of the owners (who by now were thoroughly confused) a metallographic section was taken which revealed an unusually thin patina of copper carbonates with no initial layer of cuprite (copper oxide) at the metal surface. Additionally, intergranular corrosion was, at best, minimal and more often nonexistent. While none of these metallographic observations in themselves would be enough to condemn the object, combined with the conservator's observation and suspicions, the object was determined to be incorrect. Clearly the prior empirical observations that buried bronzes should posses a significant cuprite layer contiguous with the metallic core and that the casting

features were unlikely for an ancient object were instrumental in this decision.

A Roman bronze alloy mirror

In another instance the persistence of somewhat subjective suspicions by a conservator were proven correct in the face of contradictory scientific evidence, and a clever pastiche was revealed. Figure 3 illustrates what was thought to be a Roman box mirror with female bust relief in the Getty collection. While there had never been any scholarly doubt regarding the mirror, the apparent aesthetic preferences of natural processes alerted the conservator to a potential deceit. How was it that corrosion had formed in such a complimentary way to the image? Preferential cleaning to create colour contrast and enhance the design of an object is certainly not unknown in past restoration approaches. However close examination of the two adjacent surfaces showed copper carbonates with some underlying cuprite on the mirror body but no trace at all of carbonates on the head relief. It was unlikely that any cleaning approach could have been that thorough and consistent. There was an understandable resistance to remove the head from the mirror body for examination since it is known that these were thin repoussé copper sheets normally attached with lead or organic resin. As a result non-destructive analysis was the only tool allowed the scientist. Results were relatively clear. The applied head relief was almost pure copper while the mirror cover was a bronze alloy. The corrosion on both was micro-sampled and diffraction analysis showed both to be fully consistent with ancient corrosion products: cuprite on the head and a mixture of cuprite and malachite on the mirror face. Satisfied with the results, the curatorial department requested that the mirror go back on display. The scientific analysis had shown it to be consistent with ancient characteristics and science had answered the question. But the nagging question of how this particular corrosion pattern, so specific to the design of the mirror relief, had occurred would not go away so easily. After some time the mirror was once again removed from exhibition and the conservation department once again made a request to analyse the object. This time it was decided to remove the relief head. Immediately it became clear that the supposed repoussé head was in fact an electrotype copy applied to the bronze mirror body. Metallographic sections of the head show the typical structure of an electrotype

nodule (Fig. 4). Indeed the restorer who applied, and probably made the head relief, made the investigation considerably easier by signing his work. That signature (Fig. 5) should be familiar to many, 'A.P. Ready, Restorer, British Museum, 1930'. The work of both scientists and conservators would be a great deal easier if all forgers and restorers would oblige in providing such clear evidence!

The *Philosopher's Plate*

An interesting example of collaborative work concerns a silver plate in the Getty Museum known as the *Philosopher's Plate* which, at the time of its acquisition, was said to have been retrieved from a marine burial off the coast at Gaza (Fig. 6). The plate was very heavily corroded and was conserved and extensively gap-filled after mechanical cleaning in 1986. Following this conservation work, the plate, which had been thought to date from the period of the fourth-seventh century AD, originating from the Byzantine cultural period, was seriously questioned by an art historian who held that it must be from the Renaissance (Cutler 1990). Partially as a result of these questions, the plate was carefully examined by the conservator and the scientist, with the conservator undertaking X-radiography studies and the scientist carrying out detailed analytical investigation and metallographic study of small cross-sections removed to examine both metallic structure and remaining corrosion (Scott 1990).

The cross-sections (Fig. 7) showed extensive corrosion, severe intergranular cracking, and discontinuous precipitation. It was clear that the plate had been worked to shape in a most unusual manner by hammering from the front and by carving the surface relief to produce the apparently repoussé images. The evidence of the working technique alone would usually be sufficient from a technical standpoint to assign the plate to the Byzantine period and not to the Renaissance. The art historian was, however, not convinced by this kind of secondary scientific and technical conclusion and maintained his argument. There the matter rested until very careful observation by the conservator (Colinescu 1993), using xero-radiography revealed the faint impression of a circular motif of leaves on the reverse of the plate which was quite hidden to the naked eye, (Fig. 8, arrowed). This interesting discovery by the conservator did not necessarily mean anything to the scientist in terms of the plate's possible date but it was highly significant to

the art historian. As a result of this new evidence revealed by the conservator, the art historian is now of the opinion that the plate, or rather the floral decoration, could not possibly be from the Renaissance. This, therefore, represented very important new evidence from the art historical perspective, yet, so troubling were the images on the front of the *Philosopher's Plate* that the art historian suggested that the plate may have been re-cut or re-carved in the Renaissance preserving the more ancient floral decoration on the reverse. However, this suggestion now places the judgment of the plate back into the scientific arena, at which point we can say that the preservation of the carved surface on the front shows absolutely no evidence of having been re-carved, nor is carving of silver a technique associated with Renaissance silversmithing. Also the degree of corrosion on the back and on the front of the plate is perfectly in accord with both surfaces being of the same age. It is therefore very difficult to accept the argument that the plate has been re-carved from a more ancient original, especially since every detail of the design and the extent of the corrosion attest to age.

The 'Getty' Kouros

Finally, one quite well-known case, the so-called 'Getty' kouros, remains open and clearly exhibits the limitations of both science and technology to provide sufficiently convincing evidence in answering questions of authenticity. This case also reveals the susceptibility of analytical science to mistaken results and the willingness of conservators and art historians alike to place blind trust in those results.

The object presented a number of art historical anomalies and the conservator's technical examination could find nothing inconsistent with ancient carving techniques. The focus was then turned to what evidence for antiquity or modern origin the surface alteration layer could provide. The late Dr. Stanley Margolis, a well respected geochemist from the University of California at Davis, was contracted to assist in the study of the sculpture and determine what could be said regarding its age. Dr. Margolis presented a finding that seemed to unequivocally place the carving of the surface in antiquity. He had identified a thin but consistent layer of calcite covering the sculpted surface, (Fig. 9). Since the sculpture was carved from dolomite marble (a calcium-magnesium carbonate), Dr. Margolis suggested that the almost

pure calcite layer was the result of a process known as de-dolitimization. Although well known in geochemistry, the process was almost completely unknown in conservation research at the time. Since it is a natural alteration process of dolomite and requires specific conditions and long periods of time to occur, Dr. Margolis's finding seemed to support the object's antiquity. His work was later confirmed at the Getty Conservation Institute using micro-probe analysis. Despite the continuing doubts of some scholars, the sculpture was determined to be ancient. Soon thereafter however, a young junior scientist, exploring questions of how the sculpture might have been cleaned in the past, found the true nature of the surface using more conventional X-ray diffraction approaches (an 'old-fashioned' Debye-Scherrer diffraction camera) (Muszynski 1991). The surface was covered not with a pure calcite but with a calcium oxalate layer, whewellite. The previous analytical results were incorrect.

How was it possible that two separate laboratories could have come to the same erroneous conclusion? Dr Margolis used a modern defractometer which, though among the most updated pieces of equipment at the time, was not used to look at all angles of the diffracted beam. His conclusion that calcite was present was made on less than complete data. It appears that the microprobe work was also faulty, though for a very surprising reason. The energy of the microprobe beam itself probably decomposed the thin oxalate layer on the surface and the analytical results, thought to be consistent with earlier findings, were actually presenting analysis of the calcite originating in the dolomite, not as a result of an alteration process.

In retrospect it might be asked why so much confidence was placed in a single analysis. While there is no sole explanation, the imposing power of science, or our assumptions about scientific analysis, armed with two quite current and authoritative techniques, was at the root of the problem. An improved, more sensitive technique was depended upon to the point of completely replacing a more traditional one. It represented, after all, progress and increased accuracy. Scholars, connoisseurs and conservators alike were intimidated (most quite willingly) by what appeared to be the impenetrable objectivism of 'scientific truth'. While the question about the object remains unresolved, by both connoisseurship and science, since neither can provide the proof needed to make a sound proclamation, our approach to scientific analysis has changed considerably. The scientist is seen as one partner in the effort. He or she brings to the table one set of tools which contributes to the process, but no longer dominates it.

REFERENCES

Anon. 1996. *Report of the Institute for Geological and Nuclear Sciences Ltd.*, Rafter Radiocarbon Laboratory, New Zealand. (On file at the J. Paul Getty Museum).

Colinescu, I. 1993. This observation and drawing was done by Irena Colinescu during her 1993 internship year in the Department of Antiquities Conservation, the J. Paul Getty Museum.

Considine, B. personal communication. Recent discussion with Brian Considine, Conservator of Decorative Arts and Sculpture at the J. Paul Getty Museum.

Cutler, A. 1990. The Disputa Plate in the J. Paul Getty Museum and its Cinquecento Context, *J. Paul Getty Museum Journal*, **18**, 5-32.

Gilberg, M. 1987. Friedrich Rathgen: The Father of Modern Archaeological Conservation, *JAIC*, **26**, 105-20.

de Guichen, G. 1991. Scientists and the Preservation of Cultural Heritage, in *Science, Technology and European Cultural Heritage* (eds N.S. Baer *et al.*), Butterworth-Heinemann, 24, Oxford.

Muszynski, D. 1991. The observation and analysis was made by Dawn Muszynski during her analytical work for the Museum Services Laboratory of the Getty Conservation Institute in 1991.

Rathgen, F. 1898. *Die Konsevierung von Altertumsfunder*, W. Spemann, Berlin.

Scott, D. 1990. A technical and analytical study of the two silver plates in the collection of the J. Paul Getty Museum, *J. Paul Getty Museum Journal*, **18**, 33-52.

Torracca, G. 1982. The scientist's role in historic preservation with particular reference to stone conservation, in *Conservation of Historic Stone Buildings and Monuments: Report of the Committee on Conservation of Historic Stone Buildings and Monuments*, National Monuments Advisory Board, Commission on Engineering and Technical Systems, National Research Council, National Academy Press, 13-18, Washington, DC.

Jerry Podany, Head of Antiquities Conservation, The J. Paul Getty Museum, P.O. Box 2112 Santa Monica, California 90407

David Scott, Senior Scientist, The Getty Conservation Institute, 1200 Getty Center Drive, Suite 700, Los Angeles, California 90049

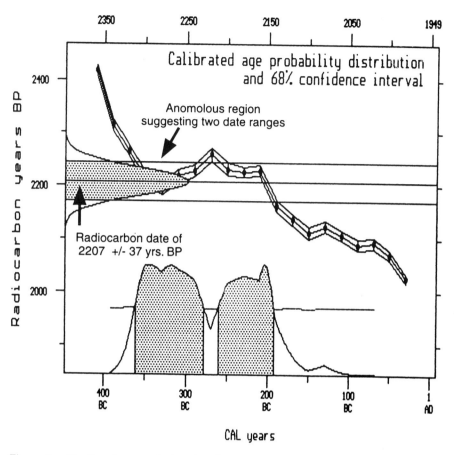

Figure 1 Radiocarbon graph showing the proposed radiocarbon date and the anomalous region on the curve. From: Institute of Geological and Nuclear Sciences, Ltd

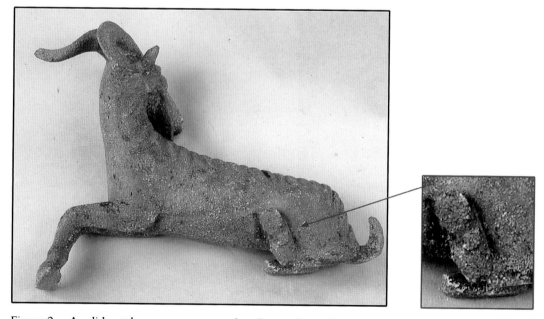

Figure 2 A solid cast bronze goat reported to date to the sixth or fifth centuries BC Note the 'broken' rear leg in the detail which was found to be cast in the position as part of the entire object.

217

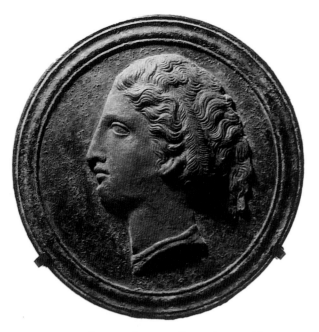

Figure 3 A Roman bronze alloy mirror with copper female portrait

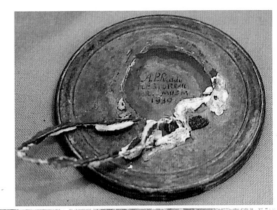

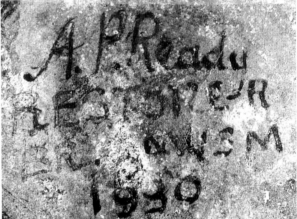

Figure 5 The signature of 'A.P. Ready' located under the electrotype head on the surface of the mirror cover

Figure 4 Photomicrograph of a polished section of a copper node from the electrotype head. Note the typical columnar structure.

Figure 6　The *Philosopher's Plate*. Late Antique
(J. Paul Getty Museum 83.AM.342)

Figure 7　Photomicrograph of a section taken from the *Philosopher's Plate*. Etched in acidified potassium dichromate. X 480. The section shows discontinuous precipitation of copper in the silver-copper alloy at the grain boundaries which is typical of ancient silver.

Figure 8　A xero-radiograph of the *Philosopher's Plate* revealed an unusual feature (arrow) in area 'A'. Under raking light conditions a floral design onthe back of the plate was discovered (B). A reconstruction drawing is shown to the left with the area of the photo outlined.

Figure 9 Scanning electron micrograph of a dolomite sample taken from the 'Getty Kouros'. The deposit at the surface labeled 'C' was interpreted as calcite.

SCIENCE AND CONSERVATION AT THE BRITISH MUSEUM: A NINETEENTH-CENTURY LEGACY

Sarah C. Watkins

ABSTRACT

This paper considers the interface between science and conservation at the British Museum during the nineteenth century. Research in the archives of the Museum has revealed a number of cases where eminent scientists from outside the Museum were consulted for advice and assistance in problems of preservation. A tradition of scientists, restorers and curators all contributing to the preservation and restoration of objects in the Museum can be traced back to at least the first half of the nineteenth century.

Key Words

science, conservation, nineteenth century, British Museum,

INTRODUCTION

One indication of a profession reaching maturity is that its practitioners realise they have a history. Over the last ten years a number of publications on historical aspects of conservation have appeared for example: (Caldararo 1987, Gilberg 1987 and 1988, Corfield 1988, Daniels 1988, Johnson 1993, Oddy 1993, Madsen 1994, Drayman-Weisser 1994, Beale 1996, Sease 1996). There is a Theory and History Working Group of ICOM-CC and conservation conferences now often include a historical paper. This is just such a paper and considers the interface between science and conservation that developed during the nineteenth century at the British Museum, with particular reference to the conservation of archaeological objects.

Dr Alexander Scott FRS, a chemist who was seconded to the Museum in 1919, was the first scientist to be specifically employed to investigate deterioration and preservation of artefacts, but he was not the first scientist to be involved with the problems of preserving the collections. Recent research in the Museum's archives has revealed a number of instances,

during the nineteenth century, where very eminent scientists were consulted on the effects of environment and on the treatment of objects direct from excavation. Case histories will illustrate that while the actual restoration was likely to be undertaken by craftsmen, it was often related to scientific theory.

SCIENCE IN THE NINETEENTH CENTURY

During the nineteenth century, scientific investigation was often undertaken solely in search of pure knowledge and understanding. This might then lead to practical application and invention resulting in commercial and industrial development. Many of these developments had radically altered everyday life by the end of the century; for example electricity, the telegraph, the telephone and photography. The speed and scale of the growth in knowledge, understanding and application entitle the nineteenth century to be called the beginning of the 'scientific age' (Dampier-Whetham 1929). Scientific methods of observation, induction, deduction and experiment came to be applied not only to the original subject matter of pure science but also to nearly all fields of human thought and study.

We now take for granted the periodic table of the elements, chemical formulae and equations, and decimal units, but these were all established during the nineteenth century.

The work of John Dalton (1766-1844) launched chemistry as an exact science. His laws of chemical combination provided a model which accounted for the results of quantitative analysis, leading ultimately to many of the advances that followed in analysis, synthesis and chemical manufacture.

The introduction of the voltaic pile, in effect a primitive battery, in 1800 (Brock 1992, 147) gave chemists a new analytical tool. The discovery that compounds could be decomposed by electrical means led to the discovery of new compounds and elements, and eventually to greater understanding of valency,

electrochemistry, the chemistry of solutions, and corrosion theory, thus accounting for the deterioration of materials. In 1807 Sir Humphrey Davy isolated the metals potassium and sodium from solution. Then Cruikshank precipitated copper and silver from solution, a discovery which led to the development of electroplating. In 1810 Berzelius was the first chemist to link chemical reactivity to electrolytic phenomena (Brock 1992, 150).

Further investigations were made of the effects and properties of electric current in the 1820s by Ampère and Ohm. It was, however, Michael Faraday (1791-1867), in the 1830s, who assigned the terminology used today, such as electrode, anode, cathode, cation, anion, electrolysis, and electrolyte. In defining 'Faradays Laws' he laid the foundations for the sciences of electro-chemistry and electro-magnetic induction.

Improved methods of analysis developed in the 1820s and 1830s, together with the introduction of commercially available chemical reagents and apparatus in the middle of the century (Brock 1992), led to advances in organic chemistry. The 1850s also saw work on the causes and mechanisms of chemical reaction; rates of reaction; the concept of dynamic equilibrium; the existence and effects of catalysts. Theories of solution, volume changes, heat evolution, diffusion of salts in solutions, and osmosis were all developed in the latter part of the century. The late nineteenth century saw chemists begin to create artificial substances and the beginning of the development of synthetic polymers.

The basis of spectral analysis was developed in the first half of the century. In 1823 Sir John Herschel suggested the spectra caused by heating metals or salts in a flame might be used to test for the presence of metals. In 1859 Kirchoff devised the first exact methods of spectral analysis, detecting the presence of elements in minute quantities. This led to the discovery of caesium and rubidium and later, in 1868, to the discovery of helium by Frankland and Lockyer (Brock 1992).

By the end of the century the range and scope of science had expanded so much that there was no longer one science but many sciences. Some felt that all that left was to do was to undertake scientific measurements to greater accuracy in order to fill in the gaps (Dampier-Whetham 1929). Röntgen's discovery of X-rays in 1895, however, opened up whole new areas of research that by the end of the century, were to challenge many of the certainties that had grown up.

SCIENCE AND THE BRITISH MUSEUM

The 1753 Act of Parliament establishing the British Museum reflected not only the encyclopaedic interests of collectors and scholars, but also the interdependence of art and science as perceived by the State in the mid-eighteenth century. The first section of the Act decreed:

> ((I,p.333) Whereas all Arts and Sciences have a Connexion with each other, and Discoveries in Natural Philosophy and other Branches of speculative Knowledge for the Advancement and Improvement whereof the said Museum or Collection was intended, do and may in many instances give Help and success to the most useful Experiments and Inventions. (Caygill 1994, 50)

Sir Hans Sloane , whose offer of his collection to the Nation under the terms of his will led to the establishment of the British Museum (Caygill 1994), was a physician, antiquary and scientist (Macgregor 1994). The majority of the Trustees of his will were Fellows of the Royal Society, many of whom were also Fellows of the Society of Antiquaries. Links with the Royal Society were further confirmed by the 1753 Act; *ex officio* Trustees of the Museum included the President, Treasurer and Secretary of the Society. The Royal Society, founded in 1660, was particularly important for fostering and disseminating scientific discovery in the late eighteenth and early nineteenth centuries. The connection between the Museum and the Royal Society continues today, although the Society now only has one *ex officio* Trustee.

For the first fifty years the organisation of the collections reflected the close interdependence of science and antiquarianism. In 1758 one of the three departments confirmed by the Trustees was 'Natural and Artificial Products'. The first three Principal Librarians, as the Museum's chief officer was known until 1898, were doctors of medicine. In preparing the collections for opening to the public on 15 January 1759 , there was concern that they should be arranged in an ordered, exact, scientific manner (Caygill 1994, 55), not just as a Cabinet of Curiosities.

From the early years of the nineteenth century, however, began a disassociation of sciences from antiquities within the Museum. This process started with the establishment of a separate Department of Antiquities in 1807 and culminated with the exodus of the natural history collections to new buildings in South Kensington between 1880 and 1883.

There was some interaction between the natural historians and antiquities curators, until the 1880s,

over matters relating to the investigation of antiquities. For example, a natural history curator, John Children, was interested in mineral chemistry. His first essay on the subject recorded what was probably the first chemical analysis of an antiquity to be undertaken in the British Museum. In 1821 he analysed pigment in the hieroglyphics on the sarcophagus from the tomb of Psammis. In 1828 Children was one of the first recipients of the first John Fuller Medal from the Royal Institution; shared with six others including Davy and Faraday. The mineral Childrenite was named after him (Gunther 1981, 60).

The Museum's first chemical laboratory was set up in 1867 for the Natural History Keeper, Nevil Story-Maskelyne, in 46 Great Russell Street, under the charge of Dr Walter Flight, FRS (1842-85) (Gunther 1981). Before this he had had no laboratory despite asking the Trustees; a request in 1864 to convert a room, under the northwest angle of the Elgin room, into a laboratory had been refused (C10670/1, C10696/7). Despite this the Trustees were not wholly averse to approving facilities for the application of new scientific discoveries and innovations.

In 1836, the electroforming of a copper plate, which on separation from its master (mould) reproduced every scratch, had been described in the *Philosophical Magazine*. A Professor Jacobi, in 1838 in St Petersburg, reported on the reproduction of copper articles by copper electroforming from an acid copper sulphate bath, with microscopic faithfulness of reproduction; this is generally taken as the discovery of the process (Spiro 1971, 8). In 1840-41 there followed a flood of reports and patents on the process. In 1859, the Trustees at the British Museum agreed to a room in the basement being fitted up for electroforming and the furniture was ordered in 1860 (C 1118, C9787). The making of facsimiles of objects is one of the oldest services provided by the Museum. Facilities for electroforming meant that metal replicas in addition to plaster ones could be made.

While no reference has been found to the Museum's own scientists being involved with preservation problems, scientists outside the Museum were consulted on occasion.

The British Museum Act of 1753 specified that its collections:

... be preserved and maintained, not only for the Inspection and Entertainment of the learned and the curious, but for the general Use and Benefit of the Public. (I, p.333)
[and]

....shall remain and be preserved therein for public use to all posterity. (IX p.339) (Caygill 1994)

The difficulties of preserving and maintaining the collections were apparent by the early years of the century and were reported in the minutes of Trustee's meetings. Until at least the late 1860s all proposals for restoration and replication were approved by the Trustees before work could be undertaken.

In 1826 Edward Hawkins (1780-1867), a numismatist, was appointed Keeper of Antiquities, a post he held until 1860. At his instigation measures were taken to preserve the collections that often involved co-operation between curator, scientists and restorers. While the 'hands on' work was either undertaken by Museum staff or contracted out, scientists were consulted over how to best proceed.

Hawkins reported to the Trustees, in December 1830, that a few objects in his department were suffering from exposure to the air and that he had consulted Mr Faraday, who recommended the application of a wash to 'prevent further progress of decomposition' (C3301-3302). The Trustees gave their approval for Hawkins to proceed but 'desired that he would consult Mr Westmacott as to the objects on which it should be used'. The minute does not specify what the objects were, however, as Westmacott had to be informed it is likely that they were stone sculptures; Richard Westmacott, Professor of Sculpture at the Royal Academy, being the Museum's artistic advisor, restorer and arranger of sculptures (Jenkins 1992).

In 1859, the Principal Librarian was requested by the Trustees to report on the 'Custody, preservation and inspection' of the collections (C9512/3). Concerns over the effects of the environment continued to be reported to the Trustees in the 1860s and the steps taken to mitigate them. For example, in 1862 display cases for bronzes were altered to exclude dust, at a cost of £20 (C10126). In 1863, wall cases in the 'Bronze Room' were fitted with metal strips to exclude dust (C10432). An iron safe for safe keeping of bronzes was sanctioned in 1867 (C11329). In the same year, experimental measures were reported and approved for preventing damage to Assyrian reliefs from the effects of damp walls (C11136). Concern over discolouration and decay of the Assyrian sculptures had been noted in 1863 (C10307, C10318, C10366/7). In 1868 the Principal Librarian was asked to report to the Trustees on the effects of the 'London atmosphere' on ancient sculptures (C11518).

The Museum's first employed restorer was John Doubleday, best known for his restoration of the Portland Vase in the 1840s (Smith 1992). In November 1836, Hawkins asked the Trustees for permission to employ Doubleday:

> ... in cleaning, repairing and fixing upon pedestals the Egyptian objects lately purchased, and such of the old collections of bronzes as may require it: Mr Hawkins suggested 15/- a day as a moderate remuneration for Mr Doubleday', (C4390).

The Trustees agreed but initially only for three months. The contract was renewed and in January 1839 the Trustees finally agreed to permanent employment; five days a week and that he 'be employed exclusively upon the repairing and fixing of such Antiquities as are to be removed to the new galleries' and they asked Hawkins to report to the next meeting on the amount of work which remained for Mr Doubleday to do and how long it would take (C4970-C4971). In February, Hawkins reported back that work still to be done would take at least two years (C4993). Doubleday died in 1856.

In 1848, finds from Layard's excavations at Nimrud began to arrive at the Museum. On 8 January 1848 Hawkins informed the Trustees that:

> ... he had received from Mr Layard a dagger and several ivory carvings discovered at Nimroud, that they were extremely injured by exposure to the atmosphere and required immediate steps to be taken to preserve them if possible from becoming worse, - and he requested permission to adopt such means as might, upon consultation with competent persons, seem most advisable.(C7411).

The Trustees promptly appointed a special committee to look into the problems of preserving the ivories and other small objects from Nimroud. On 15 January this committee reported:

> ... having consulted with Mr Hawkins, Professor Owen, and Mr H. Flower, and having with these gentlemen carefully examined the several objects, they have entrusted to Mr Flower, who has much experience in cementing and preserving decayed bone, one of the pieces of ivory, in bad condition, and of the least value, and have directed him to repair it in the best manner he can: As soon as the committee have satisfied themselves of the result of this experiment, they will report again to the Board. (C7440, OP39)

On 8 February, they reported that they were satisfied with Mr Flower's work, that they had agreed with him the completion of 18 other panels in the same way and that the remuneration for his 'skill and labour upon the whole of the carvings' would be £20 (C7470, OP39).

The problem of the bronzes took longer to resolve; on 12 July 1851 Sir Henry Ellis (Principal Librarian 1827-56) was asked by the Trustees to:

> ... convey to Mr Faraday the wish of the Trustees that at his early convenience he will be pleased to do them the favour to attend the Museum, and after examining the collection of small metal objects recently brought from Assyria by Mr Layard and report on the best means of cleaning and restoring the surfaces of the same, so far as can be done without injury either to the substance or to the designs thereon, and will he confer on the said subject with Mr Layard and with the keeper of the Department of Antiquities. (C8254)

Faraday replied, on 16 July from Tynemouth, that he would have been happy to help but as he was going to be out of London for several months he would not be able to (C8263). A letter requesting similar assistance was sent to Mr William Brande, Clerk of the Irons at the Royal Mint, who agreed to help.

At the beginning of August two objects were sent to Brande. Layard, by now, was anxious to get on with having the objects cleaned so that they could be drawn 'by some competent artist' (C8278-C8279). The Trustees replied that they couldn't proceed until Brande had reported his findings. In a letter to Sir Henry Ellis, dated 30 July, Brande reported his findings (C8279, OP46). He had analysed the metal (identified as bronze) and the corrosion and reported on its extent. He had found that in areas where metal survived under a coat of oxide and carbonate the designs could be revealed with dilute nitric acids. He did not hold out much hope for those parts of the vessels that were completely corroded through and thought these were probably best not meddled with. Initially it was hoped that Brande would treat all the metal vessels but he had to withdraw this offer. In the meantime Hawkins and Layard had surreptitiously passed some pieces to Doubleday; the results of his efforts were presented to the Trustees who agreed that he should deal with the rest (C8294-C8295).

In 1861, Sir Charles Newton (Keeper Greek and Roman Antiquities, 1861-85) reported to the Trustees on the condition of Greek fictile (clay) vases (C10013). A letter was read to the Trustees, from, Professor Hofmann and Dr Frankland, in which they reported on their examination of the efflorescence on the vases and recommended certain experiments with

a view to preserving them. Hofmann was Professor of Chemistry at the Government financed Royal College of Chemistry in Oxford Street. He retired in 1865 and was succeeded by Edward Frankland (1825-99) (Brock 1992).

The Trustees gave permission for work to go ahead on one vase but the Keeper was to report back the result before proceeding with the others. In February 1862, Newton (C10087, OP 6/2/1862) reported back the results of his experiments, carried out according to Hofmann and Frankland's instructions. Fragments of a cup, covered with efflorescence, had been soaked in distilled water 'for a certain time' and then carefully wiped. One portion of the fragments was then placed in a hermetically sealed glass case. The other portion being left to air dry in one of the 'vase cases'. The fragments in the sealed case showed no return of the efflorescence at the time of the report, whereas the others had a bloom over the surface two months after the experiment had started. Newton had written to Hofmann to ask if the controlled or 'artificial' drying was long enough but had received no reply. Frankland had also analysed the efflorescence but Newton did not report the result. The Trustees gave approval for Frankland to be paid £10 for his services.

THE LEGACY

A tradition of scientists, restorers and curators all contributing to the preservation and restoration of objects in the British Museum can be traced back to at least the first half of the nineteenth century. A scientific, rather than wholly empirical, approach to finding appropriate treatments began in the nineteenth century.

From the early 1860s, however, there began a shift away from such co-operation. Hawkins had retired in 1860. Doubleday had died in 1856. In November 1865, Robert Sparrow, a locksmith, was taken into direct employment at the Museum, at 7s a day, to repair ancient metals in addition to his locksmiths duties (C10890). He died in service on 24 December 1898. In the early 1860s the first proposals to move the natural history collections out of the Museum at Bloomsbury were made. Twenty years of public debate and disagreement followed before they finally moved to South Kensington in the early 1880s (Caygill 1992, 39); the decade in which the Royal Museums of Berlin appointed Freidrich Rathgen, a chemist, as head of the laboratories to develop

treatments for artefacts based on a scientific approach (Gilberg 1987).

Also in the 1860s, a number of the scientists who made their greatest contributions in the first half of the century died; for example Faraday in 1867. With their deaths the close link between the sciences and the arts, that had been an eighteenth-century legacy, began to disintegrate.

By the beginning of 1919, scientific input to preservation problems at the British Museum had declined to such an extent that the Director appealed to the Government's Department of Science and Industrial Research for help with:

... scientific problems affecting the collections.. [because]

...no chemical research department in the Museum, and although there is at any given moment a considerable amount of practical experiences with regard to such problems there is no provision for its permanent record and tradition, and it is often unrelated to knowledge of scientific theory. (Kenyon 1919).

By the end of the year Dr Alexander Scott, had arrived at the Museum and started his work to investigate problems of deterioration in the collections and to propose treatments.

ACKNOWLEDGEMENTS

The author would like to thank: Judith Swaddling, Department of Greek and Roman Antiquities; Janet Wallace and Christopher Date, British Museum Central Archives; and Susan Bradley, Department of Conservation.

REFERENCES

Primary Works

Trustees' Papers
The papers of the Trustees of the Museum are held in the Museum's Central Archives. These are abbreviated as follows:
C = Minutes of the Standing Committee of Trustees.
OP = Original Papers; various letters and original reports.

The following are cited in this paper:
C3301-C3302 11 December 1830
C4390 12 November 1836
C4970-C4971 22 January 1839
C4993 9 February 1839

C7411 8 January 1848
C7440 15 January 1848
C8254 12 July 1851
C8263 19 July 1851
C8278-C8279 9 August 1851
C8294-C8295 20 September 1851
C9512/3 22 January 1859
C1118 12 July 1859
C9787 23 July 1860
C10013 27 July 1861
C10087 8 February 1862
C10126 12 February 1862
C10307 28 March 1863
C10318 18 April 1863
C10366/7 27 June 1863
C10432 17 October 1863
C10670/1 12 November 1864
C10696/7 12 November 1864
C10890 25 November 1865
C11136 12 January 1867
C11329 12 October 1867
C11518 25 July 1868

OP39 15 January 1848, Report of special subcommittee to Trustees

OP39 8 February 1848, ditto.

OP46 30 July 1851, letter from W. Brande to Sir Henry Ellis.

OP6/2/1862, Newton's Report to the Trustees on Professor Hofmann's and Dr Frankland's experiments. In Department of Greek and Roman Antiquities Reports 1861-63.

Secondary Works

Beale, A. 1996. Understanding, restoring and conserving bronzes with the aid of science, in *The Fire of Hephaistos, Large Classical Bronzes from North American Collections* (ed C. Mattusch), Harvard University Art Museums, Cambridge, MA.

Brock, W.T. 1992. The Fontana History of Chemistry, Fontana, London.

Caldaro, N.L. 1987. An outline history of conservation in archaeology and anthropology as presented through publications, *JAIC*, **26**, 75-84.

Caygill, M. 1992. *The Story of the British Museum*. 2nd edn, BMP, London.

Caygill, M. 1994. Sloane's will and the establishment of the British Museum, in *Sir Hans Sloane, Collector, Scientist, Antiquary* (ed A. MacGregor), 45-68, BMP, London.

Corfield, M. 1988. Towards a conservation profession, in *UKIC 30th Anniversary Conference* (ed V. Todd), UKIC, 4-7, London.

Daniels, V. (ed). 1988. *Early Advances in Conservation*, British Museum Occasional Paper No. 65, British Museum, London.

Dampier-Whetham, W.C.D. 1929. *A History of Science and its Relations with Philosophy and Religion*, Cambridge University Press, London.

Drayman-Weisser, T. 1994. A perspective on the history of the conservation of archaeological copper alloys in the United States, *JAIC*, **33**, 131-41.

Gilberg, M. 1987. Friedrich Rathgen: the father of modern archaeological conservation, *JAIC*, **26**, 85-104.

Gilberg, M. 1988. History of bronze disease and its treatment, in *Early Advances in Conservation* (ed V. Daniels), British Museum Occasional Paper No. 65, British Museum, 59-70, London.

Gunther, A.E. 1981. *The Founders of Science at the British Museum 1753-1900*, Hasleworth Press, Suffolk.

Jenkins, I. 1992. *Archaeologists and Aesthetes*, BMP, London.

Johnson, J. 1993. Conservation and archaeology in Great Britain and the United States: A comparison, *JAIC*, **32**, 241-8.

Kenyon, F.G. 1919. Letter to Secretary, Department of Scientific and Industrial Research, 22 January 1919. British Museum Archives Letter Book pg.13.

MacGregor, A. (ed) 1994. *Sir Hans Sloane, Collector, Scientist, Antiquary*, BMP, London.

Madsen, H.B. 1994. *Handbook of Field Conservation*, Konservatorskolen, Detkongelige Danske Kunstakademie, Denmark.

Oddy, W.A. 1993. Conservation of Metals in Europe, in *Current Problems in the Conservation of Metal Antiquities, 13th International Symposium on the Conservation and Research of Cultural Property*, Tokyo National Research Institute of Cultural Property, 1-27, Tokyo.

Sease, C. 1996. A short history of archaeological conservation and its consequences, in Archaeological Conservation and its Consequences (eds A. Roy and P. Smith), IIC, 157-61, London.

Smith, S. 1992. *The Portland Vase*, in The Art of The Conservator (ed W.A. Oddy),Smithsonian Institute Press, 42-58, Washington DC.

Spiro, P. 1971. *Electroforming, A Comprehensive Survey of Theory, Practice and Commercial Applications*, Robert Draper Ltd, Teddington.

Sarah C. Watkins
Department of Conservation, The British Museum, London WC1B 3DG

SOME PROBLEMS AT THE INTERFACE BETWEEN ART RESTORERS AND CONSERVATION SCIENTISTS IN JAPAN

Yasunori Matsuda

ABSTRACT

Some problems at the interface between art restorers and conservation scientists are becoming apparent in the field of conservation in Japan. For instance, unfortunately the greater part of the conservation of works of art has been carried out for a long time only by art restorers without the support of conservation scientists. Furthermore, few of the art restorers are conscious of the philosophy of preventive conservation in the context of their conservation practice; while the conservation scientists are unable to provide a support system for restorers. The cause of the problems are the difference in historical backgrounds coupled with the current working situation of restorers and scientists in the conservation field.

Key Words

art restorer, conservation scientist, conservation philosophy, scientific technology, historical background, preventive conservation, modernisation

INTRODUCTION

It goes without saying that in Japan there are many precious and unique cultural properties, such as historical and archaeological objects, folk objects and works of art. The process of conservation of the works is of great importance for the people of Japan. Recently, the nature of the learned society for conservators and scientists in Japan has altered, in that the name of the society has changed from 'Association of Scientific Research on Historic and Artistic Works of Japan' to 'The Japan Society for the Conservation of Cultural Property'. In Japan this is seen as an epoch-making phenomenon, and is considered to be due to not only the large increase in numbers of associate members of conservators and restorers compared to scientists, but also to an alteration in the thinking on conservation. The field of conservation of works of art is confronting problems of reformation, or, in other words, modernisation. It is very important

for the future of this field, and the next generation of conservators, that the problems are resolved. The change in name, naturally, will not itself lead to a solution of the problems.

In these circumstances some points of friction between art restorers and conservation scientists are becoming clear. For instance, there is an unfortunate fact that the greater part of conservation of works of art has been carried out, for a long time, only by the art restorers without the support of the conservation scientists. In consequence art restorers consider that many conservation scientists show only a limited understanding of restoration. Meanwhile the conservation scientists, including the author, have pointed out that some of the art restorers in Japan do not have enough of an objective viewpoint of conservation practice. It is obvious that this distance between the opinions of both groups is caused by a lack of communication, and a lack of respect for each other's work. But, the author considers that the distance exists not only for this reason, but also because of other situations within conservation in Japan, which need to be explored.

In this paper, the problems are discussed. Firstly, the history of conservation practice in Japan and our standpoint in the field are described; second, the special conditions and problems applying to the working of Japanese art restorers are presented; finally, some comprehensive and concrete solutions are proposed. The views presented in this paper are not those of the Society but of the author. This paper is probably one of the first attempts to discuss these problems in Japan.

HISTORY OF CONSERVATION FIELD IN JAPAN

In Japan, there have been many traditional restorers of works of art such as paintings, Buddhist sculptures, lacquer (*urushi*) wares and wooden buildings. The unique cultural property of Japan has been restored by their efforts in each field. Their restoration practice,

characterised by skilful techniques using traditional materials, have been mainly dependent on accumulated experience gained through long-term training in the apprenticeship system. They have used traditional techniques and not taken into account new developments until recently. Naturally, they have neither the knowledge nor the technology to avoid or control deterioration as they do not understand the philosophy of preventive conservation.

In the 1930s scientific research for museum collections was introduced into Japan, and a new approach to the study of cultural property began to develop. For example, using scientific examination and analysis, some scientists tried to elucidate the mysteries of ancient techniques which were no longer practised. Unfortunately, these investigations were secondary to their normal research, and they did not expand their studies to develop a scientific approach to conservation practice.

In 1949 the valuable and famous wall paintings of Horyuji-temple, a World Heritage Site constructed at the end of seventh century, were burned down. In order to rescue the paintings some synthetic resins and traditional materials were applied, and the discoloured pigments were analysed. Thereafter they were successfully conserved with the support of scientific technology. In consequence, with the fire as a turning point, research for conservation and a law for protection of cultural heritage in Japan were established.

Later around 1960, the deceased Mr Yoshimichi Emoto (1925-92) who worked in Tokyo National Research Institute for Cultural Properties started to tackle scientific problems in conservation practice, studying the materials of works of art. In the early half of the 1970s conservation techniques for excavated waterlogged wood and deteriorated metals, utilising synthetic materials were introduced by a pioneer of this field in Japan, Prof. Masaaki Sawada (1942-) of the Nara National Cultural Properties Research Institute. The recent development of conservation science for archaeological relics and sites is dependent mostly upon his great efforts and leadership, in effect introducing a new branch of conservation practice.

Meanwhile, in the mid 1960s, scientifically based modern restoration methods for oil paintings were introduced by a few restorers who had trained in Europe or the United States. Oil paintings of Japanese and European painters have been restored by these pioneers, in private practice.

Since then the introduction of new approaches has barely touched other fields of restoration. The necessity of a knowledge of materials science, and the use of scientific examination and analysis in conservation has gradually been appreciated. Unfortunately, the pioneers did not emphasise the importance of theory and ethics for restoration, or put in place training for their successors. As a result, we have had neither common guidelines for conservation practice, or a code of ethics, nor a systematic training program, even for oil paintings, until now. Furthermore, there has been no organisation of oil painting restorers, nor the opportunity for discussion of their materials and techniques in public.

It is surprising that few restorers and conservation scientists have been employed as members of staff in national museums and private museums. (Only one national museum has an oil painting restorer.) Since most restorers are private, they are contracted by a museum to undertake restoration of a work of art, and thus have little chance to collaborate with conservation scientists on the conservation undertaken. This is one reason why there is such a distance between the thinking of the art restorers and the conservation scientists.

THE CHANGING SITUATION OF JAPANESE ART RESTORERS IN THE FIELD OF CONSERVATION

Some aspects of conservation in Japan focused on its characteristic history, were discussed above. In summary works of art peculiar to Japan have always been restored in a traditional manner, while restoration for oil paintings and excavated artefacts have been dependent on techniques imported from Europe or the United States. As a result there is a marked difference between the art restorers and conservation scientists from the viewpoint of the application of scientific technology.

It is also notable that until recently the conservation for traditional artistic works in Japan has been carried out by private restorers, who have had little experience of systematic training in ethics and science, or of collaboration with professionals in other fields, such as scientists, curators and art historians. Therefore, standardisation of restoration technology, a code of ethics, rules of practice, and the philosophy of preventive conservation have not been necessary in their work. Excessive restoration treatments of works of art have often been identified by clients and other professionals. The restorers' traditional dignity and pride in the old culture have been emphasised, and as

a result, the wish to undertake conservation, and the value of cultural property, have not been balanced rationally. Furthermore, they have continued training their successors in the same way by the typical Japanese apprentice system for restoration, which is uncommunicative and exclusive to the field of conservation.

On the other hand, the frantic pace of technical development in the conservation of archeological artefacts and in conservation science has attracted public attention. Recently, academic training courses for conservation with both technological and scientific programs have been set up at some universities. This has changed the situation in which the art restorers work. Yet, there has been no increase in communication between the art restorers and the conservation scientists because they have been moving in different directions. In consequence, the distance between the groups has become greater.

The situation can be understood through a restorer's reply to a questionnaire devised by the author, and given to art restorers at the 16th conference of The Japan Society for the Conservation of Cultural Property in 1996. The replies were as follows.

- Why do we (art restorers) need a scientific approach?
- What kind of scientific methods can help us with our work?
- How can we build the relationship between art restorers (traditional technology) and conservation scientists (scientific technology)?
- How can we obtain information concerning scientific approaches to art restoration?
- We cannot apply current scientific technologies to our art restoration by ourselves, because the principles are too difficult to understand. We have poor knowledge of fundamental science.
- We intend to put the scientific results into our practical work as soon as possible. Nevertheless, we do not have not a network for co-operation or a support system (or a related institution) to achieve this.

The conservation scientists think that they have been making progress in assessment and examination of the materials of works of art and they are able to offer restorers a suitable service. However, often art restorers do not agree, and are pressing the scientists for accessible practical scientific approaches to restoration, which take into consideration the art restorers' knowledge. In spite of the active usage of

traditional materials, the importance of reversibility of the conservation materials and the importance of maintaining the authenticity of the works of art have not been considered. Conservation ethics have also not been considered. There is little understanding that conservation now consists of two activities: preventive conservation and restoration.

Although many conservation scientists probably consider that the art restorers' should resolve these matters for themselves, the author believes that the two groups should work together to develop a new approach to the conservation of works of art in Japan. In the author's opinion, different goals must be set in the different fields of conservation.

SOME PROPOSALS TO RESOLVE THE PROBLEMS

There are obviously some problems at the interface of art restorers and conservation scientists in Japan. The author considers that it is most important for the two groups is to discuss the problems together openly. Both groups need to understand and respect the viewpoint of the other.

Firstly, working groups should be set up to deal with themes such as conservation philosophy, code of ethics, and the relationship between restoration and science, under the auspices of the Japan Society for the Conservation of Cultural Property. The working groups should write papers on the themes for open discussion, even involving the public, and conservators and scientists from foreign countries. The work of restorers should be guided by establishing regulations for conservation practice.

Secondly, a new network for sharing information on the activities of conservators and scientific developments in conservation should be set up in the near future. Experiments of practical use for the network can be done immediately. Regular seminars for the art restorers on scientific approaches to conservation should be held.

Thirdly, local organisations of art restorers and conservation scientists should be established to reinforce the interaction of both groups; and to respond to disasters such the Hanshin-Awaji earthquake in 1995. This should be introduced by setting up local facilities of scientific technology for conservation, to share scientific knowledge and technology. These will be in addition to the few national institutions that can help conservators and

curators in their collaboration with conservation scientists.

In addition, the establishment of a guild for each field of conservation is needed to increase the understanding of conservation amongst the public. An organisation of this type has already been set up for restorers of Japanese paintings on paper.

Finally, it is also very important that the next generation of conservators are fully equipped with an understanding of modern practice, technology and science. This can only occur in the training system for conservators and suitable curricula must be set up. The next generation of Japanese conservators, with fundamental scientific knowledge and practice, will play an active part in international conservation.

CONCLUSION

Japanese conservators have received information about modern conservation, including restoration techniques, materials, and concepts of conservation. Sometimes the information has confused us, considering the difference between modern and traditional thinking. Optimistically, the introduction of the excellent European and American style of conservation practice into Japan should change the outlook of the next generation of conservators. On the other hand, pessimistically, it can be anticipated that without an active intention to restructure, the Japanese style of conservation will continue forever. There is a need to face up to and resolve the problems, to modernise conservation in Japan. The author considers that a new direction in thinking and practice should be sought and an historic step forward taken as soon as possible.

Yasunori Matsuda, Conservation Science Course, Tohoku University of Art & Design, 200 Kamisakurada, Yamagata-shi, Yamagata 990, Japan

LEAVE IT TO THE EXPERTS?

Yvonne Shashoua

ABSTRACT

Many training courses for the professional conservator have increased their scientific content in recent years and now encourage students to carry out scientific investigations in addition to developing their practical conservation skills. In contrast, most novice conservation scientists have experience of planning and developing research projects, and of interpreting analytical data, but only appreciate the requirements of conservation once installed in the museum environment. This paper examines the contribution made by conservation scientists and conservators to all aspects of selecting and evaluating polymeric materials for use in conservation. It concludes that, in order for research projects to be successful, the experience and knowledge gained by scientists and conservators should be optimised and coordinated.

Key Words

conservation, materials, polymers, research, testing

INTRODUCTION

The roles of professionals in many fields have become less clearly defined during recent years, and those of conservation scientists and conservators are no exception. This overlap in roles has been initiated partly by a shift in the emphasis in training courses and partly by the need for museum professionals to increase their skills. Most of the established training courses for conservators now recruit students with basic scientific qualifications, and include scientific modules as a compulsory component of their syllabi. Final year projects often provide the student conservator with the option of carrying out scientific research-based studies, in addition to those requiring practical conservation skills. In contrast, most novice conservation scientists have experience of planning and developing research projects and of interpreting analytical data, but only appreciate the application of science to conservation once installed in the museum environment.

Is it an effective use of conservators' time to carry out their own research projects? Should all scientific work be conducted by scientists, allowing conservators to concentrate on their main field of expertise, that is, practical conservation? Do conservation scientists appreciate the requirements of working conservators? The purpose of this paper is to examine the advantages and disadvantages associated with conservator-directed research projects compared with those planned and executed by scientists. It has been assumed throughout the text that conservators have minimal experience of scientific research and that scientists have little experience of hands-on conservation. The evaluation of appropriate materials, particularly resins, used as consolidants, adhesives, decorative and protective coatings for museum objects, will be the focus for this discussion.

SELECTION OF CONSERVATION MATERIALS

The range of materials used in conservation has expanded dramatically during the last twenty years. Prior to the Second World War, the very few conservation materials in regular use were natural ones such as plaster of Paris and animal glues. Today approximately 400 different branded resins are used by the Department of Conservation in the British Museum for the stabilisation, repair, restoration, replication, and support of antiquities.

Conservation materials are selected on the basis of their physical and chemical properties, their availability in small quantities, their long term stability, and their potential risk to the health and safety of users. Sources of information concerning new materials include conservation journals, recommendations from colleagues, or manufacturers' advertisements. The search for new materials is a rather passive process; conservators and scientists rarely look for a suitable material in a proactive way, but as and when the need arises. In addition, there is a

tendency to regard any new material with some scepticism until its stability is proven.

It is the policy of the Department of Conservation that all materials to be used in contact with museum objects should be assessed for their stability with regard to, at least, the next 50 years. The first stage of any procedure involving a new material is an assessment of the risks to health and safety to comply with the Control of Substances Hazardous to Health (COSHH) regulations. If the precautions associated with use are not prohibitive, new materials are examined by conservators for a qualitative assessment of their handling properties. If a particular material shows promise, a written request for a quantitative evaluation by a conservation scientist is submitted. The chemical and physical properties required of the material are agreed between scientist and conservator and a series of appropriate tests are proposed. A plan of work outlining the timescale for the project is prepared.

A new material may be evaluated in isolation or, more usefully, against the material it is replacing, or a comparative material. The behaviour of polymers is examined in the form of a free film and also when applied to its intended substrate, if appropriate. The practical work may be carried out entirely by the scientist or may be shared between scientist and conservator. Instruction in the preparation of sample materials or in the use of test equipment may be required. After discussion of the implications of the test results, the scientist prepares a written report and disseminates the information.

EXPERIMENTAL DESIGN

Prior to planning a research project, whether collaborative or not, it is essential that scientists and conservators agree on the desired outcome of the work. Both groups frequently take different approaches to experimental design. Scientists usually aim to minimise the number of variables and to rationalise the materials and experimental samples to those most likely to succeed. Selection of materials suitable for evaluation is based on technical data supplied by manufacturers and using knowledge of the behaviour of polymer types. Data detailing physical properties, such as Glass Transition Temperature (Tg) and solubility parameter, are often used in the selection process. Conservators tend to be more interested in generating the maximum amount of information about the behaviour of all materials

involved in the project prior to interpreting the results, and often find it difficult to prioritise their requirements.

There is sometimes a tendency for a bias towards or against certain materials; both scientists and conservators may be guilty of such feelings which are often subconscious. A conservator may favour a material which is known to have good handling properties or appearance over one which demonstrates superior long term stability. Familiarity with a particular resin may increase its chance of selection. As an example, Paraloid B72 (copolymerethyl methacrylate) was developed commercially as a binder for pigmented surface coating formulations. Its excellent retention of optical and chemical properties on ageing has been proven repeatedly (Koob 1986). However, the low Tg of Paraloid B72 (40°C) renders it unsuitable for use in the high temperatures prevalent on excavation sites in the Middle East and its brittleness suggests its unsuitability for flexible substrates such as leather (Anon 1991). Nevertheless, Paraloid B72 has been used for both.

A scientist may disregard the handling properties in order to favour the most stable or soluble material. Both groups of professionals may have expectations of particular resin types based on past experience and on findings made by colleagues. In addition, any physiological sensitivities caused by particular resins will prejudice the user's views on its performance. In order to evaluate all potential conservation materials on an equal basis, it may be most effective to carry out 'blind' experiments, where the identities of the materials are unknown to those responsible for the assessment.

This approach proved successful when a group of eight ceramics conservators in the British Museum was asked to rate the appearances of a series of treated ceramic samples, in terms of discolouration and gloss. The samples had been consolidated using 5% w/v solutions of Paraloid B72, Mowital B30H (polyvinyl butyral), an inorganic sol-gel polymer Silicon Zirconium Alkoxide (SZA) (a new material under development), Raccanello E550550 (anacrylic-silane resin mixture), and Wacker OH (tetraethoxysilane). Paraloid B72 and Mowilith B30H are commonly used to consolidate friable ceramics, but the other resins, although used to treat stone objects in the past, were less familiar to ceramics conservators.

All treated samples were placed on the same blue background to facilitate comparison of discolouration. Labels bearing consolidant names were replaced with letters A, B, C, D, E so that none of the conservators

could associate the samples with their real treatment. Each conservator was asked to grade all samples following a predetermined scale of values without collaborating with colleagues and the results were collated. All participants selected ceramics treated with SZA as having the most satisfactory appearance, despite their initial concerns about the material. Few participants had guessed the correct identity of all the consolidants.

SAMPLE PREPARATION

Since conservation materials are intended for application to museum objects, their behaviour should be examined on such surfaces. However, since such action could be considered to be against the best interests of the object, and because there is rarely sufficient disposable study material available, the usual procedure is to design an experimental substrate which represents the properties of the original. The conservation scientist's normal approach is to produce an experimental substrate which is readily reproducible and suitable for handling and withstanding preparation for mechanical testing. Such substrates may be thicker and are likely to have a more homogeneous structure than the original object. In addition, preparation of test pieces may be dependent on the design of mechanical testing equipment.

For example, when determining the breaking stress of adhesives used for glass conservation, it is usual to prepare lap joins with glass microscope slides as the experimental substrate. However, due to the significant offset of adherends created by a lap join, it is necessary to prepare double lap joins in order to fit the test piece into the aligned grips of the tensile tester. Since a double lap repair is rarely used in conservation, a compromise has to be made for testing purposes, and assumptions made about the relevance of such tests to reality (Shashoua 1993).

An alternative approach, more often taken by conservators, is to devise an experimental substrate which more closely replicates the original surface, but may be less readily evaluated. A recent collaborative project between the British Museum and the Fraunhofer Institut für Silicatforschung (ISC) in Germany concerned the stabilisation and strengthening of friable, highly porous ceramics. The project involved a comparison of the effectiveness of consolidants of different polymer types. A visiting conservator working with scientists at the ISC had designed a model substrate for a similar project which had proved successful; as a result the design was adopted for the collaboration with the British Museum. The experimental material was prepared by mixing clay with various proportions of sand and woodchips. On firing at temperatures above 600°C, the organic material was volatised leaving large pores in its place (Pilz and McCarthy 1995). Porosity measurements suggested that the mean pore diameter was of the order of that determined for Egyptian ceramic ostraka in the British Museum, confirming the precision of the model. However, the inhomogeneous distribution of pores led to an uneven penetration of consolidants, complicating direct comparison of the performance of all consolidants. Microscopic examination of the upper surface was also confused by the uneven profile of the experimental substrate.

The reproducibility of experimental formulations is an important factor if evaluation of conservation materials is to prove successful. Although there is usually some minor batch-to-batch variation in physical properties for commercially produced resins, the formulations by which conservation materials are prepared should be consistent. While scientists are trained to prepare mixtures of chemicals to standardised formulations from an early stage in their careers, conservators are not always trained in this discipline. A conservator may need to vary an established formulation in order to optimise the working properties of the material and thus meet the requirements of the object being treated. Such variations may involve adding matting agents to an acrylic paint to reduce gloss levels on an inpainted surface, reducing the volume of solvent to reduce the rate of flow of consolidant into a crack or altering the solvent blend to compensate for high seasonal temperatures (Shashoua 1989).

Although such minor variations in formulation are fully justified, they are frequently undocumented in conservation records and, as a result, more difficult to reproduce at a future date. In addition, it is not always appreciated that changes in formulation are likely to alter the long term stability of conservation materials. Since the conservator appreciates the handling properties required of a conservation material and understands the physical condition of the object, and the scientist is practised in the preparation, behaviour and documentation of chemical formulations, the most useful experimental substrates are those prepared by scientists following discussion with conservators.

METHODS USED TO EVALUATE PROPERTIES OF CONSERVATION MATERIALS

Ideally the materials used for conservation should stay unaltered forever, but this is an unrealistic expectation. In his book on materials used in conservation, Horie proposes that materials should be stable for at least 20 years and, preferably, for more than a century, in order to minimise the number of interventions required (Horie 1987). Since the first synthetic polymers, cellulose nitrate and acetates, have only been commercially available for a little longer than one century, and conservation professionals need to know the longevity of these materials prior to their use, accelerated ageing has become an accepted practice. This is achieved by increasing the energy of the system using heat and light, with the intention of accelerating any reactions which occur naturally.

Although it is possible to make some predictions concerning the future behaviour of a conservation material, the only accurate test of its longevity alone, and when applied to an object, is that of real-time ageing. Access to an accurately documented collection is the most useful means of periodic monitoring of the condition of conservation materials; such opportunities are rare. Conservation scientists at the British Museum have kept samples of free films of all polymers evaluated since the early 1970s in the dark under reasonably constant conditions of temperature and relative humidity. These act as a reference collection of resin films.

A research project carried out in the Museum in 1994 with the intention of examining the effect of natural daylight on the colour of false glazes applied to plaster of Paris, polyester and epoxy filling materials revealed the complexities associated with using real time ageing. A ceramics conservator selected two locations for ageing samples both illuminated by a combination of natural and artificial sources. Colour measurements were made every six months using a UV-Visible spectrophotometer. Three years after the start of the project, results remain largely inconclusive due to an inability to control or readily monitor the total levels of illumination, the temperature profile and the relative humidity during the exposure period. The large number of variables, including the dry film thickness of the glazes, the degrees of penetration into the different substrates and the conditions prevalent in the ageing environments were too many to control. Such differences in approach to evaluating materials suggest that, while the main concern of the scientist is reproducibility of conditions, that of the conservator is replicating reality. Both factors are essential if the outcome of a research project is to be successful.

The technology available to the scientist to follow the chemical aspects of deterioration has increased dramatically during the last 20 years. Equipment used to determine the changes in mechanical properties of conservation materials with time has become computerised, allowing the results to be manipulated into almost any desired format. However, although conservation scientists may be able to quantify a wider range of properties than before, generating more information about conservation materials, such values are not a substitute for the complex aesthetic evaluations made by the experienced conservator.

A recent comparison of the ability of cellulose ethers to consolidate powdering and flaky pigments on watercolour paper required a technique for quantifying the loss of adhesion experienced when works of art on paper were transported or handled (Rugheimer and Shashoua forthcoming). A test devised to determine the loss of adhesion of the friable surface from ceramics involved the application of adhesive tape. Tape was pressed on the surface, peeled off and visually assessed for the presence of ceramic particles. Such a test proved too severe for use on poorly adhered pigments, removing all the applied colouring material. A more appropriate alternative was devised by the author and a paper conservator. A grid of 100 squares, each 1mm by 1mm, was drawn on a sheet of watercolour paper. The paper, grid-side down, was placed directly over the pigment and a print roller was rolled once over the whole. The grid was examined for evidence of transferred pigment and the number of squares affected was expressed as a percentage loss. Trials using this test showed that the loss of adhesion was lower than that expected during normal handling of objects. When the number of applications of the roller was increased to two, the conservator was satisfied that the loss of adhesion was commensurate with that observed when handling or transporting works of art drawn with chalks or charcoal.

The Conservation Research Group encourages interested conservators to actively carry out straightforward measurements on their materials. This enables conservators to appreciate the time required for testing, the quantities of experimental material necessary, and the value of replicate measurements. An appreciation of the benefits of making quantitative measurements to confirm qualitative judgements is

of the relevant equipment by the collaborating scientist, but have insufficient time to investigate its full potential.

This practice has had varying levels of success. Projects require additional time for training and discussion, a commodity which is rarely available in the current economic climate and, as a result, greater input from both conservator and scientist is needed. It has been the author's observation as a result of participating in these projects that, although a conservator may become highly efficient in the use of analytical and measuring equipment, appreciation of the meaningfulness of the values obtained requires considerably more experience. Such experience would enable the operator to distinguish between discrepancies in readings due to equipment failure or as a result of using equipment beyond its specified limits, and interesting but unexpected values. The benefits to the collaborating conservation scientist include an opportunity to further appreciate the requirements of the conservator.

PRESENTATION AND INTERPRETATION OF EXPERIMENTAL RESULTS

At a time when resources are under financial constraint, the distribution and communication of results to other museum professionals are vitally important aspects of research projects. Such action reduces the necessity to duplicate research work and encourages exchange of information. A particular conservation material is often considered suitable for the treatment of a range of substrates and may serve multiple functions, such as both adhesive and filling agent. For this reason, it is important to present data clearly and in the most comprehensive format, allowing ready access to professionals from all disciplines. It has been proposed by archaeological statisticians that tables of raw data, if not included in a publication, should be made available on application to journals. Such a practice would allow readers to judge the validity of interpretations (Reedy and Reedy 1988).

The validity of only quoting experimental data to a justified number of significant figures is a concept appreciated by scientists from early stages in their careers, but one which is often less well appreciated by non-scientists. Although an analytical balance, used to weigh the solid polymeric component for preparing a solution of, say, a consolidant, relates mass to four decimal places, quoting all four is not justified

if the other components have not been measured to the same degree of accuracy.

Also important is interpretation of quantitative data. Collaboration is needed between conservator and scientist to agree the limits of change which are considered acceptable. For example the principle of reversibility constrains the conservator to employ methods and materials which may be removed without causing damage to the object, either now or in the future (Appelbaum 1987). At least, any interventive techniques should not reduce the possibilities for future treatment of the object. In reality, few active conservation treatments are likely to be completely reversible (Oddy 1995). Polymers, used as consolidants, adhesives or paints, tend to adhere strongly to the pore walls of ceramic and stone, and become trapped on ageing. Although solubility measurements, carried out on free films of the materials by a scientist, may suggest that complete reversibility is possible by applying solvents of a suitable polarity, conservators' experience shows that this is not the case in reality. A compromise between both technical and aesthetic requirements of the object must be reached.

CONCLUSIONS

A successful research project is one which results in satisfactory results for all participants and for those with interests in the work; this may include curatorial staff and students of the artefacts concerned in addition to conservators and scientists. In the case of a project to evaluate potential conservation materials, success results in the selection of the most stable, suitable material for the object undergoing treatment. Effective experimental design, taking into account the time, equipment, finances and experience available is essential to the outcome of a project. Conservation scientists and conservators should agree the desired outcome of the work prior to collaborating on the design. The properties required of the potential conservation material should be prioritised so that it is clear which may be sacrificed, if necessary, and which are essential for the proposed treatment.

Although scientists and conservators are equally capable of completing the practical aspects of evaluating materials, perhaps with some instruction, experimental design, analysis and interpretation of results are most effectively performed by the relevant expert. Design and preparation of reproducible experimental substrates and of test formulations, once

discussed with the conservator concerned, is a practice best executed by conservation scientists. Their familiarity with standardised formulations and with preparing replicate samples allows such work to be completed more effectively than by those less familiar with the process. However, any variations to the agreed materials must be first discussed with the conservator partner to ascertain the comparability of the replacement formulations with reality. Conservation scientists are also more experienced at performing statistical analysis on experimental data.

Since conservation scientists tend to work in several areas of conservation during their careers, they can readily apply the general experience gained in one area to a variety of research projects. In contrast, many conservators specialise, and have an in-depth knowledge of one type of material. As a result, both types of professionals should be involved in applying the findings of a research project to developing practical conservation techniques. In addition, scientists and conservators should work closely to satisfy the complex technical and aesthetic requirements of successful conservation treatments.

REFERENCES

Anon, 1991, *Thermoplastic Solution Grade and Solid Grade Acrylic Resins*, Technical Data by Rohm and Haas Ltd. USA.

Appelbaum, B. 1987. Criteria for treatment: Reversibility. *Journal of the American Institute of Conservation*, **26**, 65-73.

Horie, C.V. 1987. *Materials for Conservation: Organic Consolidants, Adhesives and Coatings*, Butterworths, London.

Koob, S.P. 1986. The use of Paraloid B-72 as an adhesive: its application for archaeological ceramics and other materials, *Studies in Conservation*, **31**, 7-14.

Oddy, W.A. 1995. Does reversibility exist in conservation?, in *Conservation, Preservation & Restoration. Traditions, Trends and Techniques* (ed G. Kamalakar and V. Pandit Rao), Birla Archaeological & Cultural Research Institute, 299-306, Hyderabad.

Pilz, M. and McCarthy, B. 1995. A comparative study of Ormercers and Paraloid B-72 for conservation of outdoor glazed ceramics, in *4th European Ceramics Society Conference* (ed B. Fabbri), vol. 14, 29-39, Riccione, Italy.

Reedy, T.J. and Reedy, C.L. 1988. *Statistical Analysis in Art Conservation Research*, The Getty Conservation Institute, Los Angeles.

Rugheimer, A. and Shashoua, Y.R. Forthcoming. An evaluation of the use of cellulose ethers in paper conservation at the British Museum in *4th International Conference of the Institute of Paper Conservation*, London.

Shashoua, Y.R. 1989. *Investigation into the variations in properties between batches of HMG Heat and Waterproof Adhesive*, British Museum Department of Conservation, Conservation Research Group Internal Report No. VII-34.

Shashoua, Y.R. 1993, Mechanical testing of resins for use in conservation, *in 10th Triennial Meeting, Washington 22-27 August 1993* (ed J. Bridgland), ICOM-CC, vol.1, 442-6, Paris.

Yvonne Shashoua, Department of Conservation, British Museum, London WC1B 3DG

CONSERVATION SCIENCE AND MATERIALS HISTORY

Leslie Carlyle and Joyce Townsend

ABSTRACT

Conservation is an inter-disciplinary and expanding field, which regularly draws on the knowledge bases of a number of other specialists. Conservation research projects benefit greatly from the collaboration of a variety of specialists both from within and from outside the field of conservation. Various issues taken from the authors' personal experience in ten years of fruitful collaboration will be explored, including the growing need to 'interface' with research scientists outside the field. The breadth of knowledge required by conservation scientists and materials historians, as distinct from research scientists and historians of technology, is outlined.

Key Words

nineteenth-century artists' materials, analysis of pigments, conservation scientist, materials historian

INTRODUCTION

The analysis of the materials in works of art and archaeological finds began in a fragmentary way in the later eighteenth and early nineteenth centuries, but developed systematically only from the 1930s in the UK, in national museums. Knowledge of artists' materials has been steadily developing since the 1950s thanks to the initiative and dedication of specialists within conservation, such as we find at the National Gallery in London (Mills and White 1994, Bomford *et al.* 1988, Bomford *et al.* 1989, Bomford *et al.* 1990, Anon. 1977-96) and elsewhere.

The study of the bulk or macroscopic properties of naturally-aged materials, and their composition on a microscopical scale, is a development essentially dating from improvements to instrumental analysis and in programmes for handling analytical data. It is only in the last decade that it has been possible to elucidate the detailed composition of most materials, in an acceptably small sample, from works of art. For both paintings and watercolours, 'acceptably small' means about 100 micrograms in weight. Improved techniques of analysis provide much more information from a given sample, and makes possible numerous research projects which once could not have been carried out on scarce historic materials. They also add new possibilities for the analysis of the numerous samples which are taken in an attempt to solve a conservation problem, rather than for the purposes of pure research.

Within the conservation profession there are growing numbers of specialists who are carrying out primary research with scientific instrumentation and with historical documentary sources. In addition, through various initiatives the conservation field is receiving greater access to outside specialists.

For example, in recent years, multi-disciplinary projects have arisen to bring the resources of academic or research institutes to bear on collections of valuable artworks. One such is MOLART (Molecular Aspects of Aging in Art) funded by the Netherlands Organisation for Scientific Research over a five-year period. Involving a considerable number of Dutch specialists in paintings and several research scientists, it will also employ up to fifteen additional researchers, mainly doctoral and post-doctoral scientists. Several studies on specific paintings (Boon *et al.* 1995, Boon *et al.* 1996) and on picture varnishes (van der Doelen 1995, van den Berg 1996) have already been published in the conservation literature. This model presents an ideal, where many specialisations are brought to bear on a single issue in the conservation and treatment of artifacts.

On a smaller scale, many conservation science laboratories in the UK have formed or joined a multi-disciplinary project funded by the European Economic Community, which links laboratories and industrial partners from a number of countries, with the object of developing equipment or a novel sensor, after several years of collaboration. However, such projects introduce new groups of specialists, who are nevertheless non-specialists in conservation, therefore much of the success of these projects will be dependent on the quality of the communication between disciplines.

INSTRUMENTAL ANALYSIS

With the ever-growing sophistication and sensitivity of instruments, the interpretation of analytical information requires a more and more subtle understanding of materials and technology. And even before interpretation, the choice of instrumentation becomes an increasingly complex task when the full range of state-of-the-art equipment is to be utilized.

There are three procedures involved in the instrumental analyses of materials. The first is to determine what materials are to be investigated, ie. what questions to ask, the second is the analysis itself, and the third is the interpretation of the analytical results.

The very nature of scientific analyses dictates that for the most part we can only find what we are looking for: only a certain range of materials can be identified by a given analytical technique. If the aim is to identify all materials present, then it would be ideal to have a list of all possible categories of material potentially present before analysis proceeds. Certainly we are not likely to achieve such an ideal, however as research on historical materials continues, our list of materials known to be in use will no doubt increase substantially. For example standard modern references on artists' oil painting materials list the common ingredients in the ground: chalk, gypsum, kaolin, lead white, and barium sulphate as fillers, and animal glues or oil as the binders. These are the materials most often found in the analysis of grounds. Yet a study of nineteenth-century ground recipes indicates that starch, bone meal and casein were also used, along with egg, isinglass, skimmed milk and caoutchouc (natural rubber). Similarly the general under-standing is that animal glues were used to size canvases prior to applying the ground, however other materials, including isinglass, starch and modified celluloses (e.g. cellulose nitrate) were also cited in contemporary nineteenth-century sources (Carlyle 1991, 229-47). Currently it is difficult to establish how often these other materials were used, since they are not usually targeted in routine analyses.

Part of the analytical strategy is to choose the appropriate equipment. It may appear obvious, but it is important to establish whether or not the equipment is a limiting factor. Recognizing the limitations in sensitivity and appropriateness of the equipment is fundamental to the success of the analysis, and essential for the interpretation of the data which emerges. Yet there can be a tendency for analyses to concentrate on what is easiest to find with the immediately available instrumentation, or to answer the question narrowly without establishing the full frame of reference for the question.

In some cases what is not detectable by a given instrument is not fully emphasized leaving the conservator unable to distinguish between the genuine absence of a material and the insensitivity of the analytical method. For example, some important materials which strongly influence the ageing properties of bulk materials are likely to be present only in extremely small proportions. Driers in oil paint are a good example: according to some contemporary recipes, lead-based driers in eighteenth and nineteenth century paint could comprise up to several percent of the paint medium, whereas the driers used today can account for less than 0.5%. Another is the use of alum (potassium aluminium sulphate) in paper sizing. By the time the size is spread over the paper in a very thin layer, alum is present in such low quantities that the commonly-used method of EDX (Energy Dispersive X-ray analysis) would be unable to detect it.

Here the conservation scientist is in the best position to determine whether the readily-available equipment is adequate to answer the question which has been asked, or if not, to communicate with specialists in the fields of analytical chemistry, physics of materials, engineering and biology, etc., who can provide new techniques and state-of-the-art instrumentation. Each of these experts has a separate terminology and a set of shared assumptions with others in the same field, but less common ground with those outside the field. The conservation scientist is able to 'translate' information from scientists in other disciplines, to other conservation professionals. Unlike the research scientist, he or she is in daily contact with conservators, and examines many of the works which pass through the conservation studio. He/she understands the problems of taking samples from much-conserved works of art. Paintings, for example, have frequently been lined and consolidated with adhesive; most have been varnished several times, and some varnish and dirt layers may have been cleaned off as well. He/she also understands how the presence of such added materials will confuse or sometimes invalidate the interpretation of analytical results. The conservation scientist, as distinct from the contract analyst, also understands the numerous reasons behind a conservator's request for analytical information. These include a need to know the physical and mechanical properties of paint etc., in order to predict the painting's response to a proposed

treatment, and/or its sensitivity to display and storage environments. For an individual work of art, these reasons may be more compelling than the desire to clarify the composition in exhaustive detail.

The conservation scientist who works with several conservators and the whole range of materials in a collection is more of a generalist than the conservators, in one sense, and has a wider knowledge of the institution's current list of 'problems looking for solutions'. Such a generalist may well be the best person within the group to devote time regularly to seminars on applications of analysis, scientific or specialist conferences and the like, and to take on a role which in other fields is called 'information scientist'. The conservation scientist can also cultivate a range of instrument users in a variety of outside firms and institutions, who could be called upon occasionally, when an unusual sample would benefit from an analytical method which is not widely available, even in museum laboratories. Increasingly, conservation scientists in the UK supervise doctoral students who work mainly within a university department, not in the museum itself, assessing for example, the suitability of a range of analytical techniques on small samples from works of art. When these projects are concluded the museum in question may purchase one instrument which has been shown to be applicable to the analysis of a wide range of problems or materials relevant to its collection, for it has become prohibitively expensive for museums to purchase an instrument speculatively.

Scientific analyses provide information with various levels of confidence. It is important, for accuracy and to prevent results being misunderstood or misread, that these levels of confidence are expressed within the final report so that findings may be interpreted accordingly. For example, EDX is often used to analyse the elements present in a paint. It should be understood that extrapolations from elemental analysis to an interpretation of the compounds present (based on knowledge of the pigments and fillers that could be expected) offers one interpretation of possible compounds, but there could be other interpretations. Interpretation is the most crucial part of the entire analytical procedure. Non-specialists to conservation may well be able to detect major, minor and even trace components of complex and aged mixtures, but they will not be in a position to help the conservator to determine why they are present, what role these materials were meant to play, and indeed whether they were intentionally added by the manufacturer or the artist. Here the combined efforts of the conservator, conservation scientist and materials historian in supplementing analytical information and assisting in the interpretation of this information is most valuable.

COMPLEXITY OF HISTORICAL MATERIALS

In some scientific studies data is collected, plotted on graphs, then certain behaviours or trends are extrapolated. This data collection process has sometimes been applied to the chemical analysis of works of art where certain materials have been identified as being in use over a specific period and/or in a given country, then this fact is taken to be relevant to works of art from a wider range or context. This model can work well where early workshop practices in western Europe led to relatively uniform production methods; for example panels with identical or nearly identical ground formulations. However, this does not apply to all works at all times, and the concept of works being uniform in their materials and techniques breaks down dramatically by the nineteenth century. A case in point is the concept of a 'commercial' ground. A distinction is often made between artist-applied and colourman-applied (commercial) ground layers on canvases dating from the beginning of the nineteenth century to the present. The two are distinguished by a number of factors relating to their method of application: the thickness and uniformity of the surface and the presence or absence of the ground over the tacking margins. A relatively thin, very evenly applied ground extending over the tacking margin points to a commercially applied ground, whereas the absence of these characteristics implies an artist-applied ground.

However, a close study of one nineteenth-century colourman's archive reveals that they were formulating grounds to order, according to the artist's wishes (Carlyle 1991, 250, 364). Therefore, the ground may well have been 'commercially' prepared and applied, but since its formulation was specific to an individual artist, the materials used do not necessarily represent those in grounds usually prepared by this firm. Generalisations based on morphological characteristics alone and extrapolating from one painting only would lead to an incorrect conclusion: this ground, with its specific materials appears commercially prepared, therefore it is representative of a commercial ground.

EXAMPLE: THE LIMITS OF THE HISTORICAL RECORD FOR ARTISTS' PIGMENTS

Of course, a blind reliance on whatever documents have been preserved leads in itself to incomplete information and potentially misleading assumptions about materials which have been used in the past. The all-encompassing reference books of the nineteenth century have been superseded by detailed monographs, and then by databases of information which can be updated by primary researchers (van der Wetering and Peek 1990) and even consulted online by those in the conservation profession. (Admittedly, such open-access databases are few as yet, but they will undoubtedly multiply and become easier of access in the future.) A serious difficulty of interpreting historical sources arises when the meaning of words has changed over centuries, or even decades, and this can be a source of great confusion to anyone with limited time for historical research. A welter of terms were used to describe artists' pigments of a lemon shade in the nineteenth century: 'lemon yellow' could have been formulated with either barium, strontium or platinum, all of which were reported to be in use (Harley 1982).

The presence of an anomalous material in a painting or on the surface of a painting may not always be as clear an indicator as we would wish. Although zinc pigments were not introduced until the 1780s, the presence of elemental zinc in or on a painting does not preclude an earlier date for that work, or provide evidence of non-original overpaint. Documentary sources reveal that zinc sulphate was a common ingredient in oil paint driers, and could easily be present in the oil medium of paintings prior to the 1780s. Elemental analyses of zinc at a few percent concentration could indicate the presence of a drier, and would be unlikely in this relatively high proportion to be attributable to a previously unknown association of zinc with another pigment during its manufacture. Further analysis to determine the compound present would be advisable before any far-reaching decision such as the removal of non-original paint could be made.

Apart from authentication studies, which may reveal anachronistic pigments, providing a list of pigments present in a given work by analysis is only the starting point. In a previous paper, the authors established that by the nineteenth century, the practice of substituting and adulterating pigments was widespread (Townsend et al. 1995). Therefore it is not possible to establish by analysis alone whether the artist knowingly used that pigment or had purchased a colour where other pigments had been silently substituted. Certain colours, referred to by a single traditional pigment name, were actually compounded from several other pigments. Similarly, an individual artist's culpability regarding the use of fugitive pigments is not a straightforward matter of analysis. Stable pigments were substituted or enhanced with unstable pigments without the artist necessarily being aware of the changes. We may find ourselves in the position of knowing more about what was used in their paint than the artists did.

EXAMPLE: IMPROVING UNDERSTANDING OF EARLY OIL PAINTS AND OF PAINT DRIERS

The rapid deterioration of many of Reynolds' paintings is well known. His contemporaries attributed this to his penchant for experimenting with his materials. Despite his example, such experimentation continued amongst Reynolds' circle and by artists who followed. In hindsight, the vehicle often blamed for deteriorative effects such as drying problems, cracking and subsequent darkening, was megilp. Recently, historical research combined with practical experiments (Ara 1990) has given us a much better understanding both of the range of megilp formulations and the reasons for its use. To have the handling properties ascribed to it, megilp had to be made from a lead-based drying oil combined with mastic varnish; this formed a thixotropic gel which was then mixed with oil paint to give a significant improvement in its handling properties and translucency. All the conservators who have practised with megilps now understand much better why they were irresistible to use: they held impasto, or formed thin glazes, according to the way they were brushed, and they dried with a glossy surface and gave great depth to reflections. Their properties are still under study (Boon et al. unpublished), since their behaviour is complex, and their characterisation requires an understanding of sol or colloid chemistry beyond the normal in conservation. Such studies have provided insight into the conservation problems posed today by early paint modifiers, and have emphasised that a study of these materials is important to understanding paints used in the late eighteenth and early nineteenth centuries, as well as those of the later nineteenth century.

The drawbacks of using much-modified oil media (which were often given the cover-all name of megilps by both users and critics) are easy to see today: they were yellow when fresh and darkened to brown, certain proportions of ingredients formed fine wrinkles on drying and in many cases the paint formed drying cracks. These problems became apparent to longer-lived artists who had used these materials when younger, and it has been possible to document their gradual fall from favour in the earlier and mid nineteenth century. Further problems with variable heat sensitivity and solvent sensitivity, and differential dirt absorption when the mixing proportions varied, are more obvious now to conservators than they were to the artists who used them.

Paint driers, which form metallic soaps with the oil offer another promising avenue for further research. Until near the end of the nineteenth century, driers were generally added to oil by suspending bags of various powdered metallic compounds in the oil while it was cooked. Gradually the fatty acids in the oil reacted with the metal ions in the powdered materials (e.g. litharge, lead acetate, red lead, umber etc) to form metallic soaps. In the last decades of the nineteenth century, individual fatty acids were isolated from the oil (e.g. linoleic acid, oleic acid) and metal compounds were reacted directly to form specific metallic soaps: for example lead linoleate or lead oleate (Anon 1994). These individual metallic soaps were then added to the oil as pre-prepared driers. The next development occurred in the early decades of the twentieth century when naphthenic acids, a mixture of fatty acids, were isolated from petroleum. The result was the naphthenate driers using cobalt, lead and manganese. Then in the 1920s a single synthetic acid was used to produce the octoate driers (e.g. lead 2-ethylhexanoate) (Anon 1994). In theory, the presence of one or more of these specific metallic soaps could be used to distinguish late nineteenth century and early twentieth century oil paint films from those produced earlier.

CONCLUSIONS

Materials historians' knowledge can provide a framework for interpretation of analytical results and can also make an important contribution to the analytical strategy by providing not only a comprehensive list of possible materials in use at a given time, but also estimates of what proportions were likely to have been used. The advantage of having a specialist in materials history for a given medium is that information can be gathered from a range of recipes and periods, taking account of changing nomenclature and difficulties of language translation, and is therefore more likely to be representative. Only the limited number of conservators or conservation scientists who specialise in a particular material or period can devote sufficient time for primary research in such an area, while others now rely on secondary sources produced by materials historians.

The combined efforts of the materials historian and the conservation scientist lead to predictions which can be tested though the analysis of suitable samples from real works of art. Such studies, along with simulations of historic paints etc, lead to a better understanding of why some materials were used in preference to others that were equally easy to obtain, or why artists continued to use some materials which seem to us with hindsight to have conferred more problems than benefits. This improved model of artists' materials then indicates potentially useful areas for further analysis.

In order for the conservation profession to keep pace with developments in science and technology, greater access to other scientific specialists in a variety of disciplines is and will be needed. Conservation scientists have an expanding role in facilitating this access, while conservators and materials historians specialising in materials and techniques belonging to specific artifacts will provide the level of information commensurate with the sophistication of state-of-the-art scientific analyses.

Although not all participants in this inter-disciplinary approach were taught to work in this way, it is evolving successfully, and today the training of conservation students parallels this approach. Most carry out small research projects in treatment methods, documentary research, and analysis, before selecting a subject for a more serious project on which they may build research once they are employed. This would seem to be the working pattern for conservation in the future: the investment in travel and meeting time may seem at first to be considerable, but so are the benefits of gaining access to the knowledge base of a wide range of specialists, without the prohibitive expense of training and supporting them all.

ACKNOWLEDGEMENTS

The authors have learned much from collaborators and colleagues over the ten years that they have worked together; and Stephen Hackney and many others from the Tate Gallery conservation staff have contributed to many useful discussions, when LC was carrying out research in London. Bob Barclay and Stephen Hackney have provided constructive criticism on this paper.

REFERENCES

Anon, 1994. Driers and Metallic Soaps. *Encyclopedia of Chemical Technology*, 4th edn, vol. 8, 433, 441.

Anon, 1977-96. *National Gallery Technical Bulletin*, National Gallery, London.

Ara, K. 1990. *An investigation of Late 18th Century and Early 19th Century Thixotropic Media: Megilps and Gumptions*, Based on the Investigations Carried out by Leslie Carlyle from Documentary Sources, Student project, Hamilton Kerr Institute, University of Cambridge

van den Berg, K.J. Pastorova, I. Spetter, L. and Boon, J.J. 1996. State of oxidation of diterpenoid Pinaceae resins in varnish, wax lining material, 18th century resin oil paint, and a recent copper resinate glaze, in *ICOM-CC Preprints*, 930-7. London.

Bomford, D., Brown, C. Roy, A., Kirby, J. and White, R. 1988. *Art in the Making: Rembrandt*, National Gallery, London.

Bomford, D., Dunkerton, J., Gordon, D., Roy, A. and Kirby, J. 1989. *Art in the Making: Italian Painting Before 1400*, National Gallery, London.

Bomford, D., Kirby, J., Leighton, J., Roy, A., White, R. and Williams, L. 1990. *Art in the Making: Impressionism*, National Gallery, London.

Boon, J., Burnstock, A., Carlyle, L., Odlyha, M., Pages, O., Rainford, D., and Townsend, J. ongoing research, unpublished.

Boon, J.J., Pureveen, J. and Rainford, D. 1995. *The Opening of the Wallhalla* 1842: studies on the molecular signature of Turner's paint by direct temperature-resolved mass spectrometry (DTMS), in *Turner's Painting Techniques in Context* (post-prints), (ed. J. Townsend), 35-45, UKIC.

Boon, J.J. and van Och, J. 1996. A mass spectrometric study of the effect of varnish removal from a 19th century solvent-sensitive wax oil painting, in *ICOM-CC Preprints*, 197-205, London.

Carlyle, L. 1991. *A Critical Analysis of Artists' Handbooks, Manuals and Treatises on Oil Painting published in Britain from 1800-1900: with Reference to selected Eighteenth Century Sources*, doctoral thesis, Courtauld Institute of Art, University of London, vol. 1.

van der Doelen, G. and Boon, J. 1995. Mass spectrometry of resinous compounds from paintings: characterisation of dammar and naturally aged dammar varnish by DTMS and HPLC/GC-MS, in *Resins: Ancient and Modern* (eds M. Wright and J.H. Townsend), SSCR, 70-5, Edinburgh.

Harley, R. 1982. *Artists' Pigments c1600-1835*, Butterworths, London, 103.

Mills J. S. and White R. 1994. *The Organic Chemistry of Museum Objects*, 2nd edn. Butterworths, London.

Townsend, J. Carlyle, L. Khandekar N. and Woodcock, S. 1995. Later Nineteenth Century Pigments: Evidence for Additions and Substitutions, *The Conservator*, **19**, 65-78.

van der Wetering, E. and Peek, M. 1990. Database for art technological sources (TINCL), Historical Research Department, Institut Collectiv Nederland, Amsterdam. The collection of sources was begun by E. van de Wetering, and the database has been set up and maintained by M. Peek since 1990. e-mail cl 8ADM @ X54au.NL

Leslie Carlyle,[*] Senior Conservator, Canadian Conservation Institute, 1030 Innes Road, Ottawa, Canada K1A OM5

Joyce Townsend, Senior Conservation Scientist, Tate Gallery, Millbank, London SW1P 4RG, UK

[*] Author to whom correspondence should be addressed.

CAN SCIENTISTS AND CONSERVATORS WORK TOGETHER?

Ellen Ruth McCrady

ABSTRACT

When scientists and conservators argue with each other in person or in print, or when they ignore each other's presence in the same institution, this is a symptom of a common organizational problem. It surfaces in industry between the R&D division and production people, or when any two groups with complementary roles have to work cooperatively in the absence of arrangements to facilitate their interaction. Hostility is a result of the tendency to insularity that comes with membership of a professional work group, especially one in a large institution. Solutions may involve creating a go-between role or making arrangements to bring the two groups into better formal and informal contact, with the help of management. Arrangements that encourage employees to increase their contacts outside their own group, and to learn how members of the other group think, are crucial.

Key Words

conservation scientists, conservators, cooperation, conflict, administration

Sometimes I wish the field of conservation had a formal system of resolving public disputes between scientists and conservators - something more effective than a conference with invited papers, which have no mechanism for addressing issues and resolving them systematically. In this dream world there would be a judge and a jury, all of them specially trained in clear thinking, though not necessarily professionals themselves. On request, they would analyze published arguments and counter-arguments relating to the controversy in question, identify the sound arguments, analyze the faulty ones, and publish the results. This would be educational for all concerned, but it would be very expensive, of course, and in the end we would simply find that new controversies had arisen to replace the old ones, because the real problem is the continuing conflict between scientists and benchworkers.

Caroline Keck has described this conflict vividly and succinctly. She said, 'Not only do we fail to communicate well with the outside world, within our field only members of the same category tend to talk seriously with one another. This has to stop. One way to break the barriers is to discover precisely how the other fellow works.' She emphasises that the majority of members of both groups 'share basic intelligences and yearn for increased cooperation.' She also emphasises the need to abandon the generic dictums of the past and try to comprehend 'the details in each others' puzzles,' because artifacts are so variable in their materials, manner of construction, life experiences, and agents of deterioration, and we need to work toward our common goal of preserving the artifact (Keck 1995). Much of what I have to say in this paper is an elaboration of her theme, although I would define the problem as the wasted resources and lost opportunities resulting from the communication gap, rather than the communication gap itself.

There are distinguished precedents for Caroline Keck's diagnosis of the problem as one of a communication gap. The earliest one is Plato's allegory of the cave in the *Republic*, which surfaced again 2,000 years later as one of Francis Bacon's four idols, or sources of false opinion in scientific thinking. The Idol of the Cave is the domination by the customs of one's group, which distort our perceptions to conform with the group's beliefs and prevent us from reaching the truth. Multiple or changing group affiliations, however, give us a broader perspective and a more balanced judgement (Merton 1973).

Twentieth-century sociologists took up this theme when they studied the work setting and its influence on efficiency and other variables. Donald Pelz and Frank Andrews, for instance, looked at the work schedule of scientists in R&D labs and found that the most productive of them spent only half or three-quarters time in strictly research activities and the rest of their time in teaching and/or administration; the least productive were those who worked at research full time. This was true of both junior and senior people. After considering all other possible interpretations of their unexpected findings, they

concluded that the scientists' contacts outside their department, especially those in administrative work, actually stimulated rather than distracted them. It freed them, in short, from the Idol of the Cave (Pelz and Andrews 1969).

Whatever the setting, the natural tendency of ingroup members is to glorify their own group and to feel distrust and hostility toward any outgroup that is seen to be competing in some way, especially for the opportunity to publicly define what is right and true. These feelings are often directed at specialists who work in complementary roles in the same institution; but distance is no obstacle. Those who send letters to the editor from halfway around the world, expressing an incompatible viewpoint, may also be identified as outgroup members. A parallel could be drawn with the hostility between sports fans of opposing teams, or members of different ethnic or religious groups, but I will focus on what happens within organizations, because this is where most is to be gained by improving relationships, and where solutions have been applied. (I suspect that the institutional environment tends to isolate working groups from each other, partly because formal relationships between departments are closely regulated and people don't want to risk stepping over the line.)

BRIDGING THE GAP IN OTHER FIELDS

Managers of R&D divisions in large corporations face a challenge very much like that faced by managers in institutions with conservation departments and research labs. One of them summarized it very well almost 30 years ago. He was the Director of Engineering Services in the R&D lab of the National Cash Register.

> A 'translation gap' occurs in various degrees in every organization at the point where product or process designs are transmitted to the manufacturing organization for reduction-to-practice on a production basis. It represents a focal point of total corporate interaction since within its bounds occurs the inevitable confrontation of human resistance to change, urgency to meet product schedules, new technology infusion into products, interdisciplinary language problems, continuing design alterations, and corporate cash commitments, to name but a few.....
> The translation gap demands that every cognizant company division rigidly discharge its assigned responsibilities, but do so with a firm grasp of the importance of compromise and cooperation (Moore 1970).

The quality and complexity of the information tools required to bridge the translation gap, he says, have increased along with technology and product complexity. Human relations skills become important not only because the task today is more complex, but because of 'the vital factor of group identification, or group loyalty, or group centricity.'

Slowly but surely each group begins to think that they perform in a near-perfect fashion, and that problems, delays, and crises are the result of the inadequacy of others ... and the concept of overall corporate group loyalty becomes a secondary consideration.

He suggests certain courses of action that can ease the pain of dealing with this kind of situation. These include:
- significantly improved communications;
- the establishment of an interdisciplinary group specifically devoted to bridging the translation gap;
- broader use of the product or process manager concept within production areas;
- technical upgrading of production personnel specifically at the R&D interface.

He describes three techniques that can improve information flow:
- assign manufacturing personnel to work with the scientist or engineer as the product nears the end of the development cycle;
- transfer R&D personnel directly to production for an indefinite period of time, perhaps permanently, as the program is transferred;
- hold mutual product reviews during the R&D cycle, along with reciprocal technical seminars.

Note that when he speaks of 'information flow,' he means either the movement of knowledgeable people to the point where the information is needed, or face-to-face instructional sessions. Note also that he places just as much emphasis on R&D personnel learning about production as he does on production people learning about R&D.

He does not say whether the measures he advocates were actually used at his place of work, but similar measures were being used at the 3M Company at that time, and have been adopted more widely since then. Similar measures are also being used in Japan, where corporations have become skillful at managing knowledge.

into the overall business plan, and that innovations have champions among the senior management. Japanese companies are also more willing to enlist the (unwitting) help of consumers in designing products. Mitsubishi test-markets its latest camcorders in Tokyo's Akihabara electronics-retailing district, and withdraws them quickly if consumers fail to bite.

In Japanese firms, an apparent surfeit of managers can often be crucial to innovation. Employers routinely rotate personnel, often between vastly different areas, in order to broaden their minds and give them an overall view of the company (Anon 1996).

Jack Morton, who played a role in the early development of the computer, contributed two chapters to the book *The R&D Game*. He wrote,

> The people who design components and the people who devise the processes for making them must work together in an inseparable loop of activity. Close and daily association of development-manufacturing people is essential to resolve cost-quality conflicts through design-process trade-offs (Morton 1969).

BRIDGING THE GAP THROUGH REPRESENTATIVES OR CONSULTANTS

In southeastern Mexico, a coalition of nonprofit agencies has been successful at persuading farmers to adopt the use of a beneficial plant called the velvetbean, a leguminous 'green manure' crop. This project purposefully relies on farmer-to-farmer communication to spread the news to farmers who have not tried it yet. Its advantages are overwhelming: it drastically reduces soil erosion on the steep plots common to that area, and doubles or triples the yield per acre. Over the last five years, use of the velvetbean has increased 23-fold in the Catemaco area where it was introduced.

> In Catemaco, farmers are not being treated as receptacles to be filled with ideas from scientists but as innovators - and as collaborators with each other ... The velvetbean project has thus encouraged farmers to teach each other what they know.

'Likewise,' says Buckles (an anthropologist formerly with the project), 'we as researchers can learn from what they are doing to solve problems.' Farmers have also identified six other useful legumes with potential as green manure crops (Tenenbaum 1996).

In this case, as in so many others, the key to a productive long-term relationship between researchers and practitioners was free and respectful two-way communication.

Suppliers in the printing industry who are called in to troubleshoot for their customers are advised in a recent publication from GATF to make sure that they listen as well as advise; use the same terminology that the customer uses; let people watch him solve the problem; and talk to the people involved. Before doing anything, however, the troubleshooter is advised to listen, write down the problem, then confirm it and go over every piece of evidence thoroughly.

All this sounds like nothing more than advice to the troubleshooter to do a good job fixing whatever had gone wrong, but it is also intended to improve the social atmosphere in which he has to work. The printshop air may be heavy with hostility toward the representative of the supplier, whom they blame for their problem. Some of the advice in this article has to do with measures the rep. can take to deflate hostility so that real communication can take place. For instance:

> Once when I encountered a very hostile situation, I spent about 15 minutes unpacking only half of my technical services kit. About eight people had already gathered around, asking about the devices I was unpacking. During the next 15 minutes, we managed an informative seminar on dot gain, and I eventually gained the trust of the entire pressroom (Prince 1996).

ENCOURAGING IMPLEMENTATION OF RESEARCH FINDINGS

The US government has funded a great many investigations to find out why so few educators, social workers, managers, and farmers were utilizing the results of government-sponsored research. The results of these investigations are nicely summarized in a book entitled *Putting Knowledge to Use* (Glaser *et al.* 1969) Under the heading 'Collaboration Between Researchers and Practitioners,' it describes six factors associated with successful applied research:
- the most important factor was the identification and development of a research problem that reflects the interests and concerns of those affected by the research project.
- Practitioners should be involved in all phases of the research. Once an area of research need is identified, the collaboration should continue through problem formulation, study design, data collection, interpretation of findings, and

245

application of the results. This makes practitioners not only better informed but more committed to making use of findings.

- An important consideration is the need for the research team to contain a representative of the agency's top management. The person representing administration must have policymaking power.
- Frequent honest and open communication between researchers and practitioners reduces the likelihood that obstacles will emerge in the study and increases the chances that research findings will be put to use.
- The expectations of practitioner and administrator of the research need to be clarified at an early stage.
- Research is also more likely to proceed smoothly when, before starting the project, there is a very explicit understanding between researchers and agency administrators regarding reciprocal responsibilities.

Among the studies reviewed in the above book is one that compares the characteristics of five successful and five unsuccessful projects: factors influencing the success of applied research. It too stresses early communication and full involvement of users (Glaser and Taylor 1969).

RECOMMENDATIONS FROM THE FIELD OF CONSERVATION

A Canadian conference in 1990, 'Shared Responsibility,' gave consideration to the roles of scientists, conservators and curators in the museum.

Kirby Talley (art historian), at a 1995 conference, 'Conservation Science in the UK 95,' gave a paper in which he urged scientists to become more familiar with the arts and the materials used in art; he also urged them to make science more palatable for the conservator.

Duane Chartier (scientist/conservator) spoke at a meeting of the New York Conservation Society, strongly recommending that science be integrated into conservation more than it is at present. He would like conservators to have respect for and ability to use fundamentals; an intimate knowledge of materials past and present; a statistical understanding of real processes; the ability to use reliable predictive models; a ruthlessly self-critical attitude; and imagination, intuition and luck.

Robert Organ (scientist) suggested in a letter to the editor of the July *AIC News* that we consider bridging the divide between scientists and conservators by opening up a new category of conservation: the 'conservation engineer,' who might be able to apply the laws of science to the solution of practical problems (Organ 1996).

Mary Striegel (scientist), in the May *AIC News*, told how she had come to understand what 'the great divide' was while observing the reactions of conservators at a symposium on museum exhibit lighting and, incidentally, observing her own reactions to them. Her comments about the 'great divide,' starting with her definition of it, are worth quoting.

> The scientist searches for truths. The conservator searches for solutions. The question becomes, how can we bridge this divide? How do we put aside our pride long enough to understand each other's language? Will conservators come to appreciate that there are no absolutes in science? Will they see that solutions are built upon knowledge and that the accumulation of knowledge takes time? Will scientists see that some answers are nevertheless urgent? Will they take a chance and make recommendations now? Will they offer tools for problem solving? Whose responsibility is it to interpret and disseminate the information being presented by scientists? In typical scientific fashion, I offer no solutions to this dilemma. Asking these questions, however, can perhaps encourage a better dialogue between conservators and scientists (Striegel 1996).

Nobody mentioned one solution that works very well, though it only affects the outlook of two people: for a conservator and scientist to get married. This is an educational and broadening experience for both parties.

A WORD OF ADVICE FOR MANAGERS

I would like to give a word of advice to managers who supervise researchers or conservators. Make sure the intellectual and professional needs of both groups are taken care of, because when people feel isolated or deprived, their relationship with outgroup members tends to deteriorate. Moravcsik (1974) says it is best to have four or more scientists in a lab in an underdeveloped country, to combat feelings of professional isolation. In a developed country, perhaps two or three are enough, provided they are able to attend conferences in their specialty, and are allowed time to perform and publish their research.

Scientists are known for not liking supervision very much, so they may resist measures to encourage

communication with the conservators, however minimal (Steele 1969). Yet management holds the key to harmony between the two groups, because only management can provide some of the important conditions that encourage productive interaction. So have courage; keep your people fully informed, and proceed with care.

DISCLAIMER

In writing about what I see as a social or group phenomenon, I have had to use generalizations. This does not mean that I think all conservators or scientists are hostile to members of the other group, or that a communication barrier exists in every instance. In fact, I have had to restrain myself to keep from interjecting, 'But So and So [a chemist] would answer anyone's questions about chemistry, clearly and good-naturedly,' or 'So and So [a conservator] gave an update at the Book and Paper Meeting of AIC, and emphasized the importance of science in conservation. She ended her talk with the words, 'Take a chemist to lunch today!'

REFERENCES

Anon, 1996, In faint praise of the blue suit, *The Economist*, Jan. 13, 59-60.

Glaser, E.M., Abelson, H.H. and Garrison, K.N. 1976. *Putting Knowledge to Use: a Distillation of Literature Regarding Knowledge Transfer and Change*, Human Interaction Research Institute, Los Angeles.

Glaser, E.M. and Taylor, S. 1969. *Factors Influencing the Success of Applied Research. Final Report on Contract No. 43-67-1365*, National Institute of Mental Health, Department of Health, Education, and Welfare. Washington, DC. Summarized in *Putting Knowledge to Use*, 189-91.

Keck, C.K. 1995. Conservation and controversy (letter to the editor), *IIC Bulletin*, no. 6.

Merton, R.K. 1973. *The Sociology of Science: Theoretical and Empirical Investigations*, Chicago and London.

Moore, R.F. 1970. Five ways to bridge the gap between R&D and production, *Research Management*, **13**, 367-73.

Morton, J. 1969. From Materials to Systems, in *The R&D Game* (ed D. Allison), 236-5, Cambridge and London.

Moravcsic, M.J. *c*.1974. *Science Development: Toward the Building of Science in Less Developed Countries*, Bloomington, Indiana.

Organ, R.M. 1996. Bridging the Conservator/Scientist Divide (letter to the editor), *AIC News*, **6**.

Pelz, D. and Andrews, F. 1969. Diversity in Research, in *The R&D* Game (ed D. Allison), 73-89, Cambridge and London.

Prince, R.J. 1996. Troubleshooting tips for printers and suppliers, *GATFWorld*, **8**, 10.

Steele, L. 1969. Loyalties, in *The R&D Game* (ed D. Allison), 146-56, Cambridge and London.

Striegel, M.F. 1996, Point of View, *AIC News*, **24**.

Tenenbaum, D. 1996. Fertilizing scientist-farmer collaborations, *Technology Review*, 22-3.

Ellen Ruth McCrady, Abbey Publications, 7105 Geneva Dr., Austin TX 78723, USA